Advance Praise for

Digital Contagions

"Inspired by the work of Paul Virilio, Friedrich Kittler, and Gilles Deleuze, this book chronicles the contemporary digital landscape through the menagerie of email worms and computer viruses that infect and define it. A self-described media archeologist, Jussi Parikka is both theoretically nuanced and technically detailed, a welcome relief coming on the heels of dotcom hysteria over digital hygiene. The result is a becoming-viral of today's technological culture. It is essential reading for anyone infected by the digital contagion."

—*Alexander R. Galloway, Assistant Professor, Department of Culture and Communication, New York University; Author of* Protocol *and* Gaming

"*Digital Contagions* is the first book to look at the computer virus as a historical and cultural phenomenon, rather than simply as a technological issue. It brilliantly recounts the history of the emergence of such viruses in the context of other epidemics, and how these different kinds of contagions are ineluctably bound together in our technologized, digital culture. The book is an essential text for helping us come to terms with the massive changes this emerging culture is bringing about."

—*Charlie Gere, Reader in New Media Research, Lancaster University; Author of* Digital Culture *and* Art, Time and Technology

Digital Contagions

Steve Jones
General Editor

Vol. 44

PETER LANG
New York • Washington, D.C./Baltimore • Bern
Frankfurt am Main • Berlin • Brussels • Vienna • Oxford

Jussi Parikka

Digital Contagions

A Media Archaeology of Computer Viruses

PETER LANG
New York • Washington, D.C./Baltimore • Bern
Frankfurt am Main • Berlin • Brussels • Vienna • Oxford

Library of Congress Cataloging-in-Publication Data

Parikka, Jussi.
Digital contagions: a media archaeology of computer viruses / Jussi Parikka.
p. cm. — (Digital formations; vol. 44)
Includes bibliographical references and index.
1. Computer security. 2. Computer viruses. 3. Computer networks—
Security measures. I. Title.
QA76.9.A25P376 005.8—dc22 2007006863
ISBN 978-1-4331-0093-2 (hardcover)
ISBN 978-0-8204-8837-0 (paperback) 09-12-07
ISSN 1526-3169

Bibliographic information published by **Die Deutsche Bibliothek**.
Die Deutsche Bibliothek lists this publication in the "Deutsche
Nationalbibliografie"; detailed bibliographic data is available
on the Internet at http://dnb.ddb.de/.

Cover design by Lisa Barfield

The paper in this book meets the guidelines for permanence and durability
of the Committee on Production Guidelines for Book Longevity
of the Council of Library Resources.

Printed in the United States of America

CONTENTS

Chapter Three:

ACKNOWLEDGMENTS

Doing research is a heterogeneous assemblage, and books actualize only through various force fields. These include at least economic, institutional, social, conceptual, and affective elements. Economically I am grateful to The Finnish Cultural Foundation, Emil Aaltonen foundation, Jenny & Antti Wihuri foundation and also the TIESU-project, funded by the Research Program for Advanced Technology Policy (Proact), the Ministry of Trade and Industry and the National Technology Agency, Tekes.

Institutionally, I want to thank the departments of Cultural History and Digital Culture at the University of Turku (Finland) and all the colleagues there for feedback and a pleasant working atmosphere. A major part of this work was, however, written "in-transit", and I want to extend a thank you for their hospitality to the departments of Media Studies at the University of Amsterdam (professor Thomas Elsaesser) and the Berlin Humboldt University (professor Wolfgang Ernst), respectively.

As for individuals, so many are to be thanked. Hannu Salmi, Matthew Fuller and Jukka Sihvonen gave continuously invaluable advice. Charlie Gere and Tiziana Terranova are to be commended for their input at a late stage of the work.

Others that should not be forgotten include (in no particular order): Raine Koskimaa, Tony Sampson, Sakari Ollitervo, Milla Tiainen, Pasi Väliaho, Matleena Kalajoki, Katve-Kaisa Kontturi, Ilona Hongisto, Teemu Taira, Geert Lovink, Olli Pyyhtinen, Floris Paalman, Petri Paju, Petri Saarikoski, Tanja Sihvonen, Jaakko Suominen, Silja Laine, Maija Mäkikalli, Mikko Hyppönen and the various people I interviewed for the book.

Thanks (again) to Henri Terho for his expert work with the layout of the book. In addition, without the help of Sirpa Kelosto I would have been lost.

The people at Peter Lang were extremely professional and helpful when finishing this book. Of course, a special thanks goes to Steve Jones as the editor of the Digital Formations series.

Finally, I want to thank the most important one: my fellow voice (against the grain) in life, who taught me to endure opera, enjoy *Pride & Prejudice*, and the art of surviving everyday life quite happily—thank you Milla!

Parts of this work have already been discussed in journals, especially in

"Digital Monsters, Binary Aliens – Computer Viruses, Capitalism and the Flow of Information." *Fibreculture*, issue 4, URL: <http://journal.fibreculture. org/issue4/issue4_parikka.html>;

"The Universal Viral Machine – Bits, Parasites and the Media Ecology of Network Culture." *CTheory – An International Journal of Theory, Technology and Culture*, 15.12.2005. Url: <http://www.ctheory.net/articles.aspx?id=500>;

"Viral Noise and the (Dis)Order of the Digital Culture". *M/C Journal of Media / Culture*. URL: < http://journal.media-culture.org.au/0501/05-parikka. php> and

"Contagion and Repetition – On the Viral Logic of Network Culture." *Ephemera: Theory & Politics in Organization*. URL: <http://www.ephemeraweb. org/> Forthcoming.

I wish to thank the journals for the permissions to use parts of those texts also in this book.

INTRODUCTION: THE GENERAL ACCIDENT
OF DIGITAL NETWORK CULTURE

As usual, everything negative remains untold, yet it is, interestingly enough, always there, in an embryonic form. How is it possible to state that technologies are being developed, without any attempt being made at learning about the very specific accidents that go with them?[1]
— *Paul Virilio (1999)*

Any information system of sufficient complexity will inevitably become infected with viruses: viruses generated from within itself.[2]
—*Neal Stephenson, Snow Crash (1992)*

DISEASE AND TECHNOLOGY

The history of media and technology is filled with accidents and breakdowns. The train introduced the train accident, with the boat came the boating accident, and inherent in several techniques of data storage, such as papyrus, paper, and film, is the "accident" of the erasure of information.[3] Even the telegraph, the early network technology of the nineteenth century, was vulnerable to problems, as perceived in 1846 by Dr. Barbay, a semaphore enthusiast:

> No, the electric telegraph is not a sound invention. It will always be at the mercy of the slightest disruption, wild youths, drunkards, bums, etc. (…) The electric telegraph meets those destructive elements with only a few meters of wire over which supervision is impossible. A single man could, without being seen, cut the telegraph wires leading to Paris, and in twenty-four hours cut in ten different places the wires of the same line, without being arrested.[4]

As technological accidents have a history, so do diseases. Causes of diseases, which since the nineteenth century have been mainly recognized as harmful

minuscule actors, infectious bacteria and viruses, affect the very basics of human societies, and at the same time the structural dynamics of societies condition the spatio-temporal occurrences of disease outbreaks. Diseases are symptomatic of the ways cultures interact. They reveal paths of communication and commerce, of interaction and cultural hierarchies, which form the networks of a society: what affects what, who frequents whom and where, and so forth. Diseases *expose*.

The improvement of road networks from late antiquity exposed populations to a growing number of infectors, especially via the Silk Road, but a major change occurred with urbanization, industrialization, and the new communication channels of steamships, railroads, and airplanes, which connected people and germs more efficiently than ever. The Black Death that infected Europe in the fourteenth century was to a large extent an expression of the new paths of communication and transmission paved by the Mongol empire, as well as the new ship routes connecting the Mediterranean to the northern parts of Europe. In the nineteenth century, steam in the form of locomotives and transoceanic ships helped micro-organisms to create a single, near-global disease pool.[5]

At the end of the twentieth century another form of technological accident caused an immense amount of public anxiety that seemed to combine these lineages of technological accidents and disease patterns. Computer viruses and worms, as the latest occurrences in the history of diseases, caused something that was referred to even as hysteria—the key sexed disease of the previous *fin de siècle*. Viruses became a sign of the *fin de millennium*, similar to such accidents as Chernobyl, AIDS, and Ebola, threatening to turn digital memory banks into "terminal gibberish."[6] As Wolfgang Schivelbusch notes, before industrialization, accidents seemed to refer to "coincidences" that attacked from the outside, usually in the form of natural catastrophes such as storms and floods. With industrial machines, the accident became an internal problem as technologies threatened themselves as a result of their own power.[7] The recent decades of Western modernity have been filled with technological accidents, perceived as risks to be minimized and managed, signified, and valorized in the (mass) media system (in the traditional definition of print media, television, and, for example, cinema). The utopia of the global village, articulated by Marshall McLuhan in the 1960s,[8] and the vast number of accounts celebrating networks and cyberspaces as the key utopian (non)places of recent decades showed their flipsides to be a dystopia of global risks and accidents.

Digital Contagions analyzes the archaeological layer that made it possible to conceive and program such an entity as a "computer virus" or a "digital worm." What are the material and incorporeal conditions of existence for such

oxymoronic entities of the network age? *Digital Contagions* complexifies the tech-
nological definition and understanding of computer viruses. The book proceeds
as an encounter between my position as a cultural historian/media archaeologist
and cultural theories, in particular those of Gilles Deleuze and Félix Guattari.[9]
Hence, throughout the book there is a very strong tendency to historicize, argue
through historical sources, and use history (in the sense of archaeology) as a
method of situated knowledge: to pinpoint strategies of knowledge as historical
and contingent and to analyze within a meshwork of perspectival positions that
resist "categorical a priori condition[s] of knowledge."[10] In this introduction I give
a general context, a territorialization, and highlight the importance of mapping
the accidents of network media. I discuss the central theories and methodologies
of the book, as well as the sources, and then consider the politico-ethical perspec-
tives of such a media archaeological and ecological approach.

I analyze the network accident of computer viruses as part of the digital
culture of Western modernity, focusing on the high era of computerization, that
is, the 1970s, the 1980s, and the early 1990s. As I argue in this book, I see
that the crucial issues, discussions, and positions concerning viruses and worms
were already visible before the mid-1990s, which is why I want to underscore
these earlier threads and lineages in this discourse network.[11] This means that I
focus primarily on issues before the rise of the popular Internet in the mid-1990s.
This choice is in accordance with my belief that historical and temporal perspec-
tives can bring forth novel rewirings and short-circuitings for present discussions
and practices. I do, however, bring in elements of an even longer duration, espe-
cially from the early computer projects of the 1940s and 1950s. Hence, *Digital
Contagions* analyzes the media archaeology of this specific computer accident as a
symptom of a more abstract cultural diagram. Computer viruses and worms and
similar incidents are not, then, antithetical to the general culture of networking
and digitality but, as the book argues, at the very center of such enterprises. The
digital virus is not solely an internal computer problem but a trace of cultural
trends connected to consumer capitalism, digitality, and networking as the central
cultural platforms of the late twentieth century. The virus is also an expression of
the media ecology and the so-called biological diagram of the computer where
the biological sciences are actively interfaced with computer science, often with a
special emphasis on bottom-up emergence.[12]

In this task, I am following Michel Foucault's well-known and widely applied
ideas of cultural archaeology and genealogy.[13] Although I cannot claim to be as
thorough and comprehensive as Foucault in his archaeology of human sciences,
I proceed in the same manner when understanding the primary question to be

one of cultural mechanisms, or forces, that give birth to specific, recognizable phenomena. The question is not so much what a computer virus is, but more how it came to be what it is. This historical questioning requires that we focus on the circumstances of a thing, not its essence.[14] The archaeological and genealogical perspective sees cultural ideas, statements, and practices as effects of preindividual forces, which from time to time are condensed from the fleeting flows of molecular movements into more stable cultural consistencies. Cultural practices and entities that seem stable and autonomous always owe their existence to more general and abstract discourse networks, and my aim is to focus on this discourse network that makes computer viruses intelligible—in discourse and in practice.[15] Hence, media archaeological excavation is committed to seeking the conditions of existence of cultural phenomena and the interplay between continuities and discontinuities.

The theoretical underpinnings are always developed in a temporal and historical perspective, where temporality is seen as a polymorphous and overlapping layering, a coexistence of multiple temporal fields of longer and shorter durations.[16] Thus, in the same manner as viruses are an integral part of the computer architecture developed by John von Neumann,[17] they are an integral part of the network culture of the late twentieth century, sprouting during the early years of computing in the 1940s, taking a more familiar shape since the 1960s and 1970s as networking became a key paradigm for computing, and bursting into bloom during the 1980s and early 1990s with personal computers, the Internet, and the consumerization of digital culture. My main temporal emphasis is on the period between the von Neumann machines ideated around the end of the 1940s and start of the 1950s and the early years of the popular Internet, until 1995. Of course, this does restrict me from taking into account the multitemporal remediations that open up the viral contagions of the late twentieth century toward longer durations and wider media archaeologies of modern media technology in general.

This insight concerning the coalescence of the viral with the digital accords with how I define the idea of a general accident. An accident, as Paul Virilio writes, is not in this context intended to mean the opposite of absolute and necessary, as Aristotelian metaphysics has maintained. Instead, accidents are an inherent part of an entity. Accidents are internal to technologies: "Since the production of any 'substance' is simultaneously the production of *a typical accident*, breakdown or failure is less the deregulation of production than *the production of a specific failure, or even a partial or total destruction*."[18] For Virilio, the generality of the contemporary accident stems from its specific temporality. Key contemporary accidents,

whether the 9/11 strikes, the 1987 stock exchange crash, or the Gulf wars, are events that touch the whole globe simultaneously. Such incidents of simultaneity and ubiquity are illustrative of the cybernetic networks of global scale that take over the spatial world of human perception.[19] In my take, computer accidents illustrate similar features. Even if computer errors such as viruses can be argued to be just a *specific* form of technological accident, they reveal a whole thematics of accidents and risks embedded in issues of globalization, digitalization, mediatization, and risk society, that is, the key themes of Western societies since World War II. Yet, "general" does not mean "universal" in the sense that I would claim viruses and worms as the only accidents of network technologies. Instead, we have a bunch of faulty code, bugs, and spam that shows that the viral is merely one situated perspective on the issue. For instance, experts have recently warned that malicious remote-controlled software bots are a much more threatening form of program code than viruses.[20]

In any event, computer viruses can be conceived of as internal to the media ecology of digital capitalism, just as earlier technological accidents resided as constant potentialities within the functional systems of transport, communication, recording, and calculation. As the epigraph to this introduction by the fiction writer Neal Stephenson underlines, accidents can be understood as emergent phenomena on the level of socio-technological processes. Accidents are not external, but are perhaps *hypertrophical* of the "normal" functioning of a technological machine. Accidents do not merely break the rules of a system, but actually use and bend them to their limit, exposing them along the way. In this sense, even though Virilio brings in important insights regarding the ontology of technological accidents, his stance remains too negative. Virilio's argumentation is too involved in a work of "phenomenological mourning" that tends to see accidents in linear terms. My aim is, in contrast, to emphasize the affirmative perspective we can take on accidents, events, and hence viruses by considering them as *events* that are overflowing their rigid territorializations (as malicious software).[21]

In a more concrete manner, we can see how a digital accident connotes not merely local problems. Digitalization as the celebrated technical platform for network capitalism has achieved its place as the key archive form for sounds, images, and texts. At the same time, cultural techniques are increasingly digital techniques, whether we are referring to labor done in offices or the huge growth of digital entertainment services. Manuel Castells has divided the rise of digital network society into several distinct steps. For Castells, key components within this history of digital culture were the new technical paradigms such as ARPANET (1969), integrated circuits (1971), personal computers (1974–1976), the soft-

ware revolution, UNIX (1974), TCP/IP-protocols (1973–1978), which made the Internet technologically possible at the end of the 1980s, and so forth.[22] Even if this technological perspective is insufficient given the whole of cultural reality, it provides an understanding of the material discourse networks with which cultural reality is intermingled. The material understanding of culture emphasizes that cultural meanings, articulations, perceptions, metaphors, statements, and discourses are not free-floating ideal signs and ideas; they are very deeply rooted in the information channels that make them possible. Meanings and significations happen always on concrete "platforms", media archival layers, or *discourse networks*, which connect people, institutions, devices, and so on in a discursive and nondiscursive sphere. I will return to this point when I discuss the theoretical undercurrents of *Digital Contagions*.

The material characteristics remained immanent to incorporeal and abstract events on the socio-cultural and economic scales. The major crises of capitalism (1973–1975) and Soviet-led statism (1975–1980) coincided with the new technologies of digitality, a trend especially visible as information capitalism, which profited from the deregulation, liberalization, privatization, and globalization of this ascending world order, or "Empire" as Michael Hardt and Antonio Negri named it.[23] In *Empire* they argue that this turn toward information capitalism took place in the 1970s and at the end of the Vietnam War, after which transnational companies spread across the globe, and digital flexibility and information networks expressed the material basis of this new global order. In other words, networks of globalizing scale became the key vectors of power, wealth, and control via the material discourse networks supported by multinational computer business corporations from hardware network production to operating systems and software: "The novelty of the new information infrastructure is the fact that it is embedded within and completely immanent to the new production processes. At the pinnacle of contemporary production, information and communication are the very commodities produced; the network itself is the site of both production and circulation."[24]

Consequently, the apparent disruption of these sites of power and control is a general accident of machinery that by definition rests on establishing communications and networks on a global scale. As *Scientific American* wrote in 1986, in the midst of the emerging digital boom and the coming age of the Internet:

> This is an age of proliferating connections: among people, among machines, among silicon chips within a machine, among transistors on a silicon chip. Information is processed by networks of chips and communicated through much vaster networks of copper cables and glass fibers by electrons and photons. There are alternatives to such networks: people can travel to meet one another face to face, and they can process data themselves

rather than having computers do the job for them. But in most cases these are poor alternatives compared with what it is now possible to accomplish through electronic and photonic connections. As a result functions once carried out by people are increasingly being carried out by systems of electronic and photonic materials.[25]

To view this culture of connections from another angle, information technologies are on a material/corporeal level the stuff that increasingly holds together the symbolic (representational) frame of contemporary culture. What is distinctive in this cultural logic is a certain "totalitarian" technological basis of this environment. More than ever, a single technological accident, a computer virus or a bug, could wipe out major parts of Western cultural memory, invested in the digital products and networks of the cybernetic era. A virus can accomplish a rupture in such a symbolic frame of media culture both incorporeally and in the form of the very material interruption it can achieve in the normal functioning of a society—a virus is a disruption to the everyday logic and rhythm of the social order, a catastrophe. By adding itself, for instance, into executing code, a virus can translate a portion of technical code into repercussions across scales from economics to politics.[26]

Digital Contagions has three main themes: (1) fear and security, (2) body, and (3) artificial life (ALife). In the first chapter, the focus is on computer security discourses and practices, especially since the 1970s. Computer viruses appeared in the science fiction novels of the 1970s—for example, David Gerrold's *When HARLIE Was One* (1972) and John Brunner's *The Shockwave Rider* (1975)—but it was only in 1983 that Fred Cohen, a computer scientist, engaged in experiments that marked the birth of "digital virology." Cohen saw the potentially malicious nature of these miniprograms, depicting them as forms of risk and danger given the increasing reliance of institutions on computer infrastructure in the form of local area networks, plans for larger networks, software production, and so forth. The first chapter analyzes the technological, political, and economic tendencies in computer virus discourse, revealing how deeply the definitions of computer worms and viruses are embedded in issues of media, risk society, and (viral) capitalism.

Around 1985–1986 computer viruses reached the public consciousness for the first time and were from the beginning described as "malicious miniprograms" and as threats to national security, international commerce, and the private user. The Pakistani Brain virus of 1986, Jerusalem of 1988, and Datacrime of 1989 were discussed widely in newspapers, but the 1988 Morris worm, or the Internet worm as it has also been called, especially alarmed the computing community and the general public. It became a topic of TV news and newspaper

headlines, and it was discussed for years. Viruses and worms were no longer just self-spreading programs with which to test the coming age of network society; they were charged with a plethora of meanings, connotations, and articulations drawn from discourses of disease and disease control, crime, and international politics. Hence, what was only the imagination of some science fiction writers in the mid-1970s became very real just ten years later.[27] As a cultural historian, I regard fiction not as an impoverished shadow of the real but as an active force of creation that can articulate issues that are neglected in more accepted modes of production of knowledge—in science and engineering, for example. In this sense, the early novels, depicting computer viruses, act as powers of the false and powers of fiction, which destabilize the actual and generally accepted notions of malicious software.[28]

In Chapter 2, "Body: Biopolitics of Digital Systems", I give special attention to the virus culture of the 1980s as a culmination in several senses. "Viruses" and "virality" became central cultural figures in the sense in which tuberculosis had been in the nineteenth century and cancer in the 1970s.[29] Such figures relate, of course, to the general *medicalization* of Western culture. The whole of popular media culture became filled with parasites and viruses from the 1980s onward, pointing toward a new understanding of the openness of the body to its surroundings. The virus and virality marked a liminal state of ambiguity where the established borders of identity—whether biological or computational—became obscure and leaky. The human immunodeficiency virus (HIV) was at the center of numerous contested articulations concerning the actions, sexualities, ethnicities, etc. of human bodies; the computer virus (or the computer AIDS, as it was often referred to) incorporated several similar fields of struggle, on which contests over "proper use of computing", "safe hex",[30] "digital hygiene", and other key discursive events took place. Consequently, the chapter addresses the discourses and practices of immunology, disease, healthy computing, and digital hygienics particularly as they were expressed in the 1980s, during the AIDS debates. Just as a judge pronouncing "guilty" transforms a person into a criminal, the various "pronouncements" of the heavily loaded term "virus", with all its associations, turns technological objects into malicious software, effecting incorporeal transformations.[31] This chapter, then, adds to the more technological and corporeal themes mapped in the first chapter, using as its key concept the incorporeal transformations of a body.

The third chapter, "Life: Viral Ecologies", expands the biological emphasis of the second chapter and supplements the technological themes of the first chapter, moving in the direction of questioning the thematics of media ecology. Here

I argue that technological evolution and the notion of self-spreading computer programs have much more widespread roots in the cultural history of modernity than the security-oriented notion a computer virus implies. Von Neumann's theories of cellular automata from the 1940s, Norbert Wiener's ideas of self-reproducing machines from the same age, the whole agenda of cybernetic automation of culture in the postwar era, the sciences of artificial life since the 1980s, and even the 1872 novel *Erewhon* by Samuel Butler all testify to this widespread notion, or cultural theme, of technological life. In addition, by contributing a whole chapter of the book to artificial life, I want to emphasize the multiple contexts of the phenomenon. Even though a major portion of the public discourse of computer worms and viruses has underlined the negative sides of these "malicious miniprograms" as products of vandals and criminally oriented psychotic people, they are culturally overdetermined in a way that makes it impossible to reduce them to being solely harmful. Hence, the key concepts or themes of the chapter revolve around ecologies of networking, systems of complexity, and life as connectionism (the stuttering *and-and-and*).

Especially at the beginning of the 1990s, the question of "beneficial computer viruses" emerged. The very same Fred Cohen who had in 1983 depicted viruses as potential threats to organized society reminded his readers of the positive possibilities these miniprograms have. Analyzing viruses in the contexts of nanotechnology, artificial life, and evolutionary software, he saw computer viruses not just as malicious and nasty pieces of program code.[32] In a similar vein, Mark Ludwig sparked a whole range of discussion and critique with his books on viruses and artificial life, which included instructions for coding such programs.[33] Interestingly, and implicitly, this discourse articulates the slowly developed understanding of the new networked media spaces as environments and ecologies, thus reflecting general trends of computing and digital culture. As McKenzie Wark proposed, perhaps the digital culture of the late twentieth century is to be understood as nature, a *third* nature that supplements the two previous ones. As industrialization changed the first biological and chemical nature into a product and a standing reserve for the accumulation of wealth in a society, so the third nature is a continuation of this process of translating nature into terms of technology. "Second nature" was something conceptualized by Hegel, Marx, and Lukàcs, as Wark writes, and his own analysis of the third nature of simulated digital culture proceeds with Castells and Deleuze and Guattari.

The telegraph began the process, bypassing the spatio-temporal coordinates of locality and sowing the seeds for a global network of virtual spaces, described metaphorically during the 1980s as "cyberspace" by some more enthusiastic

writers. With this new arena and nonplace of speed and *telesthesia* (perception at a distance), the speed and flow of information became the new earth, an artificial nature, a media sphere: "Second nature, which appears to us as the geography of cities and roads and harbours and wool stores is progressively overlaid with a third nature of information flows, creating an information landscape which almost entirely covers the old territories."[34] With the discovery of electromagnetism and the electric telegraph, messages were detached from the bodies of messengers and seemed to inhabit a sphere and a life of their own. This also created a new sense of the global, where consequently disruptions, too, achieved a global sphere. Goods, money, and people circulate, but also garbage, crime, and disease.[35] This applies to the information nature of the third order as well: as AIDS has revealed the global patterns of disease in contemporary societies, so computer worms and viruses make visible the global tendencies of electrical nature that originated in the nineteenth century with the beginning of telecommunications, specifically the telegraph.

Where Chapter 2 offers a deeper understanding of how the figurations of the computer body and illegitimate tropes of computing coalesce, Chapter 3 attempts to understand why worms and viruses, those quasi-autonomous programs with self-spreading capabilities, are so disturbing. Paradoxically, the discourses of security and fear are very much dependent on the idea of viruses as living programs. Although there have been constant attempts to pin down viruses and worms as projections of human nature—whether in the form of malicious and frustrated hackers or of misguided teenagers, and so forth—they continue to be treated as quasi-natural entities. In a Latourian vocabulary, they are semiautonomous actors, hybrids between our normal categories of understanding, "monsters" in the very thorough sense of the term. Quasi-objects reside between the "soft existence" of cultural objects and the "hard facts" of scientific disciplines, being social and fabricated but completely real and "hard" in their object-like nature. They are actors, with tendencies and powers of affiliation and affordance, but not of a human sort. The notion of "third nature" implies a multiplication of such hybrid objects in the spheres of telecommunications, for example.[36]

Hence, without this life, equivalent to that of Frankenstein's monster, viruses and worms would not have been able to acquire their "identity" as origins of digital anxiety, so familiar also in current debates over malicious software. Here the technical capabilities of viral code that rest on their abilities to reproduce themselves in certain environments are translated into symbolic and representational frameworks of artificial life. In this sense, Chapter 3 differentiates and complexifies the dominant security narrative. Not only are viruses and worms an issue of security, but security is part of the general media ecology of network culture.

MEDIA THEORY MEETS COMPUTER TECHNOLOGY: CONCEPTS AND SOURCES

Digital Contagions can be characterized as cultural analysis working with material that is temporally structured and tuned to specific historical points that I regard as crucial given the topic at hand.[37] Thought never proceeds solely by its own force. Thinking is thinking *with* something, and for a media archaeologist, historical sources are material to think with.[38] Thus, as post-structuralist cultural theories of recent decades have instructed us, theories and empirical sources are deeply intertwined, and it makes no sense to return to questions which separate the analyst's act of thinking from the world the thinking is of. Already the empirical sources on viruses, namely, discourse and practices, include implicit premises and theories of what viruses are.

In my take, media archaeology does not represent history, but instead works *with* materials that are deemed historical to come up with a piece of writing that consists of different but coalescing lines of materials and texts.[39] It is a matter neither of giving form to a corpus of sources nor of submitting oneself to the historical "facts", but of following the tendencies inherent in the sources and summoning *events* from them. Historical facts cannot in this sense be taken as passively waiting reference points that a cultural analyst has to find, but as part of the constellation of *doing* research. Theoretical tools are ways of cultivating certain types of viewpoints in reality and engaging with matters of concern.[40] I return to this point of eventualization in the next section.

Because it is empirically grounded work, a key part of *Digital Contagions* is formed from the traces of viruses found within computer science, general media articulations (newspapers, magazines, television reports), and other products of media culture, such as films and science fiction literature.[41] The corpus of these sources was formed by a systematic excavation of written materials such as *Communications of the ACM* (Association for Computing Machinery), one of the leading publications within computer science. In addition, such professional publications as *Scientific American, Computer Fraud & Security Bulletin, Virus Bulletin, Computers & Security*, and *Computer Law & Security Report* have provided me with valuable sources toward a scientific understanding of viruses and worms and similar computer programs. In addition, I have used conference proceedings from the anti-virus business from the beginning of the 1990s on and invaluable web resources archiving key discussions in computer security and the underground, for example, the Computer Underground Digest and the Risks Digest Forum Archives.

These sources have been complemented with books, manuals, and guides from late 1980s and early 1990s that acted as mediators between the public percep-

tion and scientific understanding of viruses. In that role, Ralf Burger's *Computer Viruses: A High-Tech Disease* (1987), Peter J. Denning's *Computers Under Attack: Intruders, Worms, and Viruses* (1991), David Ferbrache's *A Pathology of Computer Viruses* (1992), Philip Fites, Peter Johnston, and Martin Kratz's *The Computer Virus Crisis* (1989), and Bryan Clough and Paul Mungo's *Approaching Zero: Data Crime and the Computer Underworld* (1992) are good examples. These discussions are supplemented with sources such as *Time, The Wall Street Journal, Wired*, and *Byte*, to name a few examples. The task is not merely to look for popular representations of viruses or to seek out the scientific truth of these products of scientific-technological origin, but to look at the frames themselves where, why, and how these truths are produced: What are the technological, cultural, and historical frameworks (in the Foucauldian sense of the term) or the discourse networks (Friedrich Kittler) in which such positions function and interact? The function of media archaeology is to look at the immanent strategies producing reality.[42] In our case, this connects to the key material(ity) of software that spreads out immanently in relation to the discourses about it.

A number of the sources are written from a more or less "official" point of view. Professionals in computer science are often guided by very technical interests, and much of the virus literature since the mid-1980s has underlined their maliciousness. The popular press was often found following such articulations, even though I have tried also to find opposing expressions on the topic. To find the margins, the liminal, within these discourse networks I have followed fiction literature, underground sources such as the Computer Underground Digest, and, for example, some computer art projects and activist groups. In general, it is substantially easier to find sources from the "anti" side of virus discourses, or technical diagrams and plans, than it is to follow minor practices or experimentations. In this sense, many of the antivirus protection sources contribute well to the first chapter; similarly, the popular media articulations are emphasized to a certain extent in the second chapter. The third chapter draws from computer science texts, but also, for example, from the discussion in the early 1990s of living computer software, often within artificial life scientists' discourse but occasionally in popular media.

There is an ongoing tension, then, between underlining the emergent features of the phenomenon at hand (which is well illustrated in the epigraph by Stephenson) and analyzing the actors contributing to constructing the thematics of viruses and "malicious" software. Basically, this is an irresolvable tension, as I want to demonstrate that although different actors and actor-networks have been actively trying to pin down the meanings and uses of viruses, worms, and similar programs to serve their own ends, the phenomenon cannot be reduced to merely

part of such networks of signification and valorization. In other words, there is a constant danger of homeostatic biologism that would remain on an exclusively metaphorical level of analysis.[43]

In addition, one must note how this can be connected to the issue of *perspective*: to some, network risks such as viruses can be translated as emergent phenomena of artificial life, whereas certain parties within this matrix of computer virus discourse are keen to emphasize that the harmfulness of such program routines cannot be contested. Hence, such conflicts and politics of interpretation are constantly part of the issue, which is reflected in the choice of source material as well. To put it bluntly, reading only antivirus sources or security bulletins would produce a one-sided image of the issue (which has been the case in the popular media and the majority of discourses concerning these bits of software), and bringing in novels, artificial life projects, and other heterogeneous themes from the genealogy of network cultures is in itself an important and crucial task in my effort to summon fresh insights.

A large proportion of the analysis in this book concerns U.S. society and its particular contexts of massive computerization since World War II, the atmosphere of cold war fear and paranoia, and the problematics of global consumer capitalism since the 1970s. Having said that, I argue that my main point is not to write from an American perspective or discourse on, or reception of, computer viruses, but on viruses and worms as technological singularities and events that exceed their territories (contexts). Of course, another type of perspective would have been possible and fruitful: a cultural studies perspective might, for example, have accentuated more strongly certain national appropriations of technology and social construction of media.[44]

My perspective is not in this sense on technological cultures but on cultures of global technology. The media technologies of modernization—from the telegraph to the digital networks of contemporary society—have engaged us in a deterritorialization of local cultures, a disembedding and a move toward what could be called a culture of global flows.[45] As argued above, the digital culture of telecommunications is also a world of third nature, which stretches globally and is not restricted to the spatio-temporal grids of human experience. Global cultural practices thus demand a global perspective for cultural analysis, which does not amount to a universalization and decontextualization of this culture.

This emphasis on the culturing of technology can be expressed in terms of the *machinic phylum*. Manuel DeLanda in his provocative *War in the Age of Intelligent Machines* (1991) sets out to map the history of the war machine from the perspective of the machinic phylum.[46] Taking as his point of departure the perspective

of a future robot historian, DeLanda writes the history of the human–machine military complex from the point of view of machinic organization, of which the organic human is merely a part. Cultural reality is not analyzed as the discourses, desires, and intentions of a human society, but as machines: interactive processes between various spheres organic and nonorganic.

DeLanda aims for a holistic perspective on cultural reality that proceeds via a constant interaction of heterogeneous elements in a process of morphogenesis, the formation of consistency. When a group of disconnected flows, often referred to as chaotic, reach a point of communality and cooperation, they form a plane of consistency. These ideas of complexity and order out of chaos have often been analyzed in contemporary physics, but DeLanda and Deleuze have tried to import their ontological implications into a cultural perspective as well. "A machinic phylum is the process where order emerges out of chaos. It is a process of assembling various pieces or flows of matter and energy that achieve a stability. Yet, the flow remains part of that stability, the flow of matter-movement, the flow of matter in continuous variation, conveying singularities."[47]

In brief, thinking of reality in terms of machinic phyla gives us two benefits. First, the world is primarily a material entity, but not passive: material in itself expresses a certain mode of differentiation. Second, the concept of the machinic phylum allows us to bypass such rigid modes of thought and causalities as "human" or "technology." Neither of these two are explanatory; they are merely parts in a more complex web of interaction between various flows. We need more such perspectives that aim to bypass the all-too-modern distinctions between the human world and the world in itself—noumena, in Kant's phraseology. In recent years, research in humanities and cultural studies has been embracing a form of a postmodern linguistic relativism that sees that we humans have no access to reality in itself and that the world is wholly socially constructed and made up of linguistically defined phenomena, to paraphrase DeLanda.[48]

This neo-Kantian stance (as DeLanda calls it) is unacceptable in its reduction of the activity and dynamics of the world solely to human characteristics, thus viewing matter as essentially inert—a point that, according to DeLanda, ties this postmodern antiessentialism to classical essentialism. To propose a cultural analysis of new-materialist vein, one needs to follow ideas where material, nonconscious actors are also introduced as active, differing participants. The subjectivities of, for example, network culture are increasingly nonhuman, which further underlines the need for novel conceptualizations of culture, agency, and subjectivity.

For my part, I see that such contagions as computer worms and viruses have become possible as part of a specific machinic phylum, a process consisting of

organic and nonorganic entities of various durations. In other words, certain key themes in digital computing, network applications, and, for example, information capitalism are emblematic of this plane of consistency. In this sense, even though I approach the phenomenon mainly from a U.S. perspective, I read the sources at the level of the machinic phylum, or the media ecology.

The idea of media ecology has, of course, been used in various ways. Recent years have emphasized the organizational understanding of media ecologies at workplaces, which has involved a conservative focus on engaging with efficiency-oriented flows of information. A more famous application is attributed to the environmentalist media ecologies of Marshall McLuhan, Lewis Mumford, Harold Innis, Walter Ong, and Jacques Ellul. The radical advantage in their take was a strongly historical notion of media where perception became imbued in its material realm. With the Toronto School of media ecology, aesthetics came to be about not the object perceived but the spatio-temporal conditions, technological framing, and media distribution of ways of perception. Several of the views tend, however, implicitly to emphasize homeostasis and equilibrium without offering the much-needed *becomings*. Their perhaps-too-anthropocentric stance does not fit with my task of multiplicities and multiplication of differences. Closer is the approach outlined by Matthew Fuller, who draws from Kittler, Guattari, and N. Katherine Hayles. For Fuller, using the term "ecology" to describe media phenomena is justified as it indicates "the massive and dynamic interrelation of processes and objects, beings and things, patterns and matter."[49] Here we see the resonance between the concepts of media ecology and machinic phylum.

Media ecologies consist of concrete machinic assemblages and abstract machines. Technology is here understood as an assemblage (orig. *agencements* in French) of heterogeneous parts, consisting of organic and nonorganic, significatory as well as a-significatory entities, with differing durations and overlapping histories. Assemblages can perhaps be understood as concrete stabilizations on a phylum of media ecology:

> We will call an assemblage every constellation of singularities and traits deduced from the flow—selected, organized, stratified—in such a way as to converge (...) artificially or naturally. (...) Assemblages may group themselves into extremely vast constellations constituting "cultures," or even ages. (...) We may distinguish in every case a number of very different lines. Some of them, phylogenetic lines, travel long distances between assemblages of various ages and culture (from the blowgun to the cannon? From the prayer wheel to the propeller? From the pot to the motor?); others, ontogenetic lines, are internal to one assemblage and link up its various elements, or else cause something to pass (...) into another assemblage of different nature but of the same culture or age (for example, the horseshoe which spread through agricultural assemblages).[50]

This Deleuzian view on technology asserts that technology is "machinic" and based on flows (although a machinic assemblage is never solely technological).[51] I understand technologies as elements of connectivity, not self-sustaining objects in themselves. Technologies *need* connections to survive: a computer virus needs a suitable operating system and other technological connections, but it also needs connections to various other spheres, some more concrete, some abstract. As my analysis shows, computer viruses have become what they are via their connections to themes of capitalist software production, the fear of AIDS and other viral diseases, experimental software practices since the 1950s, and so forth: a panorama of connections sustaining the virus. In this sense, there are no humans using technologies and giving birth to them, nor are there any technologies determining humans, but a constant relational process of interaction, of self-organization. Thus this is the fundamental sense of the word "machinic": connectionism.[52]

But what things are connected? Machinic assemblages help us to think of the world as intertwined in the sense that the "things" connected (the linguistic concept of "virus" articulated to self-reproductive software programs, for example) do not precede the connections. And not all machines are concrete: we have abstract machines that move fleetingly across various fields, transversally across the social field. In this sense some machines are more abstract, yet as real as the concrete ones. Connections are made across scales: biological terms are transported into technology, politics intertwines with aesthetics, diseases spread across economics.

The phenomenon of computer worms and viruses is formed of various machinations, concrete and abstract, that consist of technological, social, psychological, and economic parts—thus, it is irreducible to one determining factor or territory. This, of course, proves to be a challenge to such strands of cultural studies as focus on the representations, discourses, and intensions of human actors alone. In this, social constructionist theories of technology have succeeded in bringing issues of social need, economic interest, political control, and policy into focus.[53] Raymond Williams is quickly spotted as the key figure who accentuated the social shaping of media technologies in contrast to the presumed media determinism of McLuhan. With Williams, we have a view on technologies as cultural practices that do not proceed as autonomous forces but are subject to, for example, political decision making and cultural perceptions.[54]

The issue is not to choose sides, but to find a third alternative that I aim to decipher with my mix of Deleuze and Kittler. Contra Williams, culture does not consist solely of human beings and human interaction but takes place in a general network of media and technology. In this sense, McLuhan's thesis of media as

an environment, as imperceptible as water to a fish, points in the same direction as Kittler's ideas of discourse networks.[55] These networks are those abstract machines or diagrams that connect heterogeneous parts together, creating new functional machines, new interconnections and media systems we call culture. In this specific network, the computer worm and virus rose to be not only the object of human discourse but also an actor with its own level of consistency. With this I want to underline the "media materialism" that is part of my work, inspired by Kittler in particular: cultural reality is not merely about humans connecting but very much about the material discourse networks, which can be understood perhaps as a plane that gives the so-called human culture that cultural studies and hermeneutics are usually focused on.[56]

The material, or corporeal, aspect has to be complemented with the *incorporeal* as conceptualized by Deleuze and the new materialism of, for example, Rosi Braidotti and Elizabeth Grosz. Such an intertwining produces an image of thought where the material is immanently pierced by the incorporeal and the discursive instead of a bifurcation between mind and matter. Even though the corporeal reality of a computer virus might stay the same, as it is a certain pattern of code that replicates, infects, and spreads, it can be understood very differently. To use Claire Colebrook's example: "A knife may cut a body, but when we call this event punishment we create a whole new (incorporeal) world of morals, crimes, criminals, laws and judgments."[57] This type of conception of language emphasizes pragmatics over semantics, underlining the order-word nature of acts of language. Language is not, then, communication or the pure sphere of thought but a force that connects rhizomatically with its outside.[58] Material processes have their own duration that is not reducible to signification, but at the same time acts of order-words impose actual transformations in terms of categories, definitions, and events. Deleuze and Guattari refer to the incorporeal transformation of an airplane (the plane-body) into a prison-body in a hijacking situation, where the transformation is enacted by the "mass media act" as an order-word.[59] Similarly, a computer virus has been turned in various assemblages of enunciation (such as mass media acts) into malicious software, a security problem, but also a piece of net art, an artificial life project or a potentially beneficial utility program. This logic also organizes my chapters into the incorporeal themes of "security", "body", and "life."

So, in other words, my general framework is to move in patterns and vectors outlined by Kittlerian material analysis but with a Deleuzian twist of embracing incorporealities and multiplicities. My theoretical references in this work should primarily be read in relation to this bipolar theoretical phasing between Kittler

and Deleuze. Whereas Kittler brings in the technologization of Foucault and hence a good perspective on how to analyze material genealogies of technical media, Deleuze is important as a thinker of becomings. Their marriage in this work is obviously not the most frictionless one, but it can produce important ways to bring some Deleuzian movement into Kittler's way of analyzing discourse networks, which otherwise might tend to become too rigid. Whereas Deleuze (with Guattari) is important in creating the ethico-aesthetic agenda of the work (which is addressed below as minoritarian cultural memory), Kittler is suitable for a historically oriented analysis and synthesis of discourse networks. Hence, the discourse network acts as a media ecology and a machinic phylum of sorts, consisting of incorporeal acts of ordering and corporeal movements of, say, hard-wares, softwares, networks, people, and architectures. Kittler is very keen on underscoring the fact that media determine our situation and make possible what it is to state and think in a certain age; in contrast, Deleuze, with and without Guattari, tends to think in terms of movements and assemblages. Technologies are always part of social assemblages that select and employ them for particular uses and functions. Media technologies can be thought to occupy a certain phylum and virtual tendencies, but they are always situated as part of even larger and heterogeneous assemblages, which also helps us address issues of politics and agencies.[60]

Deleuze's notes on Foucault in "Desire and Pleasure" (originally published in 1994) are apt regarding Deleuze and Kittler as well. Kittler, indebted to Foucauldian discourse analysis, offers us a perspective on the power mechanisms of media technological networks. It is through *dispositifs* of media technological power that what exists and what is true become defined. Power, then, is the primary enactor of cultural techniques and functions as the filter through which cultural discourses and nondiscursive practices emerge. For Deleuze, power is subordinated to the primacy of desire, the principle of connectionism, and the event that becomes before power apparatuses that capture the flows. Lines of flight and movements of deterritorialization precede the *dispositifs* of power, which emphasizes the analysis of events as irreducible to power/knowledge apparatuses.[61] The virus, then, is in this work twisted between these theoretical poles: on the one hand, the analysis of how malicious software is produced in *dispositifs* of network culture; on the other hand, an analysis that emphasizes the event and the method of eventualization at the core of media archaeology.

On a technical layer, a digital virus is designed to attach a copy of itself to a host program. These have often been executable files (.exe, .com) but can also be boot sectors and macroscripts. Often computer viruses also include a "trigger" and

a "payload." This means, for example, that a virus will trigger after, say, 50 boots, releasing its payload. These payloads vary: some viruses play a song, others format your hard disk, and some do nothing out of the ordinary. Some famous viruses have made letters fall off the screen one by one, imitated the Yankee Doodle tune, and printed insults. The viruses can be seen as a special form of the IF/THEN routine pair. The infection mechanism looks for infectable objects and IF it finds them, THEN it infects them. The trigger can be set for a specific date, and IF it is reached, THEN the trigger is pulled.[62]

Whereas a virus attaches itself to other programs, computer worms are more self-contained and do not need to be part of another program to propagate. Worms have been a phenomenon of recent years in network techniques of the World Wide Web, e-mail, and file sharing (although these techniques and worm programs date from the 1970s). Basically, and technically, viruses and worms are two different types of programs.[63] Often they are referred to via the generic terms "malware" or "malicious software." Malicious software, of course, includes a wide variety of different programs such as Trojan horses in the form of spyware, botnets, loggers, and dialers. Several such programs are designed for commercial purposes. What is curious is that viruses spread across particularly homogeneous platforms, which has focused attention on the Microsoft Windows operating system. The negative image of the company probably entices virus writers to target Windows, but the socio-technical characteristics are also worth noting. The Windows operating system has become notorious for its security flaws, which seem recurrently to pile on top of each other with the massive penetration of this specific operating system across the world. In addition, compared with Open Source projects, which more efficiently employ user input in improving design flaws, the Microsoft model seems rigid and inefficient. Microsoft products have for years been filled with security loopholes, which has also made them a tempting target for viral experimenters.

It is important to note how fundamental these issues of definition are concerning the life of software. If the emphasis is placed on reproduction routines, virus- and worm-like programs cannot be said to be malicious by definition. Often it is taken for granted that computer viruses are malicious by nature and that their payload is always harmful. Yet, as several writers such as Fred Cohen have argued, virus-like programs can contain various types of payloads and perform several different routines in addition to their fundamental nature as semiautonomous and self-reproductive software.[64]

Hence, as this book advances, one notices the impossibility of giving a neutral definition of viruses and worms and other programs that are most often thought

of as "malicious." They are always understood within networks of power and knowledge, the basic elements forming a cultural reality according to Foucault. Aptly "virus" in Latin means "poison", and it also has its etymology in the term "vir"—meaning "virility", "life", "desire", and "drive." Thus, although in the biological sense viruses became an issue at the end of the nineteenth century with new techniques of perception and the birth of modern virology, the concept itself is not tied to this short history but presents an ambivalence in itself. The biological virus became intelligible only through complex scientific and cultural assemblages, especially the grounding of virology as a set of discourses and practices. Similarly, the fleeting articulations and possible contexts of digital viruses and kindred programs have been stabilized, objectified, and made intelligible as malicious software in complex assemblages that include computer scientists, media practices, capitalist discourses, and other elements that I address in this book.[65] Yet, there is a continuous potential to see more than meets the eye in these strange hybrid creatures of self-reproductive quality, to dig into the multiplicity of network culture.

MEDIA AND MULTIPLICITY: NOMADIC CULTURAL MEMORY

To refer to my title *Digital Contagions*, "contagions" has a double role here: to present the contagions induced by computer worms and viruses, and to produce new types of contagions of thought within cultural theory and media history. In other words, "contagion" is not only the "object" of this study but also the basic ethos of conducting the research. Contagions are thus to be understood in the ambiguous sense Michel Serres gives to parasites: parasites are not actually disconnectors of communication, but thirds-excluded that guarantee the inter-connectivity and movement of a system. Communication cannot go on without the element of miscommunication, of contagion, at its center: communication is constituted of both signals and noise, just as the classical communication theory of Shannon and Weaver taught us.[66] The task is to focus on the noise, the interference, not just as an engineering element to be reduced but as a key trait within the network societies of digital culture, a trace to be followed, a tendency to be thought with. Contagion is a jump cut, an open-ended system, an experiment.[67] What has to be noted early on, however, is how the theories and theoreticians used here are part of the same field as the phenomenon of computer viruses and the culture of virality (comprising, for the most part, continental theories of post-structuralism

and radical difference of the 1960s–1990s). Just as various ideas in computer science, cybernetics, and, for example, ecological thought were wired into the philosophies of Lacan, Derrida, Foucault, and Deleuze and Guattari, so their and other "post-structuralist" philosophers' ideas concerning systems, aesthetics, and, for example, politics have had a huge impact on the digital (counter)culture in Europe and the United States since the 1980s.[68] Instead of being a problem, this has further enticed me to use Deleuze and Guattari as their work in itself is "viral" in a way; it works as a form of nonlinear ecological system, relying on the viral as a force of differing, difference in itself, that can act as a trigger of becomings, new modes of thought and action. Theories are not, then, used as direct applications of an explanatory grid to a material but as ways of cultivation. They are different, more conceptual ways of articulating and mapping the contours of the viral ecology of late twentieth-century computer culture.

Tracking and mapping multiplicities is a key focus of this work, and the task is reflected also at the methodological level. As noted above, this work is a meshwork of a number of elements instead of being an *application* of any clear-cut theoretical idea or methodological guideline. In this task, I follow Foucault's general method, or ethos, of *eventualization*, of summoning events. In an interview published in 1980, Foucault outlined his views discussed in the earlier genealogical papers. An analysis and production of events aims to make visible singularities "at places where there is a temptation to invoke a historical constant, an immediate anthropological trait, or an obviousness that imposes uniformly on all."[69] For me, this produces an important impetus with which to break out from the hegemony of representation analysis. Analyzing representations can be defined as focusing on how cultural identities are reproduced (and resisted) in cultural discourses from mass media to everyday life. It is an attempt to focus on the productive power that moulds identities and produces cognitive and affective ways of being. Such an analysis can be seen as successful in its underlining of the dynamics of subject formation as part of representational grids, but recent years have also seen a critique of its insufficient approach toward the immanent materiality of culture.[70]

Here, Deleuze and Spinoza contrast with the Kantian tradition of cultural analysis, which can in broad terms be characterized as critical analysis of conditions of knowledge. Kant's questioning for the conditions of knowledge that filter the world to us humans can be seen still as a dominant method of cultural analysis that sees the world as mediated by a priori categories (mental and cultural), which is why the world in itself is beyond our reach.[71] The world is divided into spheres of the world-in-itself (noumena), the appearances and the subject, a division that

has contributed to the representational emphasis of contemporary cultural analysis. In this mode of thought, the world is mediated by representations we have of it.

Elizabeth Grosz argues that the problem with representation-oriented cultural studies is that it restricts nature (and the material) to being the passive nonform that culture as an active force moulds. This type of constructionism, in the wake of, for example, Judith Butler and Jacques Derrida, thinks of culture and history as the only potentialities for "change, upheaval, even revolution", whereas the materiality of the world is regarded as an essentialist obstacle to such radical politics of representation.[72] In such strands of cultural studies, inspired especially by Butler's earlier writings, the issue is to map representations that would take into account the neglected terms, whether sexual, racial, economic, or social, and to create new regimes of performative representation (the symbolic/discursive).[73] From a perspective influenced by Deleuze, for instance, that of Grosz and Braidotti, this presents a problem as it neglects nature and the material as mere restrictions of the cultural. For a Butlerian approach, there is no outside that is accessible except via the discursive, no material but the one integrated in the symbolic. Such ideas have presented important ideas of the intertwinedness of the material with fields of power and articulation but simultaneously have failed to produce sufficiently refined and complex notions of the ontology of the material. Instead, as Grosz notes, one should think of the material as the outside of the representational, as the event that *produces* the symbolic. Nature, the material, the event are the outside of the representational, the multiplicity that enables the emergence of a cultural order.[74]

In the Deleuzian–Spinozian approach to cultural reality, there is no primary division between noumena and appearances. Instead, reality is characterized by univocity. There is one voice for the world; all things are expressions of the same force of the world. The world is characterized by the fundamental immanence of processes and things, of relations traversing the whole. However, the whole is not a uniform and determined essence, but a multiplicity, which leaves open the possibility of change, creation, and politics. In Deleuze's view, the world does not consist of differences between representations but more fundamentally of a differing at the heart of the nature–culture continuum: a force of differing that endows the material world with the potential to change, irrespective of representations "attached" to things and relations.[75]

In a Deleuzian–Spinozian vein, Luciana Parisi calls for new modalities of thought that would take representational analyses one step further to encompass a more material level of analysis. Representational cultural analysis ends easily

merely reproducing the same grid on which the entities are positioned. According to Parisi, critical theories from semiotics to structuralism and post-structuralism do concentrate on determinants ("a semiotics of signification, bodies' positions in a structure, ideological overdeterminations"[76]) but are not able to take into account the material ethics of becoming. Thus, a focus on assemblages (Deleuze) or mixed semiotics (Guattari) articulates how signifying discourses and material a-semiotic encodings always act in pacts. Parisi's point, following Deleuze and Guattari and Spinoza, is, then, that reality is not "exclusively constituted by signi-fications, discourses and ideologies",[77] and hence critical analysis of reality should methodologically focus not merely on reflections or representations of reality but also take reality itself as under construction.[78]

Following such ideas of Deleuzan–Guattarian origin, *Digital Contagions* moves in the direction of thinking of the outside, the event as radically new, the unexpected—and not merely mapping representational and symbolic orders and engaging in a politics of representation. Even though these Deleuzian-Spinozian ideas differ from the "critical" analysis that seeks to question our modes of knowing the real, this does not mean "uncritical" reflection. I am not throwing cultural studies, representational analysis (propagated by various cultural studies retakes of Stuart Hall's ideas), and, for example, Butler-inspired approaches overboard but merely taking them a bit farther along the road of becoming—the becoming-viral of technology and culture, a becoming that is material and, hence, connected to the ethics of the *event*. Here, the relations of the world are not divided into real and appearance, and the work of critique is not to question but to produce, create, and open up novel potentials. Many of my theoretical and conceptual choices (for example, deciding not to refer to "metaphorics of viruses") stem from the desire to underline such ontological presuppositions that do not see language and repre-sentations as the only spheres of dynamics. In addition the much wider material fluxes of matter–energy are to be seen as dynamic processes (and also processes that are not material and energetic, such as certain ideas concerning information, are immanent to matter–energy, as DeLanda notes[79]).

As eventualization, my project is to challenge the uniformity that surrounds this special class of software. Not merely malicious software made by juvenile vandals, but an inherent part of digital culture, computer worms and viruses represent a victimized partner in contemporary network culture. Hence, the task is not only to reproduce the banal fact that viruses are represented as malicious but also to challenge this one-sided approach and to produce singularities that would open up novel fields of understanding. This attributes an active interpre-tive or, more accurately, connective role to the writer. As stated above, the writer

connects, works with, materials to summon or conjure forth worlds that have been neglected, frozen. The analyst, or media archaeologist, eventualizes, which in Foucault's wake means "rediscovering the connections, encounters, supports, blockages, plays of forces, strategies, and so on, that at a given moment establish what subsequently counts as being self-evident, universal, and necessary."[80] Media archaeology should not only track the majoritarian understanding of the discourses and *dispositifs* of digital culture but also aim to follow the detours and experiments that remain virtual, yet real, in the shadows of the actuality of hegemonic understanding.

Eventualization and complexification are not to be understood as loose, "anything goes" methodologies of pluralism or as methods of merely deconstructing and analyzing media archaeological lineages of power and knowledge. Instead, they build novel synthetic alternatives and variations. This accentuates the active position of the author not as a demi-urge but as a conveyor of preindividual force fields: I do not merely passively remediate "truths" of the past, or critique such truths and the power constellations in which they are born, but try to rewire these issues as part of the discussions concerning network digital culture, capitalism, and subjectivity in the age of semiautonomous technologies. The accidental is not merely an object of research but points toward this method of eventualization in a Deleuzian manner. In *Difference and Repetition* he categorizes the questions "How much?", "How?", "In what cases?", and "Who?" as demands that restore multiplicity to ideas, and hence bypass the rationalist ethos focused on essences.[81] This can be understood as a Nietzschean questioning of genealogy, as further developed by Deleuze and Foucault, where thought and representations are revealed as posited via *violence*, not good faith. This type of genealogical perspective on accidental ontology admits that any position is unstable, situated in relation to others, and void of illusions of eternity. No knowledge (*connaissance*) is outside the will-to-knowledge (*vouloir-savoir*), a realization that leads not to relativism but to admitting that knowledge is imbued in power and hence always a system that is more or less unstable.[82]

The method is intimately connected to an ethos of nomadic cultural memory. Memory is a specific instance of power and knowledge, playing a crucial role in the creation of meanings, values, and perceptions, or, to use a better term, social apparatuses. History and the archive as a structuring logic of history form an essential part of "what we are and what we are ceasing to be",[83] acting as a form of depositary for possible actions and significations. Following Deleuze and Braidotti, we can discern two poles of memory: majoritarian and minoritarian, or nomadic. A majoritarian machine of subjectivity and memory functions to create

solid forms or strata of cultural continuity that are based on already received and appropriated ways of thinking. A majoritarian way of memorizing and (understanding history) thus proceeds via a setting of landmarks based on concepts already grasped. A perfect example of such a concept is "Man", which constitutes a conceptual majority, a standard to which all conceptual minorities (women, children, animals, plants, molecules) are deemed secondary. [84] Of course, within the cultural theory and cultural history of recent decades, this has already been tackled: writings of "new histories" of women, the insane, homosexuals, children, and the disabled all demonstrate a rise of a countermemory, which can mark a point of resistance and a becoming of new subjectivities. This means giving consistency to events otherwise (or before) seen as accidental, giving them duration, and creating series of a novel nature—creating memory, that is.

My work continues alongside such lines of multiplicity and follows the idea of a minoritarian nomadic memory, which commits itself to the project of becoming. Becomings are movements without transcendent central points, which are secluded islands of nonmovement (the universal content beyond forces of time), attempts to extract stabilities from the plane of immanence. Becomings are vectors and aim at finding new territories of subjectivities—territories that are not already inhabited by the majoritarian coordinates of predefined concepts. Now, Deleuze and Guattari remain suspicious of history and juxtapose it with becoming. History is for them a site of majoritarian memory, or "history-memory" systems, whereas only transhistorical lines can lead us toward becoming. Creation is transhistorical, subhistorical, superhistorical; it is the sphere of Nietzsche's Untimely, which is a vector that should be incorporated into theories of media archaeology as well. [85]

Hence we are dealing not with a neglect of history but with a new opportunity in subhistorical memories, in minoritarian becomings. Whereas the majoritarian central memory, or archaeological stratum, has so far devalued nomadic memories as secondary a-signifying practices, a Deleuzian ethos of memory emphasizes the constant need for deterritorialization of this central memory, but in a thoroughly affirmative manner. As Braidotti wonderfully notices, this is an "intensive, zigzagging, cyclical and messy type of remembering" that endures complexities, thus dislodging the established points of subjectivity from their places, opening up new sites and territories of acting and remembering. [86]

Braidotti also brings the issue of imagination to the fore. Becoming minoritarian means engaging with the force of imagining "better futures." A nomadic memory of zigzag territorialization aims at actualizing "virtual possibilities which had been frozen in the image of the past." [87] Memory is, in this Braidottian scheme,

conjoined with a creative imagination to bring forth a new, monstrous future of nomadic subjectivities that are resistant to the majoritarian modes of affecting, perceiving, thinking, and remembering. Historical analysis is also stretched toward the future. In general, cultural analysis is a matter of how to fold the outside, the event (*accidentum*), the unpredictable into effective and affective assemblages that make a difference—in other words, how to come up with a different future. As Grosz notes, this problematics is inherently tied to the question of time and bringing forth such a form of duration that is not committed to continuous growth but to "division, bifurcation, dissociation" and difference.[88]

More concretely, as *Digital Contagions* advances, we notice how explicitly "nature", "ecology", and "biology" seem to be key elements in the metaphorics and metamorphosis of the digital culture of recent decades. This means not conflating the biological and the digital, but taking seriously the influence biological sciences and ways of thought have exercised on technology during recent decades. It is not my task to define the *essence* of biology or technology per se, but to look at the translations, transformations, and interfacings (in other words, the assemblages) of recent decades. The coupling of biology and technology, which, of course, has longer roots beyond digital culture,[89] finds itself alive and kicking within the media ecology of digital culture. These types of couplings can also provide vectors of becoming for a novel understanding of digital culture. Life does not remain a mere metaphor but also becomes an implication of autopoiesis, of self-moving, of acting and force. This is also the "life proper to matter",[90] which rests and builds on the vitalism of matter itself, namely, the nonorganic life of technologies, materials, and assemblages of heterogeneous nature. Such a stance differs from "naturalizing" digital culture as a teleological system, or a law-governed Nature. Quite the contrary, the media ecological way of analysis wants paradoxically to de-naturalize, to show the continuous contingencies, metastabilities, and politics that abound within this constellation. Ecology is unnatural; it does not follow prescribed rules but is open to changes, which can be enacted on various scales from human political action to the flow of matter–energy.

NOTES

1. Virilio & Kittler 1999, 84.
2. Stephenson 1993, 371.
3. Schivelbusch 1977. Lundemo 2003.
4. Quoted in Sterling 1994, 12.

5. McNeill 1998, 170–178, passim. Vuorinen 2002. DeLanda 2003, 242.

6. Clark 1997, 79.

7. Schivelbusch 1977, 118–119.

8. McLuhan 1962.

9. A focus on accidents opens up a whole new perspective on media technologies, as Paul Virilio has often suggested See, e.g., Virilio 1993, 212. On the cultural history of accidents, see also, e.g., Schivelbusch 1977. Trond Lundemo (2003, 25) has analyzed the ideas of uncontrollability and danger inherent in media technologies, demonstrating how "the decomposition of the machine and the erasure of memory", in particular, are key themes considering the age of digitality. Ontologically invisible digital technology reveals itself only in the event of breaking down, which gives accidents a special status in a cultural sense. Every media ecology or discourse network seems to have an accident of its own, and this work aims to highlight the position computer worms and viruses have in relation to the network culture of the late twentieth century. They *reveal* technology, and the power/knowledge relations that media are embedded in. These ideas stem originally from Heidegger's notions of the ontology of Being. See Heidegger 1996, §16.

10. Fuller 2005, 63.

11. John Johnston explains Friedrich Kittler's term discourse network as follows: "Kittler deploys the *term* to designate the archive of what is inscribed by a culture at a particular moment in time. The notion of the discourse network points to the fact that at any given cross-sectional moment in the life of a culture, only certain data (and no other) are selected, stored, processed, transmitted or calculated, all else being 'noise.' (…) In other words, on the basis of this particular selection of data not only perceptions, ideas, and concepts—all that is coded as meaningful in short—but also a system authorizing certain subjects as senders and others as receivers of discourse is instituted." Johnston 1997, 9–10. Cf. Kittler 1990, 1999. The term "discourse network" is thus not the best translation of *Aufschreibesystem*, "systems for writing down", for engraving or for recording. Kittler has attempted to broaden this perspective to encompass more technical information channels as part of the archival layer, or discourse networks. As Kittler puts it, even if all books are discourse networks, not all discourse networks are books: "Archeologies of the present must also take into account data storage, transmission, and calculation in technological media." Kittler 1990, 369. I use the concept of discourse throughout this work, but it should be read as stemming from a materialist understanding of discourse networks. Foucault underlines the need to see discourses and nondiscourses (material practices) as inherently intertwined. Discourses are immanent to, for example, habits, operations, spaces, and practices that mold the world—cultural techniques in the material sense. Discourses are about producing certain effects and affects, implying that the concept is not to be taken as solely textual. Deleuze insists that Foucault is not to be understood as an archaeologist of linguistic statements alone. Foucault's focus is on the relations of the visible and the sayable, which form the space of "the audiovisual archive." Historical *dispositif* consists of architectural, technological, and philosophical or conceptual elements. Deleuze 1998. See also Rodowick 2001, 49–54.

12. Cf. Terranova 2004, 98–100.

13. I regard the later genealogical approach of Foucault as complementing his earlier archaeological analysis with a more temporal twist. The genealogical ideas bring in an important emphasis on the nondiscursive and, for example, the idea of writing counterhistories. See Gutting 1989, 271. Several media archaeological theories are actually a combination of the genealogical and the archaeological. See, e.g., Zielinski 2006. I want to emphasize how the archaeological analysis for a priori

conditioning of statements, objects, and processes (a certain form of Kittlerian view of discourse networks) should be tied intimately with a commitment to producing new short-circuitings, events. Here, as Foucault himself noted in his Berkeley lecture in 1983, genealogy becomes a mode of inquiry into how archaeological events condition the present, how the archaeological a priori continuously translates into our contemporary condition. This view is addressed in the "Media and Multiplicity" section of the Introduction.

14. See Deleuze 1990. In a manner reminiscent of Larry Grossberg's radical contextualism, I understand context not as the background of a study but as the essence of what a study tries to map, the "very conditions of possibility of something." See Grossberg 2000, 41. Context understood in this way draws from a Deleuzian–Nietzschean understanding of forces as the processes of differentiation that create the world. See Deleuze 1986.

15. Foucault 2002. Cf. Kittler 1990. Siegfried Zielinski (1999) positions his archaeological quest in three intellectual traditions: (1) Raymond Williams's idea of culture as a way of life and technologies as cultural practices; (2) systems-theoretical approaches where technology is considered as unities of origination/production and use; (3) the metapsychological film theories of Jean-Louis Baudry, Jean-Louis Comolli, and Christian Metz, where the concept of apparatus is developed. My take on media archaeology follows this partially, but taking more elements from Kittler, Foucault, and Deleuze and Guattari. On media archaeology, see also Huhtamo 1997. Elsaesser 2004. Zielinski's (2006) recent move toward variantology and (an)archaeology is also of interest to my nomadic approach to cultural memory.

16. This connects to the conceptualizations of time in cultural historical research promoted by, for instance, Fernand Braudel as well as the remediation thesis of Bolter & Grusin (2000). For instance, Braudel (1997, 205) notes how every actuality is composed of multiple durations and variable rhythms that coexist.

17. Cf. Longley 1994b, 589–590.

18. Virilio 1993, 212.

19. On Virilio and his notions of accidents, see Redhead 2004.

20. Scott Berinato: "Attack of the Bots." *Wired*, vol. 14 issue 11, November 2006. <http://www.wired.com/wired/archive/14.11/botnet.html>.

21. Malicious software can be defined generally as software that intentionally and without consent damages software or computer systems. It differs then from software bugs that are unintentional.

22. Castells 2001, 172. Cf. Campbell-Kelly & Aspray 1996, 283–300.

23. Castells 2001, 172–173. Hardt & Negri 2000. Castells refers also to the libertarian social movements of the 1960s and early 1970s in Europe and America as influential in this context.

24. Hardt & Negri 2000, 298. See also Hardt & Negri 2000, 32. Urry (2003, 9) emphasizes how global power should not be conceptualized as a substance of sorts, but an emergent complex process. The Empire should not, then, be understood as a hierarchy of power but as part of an emergent networked process that interconnects local issues with global vectors.

25. John S. Mayo: "Materials for Information and Communication." *Scientific American*, vol. 255, October 1986, 51.

26. The intermingling of media and catastrophe is, of course, not a novel theme, as exemplified, for example, by Mary Ann Doane (2006) in her analysis of the televised catastrophes that break the temporal and spatial habits of everyday life in a mediatized society.

27. See Gerrold 1975. Brunner 1976. Ryan 1985. Beeler 1973. Latva 2004.

28. See Parikka 2007.

29. See Sontag 2002.

30. "Hex" refers in computers to hexadecimal, a specific way of marking the binary code in a base-16 system.

31. Cf. Deleuze & Guattari 1987, 66, 504. Wise 1997, 63. Following Wise's Deleuzian–Guattarian reading, technology is here seen as enacting corporeal materiality and being always entwined with the incorporeality of language (as the order-word). Slack & Wise 2002, 495.

32. Cohen 1994. See also Cohen 1991b.

33. See, e.g., Ludwig 1993. Cf. Vesselin Bontchev: "Are 'Good' Computer Viruses Still a Bad Idea?" *EICAR Conference Proceedings* 1994, 25–47. Julian Dibbell: "Viruses Are Good for You." *Wired*, vol. 3, issue 2, February 1995.

34. Wark 1994, 120.

35. Sontag 2002, 177–178.

36. Cf. Latour 1993, 51–55.

37. As Kittler (2001, 14–19) notes, cultural analysis, or *Kulturwissenschaft*, is in its modern form fundamentally cultural *historical* analysis.

38. As Wolfgang Ernst (2002) underlines, archives are not traces of a continuous past life; they are by nature fragmentary monuments embedded in media technological networks. The media archaeological task is, then, to write discontinuous links between such archival events. Archaeology does not write of things behind the archive, and it does not attempt to restore a way of life of human beings. Instead, it focuses on the *arche*, the technological conditions of existence, of culture.

39. On cultural analysis, see Bal 1999, 1, 12–14. See also Deleuze & Guattari 1987, 3–25. Walter Benjamin's concept of cultural history rests on a similar idea of historical materialism as a mode of thinking that proceeds *with* the past. Historical "objects" are thus no mere objects of thinking but participants in historical modes of thought. See Caygill 2004, 90–91, 94–95. Benjamin's stereoscopical historical research aims at combining the images of the past with the contemporary moment to create a critical constellation. It taps into tradition to find cracks that are to be transported as part of a creation of a novel future. See Buck-Morss 1991, 289–292. This type of discontinuous view of history resonates with Foucauldian themes of archaeology.

40. Cf. Latour 2005.

41. In general, the fleeting status of computer worms and viruses themselves, being just bits of digital code, which is in itself reproducible and without one real version, presents problems for the historical mind. The traces these miniprograms leave would be impossible to find in the actual files, computers, and networks the viruses pass through. Hence, these digital programs have archived themselves in the "older media" of the written word (newspapers, books) and the audio-visual signs of television (news, documentaries, fiction series) and cinema (fiction films). Digitality also inscribes its being in the earlier media systems.

42. Cf. Massumi 1992, 46.

43. Munster and Lovink (2005) argue "against biologism."

44. On appropriation of media technologies in cultural history, see Hård & Jamison 2005.

45. See Castells 1996. Cf. Beck 2002. Beck argues for a *cosmopolitan* agenda and theory of social research.

46. DeLanda 1991. Following Deleuze (1998, 39–40), machines are not solely technical machines but also social. The social machine—which does not refer only to human societies—selects and assigns

the technical elements used. Thus, to paraphrase Charlie Gere (2002, 13), digitality is not solely about computers but also about ways of thinking and doing that digitality embodies and that make its development actual. Such ideas include abstraction, codification, self-regulation, virtualization, and programming. A machinic ontology is, then, a world of immanent connectivity, where the focus is on relationships and functions not essences of things. An *abstract* machine is a virtual principle governing the actual machinic assemblages of the world. Abstract machines are *diagrams* governing the interactions of culture. To quote Deleuze and Guattari: "Defined diagrammatically in this way, an abstract machine is neither an infrastructure that is determining in the last instance nor a transcendental Idea that is determining in the supreme instance. Rather, it plays a piloting role. The diagrammatic or abstract machine does not function to represent, even something real, but rather constructs a real that is yet to come, a new type of reality. Thus when it constitutes points of creation or potentiality it does not stand outside history but is instead always 'prior to' history." Deleuze & Guattari 1987, 142.

47. DeLanda 1991, 20.

48. See DeLanda 1999.

49. Fuller 2005, 2.

50. Quoted in DeLanda 1991, 140. Cf. Deleuze 1997b, 185–186.

51. In a Deleuzian–Guattarian ontology, flows are primary. The seemingly solid objects of technology, or of culture, such as identities, sexualities, gender, and institutions, are only a consequence of a more underlying flux. The world is about connections between these flows, and in these connections seemingly solid objects form: technologies, humans, animals, cultural artifacts, and natural things. The solid objects are the molar entities of culture, whereas movement (as change) happens always on a molecular level. Murphie & Potts 2003, 30–35. Deleuze & Guattari 1987. Flows do not emanate from individuals, but instead individuals are formed at the intercrossings of cultural flows, as slowing-downs of movements. Individuals are always part of synthetic (machinic) assemblages, which consist of a partial conjoining of heterogeneous flows. This Deleuzian–Guattarian view differs from the more rigid post-structuralist (and Marxist) versions, where individuals are determined by the structures. Individuals are not effects of an underlying power structure, whether economic, linguistic, or psychic, as some psychoanalytic accounts might suggest, but overdetermined sites of power and knowledge, not reducible to one type of power relationship. In other words, as Foucault reminds us, where there is power, there is also counterpower, implying the constant dynamics going on in cultural discourse networks. Deleuze conceptualizes this as the primacy of lines of flight: a society is defined by the lines that escape the molar machinations, not the stable entities (Deleuze 1997b, 188–189). In Foucault's terminology, the issue is about cultural techniques, where knowledge is in itself a technique for organizing, participating and delineating the flows. Cultural techniques mediate how the world appears to us and the media archaeologist's task is then to reevaluate these techniques and mediations. Murphie & Potts 2003, 30.

52. Murphie & Potts 2003, 30–35.

53. Ibid., 17–19.

54. Ibid. See Lister et al. 2003, 72–92.

55. Kittler 1990, 369. In addition, certain materialist and perhaps structurally oriented perspectives in historical research are relevant to my take, for example, those of Fernand Braudel (1997) and William McNeill (1998), mentioned above, both of which are also mentioned as inspirations by DeLanda.

56. On Kittler, see Gane 2005. See also Ernst 2002.

57. Colebrook 2002, 119.

58. The materiality of the "object" of research is summoned by my understanding of how texts *function* as part of their surroundings. As a major component of my sources is written material, this would easily imply that the tracings I make are merely "symbolic", or semantic signs of *meaning* (signified). Nonetheless, the rhizomatic stance toward texts, as a supplement to representational analysis, feeds on Deleuze and Guattari's notions from the first chapter of *A Thousand Plateaus*, where they emphasize that texts are not to be (merely) interpreted, nor are they images of the world, but more accurately, they *work* within the world. The linguistic model of the world is too restricted to account for the connecting of language "to the semantic and pragmatic contents of statements, to collective assemblages of enunciation, to a whole micropolitics of the social field." Deleuze & Guattari 1987, 7. In cultural history, the reception of Foucault can be deciphered as the significant distinction. Whereas such Anglo-American writers as Peter Burke (2004, 76) see Foucault as part of the linguistic turn and as a thinker of the discursive, Roger Chartier (1997, 68–69), for example, has, rightly in my opinion, criticized this one-sided notion and highlighted the necessary articulation of the discursive with the nondiscursive. This is what Foucault clearly states in his *The Archaeology of Knowledge*. See Foucault 2002. I approach texts as machines of production, as creators of effects, affects, and thoughts that intertwine with nondiscursive planes of culture, and in this they are always multiplicities that cannot be reduced to their majoritarian, hegemonic uses and interpretations. There is always potential for some more, some new connection.

59. Deleuze & Guattari 1987, 80–81.

60. See Deleuze & Parnet 1996, 85. Cf. Kittler 1990. Also Matthew Fuller (2005, 60–62) notes that Kittler attenuates the political aspects of Foucault's discourse thinking.

61. Deleuze 1997b, 186–189. Of course, Foucault also emphasized the event and the thought of the outside that resonate with Deleuzian themes of the primacy of the desiring assemblages. Yet, with Kittler the *dispositifs* of power are emphasized.

62. See Harley, Slade, & Gattiker 2001, 87–88.

63. In this study, I use the term "virus" as a generic one, referring to "worms" only when required to emphasize something. This is also the general way these programs are discussed in popular media. See the Wikipedia entries on "computer virus" and "malicious software." <http://en.wikipedia.org/wiki/Main_Page>.

64. See Cohen 1991b, 1994. See also John F. Shoch & Jon A. Hupp: "The 'Worm' Programs—Early Experience with a Distributed Computation." *Communications of the ACM*, vol. 25, issue 3, March 1982, 172–180.

65. On modern biological virology and the assemblages of the biological virus, see Van Loon 2002b.

66. Shannon & Weaver 1949. See Serres 1982. Brown 2002. Kittler 1993b. These types of cross-breedings on the topic of the computer virus have been rare. Viruses and worms have been analyzed only partially and/or fleetingly from a cultural perspective, whereas technical and practical antivirus manuals and books have been abundant ever since 1988. On useful sources on the cultural contexts of computer worms and viruses in relation to the Internet, the AIDS phenomenon, the rise of the digital culture, and cyber risks see Ross 1990. Lupton 1994. Saarikoski 2004, 360–377. Van Loon 2002a, 147–168. Sampson 2004, 2007. Galloway 2004, 176–184. Mayer & Weingart 2004a. Thacker 2005. Bardini 2006. O'Neil 2006. See also my articles Parikka 2005a, b,

c, 2007. Forthcoming (approx. 2008) is also the collection *Spam Book: On Viruses, Spam, and Other Anomalies from the Dark Side of Digital Culture*, edited by Parikka and Sampson.

67. See Massumi 2002, 18–19.

68. Gere (2002) has noted how post-structuralism has contributed strongly to the same discourse and our understanding of digital culture. There has, since the 1960s, been a constant feedback between issues technological, theoretical, and cultural, which is why there is a constant strong resonance between issues of digital culture and, for example, certain strands of "French theory" such as that of Derrida or Deleuze and Guattari.

69. Foucault 2000c, 226. This approach resonates with certain themes of media archaeological research where the focus has been on similar minoritarian tracings and analytics of becoming. Zielinski 2006.

70. See, e.g., DeLanda 1999. Grosz 2005, 44–46. Terranova 2004, 8–9, 35. Tuhkanen 2005. Wiley 2005. Parikka & Tiainen 2006.

71. See Hallward 2006, 11–12.

72. Grosz 2005, 45.

73. See Tuhkanen 2005.

74. Grosz 2005, 52, 220–221 n4. In digital media studies, Lev Manovich (2001, 15), for instance, follows the representational paradigm in his *The Language of New Media*. For a postrepresentational approach in media studies, see Terranova 2004.

75. Cf. Hallward 2006, 11–26.

76. Parisi 2004b, 74.

77. Ibid., 75.

78. Ibid., 84.

79. DeLanda 2002, 5.

80. Foucault 2000c, 226–227.

81. Deleuze 1994, 188. This stance can be attached to the division between majoritarian and minoritarian readings of culture and history. See Goodchild 1996, 54–55. On cultural analysis as experimental perturbations, see Massumi 1992, 68.

82. Foucault 2000e, 387.

83. Deleuze 1992, 164.

84. See Braidotti 2001. Not merely antihumanism, this can be also understood as a new Spinozian humanism, where the human is part of the surrounding world not any *imperium in imperio*. In this sense, as Hardt & Negri (2000, 91–92) suggest, Foucault, Althusser, and, for example, Donna Haraway are continuing the project of Spinoza.

85. Deleuze & Guattari 1987, 296. See also Deleuze 1986, 133–141, 195–198.

86. Braidotti 2001, 187.

87. Ibid., 188.

88. Grosz 1999. It would again be interesting to connect such themes to a Benjaminian ethos of critical historical analysis. See Buck-Morss 1991.

89. Channell 1991.

90. Deleuze and Guattari 1987, 411. Cf. DeLanda 1992, 2002. Cf. also Matthew Fuller's (2005) thoughts on the "medial will to power."

FEAR AND SECURITY: FROM BUGS TO WORMS

Society is becoming increasingly dependent on the accurate and timely distribution of information. As this dependency increases we become more vulnerable on the technology used to process and distribute information (…) This is particularly true for what are sometimes called infrastructural industries—banking, the telephone system, power generation and distribution, airline scheduling and maintenance, and securities and commodities exchanges. Such industries rely on computers and build much security into their systems so that they are reliable and dependable.[1]
—*Information Security Handbook (1991)*

Do you remember the VIRUS program?
Vaguely. Wasn't it some kind of computer disease or malfunction?
Disease is closer. There was a science-fiction writer once who wrote a story about it—but the thing had been around a long time before that. It was a program that—well, you know what a virus is, don't you? It's pure DNA, a piece of renegade genetic information. It infects a normal cell and forces it to produce more viruses—viral DNA chains—instead of its normal protein. Well, the VIRUS program does the same thing.
Huh?[2]
—*David Gerrold: When HARLIE Was One (1972)*

PROLOGUE: FOLDINGS OF ORDER AND CLEANLINESS

Sigmund Freud's text on cleanliness and culture from 1930, written in the midst of slowly developing European turbulence, remains an influential reference point for cultural theorists. In *Civilization and Its Discontents* he wrote:

Dirtiness of any kind seems to us incompatible with civilization. We extend our demand for cleanliness to the human body too. We are astonished to learn of the objectionable smell which emanated from the *Roi Soleil* and we shake our heads on the Isola Bella when we are shown the tiny wash-basin in which Napoleon made his morning toilet. Indeed, we are not surprised by the idea of setting up the use of soap as an actual yardstick of civilization. The same is true of order. It, like cleanliness, applies solely to the works of

man. But whereas cleanliness is not to be expected in nature, order, on the contrary, has been imitated from her.[3]

In the age of digital machines and cybernetic bodies, this insight seems as apt as it did then, especially since the themes of *digital* hygiene, orderly computing, and clean communication have appeared in the vocabulary of Western culture since the 1980s. As they are not expressions of a universally objective matter of fact, such arguments for purity are deeply entwined in the politics of software and the post-Fordist capitalism of network culture.

The politics of definitions taps into a longer genealogy of modernization and modern computing, which has emphasized control, reliability, and order. Here, various types of accidents, deviations, errors, and mistakes stand out as anomalies. Computer viruses have not been mere "accidents of nature", but are seen also as cunning forms of vandalism and an indication of sabotage mentality: "Rather like Hitler's V1 'flying bomb', no one knows when or where a computer virus will strike. They attack indiscriminately. Virus writers, whether or not they have targeted specific companies or individuals, must know that their programs, once unleashed, soon become *uncontrollable*."[4] In a more polyvalent context, several science fiction writers of the 1970s also mapped the issues of noncontrol in new networks of communication, where actions are attributed not merely to human beings. David Gerrold's *When HARLIE Was One* (1972), John Brunner's *The Shockwave Rider* (1975), and Thomas J. Ryan's *The Adolescence of P-1* (1977) all played with the idea of self-perpetuating software programs that are not reducible to the physical or conceptual territories of computers as number-crunching machines.[5]

Computer security journals, books, and other publications have for years constructed an image of the computer virus as an unreliable and unexpected danger: viruses are a *chaotic* element within a system based on security and order. According to one widely embraced view, computer security means (1) confidentiality (the privacy of sensitive information), (2) integrity (authorized information and program exchange), and (3) availability (systems work promptly and allow access to authorized users).[6] In the mid-1980s computer security was defined in terms of access control and protection:

> Prevention of or protection against (a) access to information by unauthorized recipients or (b) intentional but unauthorized destruction or alteration of that information. Security may guard against both unintentional as well as deliberate attempts to access sensitive information, in various combinations according to circumstances. The concepts of security, integrity, and privacy are interlinked.[7]

Viruses and other forms of malicious code are, consequently, a direct threat to these values, which are part of the modern episteme in general. This is one mode of "a computational way of thinking." The concept refers not only to the epistemological and ontological presuppositions in actual computer science discussions, but also to the larger cultural historical contexts surrounding the design, implementation, and use of computers. Of course, one has to note that computers have never been the reliable and rational dream machines they have been taken to be, as they are exposed to various possible causes of breakdowns, of which viruses and worms are just two among many.

Computing is hence a matter of trust and control, but viruses play the role of an obvious disruption in that scheme. A virus steals control and ruins "the trust that the user has in his/her machine, because it causes the user to lose his or her belief that she or he can control this machine", as antivirus researcher Vesselin Bontchev noted in 1994.[8] Gradually during the past few decades trust has come to be debated in discussions of computer systems, and the Trusted Computing Group (in the wake of the Trusted Computing Platform Alliance) has underlined the value of designing so-called trusted systems. For critics, this has meant the reduction of users' scope to have control over their computers and networks, which are increasingly defined already by system designers. This has been justified with security reasons and arguments that trusted (which does not equal trustworthy) systems are less vulnerable to malicious attacks than open systems.[9] But trust is also a recurring theme in modernization in general. Zygmunt Bauman has described the nature of modern science as an "ambition to conquer Nature and subordinate it to human needs."[10] This is control management, where control and communication have become vital, heavily politically loaded terms and tools. At the same time, from the nineteenth century on, these values of order, system, and control have also been embedded in machines and technological systems, and, over time, these values have become the characteristics of modern technological culture.[11]

James Beniger articulates the vitality of control in his book *The Control Revolution* (1997). According to Beniger, the modern information society was born in the nineteenth century as part of the societal practices expressed by Max Weber as rationalization and bureaucratization. Both practices serve the objective of achieving control of the socio-economic complexity of modernity. Beniger analyzes technological solutions and formal models to provide control—for instance, the ideas of social programming and the machines of production, distribution, and data processing—from the Jacquard loom to the pre–World War II computing revolution.[12] Such modes of algorithmic processing automated

complex patterns in coded form and produced seemingly reliably mechanisms for mass production. Production information (i.e., instructions) became coded into "software" form, whether as early music rolls for pianos or models for automated looms, or later as census punch cards recording national population for statistical control purposes. Either way, the mode of production was controlled via coded operating instructions.

Modernity marked a new attitude toward *controlling information*. Capitalism and digital culture as historical phenomena are based on the cultural techniques of abstraction, standardization, and mechanization, which were already part of the technological culture of the nineteenth century. Similarly, Turing's universal machine was above all a machine of ordering and translation, with which heterogeneous phenomena could be equated. This idea, concretized in typewriters, conveyer belts, assembly lines, calculators, and computers, served as the basis for both digital machines and capitalism. The concrete connection was the need to control increasingly complex production, circulation, and signs. Rationalism—as exemplified in Babbage's differential calculators, Taylor's ideas of work management, and cybernetics—was the image of thought incorporated in these machines.[13] In general, this might also be referred to as the abstract machine of control and order, actualized, for example, in the cybernetics of the post–World War II situation.

First-order cybernetics fulfilled the project of modern abstract rationalism. Notions of control and order play a significant role in the archaeology of information-technological security, and these themes are especially visible in the thinking of Norbert Wiener, the pioneer of cybernetics. Wiener's cybernetics touched, most of all, upon the question of understanding the world as a series of communication circuits and controlling them via successful feedback loops that maintain the homeostasis of a system. This theory relates closely to the problem of entropy, a notion in statistical mechanics from the nineteenth century: information was understood as a degree of organization; entropy translated as a degree of disorganization—not an absolute transcendent but a relational negative twin of organization.[14] Already Claude E. Shannon had transported the concept of entropy to information theory after World War II in his 1948 paper "A Mathematical Theory of Communication", where he described entropy in terms of randomness in a message system. Entropy was, then, introduced as a certain necessary component in communications intimately tied to the information value of a message.[15]

Wiener himself recognized cybernetics as part of the history started by G.W. Leibniz, and especially his dream of a universal language of mathematics. Following Aristotle's idea of the categorization of concepts, as well as the *ars*

combinatorial plans of Raymond Lullus and Athanius Kircher, Leibniz established his plan to decipher the grounding alphabetical system and conceptual basis on which the world rests. Leibniz's idea can be divided into three parts: (1) to create a handbook or an encyclopedia that would gather human knowledge in its entirety; (2) to select the most appropriate concepts and symbols to refer to this knowledge; and (3) to create a logic to handle these concepts, a mathematical tool (a calculus). For this task Leibniz planned his own *calculus ratiocinator*, the rational calculator that—more than being a machine—was a way of performing symbolic logic.[16] With it, numbers seemed to be doing the counting themselves, as suggested by the Greek etymology of the term "automata" (*autos*, "by itself").[17] Thus, the origin of the computer is connected to automata, implying that the platform of computer viruses is also a self-perpetuating machine of a sort. This notion pertains to modernization in general as the era of self-moving machines, such as the clock or the cinema, automated movement not reliant on an external mover.

For Wiener, Leibniz represented "the patron saint of cybernetics" because of his concepts of universal symbolism and calculus of reasoning.[18] The dream of achieving control through meticulous, discrete categorization led to more concrete practices of design, manipulation, management, and engineering.[19] The *calculus ratiocinator* can therefore be seen as a precursor to the information machines of the control revolution that Beniger analyzes. The early strand of cybernetics that to a large extent was the outcome of the Post–World War II Macy Conferences underlined the themes of homeostasis and feedback. As Charlie Gere notes, this amounted to a view of "effective and efficient control and communication."[20] As part of the modern modulations of desire, cybernetics, systems theory, and information theory were all in a way theories of order and cleanliness.

The engineering problem of logical calculation and communication of signals without noise expands toward the more general cultural fields of power and articulation. The notion of noise deserves special attention. Noise, as understood by Bauman, means undefinability, incoherence, incongruity, incompatibility, illogicality, irrationality, ambiguity, confusion, undecidability, ambivalence—all tropes of "the other of order."[21] For cyberneticists and early computer pioneers, noise represented a management problem, objects in the way of transmitting signals. Noise as the most important problem for the rise of modern discourse networks was not solved once and for all in any historical phase and has remained part of communication acts; the only resolution to the problem of noncommunication was to incorporate it within the system.[22] Yet, noise is not merely pure noise as the Other, but an indication of another form of logic that is *defined*, posited, as the

Other in the fields of power/knowledge of network culture. Noise does not automatically mean chaos. In other words, viruses and similar types of programs do follow certain types of logical algorithmic patterns and are products of a "rational" piece of code. Hence, it is interesting how the biopolitics of digital code translates certain expressions of sense into noise and simultaneously suppresses alternative logics of computer software.

By definition, viruses have been conceived as a threat to any computer system, for (1) virus activity is always uncontrollable, because the actions of the virus program are autonomous, and (2) viruses behave indeterminately and unpredictably.[23] Viruses seem, then, to be in fundamental tension with the imaginary view of computers as linear number crunchers. Turing's machine proposed an ontology of digital culture that would have been based on errorless functioning of the machine and thus the system. Of course, Kurt Gödel had already proved the logical impossibility of such a self-consistent machine, and dozens of works of fiction have similarly taught us (as if we did not know it) that machines do break down. HAL 9000 breaks down in *2001: A Space Odyssey*, the computer-controlled robots "fall ill" in *Westworld*, the security mainframes threaten the whole world with their unpredictable functioning in *War Games*, and the computers in the famous TV series *Star Trek: Next Generation* are infected with a virus. Several similar audiovisual and textual examples of mechanical and digital machines failing their duties could be given.[24] There is a whole history of things breaking down. Hence, there is always the possibility to write a countermemory of the disorderly, accidental, and contingent nature of technological culture. Perhaps viruses might turn out to be also intellectual tools with which to create new concepts in, and viewpoints on, digital culture and the cultural history of computing and technology in general. In this sense, "viral noise" does not refer to any logic of the Other—the virus as the Other of system—as such a view would rely on a logic of negativity, of the Same and Other. Instead, the thematics of noise are relational and part of the establishment of systems. Noise is to be understood as a differentiation of a system; in other words, a system creates its noise and viruses, whereas noise and viruses are a residue, or a surplus, of a system. Instead of antithetical relations, noise is already a folding within the system in the Serresian way of understanding the parasite. It is a question of the anomaly, of *anōmalos* as the uneven, the differing, the deviating, as well as the apocalyptic revealing of its own conditions of birth. The virus, the noise, is the bastard offspring: unrecognized yet not foreign.

This emphasizes the conceptual space we should give to the parasites that reveal the networks of power that otherwise go unnoticed. The challenge is to draw a cartography that respects this multiple articulation of viruses and worms as a part

of the capitalist society of information, deeply rooted in the *mathesis universalis* of the seventeenth century, yet constantly revived in the new contexts of the risk society and the nonlinear logic of complexity it adheres to. Thus, with the end of the twentieth century, new forms of flexible modernization introduced reformed ideas of noise-tolerating systems capable of living with the uncertainties of contemporary (digital) culture. Risk society understood through the language of cybernetics marked a step from controlling information to adjustment and toleration of uncertainty and risk. In short, the discourse of computer worms and viruses is held in tension between elements that underline the need for top-down control, hygiene, and digital cleanliness and the forces that draw digital culture toward flexibility and self-organizing meshworks.[25] This chapter is a mapping of the forces that want to define computer worms and viruses as malicious software, *a security problem.*

SECURITY IN THE MAINFRAME ERA: FROM CREEPERS TO CORE WARS

Security and computer protection after World War II proceeded along the paths outlined by cybernetics in the form of *control, inspection,* and *integrity.* Inspection has meant locating security holes and known viruses, and integrity has meant methods for detecting unauthorized change in systems, but control "has been the primary intent of the U.S. national standards on computer security."[26] As the key concept of computer security, it has meant controlling access to systems, as well as functions, resources, and the moving and sharing of data.

Such ideas of security suited the techno-political global situation until the end of the 1980s. As Paul N. Edwards has noted, global politics (which, of course, folded with domestic politics, for instance, in the United States) worked according to a closed-world discourse.[27] Such a model of organization was based on strict control of insides and outsides, of borders and crossings. With the change of the global system of balance around the end of the 1980s and during the 1990s this changed, and there arose a new emphasis on global vectors in trade, culture, and the movement of people and goods, a fact that also spurred global flows of information as well as viruses. The localized barriers of the cold war gave way suddenly to a new informational regime, of which the Internet rose to be a key symbol and organizer. Viruses were neither an issue nor a security problem back in the age of the first mainframe computers—but bugs were.

The first relay computers in the 1940s encountered strange problems that caused malfunctions. Upon closer inspection, the engineers found that little bugs

had crawled between the relays. The operators of the Mark II Aiken Relay calcu-
lator found a moth inside the computer, and even reported it in the computer log
as the "first actual case of [a] bug being found." Because the computers were used
at nighttime, the bright, warm lights attracted different sorts of bugs. Debugging
meant, of course, removing the moths and other bugs from the relays.[28]

Yet, "bug" was a term already in use in industrial production at the end of the
nineteenth century. An electricity production manual from 1896 makes an inter-
esting reference in this case: "The term 'bug' is used to a limited extent to desig-
nate any fault or trouble in the connections or working of electric apparatus."[29]
Similarly, the term "bug" was used for other types of communication failures with
the telegraph and Morse code.

Debugging is nonetheless an interesting form of computer practice, and the
early programming ideas of viruses and worms can be dated back as far as the early
debugging of programs of the 1950s and 1960s. A short history of viral programs
reveals the existence of these early self-reproductive programs as recurring utility
program loops, not malicious by nature. These self-replicating programs func-
tioned according to instructions that made the programs copy themselves from
one memory location to the next. This was intended to fill the memory space with
a known value, consequently allowing it to be programmed with a new applica-
tion.[30] Thus, the simple instruction "move (program counter) --> Program counter
+ 1" seemed to mark the beginning of the era of the virus.[31] The early ideas of recur-
ring algorithms and other self-referential code also incorporate the basic tenets
of viral programs. Michael Apter had conceptualized self-reproductive programs
already in 1966 in his *Cybernetics and Development*. There he pointed out the same
problem on a technical level. Using reproduction subroutines that were able to
recycle the original instructions into the copy meant also taking into account that
such growth subroutines would easily fill the whole memory space if they were
not stopped manually via the keyboard.[32] Later, such program routines were also
referred to as "forkbombs", a way of potentially crashing a UNIX or a Windows
operating system with a little program that exponentially multiplies itself.

In another account, the first self-replicating programs were characteristically
called "rabbits." The rabbit was a mainframe program routine that could poten-
tially make thousands of copies of itself, which would jam the executable proc-
esses, preventing the normal functioning of the computer. David Ferbrache dates
rabbit programs to the 1960s, giving an example from 1966 when some students
wrote a script that "would invoke itself continually, generating large numbers of
temporary files which would exhaust disk space."[33] Another recollection dates the
rabbit program to 1974, when a programmer working at a large company wrote a

program for IBM 360 computers called Rabbit. The program kept copying itself until the rabbit slowed down or "constipated" the computer.[34]

During the 1970s another form of self-spreading program appeared on the U.S. computer scene. Originally it was a game program called Animal, but it was modified by its creator, John Walker, into a self-spreading and self-updating version, Pervade. Walker's efficient program was able to spread and find older versions of the game and replace them with newer ones. As it only replaced the old program, there was no fear of clogging the system. Pervade, however, encountered problems with other commands in some Univac systems. Walker recollects one incident in particular when the Pervade program interacted with a certain company's Univac system to produce problems in the daily running of programs. This was, however, considered then to be more amusing than dangerous. Walker's testimony is worth quoting at length:

> More than 20 years after ANIMAL was born and briefly thrived, it's hard to imagine that the first computer virus was viewed, in those days, not as a security threat but entirely with amusement. I was, at the time, very conscious of the threat a malicious program might have created and frequently, in discussions with other programmers and site managers, used ANIMAL as an example of an easily-exploited yet little-perceived vulnerability in a sophisticated operating system which its vendor considered reasonably secure (and was, in fact, far more secure than typical present-day personal computer operating systems). I had hoped that ANIMAL would, in some small way, get people thinking about operating systems in which security was based on a formal model, as opposed to the chewing-gum and baling wire *ad hoc*, "find a hole and plug it" approach of the vast majority of systems, then and now.
>
> In 1975, when most computers were isolated islands which communicated with one another primarily by exchanging magnetic tapes or card decks, with modem connections used mostly by remote terminals accessing a central computer, the risk posed by a malicious ANIMAL-like program was small and could have been easily contained. Today, as the Internet is knitting together all the computers of Earth into an intercommunicating and cooperative tapestry, the lessons of ANIMAL are more significant than ever.[35]
>
> In later, networked systems, controlling the computing environment was even more demanding. New operating system and programming paradigms were developed, especially from the 1960s and 1970s on. The "complexity barrier" was discussed early on, along with emergent ideas for computer programs. This referred to finding learning patterns that could "evolve" from simple structural elements toward new semiautonomous patterns.[36] From the 1970s, such distributed systems were also part of network worm programming. Each program was allocated its own niche in memory space, but from time to time the programs had problems maintaining these boundaries, resulting in operations on data or programs that belonged to different procedures. This caused random operations and damage and contributed to a development of the concept of "wormhole patterns" as rogue programs that infiltrated other memory locations and also foreign computers.[37]

Hence, the origins of self-reproductive software were far from malicious in intent. In some contexts, such programs were described as an amusement. Writing self-reproducing programs with FORTRAN, the first programming language, was even considered to be a form of popular entertainment in early computer programming circles, an activity that was compared to playing video games.[38] In other words, such programs inhabited a very different incorporeal status from that they have come to occupy. On the level of material code, such programs are deeply (although nonlinearly) connected across decades, with several routines and practices surviving from different contexts. Yet, on the level of incorporeality where the programs are perceived, valorized, and signified, the difference is huge. This, of course, underlines the fact that media ecologies consist of articulations between corporealities and incorporealities: the temporal-material processes of virus programs are translated into agendas of politics, national security, and economics. In addition, the actor network was altogether different during the 1960s: self-reproductive software was an issue of experimental computer programmers and hackers, and the power to define the legitimacy of software was not restricted to security professionals, administrative personnel, and antivirus researchers, as it came to be at the end of the 1980s.

Computers were an inspirational aid in the scientific community of the 1960s, which resonated in the enthusiasm with which they were received, especially in institutes such as the Massachusetts Institute of Technology (MIT). The military was a key sponsor, a fact reflected in the amount of money the laboratories received. Cybernetic research was used to model and simulate war scenarios, but new automated and distributed systems were also of interest to the military.[39] In addition to MIT and other university computer labs, interesting experiments were conducted at the AT&T Bell Laboratories. The game Darwin, created in 1961 by Robert Morris, M. Douglas McIllroy, and Victor Vyssotsky, is one of the experimental programs that can now be seen as precursors of modern-day computer viruses. The game was played on an IBM 7090 by programming an "organism" with which to conquer the core memory of the computer. The player with the better organism program would eventually wipe out others and inhabit their memory space. The player with the most cunning and adaptive program came out as the winner most of the time.[40] The programmers described the game in warlike terms as "a game of survival and (hopefully) evolution": "Each game continues until either time runs out or only one species remains. If the members of one species manage to destroy all members of all other species, the player who coded the surviving species wins."[41] The authors of the program referred to it occasionally as a "virus", with the quotation marks included.

The idea of Darwin was developed in Core Wars, a 1980s adaptation of the program. It was introduced in 1984 by A.K. Dewdney in his Computer Recreations section of *Scientific American*, describing the technical basics of such battle programs. Very similar to Darwin, Core Wars was about programs as efficient as possible with the aim of *killing* other inhabitants of the memory space. The four main technical components of the game were (1) a memory array of 8,000 addresses, (2) an assembly language called Redcode, (3) an executive program called MARS (Memory Array Redcode Simulator), and (4) a set of contending battle programs.[42] Core Wars was quickly adopted by artificial life researchers when Christopher Langton invited Dewdney to introduce the game at the first ALife conference in 1987. The scientists, led by Steen Rasmussen, remodeled Core Wars into a computational ecology where the focus was not on war among programs but on analyzing and synthesizing software interaction—artificial chemistry of sorts.[43]

The game programs were innovatively named: Dwarf "is a very stupid but very dangerous program that works its way through the memory array bombarding every fifth address with a zero."[44] Dwarf itself did not move, unlike Gemini, which Dewdney described as an intelligent program: "The Gemini program has three main parts. Two data statements at the beginning serve as pointers: they indicate the next instruction to be copied and its destination. A loop in the middle of the program does the actual copying, moving each instruction in turn to an address 100 places beyond its current position."[45] Similar self-copying and spreading battle programs were Bigfoot and Juggernaut, modifications of the Gemini code.[46]

Experiments from the 1950s on demonstrated the technical feasibility of recursive code, interacting program types, and the connectionist ecology of computer platforms. The similarities of Core Wars to the technical basics of computer virus code were so striking that Dewdney had to return to the Core Wars program twice, in 1985 and 1989, after the infamous Morris worm incident, emphasizing that Core Wars programs were not harmful, unlike *real* viruses.[47] Even if Core Wars might to some have resembled the "abundant examples of worms, viruses, and other software creatures living in every conceivable computer example", Dewdney's battle programs created with the Redcode programming language were, despite their militant nature, harmless. No computer came equipped with that particular programming language, which also prevented Core Wars programs from spreading. Nevertheless, Dewdney listed a number of such militant viral programs that resembled the game described by him.[48] Core Wars can perhaps be understood as one of the key models with which to grasp the idea of hostile programs. It also can be seen as working toward the neo-

Darwinist understanding of computer culture, where natural selection, variation, and heredity are the key processes in the fight over limited resources. Although importantly addressing computers as platforms for evolution and learning, these types of models hindered the emergence of more fruitful ideas of evolution as symbiosis, for example.[49]

Core Wars, and the other programs introduced above, illustrate the technological lineage, the ontogenetic lines, of the virus assemblage. These types of (semi)automatic programs seem to be characteristic of the media ecology of digital network culture, making it hard to reduce viruses and worms merely to anomalous objects. In addition, the science fiction literature of the 1970s had already demonstrated how cybernetic ideas of self-reproducing and learning programs spread on the popular cultural level.[50]

How, then, was computer security oriented before viruses? Against what sort of threats did the computer professionals (and to some extent the public, as addressed in newspapers and magazines, for example) prepare during 1960–1980? I present here three fears of such undesirable things that also shed light on the computer virus phenomenon: (1) computer errors and bugs, (2) surveillance and threats to privacy, and (3) physical dangers.

Until the 1970s computers were mostly professional tools—meaning that their use was restricted to computer professionals and those in certain jobs, such as bank workers. The main applications included counting, registering, and controlling.[51] At the same time, automation was becoming the keyword of future cybernetic systems, where computers would take over most routine tasks in society.[52] Thus, first, one of the key computer fears had to do with programming errors and unintentional bugs, as *Scientific American* noted in 1980:

> The computer error has become legendary for its mindless disregard of plausibility and common sense. Most such errors can of course be traced to mistakes made by those who program or operate the computer; now and then, though the machine itself blunders. Parts fail or malfunction; extraneous signals are introduced into the circuitry; legitimate signals go unrecognized. Even if each component is highly reliable, the computer has so many parts that errors are not infrequent.[53]

In general, "bad bits" became a problem in the 1980s with the mass production of commercial consumer software. Since the 1980s, bad bits have haunted not only office computers and software but also leisure products.

Second, during the 1970s the computer's status in discourse became more that of a personal assistant, and the potential user group grew from a limited number of computer experts to office employees, hobbyists, and, with the advent of the

personal computer in the 1980s, children—hence the growing fears of surveillance and threats to privacy, key themes of digital culture since the 1970s.[54]

Malicious technology, surveillance, and loss of privacy were themes that occurred in a bunch of films dealing with the computerization of culture, such as Jean-Luc Godard's *Alphaville* (1965). This is also a theme particularly tied to the mental history of North American culture, often expressed in the number series "1984", referring to Orwell's novel of the same name from 1949.[55] From the 1960s on, cybernetic automation was debated intensely in most Western countries; for some, it was a promise of an optimized command-and-control system that spanned from leisure to work; for others, it represented the bypassing of the human being by self-referential machines.[56] The U.S. legal and political system had devoted itself to protecting its citizens against the powers of surveillance, but several technological advances, from the telegraph and the telephone to computers, had been eroding this "social value of the individual":

> Now, the contemporary era of electronics and computers has provided the final coup de grace to the technological premises on which the classical American law of privacy has been based. Micro-miniaturization, advanced circuitry, radar, the laser, television optics, and related developments have shifted the balance of power from those who seek to protect their conversations and actions against surveillance to those who have access to the new devices. What was once Orwell's science fiction is now current engineering. (…) Fears of manipulation and of penetration into the intimate spheres of autonomy through such techniques have made worried protests against "Big Brother" a growing response to such psychological surveillance.[57]

The fear of personal secrets getting into the wrong hands, which has been raised also in several computer virus incidents where viruses have spread through personal e-mails, has long genealogical roots. It is in interesting tension with the "culture of confession", where the public expression of presumably intimate issues is considered as a value (as with reality TV shows). However, as the quotation illustrates, individuality and personal security have been the foremost American values of the modern period, and this historical perspective provides a good understanding of the meanings and fears attributed to network computing. When computer systems were for the first time planned as "public utilities", with suggestions even of public "data bank grids", the threat to personal privacy was the first concern that the new data storage and retrieval systems raised.[58]

The physical safety of machines was a third vital security issue. Computers had to be protected against physical malfunctions as well as concrete attempts at intrusion. If computer viruses illustrate the new understanding of space that

comes with the telecommunicatization of the world, then the computer security discourse until the 1970s and 1980s ran along more Euclidean lines. Computers were machines in a room, not virtually connected networks that communicate in digital bits—hence the need to contain and control the *people* using computers. As noted in a computer security ad in *The Times* (1972): "the trend to centralization, confining data to a single physical location aggravates the consequences of fire, flood and technical failure. And simultaneously provides increasing opportunity for malicious damage, espionage and fraud."[59] In other words, when computers were "big cabinets locked away in a data-processing department",[60] computer security was the task of keeping people out of such confined spaces.

White-collar crime and especially the growing amount of computer abuse were recognized as an alarming trend during the 1970s and beginning of the 1980s. The most urgent computer security problems had to do with data entry, with thefts or embezzlement by trusted employees, and also with pranks and sabotage. As noted at the end of the 1970s, a shift was taking place, however, from external security toward internal security problems. This meant "design flaws within the computer system itself."[61]

Internal computer security had been the object of extensive research since the 1960s. It was described as a field that regulates "the operation of the computer system in four areas: access to stored objects such as files, flow of information from one stored object to another, inference of confidential values stored in statistical databases, and encryption of confidential data stored in files or transmitted on communications lines."[62] The extensive security of spatial arrangements had to be supplemented with new techniques of intensive, non-Euclidean procedures that worked also on the program code level. This meant a media ecological turn where not only humans but objects, processes, and so forth are put to work to maintain security: the automated, digital program code as a gatekeeper, or as a security man—the pun that was visualized in *The Matrix* (1999), with the pastiche agents of the system roaming around in their dark suits, devoid of human personal features. Interestingly, in the sequels to the first film, the key agent, played by Hugo Weaving, turned into a virus-like replicator that threatened to take over the whole system.

The new security principles were established in a field of changing computing practices. Computing was beginning to be more than a playground for programming experts; it was spreading itself to workplaces and homes and at the same time transforming itself from centralized computing procedures to networked, distributed, and decentralized notions of telecomputing. The third nature of telecommunication, to use Mackenzie Wark's term presented in the Introduction, proved

then to be an incentive for new types of threats. The new spatial and temporal arrangements that started with the telegraph in the late nineteenth century had grown their own problems. Information was threatened by the noise of bad bits and the virtual networks of telesthesia (perception at a distance) that worked also as vectors of a new class of crime.[63]

Attention moved to securing information flows. As defined above, this meant limiting access to authorized personnel, controlling the flow of information to third parties, making sure that access to databanks is controlled, and securing communication lines against *noise*, which in this case no longer referred to the physical noise of the information channel structure but to malicious attempts to disrupt and steal from the flow of confidential data. Viruses or digital worms were not mentioned, because they were recognized as a plausible security threat only years after the earlier 1970s reports on computer crime. Yet, it is justifiable to claim that the computer security discourse of the 1970s started to recognize the new security problems, which now included such virtual agents as viruses and worms. In fiction, the idea of a virus had been articulated already in 1972 in David Gerrold's *When HARLIE Was One*:

> You have a computer with an auto-dial phone link. You put the VIRUS program into it and it starts dialing phone numbers at random until it connects to another computer with an auto-dial. The VIRUS program then *injects* itself into the new computer. Or rather, it reprograms the new computer with a VIRUS program of its own and erases itself from the first computer. The second machine then begins to dial phone numbers at random until it connects with a third machine.[64]

Instead of securing computers against physical intrusion by malevolent individuals and criminals, computer security started to mean protection against malevolent computer programs. For instance, Trojan programs, which for many represent an early form of computer virus, have been discussed at least since the 1960s. But what does this reference to computer *programs* as a threat to security mean? Perhaps the recognition marks a certain "posthumanist" shift, meaning that it is not only human actors who represent danger. Trojan horses can be defined as programs that are not what they seem to be on the surface. Named after the Homeric legend of the Trojan horse, which allowed the Greeks to gain entry into Troy by smuggling soldiers within a wooden horse, the digital versions usually refer to shareware or freeware programs that contain malicious code or, for example, create a backdoor to the computer system.[65] Consequently, several commentators, especially in the 1980s, defined computer viruses as self-replicating Trojans, expressing the implications that I am trying to map.[66]

This shift in security priorities can be understood by noting how certain key concepts and practices of security remediate or *deterritorialize*[67] with the digitalization of culture. Such widespread security concepts as barriers, detection, surveillance, guards, protection, and observation were widely adopted within the context of computer security.[68] As the security discourse moved from emphasizing *physical* safety to securing the safety of *information patterns*, or internal security, it deterritorialized from practices based on human-to-human interaction to interactions between machines, programs, and the temporal, nonrepresentational processes of digital code. Computer networks had been a key theme in research and design, and networking in general was compared to the building of the new interstate highway system in the 1960s.[69] With such networks, security could no longer be achieved through physical measures such as controlling access to computing terminals. Computer networking made computers susceptible to "breaking in from a distance", with imperceptible "hidden programs" being the new destructive threat.[70]

This corresponds also to the move from disciplinary societies to societies of control, where institutions are forced to open up their spaces of confinement and turn into apparatuses of open terrain modulation, as with computer networks.[71] Interestingly, already in 1975, Brunner's *The Shockwave Rider* had introduced the computer virus (or the tapeworm traveling across communication lines) as a vector of control societies and the novel nonplaces of electric media systems.[72] In addition, Ryan's *The Adolescence of P-1* addressed the issues of network security problems.[73]

In both official administrative and fictional texts, viruses and worms were understood as remote agents of computer network intruders, articulated as *prostheses* of the criminal mind, cracking passwords and tricking operating systems.[74] Computer viruses and the humans writing them were seen as interdependent: "The would-be perpetrator writes a program to do his dirty work for him. Although he must identify the weaknesses in the defense, it is the program that probes them remorselessly and at high speed, missing very little."[75] In a way, antivirus and security experts saw the security infoscape turning into a deterritorialized field of prosthetic technologies, originally conceived by humans but basically independent entities of a self-reproducing (third) nature—"electronic surrogates."

From the legislator's point of view, things were problematic. Computer crime and viruses were equated with wrongful entry into property or illegal intrusion, but the analogies were far from clear-cut. Laws against such vandalism and malicious harm were originally aimed at protecting clearly definable *physical* objects such as houses from harm.[76] How was this type of legislation supposed to address

the problem of crime where the criminal was several hundred or thousand miles away? In other words, the concept of computer crime was, during the 1960s and 1970s (and still at the end of the 1980s, after several larger computer virus and worm outbreaks), hard to grasp. Security was usually designed to provide physical protection for data and equipment, but now access control and protection against manipulation were required at the level of software and network access.[77]

In general, this process of deterritorialization expresses how the whole media ecology and information ecosystem was changing to one that would have to deal with new types of threats such as worms, viruses, and Trojans. This also spurred new regimes of power at the level of program code: security specialists, government officials, and scientists working with such regimes of power and knowledge as could control the fluid field of computing and networking. This represents the often-quoted shift from Foucauldian societies of discipline working on anthropological bodies of men and women to the control routines that focus on codes and passwords and the intensive processes of cybernetic machines, as Deleuze notes.[78] Control, as a form of smooth power, focuses not only on the anthropomorphic bodies of humans, but increasingly on the technological bodies of network culture.

Among the most powerful expressions of this change was the rising trend toward connectivity. The linking of machines via local area networks and telephone lines served as one of the most important preconditions for the virus phenomenon. Or, to think about the issue the other way round, worms and viruses express the change in digital culture from number-crunching machines such as the ENIAC, EDVAC, or Mark II Aiken Relay calculator to networks such as ARPANET or Telenet and Tymnet and personal multimedia machines such as the IBM PC, Amiga, or Atari. New technological lineages incorporated new types of social actions, including criminal ones. In other words, they offered new types of vectors for actions that were at times clearly illegal (such as fraud) but mostly in the gray area of law (such as hacking and system entry just for fun).

Time-sharing computing became more common from the end of the 1960s. Until then, computing had meant basically batch processing: writing the program to punch cards and taking the instructions to the computer personnel, who then input the orders into the computer. The results were retrieved later as a pile of fanfold paper. Time sharing marked the first steps of interactive computing: users had direct access to the machine, which would be used by several others at the same time. Thus, a single computer's resources were at the disposal of several users at the same time via remote terminals.[79] For security specialists, time sharing represented grave dangers. Sharing resources and software via networks or floppy disks

meant continuous exposure to potential viral attacks. [80] The novel media ecological concern was how to fit dozens of people within this electronic "space"—a problem that was analogous to the general problem of modernity in cities: how to deal with the issues raised by a huge number of people living in condensed urban spaces? As with the politics of urban spaces, this was a question of definition, perception, and mobilization: what is overgrowth, waste, or a social problem; how and by whom is it perceived; how are countermeasures activated; who are defined as the participants; who and what are the problematic agents?

Networking was seen as the next step from time sharing.[81] Leon Bagrit prophesized in the mid-1960s that the future of computing would be in personal computers that were connected to national computer grids for information retrieval.[82] Computer networks incorporated new types of software, too. The first recorded real virus incident seems to have been the Creeper virus, which spread through the ARPANET network in 1970. Creeper was a utility program made to test the possibilities of network computing. Inspired by the first program, written by Bob Thomas, several programmers made similar virus-like programs.[83] For example, the Xerox Palo Alto Labs worked with worm-like utility programs, which will be addressed more fully in Chapter 3. Interestingly, the same labs were keen on developing new networked personal computers, such as the Xerox Gypsy and Star, that were to be key in the interactive local area networks of the future. They were from the start designed to be nodes in a distributed system, something that is taken for granted in the contemporary culture of the Internet.[84]

ARPANET was a networking project that has been called the first interactive computer-to-computer network.[85] It was built according to the aspirations of the military, as reflected in its central characteristics: capacity for survival, flexibility, and high performance. ARPANET also attracted a lot of attention owing to its technical innovations, such as packet switching and other networking services, including e-mail. Of course, the ALOHAnet project from 1970 had already introduced itself as the world's first wireless packet-switched network— although it used a 9,600-baud radio messaging system. It had also introduced the Aloha LAN protocol, forebear to later key networking protocols in its ability to wait for a suitable turn in relation to ongoing message transmissions.[86] Such network projects, often torn between military and academic interests, represented a living actualization of the aspirations and utopias of connectivity so central to digital culture.[87] Of course, other networks, such as Telenet and Tymnet, the first commercial networks, also provided a platform for new types of tele-actions that attracted the phone phreakers of the 1970s to try out the possibilities of computing at a distance.[88]

What is important to note is that the basic ARPANET network programs contained worm-like routines, blurring the distinction between "normal" programs and parasitic routines. Creeper was only one of the early virus and worm programs that were part of the new multimachine architectures being tested in the 1970s. Thus, we can justifiably claim that the origins of worm-like—and partly virus-like—programs lie in the needs of network computing in general. The ambiguity is part of the virus problem even today, because essentially the same program can be defined as a utility program in one context and as a malware program in another.[89] Similarly, many basic utility programs have for years been virus-like, even though such programs often require the consent of the user to operate.[90]

To restate the point: on a corporeal level, viruses have been primarily a phenomenon of time sharing, networking, and, broadly speaking, connectivity. As antivirus manuals warned, "increasing compatibility of computers and communication" also meant greater exposure to viruses that could spread even faster. The more users on the same network, the more viruses as well.[91] The modern-day problem seems to have begun in the 1970s with the increasing trend toward connectivity. The ARPANET project was started in the 1960s, and in 1974 the National Science Foundation emphasized in a similar, network-inspired spirit the need to create a "frontier environment which would offer advanced communication, collaboration, and the sharing of resources among geographically separated or isolated researchers."[92] Alas, although connectivity basically meant that people could share data, programs, and computers, it also meant that all the users and machines that became interconnected became exposed to the malicious software on other machines. Consequently, security became a *system* problem, which reflected the change of emphasis from single computing machines to interacting networks of computers. It was not the machines per se but the networks that started to characterize the modern digital culture. At least from the 1960s on, computers (or televisions) interconnected via information networks were seen as the future mode of media culture.[93] Although industrial espionage, surveillance, and privacy were more acute security problems in the 1960s and 1970s, the true virus dilemma started during the 1980s. Viruses were understood as part of the history of computer crime, which was reflected in the use of similar terms to those used for previous security menaces. The incorporeal morphing of these programs into malicious creatures was linked to the increasing importance software and network computing played in a post-Fordist culture. As networks and cybernetic machines started to grow into prime tools of global capitalism from the 1970s on, the need to *control* such environments became a key societal concern.

THE SHIFT IN SAFETY: THE 1980S

The self-spreading battle programs of Darwin seem somewhat removed from the viruses and worms that were identified as a security problem especially in the 1980s. Yet, as one of the programmers of the Darwin program stated in an interview, security and military issues were always present during the cold war years and, for instance, the Korean war. War was part of the cultural assemblage of computers and computer science research in universities and labs. This was described as casting a veil of secrecy over computer development:

> The tangential relationship of this background to Darwin is that although in Darwin we were exploring what we regarded as a purely academic interest, we were well aware that technical advances can be put to use for destruction as well as for beneficial uses. I would guess, without clear recollection, that this understanding significantly influenced the precautions we took to avoid any results of our investigations with Darwin from being too widely known.[94]

Years later, but still in the midst of the cold war, the first "officially" recognized virus incidents occurred in the 1980s. Richard Skrenta's Elk Cloner virus, Joe Dellinger's virus family, and the Pakistani Brain virus were the first to be spotted and recorded in newspapers and other media. In addition to being the first publicized computer viruses, they are part of the shift of security practices and discourses that occurred with the general "computerization" of society throughout the 1970s and 1980s. In this, the corporeal and the incorporeal intertwine. The increasing number of computers and computer users, new types of computing devices, such as floppy disks, and general ideas of network computing also contributed to the emerging viral phenomenon. These were the essential vectors for the spread of worms and viruses, and represent the material, the corporeal, part of the change. The material vectors were supplemented with the incorporeal transformation of self-reproducing programs into the category of malicious software and succinctly into the world of crime, criminals, laws, vandalism, and so forth. This incorporeal event, which turned the focus toward jurisdiction, criminal law, and business issues, was an integral part of the standardization of software culture (objects, processes, definitions, etc.) during the 1980s and the creation of a media ecology based on mass-produced standard objects.[95]

The first virus-like programs copied themselves only in the memories of single computers, but with time sharing and networking the programs spanned machine boundaries. In general, it was warned that as a "mathematical fact",

one cannot be entirely protected if sharing, transmission, and general access are allowed in a system. Flow restrictions were seen as difficult to implement in an atmosphere that since the 1970s had underlined the free flow of information.[96] The idea of connectivity, desired for decades, proved to be a security liability. Computer viruses were part of the system they operated in—underlining the fact that understanding the functioning of this system was the key to understanding the phenomenon of self-copying programs.[97] So, although before viruses, hacking, unauthorized system access, and software piracy had been the main threats of this media technological system, the emphasis changed with the development of a new media ecosystem biased toward telecommunications and networking.[98] Later, during the 1990s, such ideas were developed in experimental software that emphasized evolution, mutation, and self-referentiality in the form of "floating code", which is not hardware specific but designed for fluent network behavior across systems.[99] Such semiautonomous programs can be seen as new forms of optimizing behavior in complex and dynamic network environments, but in some instances they also brought forth new security and control problems.

In addition to technical control, the issue of security policy was raised, as was the more general question of what electronic interaction means. The threats to internal security via networks and malicious software created an atmosphere of distrust, reflected in Ken Thompson's frequently cited article "Reflections on Trusting Trust" from 1984. Thompson was the 1983 Turing award winner of the Association for Computer Machinery (ACM)—a prize that has been referred to as the "Nobel Prize within computer science." The message of his Turing award lecture was simple: every piece of code is potentially malicious if it does not originate from yourself.[100] The problem of modernization within cybernetic culture was tied to the paranoid feeling of having to interact with potentially malicious code and untrustworthy people.

Thompson's statement of suspicion can be understood as an expression of a certain "modernization and detraditionalization" of the computer world: the birth of network computing meant also being in frequent contact with more people, most of whom you do not know. Implicitly, Thompson posed the problem as follows: as long as self-reproducing programs are made by computer specialists, everything is fine, but when this knowledge ends up in the hands of a wider public, the key institutions of society become threatened. The legal system viewed these instances of vandalism still as foreign, a fact that Thompson hoped soon to change. According to him, the problem was the lack of general understanding of the security problems of digital culture:

I have watched kids testifying before Congress. It is clear that they are completely unaware of the seriousness of their acts. There is obviously a cultural gap. The act of breaking into a computer system has to have the same social stigma as breaking into a neighbor's house. It should not matter that the neighbor's door is unlocked. The press must learn that misguided use of a computer is no more amazing than drunk driving of an automobile.[101]

So "kids" were a potential security threat, and program code became malicious in a way that was earlier reserved for a much more physical damage—breaking and entering as well as drunk driving. The 1980s saw a rising number of computer crime and virus and worm incidents, which reflects also that such events were being increasingly recognized by the legal system, the mass media, and the computer (security) community. Computer crime represented a grave danger for societies increasingly dependent on electronic transactions.

The problem was articulated within international politics as well: the need for more efficient encryption mechanisms in the face of national crime and international espionage originating from the Eastern bloc was emphasized.[102] The communist countries served as an integral part of the cold war–era "closed-world discourse", where issues of border control—in physical and information terms—were underscored. This, of course, changed after the turn of the decade with new globalized vectors for information, where computer viruses were no longer perhaps metaphorical communists, but increasingly, for instance, transnational terrorists.[103]

The United States had encountered hundreds of cases of computer crime and abuse already in the 1970s, and the majority of cases probably went unreported. The increasing automation of society meant new forms of crimes (and jurisdiction concerning crimes) that focused on the seemingly nonmaterial aspects of property:

As we enter the information age, business and white-collar crime is changing significantly. Valuable assets are increasingly represented by information, an intangible property, and its processing, transmission, and storage are rapidly becoming the targets of crime. Such crime includes fraud, theft, embezzlement, larceny, sabotage, espionage, extortion, and conspiracy.[104]

National and economic interests were central when new security practices were argued for. References to international politics were frequent at the time of the cold war. The "privatization" of the media sphere with personal computing in the 1980s changed certain emphases, but the basic arguments stayed the same:

computer crime and malicious software constituted threats to organized society, the economy, and the American way of life. The home became (once again, one might add) a central point of defense against the frightening world of media technologies.

Definitions of computer security can then also be read as expressions of a cultural situation. Computer security was understood as

> that body of technology, techniques, procedures, and practices that provides the protective mechanism to assure the safety of both the systems themselves and the information within them, and limits access to such information solely to authorized users. *Computer security is of importance whether the information to be protected is personal in nature and therefore related to privacy concerns, whether it is defense in nature and therefore related to the security of the country, or whether it is sensitive in nature from a business point of view and therefore relevant to corporate well-being.*[105]

The definition reveals in its second sentence the key concerns of information culture, revealing the values implicit in computer security: individual privacy (a key theme of the modern world for the past 300 years), national security (a key theme from the nineteenth century on), and commercial security of international transactions (another key value of capitalist culture, particularly emphasized since the latter half of the 1980s). As the early capitalist societies of the mid-nineteenth century turned statistical mathematics and understanding of systems into insurance companies, probability management, and other tools for coping with insecurity and randomness, so the digital problems in unstable systems were battled with territorializing definitions and policy management. Viruses became both a national threat and an international problem for information capitalism. Consequently, in the 1980s security became even more important a factor in the design of computer systems than ever before.[106] Although university computer labs emphasized openness and access to all users through to the beginning of the 1980s, the growth in hacking was about to change this stance.[107] In addition, the culture industry discussed security problems; for example, John Badham's movie *War Games* (1983) raised the possibility of a nuclear war being launched by a computer error and a hacker.[108] Another key film, *Tron* (1982), introduced a hostile computer system that threatened not merely the ecosystem of the computer world but also the world outside its digital domain. In another context, in 1983 the U.S. national media brought "hacking" to the lips of the public with its reporting of the incidents of the "414 Gang" and the infamous Kevin Mitnick.[109]

Computers were no longer used solely by professionals in computing centers, state bureaus, banks, and insurance companies, but by smaller companies and

people in their homes. Computers meant not just number-crunching business or science tools but increasingly everyday media machines with leisure applications. Microcomputers appeared in the United States during the mid-1970s, a period marked by new perspectives on computing. Texas Instruments, for example, saw the future of computing in home computers connected to telecommunications systems. Even if this was realized only in the 1990s, with the Internet, the computer was transformed into a versatile media player offering a real challenge to the hegemony of the television as the center of the household.[110]

However, with personal computing came also new types of problems, such as malicious software. The first much-reported computer virus, as mentioned above, was Elk Cloner, programmed in 1981–1982 by Richard Skrenta and intended to be only a harmless prank.[111] After 50 boots (according to some sources 30 boots), Cloner printed a "poem" on the computer screen:

> Elk Cloner—the program with a personality
> It will get on all your disks
> It will infiltrate your chips
> Yes it's Cloner!
> It will stick to you like glue
> It will modify ram too
> Send in the Cloner!

Cloning and copying were presented as the key diagrammatic features of digital culture. Cloner was a boot-sector virus that intercepted certain command lines (DOS RUN, LOAD, BLOAD, and CATALOG). The virus remained resident in the system and infected every disk inserted to the floppy drive.[112] It was more of a harmless curiosity than a grave danger to the computer community, even if the virus was also described as a possible danger: "'I wrote it as a joke to see how far it would spread,' says Skrenta. 'But it's easy for a malicious mind to change or add a few lines and turn a harmless toy into a vicious tool.'"[113] Yet, the question was about not merely malicious people but the media ecology where viruses spread.[114] Nobody was looking for computer viruses back then, and the viruses themselves had trouble finding suitable vectors for spreading. For example, Elk Cloner was a boot-sector virus that spread only via floppy disks. The boot sector is a key part of data storage systems (from hard disks to floppies) that contains the vital booting information for the computer. The usual way for a virus to infect other machines was through the copying and exchange of disks—cultural habits that gained ground during the 1980s.

Apple II also hosted viruses in the early 1980s. Despite the diseases, Apple II had succeeded in creating a friendly face for computing in general.[115] As Paul Ceruzzi

notes, Apple II, introduced in 1977, had "excellent color graphics capabilities" and it was optimal for new "fast-action interactive games"; it was packed in an attractive plastic case and through its name and other qualities was perceived as friendly and nontechnical.[116] Of course, other examples illustrated the same point, for example, the Commodore PET—who could imagine a computer with a kinder name? Thus, it is exactly against this background of "user-*friendly* personal computing" that worms, viruses, and other malicious programs were constructed as menaces of the information society: the wild viruses versus the tamed pet computers.

The history of friendly personal computing begins in the 1960s. The PDP8 minicomputer was released in 1963, aimed especially at "educational users." The number of computer enthusiasts increased throughout the 1970s, as reflected in the publication of the first home computing magazine, *Byte*, in 1975 and the opening of the first computer shop in Los Angeles the same year. Increasingly, the emphasis was on average consumers and applications such as entertainment. Office applications such as word processing remained in the spotlight, but at the same time the designers kept the larger audience in mind.[117]

Games represented the new face of computing and the new computing audience; in general, applications marketed to children and youth, especially home computer entertainment, expressed this new trend as a revolution. "Probably the most important effect of these games, however, is that they have brought a form of the computer into millions of homes and convinced millions of people that it is both pleasant and easy to operate, what computer buffs call 'user friendly,'" reported *Time* in 1983.[118]

This effect was represented as a generational shift, as illustrated by the widely cited Apple Macintosh TV commercial from 1984, directed by Ridley Scott, which shows the new frontier of computing as revolutionary, personal, and playful in contrast to the gray standard image that IBM had risen to symbolize.[119] The new "dream machines" (as Ted Nelson described them in 1975) were supposed to act as catalysts of a new era of equality and innovation and the spreading of the hacker ethic. The imaginary of the computer underwent maybe not a revolution but at least a change between 1975 and 1985. A few years after the aspirations of early pioneers were adopted as part of the marketing campaigns and industry visions of a new commercial network culture.

Such visions were in a key position to dampen the traditional threats and fears surrounding computers. In addition to being nice and tame, the computer was also prestigious and reliable. *Time* magazine elected the computer the machine of the year for 1982. Hence it is no wonder that the computer industry predicted a gold rush of the digital age:

There are 83 million U.S. homes with TV sets, 54 million white-collar workers, 26 million professionals, 4 million small businesses. Computer salesmen are hungrily eyeing every one of them. Estimates for the number of personal computers in use by the end of the century run as high as 80 million. Then there are all the auxiliary industries: desks to hold computers, luggage to carry them, cleansers to polish them. "The surface is barely scratched", says Ulric Weil, an analyst for Morgan Stanley.[120]

The same year *Scientific American* described the revolution inherent in personal computing in a similarly striking way: "If the aircraft industry had evolved as spectacularly as the computer industry over the past 25 years, a Boeing 767 would cost $500 today, and it would circle the globe in 20 minutes on five gallons of fuel. Such performance would represent a rough analogue of the reduction in cost, the increase in speed of operation and the decrease in energy consumption of computers."[121] Computers were seen as the avant-garde of an ongoing "revolution", yet the revolution was constructed of numerous complex, interconnected parts.

Computers were defined as machines for receiving, storing, manipulating, and communicating information. Different tasks involved hundreds of thousands or even millions of logical operations carried out using binary numbers. This underlined the complexity of the computer machinery. It was practically impossible for the human intellect to follow this number of operations, which meant more or less trusting that the computer did what the user wanted it to do. Paradoxically, the fact that the computer automated several number-crunching functions on behalf of the user, which is often considered the advantage of computers, was also at the heart of the problem. A tiny piece of program code acting as a virus easily went unnoticed within the complex heart of automated computer operations.[122]

Computers, after the "revolution" of the 1980s, were increasingly "plug-in" systems designed to suit the needs of people without professional knowledge of them. In a sense, at the core of this turn is a new cultural perception and understanding of computers. The media theorist Norbert Bolz has emphasized the importance of this new cultural situation in a Marxist vein: modern perception informed by critical reason concerned itself with profundities, thus exposing and tearing "away the veil of appearances", whereas the contemporary situation is marked by an enchantment with the surface.[123] According to Bolz, the main function of modern user-friendly (computer) systems has been the concealment of the complex mechanisms of technical and cultural power inherent within such machines. Around 1980, structural complexity became functional simplicity, where the user submits to a "voluntary slavery." To paraphrase Bolz, technological objects demand the replacement of understanding with consent, where the

graphical user interfaces (GUIs) are hiding the actual control logic of the machine. Friedrich Kittler has proposed similar arguments from a different point of view: the modern culture of operating systems is hiding the real mode of the computer. The user-friendly computer, even though it presents itself as a ubiquitous, interactive machine, is actually a hierarchical control machine that prescribes passive user positions.[124]

The new commodity computers, such as the Apple II, were designed to be attractive to the eye. Until then, computers had been collections of screws and bolts; Apple designed these inside an attractive cover, making the computer an affiliate of the typewriter family. The processing units, circuits, and other hardwired bits and pieces were inside the cover, functioning autonomously, with the user having only limited power over the inside of the machine.[125]

Viruses, then, were initially understood as a problem pertaining to personal computing, as a 1992 "management overview" concerning IBM PC machines running DOS operating systems reflected:

> Thus there is an enormous common platform by which a virus may spread and a far larger number of people with the knowledge to use or misuse these computers. The computers are comparatively cheap and thus readily affordable to amateur or deviant programmers. PCs running MS-DOS have no inbuilt security whatsoever; as soon as the machine is switched on it is wide open to investigation or attack. The IBM PC is a near-perfect platform for virus propagation.[126]

What were the reasons for this? First, mainly average users, not experts, used personal computers; this is what the whole computer revolution was about. People using mainframes were professionals who knew how to react when the computer started to act oddly.[127] Second, personal computers were designed for single users only, with limited security measures against any illegal access. However, the machines were used for networking and file sharing, resulting in security and virus problems.[128] Third, whereas mainframe computers had much more complex operating systems, writing viruses for personal computers was not that hard. Even if most average users had no clue how the machine actually functioned, it was not an insurmountable problem for a student who mastered the basics of programming to write a self-replicating and spreading program.[129] A large number of the early viruses were written in PC assembler language or in such high-level languages as C and Turbo Pascal. The assembler language, closer to the machine language, made it easier to write boot-sector viruses and also more compact programs. This was especially important before large hard drives and GUI systems, which usually in any case have the side effect of users neglecting virus-increased file length.[130]

All in all, the home user of a personal computer was in several respects destined to be on the defensive. As a Data-Fellows virus protection manual from the early 1990s pointed out, security in personal computers is such a big problem because the internal mechanisms of the computer are so vulnerable to infection. The manual argued that it is practically impossible to control a program once it is running. Thus, a program could basically destroy or at least corrupt data on the computer without the user knowing about it.[131] Viruses demonstrated that users were neither alone nor autonomous with their computers and that malicious software taking control of the machine could interrupt users' standard routines (as it interrupts the call routines of an operating system).[132]

In short, maliciously minded hackers were not the only issue the user had to deal with; the whole computer system proved to be part of the problem. Computer architecture was so complex that the user was left feeling helpless. In this technical light, important issues contributing to the phenomenon of viruses were the new vehicles for transporting data introduced during the 1970s and 1980s: portable diskettes, or disks. First with disks, bulletin board systems, local area networks, and computer information services such as Compuserve and the Well, and later with Internet networking protocols and paradigms, the computer could connect with the outside world, downloading useful information but also potentially vectors of disorder.

At the beginning of the 1980s, the standard medium of personal computers was the floppy disk made of Mylar plastic coated with magnetic material.[133] The disk was an important vehicle in promoting the arrival of computers among ordinary people. It was relatively fast, had both read and write abilities, and allowed "random access": a specific piece of data could be retrieved more easily than from a magnetic or paper tape, the earlier versions of mass storage.[134] Of course, the small, portable size was important as it eased the transport and exchange of data. Again, we encounter the theme of standardization, which touched also the question of operating systems. The CP/M operating system, which facilitated the interaction of different computers, was soon replaced by the IBM MS-DOS system, resulting in "an almost unlimited pool of software" that programmers on another continent could develop for computers in other parts of the globe, but also allowing viruses to "spread across the scores of MS-DOS computers almost unstopped",[135] as Ralf Bürger noted.

In other words, technical potential was crucial for digital contagions. Although, for example, the first PC virus, Brain, observed in 1986, used diskettes to spread, it became practically extinct when hard disks became more popular. Brain could use only the boot sectors of 360-kb floppy diskettes and was unable to infect the

boot sector of a hard disk.[136] It did, however, spread successfully for several years, becoming perhaps the most widespread virus of the late 1980s. Even though it spread via diskettes, it did so practically worldwide: Brain started its life in Pakistan, but in no time crossed the Pacific, "spreading through the United States like a forest fire in a high wind."[137] According to one estimate, it infected 100,000 IBM PC disks in the United States alone.[138]

Some argue that the virus was meant as a warning to software pirates and that it spread only via illegal copying. The authors of the virus, Basit Farooq Alvi and Amjad Farooq Alvi, sold software applications and wanted perhaps to teach pirates a lesson. The virus contained the following message:

> Welcome to the Dungeon
> © 1986 Basit & Amjad (pvt) Ltd.
> BRAIN COMPUTER SERVICES
> 730 Nizam Block Allama
> Igbal Town
> Lehore, Pakistan
> Phone: 430791, 443248 2800530
> Beware of this VIRUS
> Contact us for vaccination[139]

Brain, most active from 1986 until the end of the 1980s, was originally a relatively harmless virus. It exhibited interesting "stealth behavior" in that it could hide its presence from scanners. It infected the boot sector but was able to mimic a healthy boot process. It placed a part of itself in another section of the disk, which was consequently marked as "bad" to prevent it from being used. The first version was harmless (and merely changed the disk name to © Brain). Some commentators even suspect it to have been merely a publicity stunt. Later versions were more of a nuisance, causing real trouble for the computers infected. Brain spread worldwide within a few years.[140]

Ever since the early viruses, pirate games had been among the main scapegoats. Manuals and other instructive articles listed illegally copied applications and games as central risks, because these disks had the biggest and widest circulation via multiple channels. This exposed the software to infection.[141] Such *prophylactic texts* recommend as a key point of "safe microcomputing" the avoidance of pirate programs and other suspiciously acquired applications. Often these protective measures were extended to pornographic material and other examples of leisure software.[142] This articulation of viruses–pornography–games highlights the economic basis of computer virus discourse: most of the texts are written from

the viewpoint of a business or the economy in general. Such wasteful and morally dubious distractions as pornography and games represented a malfunction in the early (Protestant-oriented) capitalist information system.[143]

However, two objections can be raised. First, some computer security experts have acknowledged that the connection between viruses and software piracy was overstated. It has been accepted as a myth—but a useful myth in fighting piracy.[144] Second, commercial, legitimate software was also infected. Among the first Macintosh viruses was the peculiar Peace virus, which was programmed in 1987 and infected thousands of computers in 1988. The virus was basically benign, even ethical, as the message it displayed was supposed to underscore: "Richard Brandow, publisher of the MacMag, and its entire staff would like to take this opportunity to convey their universal message of peace to all Macintosh users around the world."[145]

The virus spread to Aldus Corporation's main duplication facility, resulting in 10,000 copies of the Freehand program becoming infected. Thus, even though the virus was supposed to be peaceful, Richard Brandow was some years later charged with malicious mischief by prosecutors in King County, Washington.[146] The incident demonstrated very early on that official software was in no way virus-free. This resonates well with Ken Thompson's point quoted above: in a postindustrial society based on mass communication and handling of standardized software, you can never be too sure of the purity of your software. Similarly, average users were always forced to trust their computer software providers, even though trusted systems cannot be equated to trustworthy systems.[147] Viruses such Peace or Concept, which spread on the Microsoft Windows '95 Software Compatibility Test, also demonstrated the potential dangers. Similarly, the AIDS Trojan incident of 1989 exemplifies the problems of trusting otherwise convincing sources. A company called PC Cyborg shipped 10,000 Aids Information diskettes that actually included a hidden malicious program.[148]

Software seems to have become a major problem as it spread to lay users. Initially, the users themselves designed the programs and thus had the ability also to improve the software, but from the early 1980s on, computers were perceived as being "used by people who know no more about [their] inner workings than they do about the insides of their TV sets—and do not want to. They will depend entirely on the commercial programmers."[149]

There was a constant lack of good and reliable programs. Badly programmed software was not the only problem—so was software programmed to do bad things. This issue touched simultaneously the economic, political, and individual levels of society, as it was turned into an issue of risk and risk management. Although

the first viral programs were made in computing laboratories by early hackers, one could no longer count on the same ethical standards during the 1980s. As Thompson warned, software was no longer safe—it became a risk. Consequently, the notion of a risk society, coined by sociologists in the 1980s, resonates with this threat of malicious computer software.

FRED COHEN AND THE COMPUTER VIRUS RISK

Several early harmless viruses were modified over the years and equipped with increasingly malicious payloads. During the latter half of the 1980s, many more computer programs were more than funny pranks or innocent scares. "Dangerous miniprograms" became an issue around the middle of the decade. Viruses were the new software demons that could turn the computer's memory into "a mass of confusion."[150] Leligh University was hit in 1987 by a particularly calamitous program that infected the COMMAND.COM file, a crucial routine in DOS, and later also in Windows, that sets up the system during booting. In this sense, the virus could perhaps have come up with no better part of a system to infect. In fact, the virus was so destructive that it damaged the machines it infected *too* quickly; consequently, it did not succeed in spreading beyond the university's computers. The virus received a lot of publicity, resulting in growing public awareness of computer viruses. It also led to the creation of the important Virus-L news group on Usenet, coordinated by Ken van Wyk, who was at the time working at the university.[151]

Another classic virus from the same year, and still well remembered, was Cascade, which made letters "fall" to the bottom of the screen. In a way, Cascade demonstrated the breaking down of the new digital era, as well as the digital ontology of writing: no more Gutenberg Galaxy of letters; instead, the invisibility of the code as an executed order-word. This invisible machine code caused the visible surface layer of graphical user interfaces to crumble into pieces, underlining how language was no longer only about meanings and natural languages; it functioned increasingly as the binary machine code (and the program language intermediaries) that was more pragmatic and function oriented than semantic.[152] Viral code was rearranging not only the surface level of the computer screen but also the inner workings of the machine.

Soon the virus was also attracting explicit AIDS analogies: "It might do to computers what AIDS has done to sex."[153] Where AIDS had created a new culture

of bodily anxiety and political paranoia, computer sex diseases were thought to create similar fears of communication and digital contact. The Datacrime virus was deemed one of the first so-called media viruses, attracting wide press and television coverage. Commentators noted that the activation day, Friday, October 13, 1989, fell near Columbus Day, a festival honoring Columbus's arrival in the "New World" in 1492—probably why the media paid special attention to this program.[154] This demonstrates how viruses are parasitical in the wider sense: clinging not only to programs and operating systems but also to symbolical dates and routines. The technical virus moved on the social bond.[155]

Nonetheless, even after several reported virus outbreaks, certain commentators declared that there existed no such thing as a computer virus and that it was solely an urban myth. For whatever reason, much of the security community seemed to be uninterested in computer viruses. One such commentator was Peter Norton, who later became known through one of the best-selling virus protection programs, Norton Antivirus.[156]

It was one particular computer pioneer who brought these miniprograms to the attention of the computer security community. Fred Cohen illustrated the *risks* of digital contagions. From 1983 on, he warned of the dangers of computer viruses to organized society. I am not alone in emphasizing his importance: antivirus researchers and writers have, since the late 1980s, touted Cohen as the originator of virus awareness as a result of his work as a scientist (and also part of the commercial information security scene from 1977). Cohen demonstrated the universality of risk and limitations in protection: practically any computer system was vulnerable to attack. Cohen's writings and tests proved that we have no universal foolproof way of determining whether a virus is present in a system.[157] Through Cohen we can also grasp the idea of viral risks and risk society, and the creation of the novel risk policies these programs spurred.

Cohen was already working with viruses in 1983, under the supervision of Professor Len Adleman at the University of Southern California. The school (now renamed the Viterbi School of Engineering) was then a hotbed of computer and network research. Adleman had previously been engaged with encryption analysis, and security research was obviously already on the agenda in the department. Later he became one of the pioneers in DNA computing. In the 1970s, Cohen for his part was occupied with designing protocols for voice, video, and data networks. Cohen's virus test results were publicized in a paper in 1984, and in 1986 in the dissertation "Computer Viruses." The texts—and Cohen's work in general—marked a new phase of digital culture demonstrating the characteristics of a risk culture. Cohen's frequently cited 1984 paper "Computer Viruses—

Theory and Experiments" showed that even if several potentially widespread threats to academia, business, and government had been recognized, policies for the prevention of viruses had not been considered.[158] Cohen came up with the widely recognized and accepted definition of a virus as "a sequence of symbols which, upon interpretation in a given environment, causes other sequences of symbols in that environment to be modified so as to contain (possibly evolved) viruses."[159] In this definition, "sequences of symbols" means computer programs and "environment" refers to computer systems; that is, viruses are programs that attach themselves to other programs and transform them into viruses.

More generally, the question was not merely one of viral code but of the communication paths that connect computers together into networks. Cohen in fact introduced a modified theory of Turing machines in the age of networking. Interpreting data was not restricted to the machine where the data was stored; theoretically, open-flow models made it technically feasible to teleoperate machines. The control of a machine did not, by definition, lie with the machine, but potentially with a telemachine or even in semiautonomous computer programs.

As mentioned above, the software threat was already an issue in the 1960s and the 1970s (e.g., in Trojan horse programs), and people in computer security became increasingly aware of the new dangers inherent in malicious miniprograms. However, Cohen was the one who—with Ken Thompson—pointed out that viruses, which had earlier been simply intriguing experiments in programming, would present a grave danger to information society. "Computer Viruses— Theory and Experiments" and Cohen's dissertation outline (1) the definitions and the internal structure of virus programs, (2) the prevention and the cure for infected computers, and (3) the reasons viruses were such an effective and difficult problem for the security systems and policies of the 1980s.

According to Cohen, the problem with established security procedures was transitivity.[160] In grammar, transitive verbs can be understood as connectors between subjects and objects, forming a circuit between them in a sentence. Transitive relations in general also form circuits, via relations of equality, set inclusion, divisibility, implication, and so on. For Cohen, the logical relation of transitivity had to do with the flow of information and, in general, the trend toward sharing and networking. Communication systems functioned transitively in their mathematical nature. Even though isolationism would have provided perfect security against viruses and other network problems, it was not an option in a world becoming increasingly dependent on the flow of information.[161] Transitivity of information means that any information flow from A to B and from B to C implies also a link from A to C. Thus, it describes an open (but controlled, as

with protocols) system of flows. The partition model was conceptualized as a basic limit to this flow, closing a system into subsets and consequently restricting the free flow of information. Cohen cites the Bell-LaPadula security model (1973) and the Biba integrity model (1977) as policies that "partition systems into closed subsets under transitivity."[162] In Cohen's own words:

> In the Biba model, an integrity level is associated with all information. The strict integrity properties are the dual of the Bell-LaPadula properties; no user at a given integrity level can read an object of lower integrity or write an object of higher integrity. In Biba's original model, a distinction was made between read and execute access, but this cannot be enforced without restricting the generality of information interpretation since a high integrity program can write a low integrity object, make low integrity copies of itself, and then read low integrity input and produce low integrity output.[163]

Cohen demonstrated the vulnerabilities in existing security systems in a rather dramatic way. During 1983 and 1984, he conducted experiments on various computer systems that were aimed to demonstrate the powers of virus programs. Essentially, viral programs were able to use the transitivity of systems to their advantage. This demonstrated the logical basis of computer viruses. They also lived on logical connectors that in language guaranteed the subject–object circuit and in systems design formed the basis of communication of information.

Cohen's own account of the first test sounds rather blunt in its description of the birth of the first "official" computer virus. No sublimity there, even though Cohen was underlining this as the first virus ever:

> On November 3, 1983, the first virus was conceived as an experiment at a weekly seminar on computer security. The concept was first introduced in this seminar by the author, and the name "virus" was thought of by Len Adleman. After 8 hours of expert work on a heavily loaded VAX 11/750 system running Unix, the first virus was completed and ready for demonstration. Within a week, permission was obtained to perform experiments, and 5 experiments were performed. On November 10, the virus was demonstrated to the security seminar.[164]

The demonstrations did what they were supposed to do: they proved the real threat of viral penetration into most computer systems. In these simulated attacks, the virus acquired all systems rights in under an hour; in one case it took only five minutes. According to Cohen, everyone was surprised, especially with how short a time it took to take over a system.[165] The virus had proved its dangerous nature.

In fact, the virus tests were a little too efficient. After the amazing spreading capacity was perceived, and the potential dangers understood, the UNIX system

administrators at the University of Southern California wanted to back out and terminate testing. Several months of negotiation resulted in deadlock, leaving Cohen with an extremely important and fresh concept in his hands but without a system to test it.[166] However, in 1984 Cohen was back in business and testing a Bell-LaPadula integrity system on a Univac 1108 computer. Consider Cohen's words, where the virus is presented as an autonomous actor, as if alive:

> After 18 hours of connect time, the 1108 virus performed its first infection. A fairly complete set of user manuals, use of the system, and the assistance of a past user of the system were provided to assist in the experiment. After 26 hours of use, the virus was demonstrated to a group of about 10 people including administrators, programmers, and security officers. The virus demonstrated the ability to cross user boundaries and move from a given security level to a higher security level. Again it should be emphasized that no implementation flaws were involved in this activity, but rather that the Bell-LaPadula model allows this sort of activity to legitimately take place.[167]

Cohen discusses various types of viruses that exhibit different forms of behavior in varying environments. For example, the evolving virus was input with random code to produce Darwinian effects:

```
Program evolutionary-virus:=
{print random-variable-name, " = ", random variable name;
loop: if random-bit = 0 then
        {print random-operator, random-variable-name:
        goto loop:}
print semicolon:
}
Subroutine copy-virus-with-random-insertions:=
{loop: copy evolutionary-virus to virus till
        semicolon found;
if random-bit = 1 then print-random-statement;
if -end-of-input-file goto loop:
}
main-program:=
{copy -virus-with-random-insertions;
infect-executable:
if trigger-pulled do-damage:
goto next:}
next:}[168]
```

In practice, the idea of a virus with randomly inserted code was extremely unlikely to work. Computer programs are so unstable that there is always a very high chance that the program will not work with additional code. Hence, the artificial life prospects of this EV **(evolutionary)** program were still more imagi-

nary than real. Of course, some years later, breeding programs in the form of genetic algorithms were incorporated as software tools into commercial projects. These provided a far more stable form of "evolution" as they were always oriented toward some specific task or a goal they were supposed to optimize.

Cohen's general aim was obviously to find models and procedures for secure computing—to maintain the flow of information in society, a particularly important idea in the age of Reaganism and Thatcherism. Flow and deregularization had become widely distributed cultural symbols but also logics of action. For Cohen, the virus was not a passive material, technological component but something acting and spreading. In fact, Cohen suggests in his PhD thesis that computer viruses express the fundamental properties of life: reproduction and evolution. Cohen's mathematical definition of life allows it to be regarded as a phenomenon that is not an attribute of a particular substance, but a form of connection:

> The essence of a life form is not simply the environment that supports life, nor simply a form which, given the proper environment, will live. The essence of a living system is in the coupling of form with environment. The environment is the context, and the form is the content. If we consider them together, we consider the nature of life.[169]

What is interesting is that Cohen seemed to touch on ideas of evolution as symbiosis rather than mere neo-Darwinist models of competition. In a cybernetic fashion, life seemed to be a transitive circuit, an articulation between organisms and their environments. I return to this point in Chapter 3.

However, it should be noted that Cohen was not the only one drawing such analogies: one often-neglected work is the thesis "Selbstreproduktion bei Programmen auf dem Apple II-Rechner" by Jürgen Kraus, submitted at the University of Dortmund, Germany, in 1980, which was also an attempt to schematize principles of artificial life as similar to computer viruses.[170] The cultural representation of computer viruses and antivirus research seems to emphasize the Anglo-American world, neglecting the work done elsewhere. Nevertheless, self-reproductive software was emerging as a theme that cut across the whole machinic phylum (media ecology) of network culture and was not restricted to national cultures.

The viral life of digital code reads as part of the new conception of postindustrial society as a risk society. This discourse of risk has also, since the 1980s, become commonplace in contemporary digital culture. The changes in the use and management of computers alongside the erosion of centralized computing and the rise of personal computing have resonated with new security anxieties. Networking opened information channels between various parts of the world, but

these channels also enabled the flow of contagious information and malicious software. Consequently, the fact that we are increasingly dependent on computers has become the greatest of our anxieties, as recognized by computer security professionals in the early 1990s. As the first epigraph to this chapter noted, the increasing dependence of society on information leads to new problems of reliability and communications vulnerability.[171] This new state of risk produced in its wake a new industry of digital risk management and security services.

Telecommunications and computers have, since the early 1970s, been perceived in the United States as a vital technological field for future improvements in education, public health, postal services, and the institutions of law and criminal justice. The 1970s were also the time when "information society" spread through various countries as a domestic strategic catchphrase. Soon it evolved into a neoliberal agenda. Around 1984–1985, the deregulation of financial markets and telecommunications took off in the United Kingdom and the United States. Neoliberal doctrines of free competition, transnational markets, and privatization arose at the same time as the technological adjustments of high-speed networks, optoelectronics, and increases in memory capacity.[172] Computers were particularly important for industry and commerce, where computer risks started to equal business risks. New transnational networks seemed to bring new sources of wealth in the 1970s, but they also meant new forms of risk, often related to computer interconnections. This meant new dangers owing to the massive interconnectedness of networks, a sort of risk society of complex systems where "[m]any believe the point has been reached where a failure within one key computer on a networked system could have repercussions which might impact a whole economy, for example, in a programmed securities trading or in the transfer of electronic funds out of one country and into another",[173] as the *Information Security Handbook* wrote in 1991.

The importance of battling digital security problems is asserted via the economics and rhetoric of the business world. The thematics of risk society led to a wide-ranging change of procedures, emphases, and discourses of computer security, which from the end of the 1980s increasingly emphasized risk *management*.[174] Because isolationism was unacceptable (especially business-wise), the computerized society had to tolerate a certain amount of insecurity and uncertainty in its communication networks, as Shannon had argued in his communication theory. This was an expression of something inherent in a technological culture: the necessary by-product of communication was the *waste* of communication—and information in general. Thus, even if I outlined the modern fear of noise and error at the beginning of this chapter, computerized culture since

the 1980s has become more tolerant of noise, in a way. Noise and security problems have become internalized with cultural practices and discourses under the heading of risk. Accidents are not just something that happens "out there"; they have become statistics, probabilities—things to be accounted for. Risks became part of everyday life when it was realized that the most efficient way of coping with them was to fold them in as a productive part of the consumer machinery. Hence, from a systems-oriented perspective, we might note how the issue was one of translation: how could the noise be translated as part of the network; how could the deterritorialized flows of self-reproductive programs be reterritorialized as part of the established capitalist institutions?

Ulrich Beck, in his influential *Risikogesellschaft* (1986), described this as the birth of risk society, stating that modernity had moved from industrial production to risk production as well. Focusing on key accidents of the 1980s (Chernobyl, Bhopal, Exxon Valdez), the risk society thesis suggested that such risks were crucially different from the dangers of the industrial society of the nineteenth century. The new risks were spatially, temporally, and socially unbound and, thus, not causally determinable: responsibilities were no longer easily defined when the whole notion of causality was at stake. Technological society produced risks and dangers that could not be dealt with totally, but only minimized. In other words, the production of wealth was necessarily accompanied by a production of possible accidents and risks as the surplus of the system.[175]

At the turn of the millennium, Beck redefined his thesis with some new emphases. For Beck, risks mean not actual damage, but potential damage in the future. This creates a peculiar time-loop where the future appears to act on the present. The linear continuity of time is broken, and a new type of interphase is created that fluctuates between the attractors of security and destruction.[176] I would like to pick out three themes from Beck's writing that I find particularly important given the discourse on the risks of computer viruses and worms.

First, risks are always part of the future tense; they are something expected and feared. They are constructed via techniques of cultural perception and definition, which means that they also are connected to a political agenda. Who is in the position to make publicly valid risk statements? What types of phenomena are defined as risks? Who benefits from the fear that discourses of risks engender? In a web of similar questions, Joost Van Loon argues that risks are always constructed via visualization, signification, and valorization, all of which refer to processes of assigning risks a certain cultural place and meaning.[177] As analyzed in the next chapter, viruses work as part of a certain imaginary of a healthy body of digital society and are territorialized as diseases of such a body.

Second, as Van Loon and Beck argue, the media has a special place in the definition of contemporary risk culture: risks are mediated risks, defined and perceived via the technologies, discourses, and institutions of the media. Mediation refers here to virtuality in its philosophical sense: risks are virtual but not actual, potential but real. Risks are *becoming* real. Risks live in media representations and simulations, meaning that they are virtually real in various (scientific) scenarios and probabilities, news reports, (science) fiction stories, and so forth, all of which enjoy a considerable amount of cultural prestige in contemporary media culture. Risks make good media events, and it is to a certain extent irrelevant whether the virtual risks ever actualize. Van Loon's analysis of the I Love You virus (1999) demonstrates the logic of media culture. The virus spread as an actual computer program via people's e-mails and information networks, but it attracted media attention and so spread as a media virus as well. The reproductive technological logic of the viral was duplicated in the media publicity logic that spread on the social bond of cyberrisks:

> A simple example would be the "I Love You" computer virus which, apart from directly jamming network systems, also caused immense indirect problems as system operators and webspinners across the world had to generate warning messages and upgrade virus detection systems. This is an example of a risk that is able to reproduce itself not simply through failures of regulation and security, but exactly because of the risk-aversion ethos already put in place by the systems themselves. Once risks are able to work through successful risk-management systems and use them to proliferate themselves, that is, once they are not only able to act but also to anticipate and learn, we could speak of cyberrisks.[178]

A third theme of risk society, the blurring of boundaries between nature and culture, seems apt given that this is a book about *technological viruses*—an oxymoron, of course. The modern distinction between (passive) nature and (active) culture is not valid in a world defined by artificial and constructed mediations that continuously rest on corporeal and incorporeal events.[179] As Beck notes, natural phenomena such as ozone holes and pollution and diseases such as BSE are produced by humans and human activities. Paraphrasing Latour, Beck suggests that we live in a world of hybrids, made up of interconnections between heterogeneous phenomena interacting on an immanent plane. Thus, Beck sees risks as human-made hybrids that combine politics, ethics, mathematics, mass media, technologies, cultural definitions, and perceptions, which are all a real part of the construction of a society (or culture) of virtual risks.[180]

Hence, instead of seeing noise as something reterritorialized outside the communication event, the flexible risk society actually does not *exclude* dangers and

risks but *includes* them—exclusion but only via inclusion. Risk society is a society
not of Wiener's cybernetics but of the second-order cybernetics that emerged
in the 1960s, illustrated, for example, in the work of Humberto Maturana and
Francisco Varela. Within cybernetics, the problem of solipsism was recognized
early on. Reflexivity, the ability of a system to adjust itself via self-perception, was
seen as a partial solution. Heinz von Forster suggested this solution in 1960, but
Maturana and Varela went further, arguing that all systems and life in general
are to be understood as autopoietic systems that maintain coherence against the
flows of the outside. However, the boundaries between inside and outside are not
fixed but constantly changing, as is the whole of the system. An organism—or, for
example, a machinic system—is actively engaged with the surrounding environ-
ment, as emphasized later by Varela in his concept of "enaction."[181]

Autopoietic machines work in this sense via organizational closure, where
the system is open to flows of matter and energy from the environment (and
vice versa) but maintains their organization. This was, according to Maturana
and Varela, the key characteristic of living systems, whereas self-reproduction
was argued by them to be part of an autopoietic system. Here self-reproduction
continues the work of autopoiesis as a constant reformulation of the system—not
a constant rebuilding of the same system but a creative reproduction.[182]

According to this idea, complex systems become stronger by becoming more
tolerant. A rigid system that tries to cast out the parasite, the noise, the accident
does not last as long as a system accustomed to the deviant. Hence, "flexibility" is
a key word in late twentieth-century culture.[183] Risk society understood through
the language of cybernetics marks a step from controlling information to adjust-
ment and tolerance of uncertainty and risk. Dangers are to be understood as risks
to be perceived, signified, and valorized—and, in sum, managed.

Cohen's work in the early 1980s marked a transition, a crossing of a threshold,
to the understanding of computer viruses as potential dangers of the information
society. What Cohen emphasized was that viruses and similar malicious software
programs were to be seen as threats to be studied not neglected. Cohen himself
sees his studies as the first serious published attempts to highlight these risks,
whose dangerous nature was accentuated by the transitive nature of corruption:
small amounts of code causing large-scale damage to computer systems and the
people connected to these systems. Again, transitivity crops up as the key relation
that guarantees logical information communication, but it is also the vector for
the spread of viruses. To paraphrase Cohen, the security community found the
work on computer viruses uninteresting and even offensive. Cohen was also once
accused of himself breaking into university computers.[184]

Despite the hostile first reactions, Cohen was later acknowledged as a key figure in the fight against viruses and as the one who recognized the universality of the virus risk. With the number of viruses "in the wild" rising phenomenally from the end of the 1980s onward, Cohen's work was seen as increasingly feasible. As the threat was being recognized in the media, the first antivirus products appeared. Suddenly, around 1987–1988, there were probably dozens of programs aimed at finding and removing viruses and other intruders. Among the first were McAfee Viruscan, IBM Virscan, Turbo Anti-Virus, Flushot, Mace Vaccine, Vaccine, Aspirin, Datacure, Condom, and Virus Detective.[185] Paradoxically, even as the virus was spoken of as a central threat to information capitalism, it spurred a whole new industry sector producing virus cures, scans, and security information. The increasing knowledge of computer worms, viruses, and other malware was quickly turned into practices that benefited the growing computer industry and digital culture.

Of course, the products often promised a lot while delivering less. For example, leaflets from the early 1990s promoting antivirus products promised "absolute protection", "ultimate prevention, detection and treatment" or simply the ability to detect "all viruses, known and unknown."[186] This illustrates how the discourse of risk was easily transformed into a business opportunity through the promise of a totally risk-free future. For cases of unsuccessful security, Lloyds of London offered virus insurance in 1989 after the Internet worm case, which caused a lot of worried voices to be raised among the public and in the media. The policy covered loss of telecommunications, market information services, and electricity supply; software and data faults; and virus attacks. At the same time, Control Risks Group Ltd. formed a new company called Control Risks Information Technology Ltd. (CRIT), specifically designed to battle computer crime, including espionage, fraud, malicious or illegal data modification, and denial or destruction of services. In the following years, virus insurance policies were frequently under discussion.[187] As *Byte* magazine warned lay users in 1989: "computer security is one of the safety features that you don't think about until it's too late. It's an insurance policy you hope you'll never need. While it would be nice to work where you don't need security, most of us never will."[188]

However, as more critical commentators have noted, any programs that claimed to get rid of all viruses once and for all were "flat-out lying." Instead, as long as there were computers, there would be computer risks and viruses of some sort; computer viruses used normal computing functions and, thus, could affect any computer systems.[189] This is Neal Stephenson's insight in his novel *Snow Crash*: "Any information system of sufficient complexity will inevitably become

infected with viruses: viruses generated from within itself."[190] Such a systems-
theoretical point of view underlines the emergent processes in potentially any
system complex enough: only closed systems can be "clean" and "organized", and
one does not often come across such ideal systems.

The acceptance of risk led to a viral proliferation of manuals, handbooks,
mailing lists, and newspaper articles, all giving up-to-date information on viruses
and protection. "Information" became the key word: people had to be educated to
become better and more security-oriented users; policies to manage malware were
to be implemented; potential loopholes were to be examined. "Threat-oriented
risk analysis" became another key phrase, and everyone was to be on the alert.[191]
But who was responsible for taking action? Who was to be aware of the situa-
tion? In addition to official national and international bodies in business and
computing, the individual user was incorporated into a web of responsibility. She
or he, whether using computers in the workplace or at home, was to be educated,
which accurately illustrates several key points of information society capitalism.
The potentially incompetent mass of users was part of the problem, integrated
into the security checklist of this network ecology. In other words:

> (t)raditionally, computer security was someone else's problem, invariably performed by
> someone else on behalf of the user. Distributed Computing has removed the traditional
> support personnel from the scene and made the user perform all the management roles:
> system programmer, analyst, engineer, support group, recovery manager, capacity planner,
> security officer, and so forth. PC viruses brought the issue of technology and support for
> end users to the forefront. Now the user had to make sure they could recover and perform
> the security officer role on their system. Many failed, most did not know what to do,
> others chose to ignore the problem, many were unaware.[192]

In Chapter 2, I refocus on the practices of safe hex (as a digital version of safe
sex) and virus-free protection as the creation of a responsible user. Here, I continue
with the theme of risk perception within the media and the growth of public
awareness (and anxiety). In short, if Fred Cohen's work marked the first stage and
a certain singularity in computer risk perception using technical tools, the media
channels and institutions were the next threshold, bringing viruses to the public
through their media microscopes. Therefore, during the 1980s, computer viruses
were not only technical viruses but also media viruses, and virality proved to be a
key organizational logic of the rising network culture.

THE MORRIS WORM: A MEDIA VIRUS

According to computer security professionals, the first generation of computer viruses was programmed by a small bunch of computer enthusiasts with no intention to do serious harm: the first viruses merely flashed Christmas greetings and other screen effects. In Italy, the pioneer of "hacker art" Tommaso Tozzi designed a benign experimental virus in 1989 that displays the word "Rebel!" on the computer monitor.[193] At least in Europe, viruses were quickly turned to new contexts and uses as interesting software tools. Often such demonstrations or tests actually had a positive side effect in exposing "the extreme weakness of PC security systems."[194] "Tactical accidents" were already part of the repertoire of early hackers in the 1960s and 1970s. System breaking and potentially also virus-like programs were used to discover flaws in time-sharing and network environments.[195] However, there were more alarming trends in computer sabotage. The Red Brigade leftist group, active in Italy since the end of the 1960s, threatened to hit the core of capitalist institutions by sabotaging government and organizational computers. In the United Kingdom, the Angry Brigade attacked a police computer in the early 1970s, and the U.S. leftist activists the Weather Underground worked actively toward similar goals. Interestingly, John Brunner's *The Shockwave Rider* depicts virus-like tapeworm programs as hackers that scramble the codes of the power elite to produce dubious messages: "As of today, whatever you want to know, provided it's in the data-net, you can now know. In other words, *there are no more secrets.*"[196] The tapeworm that the main protagonist programs and releases is described as consisting of a code that forces computers "to release at any printout station any and all data in store whose publication may conduce to the enhanced well-being, whether physical, psychological or social, of the population of North America."[197] Computer viruses were imagined in this example as a form of social luddism of the network era.

Where such novels introduced alternative ideas of viruses, some computer clubs tried to see the problem in a wider perspective. The Chaos Computer Club (CCC), one of the most famous virus and hacker clubs ever, issued a virus construction kit that enabled even users not familiar with the finer points of programming to make their own viruses, increasing the potential number of virus writers enormously. Yet, their interest was to write antivirus programs and look for ways to counter the rising number of malicious viruses.[198]

Hacker clubs also worked to dispel myths, as with the CCC's 1986 conference in Germany on computer viruses. The conference aimed to contextualize the new class of programs.[199] Computer viruses were part of a larger social issue

concerning dependence on technology and the social conditions of program-
mers. A keynote address was given by Ralf Bürger, a programmer inspired by Fred
Cohen's work. Bürger's mission was to educate people on computer viruses, which
he tried to achieve by programming a virus of his own, Virdem, and handing out
copies of the virus to conference participators. In 1987 Bürger also published *Das
grosse Computervirenbuch*.[200]

By 1988 the risks of self-replicating software were widely acknowledged in
the generalist media. In the July 1988 issue of *Byte* magazine, Jerry Pournelle
gave a near-hostile account of viruses, which he represented as merely machine-
wrecking nuisances, as dangerous as piracy and hackerism. Pournelle identified
the Christmas message virus, the Leligh virus, and the Israeli virus, even if he
admitted to being unsure whether the latter was a legend or not. According to
Pournell, viruses were stimulating an atmosphere of fear where "[m]any [bulletin
board] sysops are getting scared enough to deny upload capabilities to new
users."[201] Pournelle recommended fighting the fears—and viruses—with new
vaccine programs, a dose of care, and avoidance of pirated software.

A couple of months later, *Time* magazine released its widely cited cover story
"Invasion of the Data Snatchers." By providing animistic metaphors of intention-
ally malicious diseases, the article succeeded in capturing the attention of readers.
As a protagonist the article used the fictitious Froma Joselow, a reporter who
catches a computer virus:

> Joselow had been stricken by a pernicious virus. Not the kind that causes measles, mumps
> or the Shanghai flu, but a special strain of software virus, a small but deadly program
> that lurks in the darkest recesses of a computer waiting for an opportunity to spring to
> life.[202]

Viruses are depicted as information diseases reaching epidemic proportions.
As the sexual revolution encouraged AIDS, it is hinted, so the open sharing of
software exposed the body digital to novel diseases of communication. Similarly,
as AIDS is seen as a disease syndrome eating humans—and society—from the
inside, viruses are crumbling the information infrastructure, the pride of the
country:

> Across the U.S., it is disrupting operations, destroying data, and raising disturbing ques-
> tions about the vulnerability of information systems everywhere. Forty years after the
> dawn of the computer era, when society has become dependent on high-speed informa-
> tion processing for everything from corner cash machines to military-defense systems, the
> computer world is being threatened by an enemy from within.[203]

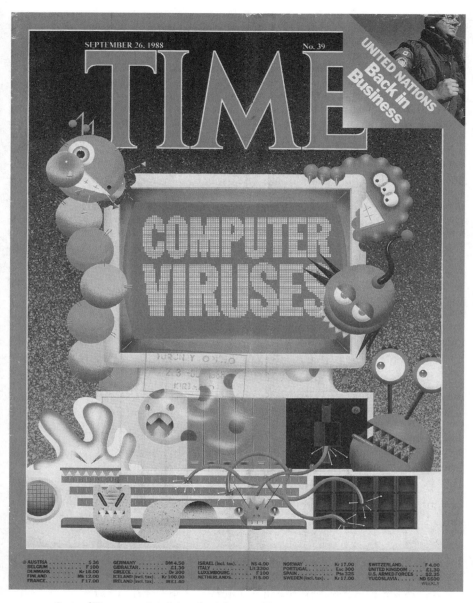

Cover of Time magazine, September 26, 1988. Time Magazine © 1988, Time Inc.
Reproduced by permission.

Using the voices of several commentators, experts, officials, and representatives, the article argues how "the worst is yet to come." Recounting the major incidents of recent years, the text succeeds in creating an atmosphere of digital risk, insecurity, and paranoia, which, in a way, are captured even in the title. The title is, of course, a reference to the 1956 cult film *The Invasion of the Body Snatchers*, directed by Don Siegel, which depicts a nice country town being infiltrated by aliens in the form of humans. The general theme of the movie is paranoia, and it has been seen as commenting on both the persecution of suspected communists by McCarthy in the 1950s and the paranoid logic of the McCarthy-led hunt itself. Even though the *Time* article hints at the dangers of hysteria, it probably only adds to the general atmosphere of insecurity—just as Pournell's overkill warnings did. As Andrew Ross aptly noted, the article tapped into a specific American context of fears of national and individual bodily invasion. The discourse of computer culture, the rhetoric of AIDS, and the goals of the Defense Department are in full sync. According to Ross, U.S. political culture has its historical roots in the obsession with "hostile threats to bodily and technological immune systems."[204] As *The Invasion of the Body Snatchers* was positioned in the atmosphere of the 1950s, which emphasized the differences between us (America) and them (the Soviet bloc), so these data snatchers were the 1980s equivalent. The aliens of the Don Siegel film were perhaps threats to the idea of American liberal freedom, and the allegory of viruses represented them as somewhat similar: they were threats to the basis of organized society, democracy, and civil rights. Of course, Siegel's film hints that the countermeasures against the aliens might prove at least as harmful as the original menace—an issue that was occasionally considered in the computer virus context as well.[205] The body digital and the power/knowledge apparatus producing it are discussed further in the next chapter.

Alas, the worst did come, at least according to some commentators, by the end of that same year. The Internet worm, also known as the Morris worm, forced several thousands of computers connected to the Internet to be shut down, hindering the normal functioning of the network. The incident generated a huge number of texts and commentaries when it was discussed on TV programs and the news, and in newspapers, magazines, and journals. Where Fred Cohen was the one to wake up the security community, the 1988 worm was the one to shake up the popular consciousness, in the United States especially. As John McAfee and Colin Haynes put it: "For the past fifteen years, computer security has been a dull field; suddenly, with the advent of viruses, it is making national headlines and the cover of *Time* magazine."[206] Of course, Hollywood productions with wide distribution played a key role in this revaluation. *War Games* included such

hot topics of the cold war as accidental nuclear strikes and hacking, and *Tron*, a Disney production from a year earlier, 1982, transported not only the protagonist but also the viewer inside the screen and the computer into a digital world where good and bad programs engaged in a battle reminiscent of the dualism of global politics. Several such films (alongside cyberpunk novels) gave a visual face to otherwise nonvisual information.[207] For most computer users, code was becoming invisible with the creation of new, easy-to-use graphical operating systems that hid the code layer behind visual icons, but at the same time, program code was becoming highly visible in another sense in the media.

The Internet worm was the first real media virus, in a sense not alien to contemporary virus discourse: similar to risks of technological culture in general, computer risks are essentially produced, signified, and contextualized within the media. The creation of moral panics with the aid of the media is essential to the logic of risk society, and computer viruses function as media hybrids, assemblages of heterogeneous elements that are, however, articulated as consistent entities within the media. The assemblage works, then, in the mode of addition, $n + 1$: viral code + standard operating systems + distributed networks + media coverage + security concerns + Hollywood + capitalist profit + international and national political agendas + HIV + …[208]

The worm was not the first network incident. I have mentioned the Creeper virus, which caused trouble at the beginning of the 1970s for the ARPANET network. ARPANET also collapsed on October 27, 1980, owing to a programming error that exemplifies the problems in distributed systems. This particular incident was due to "an overly generous garbage-collection algorithm" that apparently constipated the network in a virus-like fashion. The problem was later defined as a software process running out of control, but it actually involved a larger set of interacting problems between software, hardware, and the ARPANET protocols.[209] In 1987 the dangers in network worms were proven. The Christmas Tree worm originated in West Germany and spread to the Bitnet network and from there to IBM's internal network, which it paralyzed on December 11.[210] A year later, the Morris worm did something that seems to have changed the way people thought and felt about viruses, worms, and computers forever.

The 1988 worm incident can be understood as part of the history of the Internet. The Internet was from the start a system based on noise—meaning that uncertainty and error were at the center of its architecture. The Internet can in this sense be deciphered as a paradigmatic example of the technology of risk society, based on similar ideas to the second wave of cybernetics, as described above. According to the historian Janet Abbate, the original builders

of ARPANET "designed it to accommodate complexity, uncertainty, error and change",[211] which are defining features of the network culture. Hence, worm and virus programs are not to be understood solely as anomalies of the computer environment but have a more fundamental role to play as an inherent part of distributed network computing. Worm programs demonstrated the potentials in distributed computing while at the same time involving the risk of "things getting out of hand" and the worm breaking loose.[212]

More specifically, it is worth giving an account of how this worm incident connected to the history of networking and how the media participated. First, then, what did Morris (Jr.) do? On a technical level, he programmed a worm that was supposed to propagate itself from one computer to another using the networks of the Internet. It used three techniques to penetrate security procedures: Sendmail, the Finger daemon (Fingerd), and password guessing. With the Sendmail e-mail program, the worm infiltrated a computer via a backdoor fault left in the application. With Fingerd, a UNIX system demon program, it caused a malfunction to get in, and in 5 percent of cases the worm got in by guessing the passwords of users. The worm, often mistakenly called a virus, was launched on November 2, 1988, at 5 p.m. It spread within a few days to thousands of university and state officials' machines, and even though it did not include any form of malicious payload, it apparently jammed several thousand computers. This, as one infected party commented, brought the network to its knees.[213] Consequently, online communications were shut down and e-mail messaging was denied.

So it appears that a Cornell college student released a ferocious, blood-craving digital monster. The technical issues involved in self-reproductive programs and the problem of controlling their spread had been discussed in Apter's *Cybernetics and Development* (1966),[214] but now this technical code entered into a novel assemblage when computers were used by an increasingly larger and nonprofessional group. Even though some commentators have agreed that the release of the worm was an accidental event and that it was not intended to do harm, Morris was penalized for his actions. On an official level, he was convicted in 1990 of violating the Computer Fraud and Abuse Act. His college punished him after a special commission found that even if Morris did not mean to do any serious harm, his act was "selfish and inconsiderate of the obvious effect it would have on countless individuals who had to devote substantial time to cleaning up the effects of the worm, as well as on those whose research and other work was interrupted or delayed."[215]

However, the emphasis should be placed not on the *particularity* of this one incident—or the person responsible—but on its *singularity*: on how this inci-

dent created a whole new cultural field that worried over digital contagions and feared digital demons that would "render our entire datasphere into terminal gibberish."[216] This singularity is due to the general media logic of virality and the views raised within the security community, which marked a new era in attitudes toward self-reproductive software. Paradoxically, as computer epidemics were increasingly monitored and controlled, the overall mediascape turned viral.

As Marc Guillaume notes, the abstract model of epidemics works on a certain logic of parasitism that need not have anything to do with disease per se, being more accurately about "circulation of objects, money, customs, or the propagation of affects and information."[217] This remark concerning the epidemic can be seen as characteristic of contemporary media as well: working as a form of circulation and parasitism, selective propagation, and intensification. The viral media is, then, to follow Guillaume, a machine of overexposure:

> By overexposing specific real or artificially constructed elements, the media instantaneously causes a set of beliefs, fears and expectations to arise. The flow of rumours and representations is replaced by the remote-controlled polarization of opinions. Simply by exposing a few acts of terrorism or delinquency, the media engenders a flocculation of fear within the collective whole. The contagious sense of insecurity that results is merely a secondary phenomenon.[218]

In this sense, the media does not merely represent viral outbreaks but engages in a more complex tracking that uses a similar logic of contagion. The media as a contagious mechanism of exposure is also viral to a large extent, and the pace of media is telling in this regard. The evening news reacted to the Morris case within hours. On November 3, the ABC evening news mentioned the incident. The next day, ABC returned to the subject, reporting the "worst case of computer 'virus.'" CBS and NBC News were also alert. They introduced the basic facts of the spread of the virus and gathered comments from MIT "virus hunter" John McAfee, a former Defense Department official, and even a colonel. It was clear that from the beginning the emphasis was placed on issues of national security, increasingly dependent on computer systems.[219]

Within a few days, on November 5, the media discovered that Robert Morris Jr. was the likely designer of the worm. His father was instantly drawn into the discussion and interviewed several times: he had worked with computer security issues for years and had codesigned the Darwin program. Morris Sr. stressed that the damage was not intended, but the U.S. Federal Bureau of Investigation (FBI) had already started its investigation. The world of computers was no longer a world of computer *specialists* but something that touched the whole of society:

"epi-demos: upon the people."[220] The implication of this computerization or informationalization of society was that computer security, too, touched organized society as a whole, raising the corresponding fear: What if national computer systems fell into the hands of irresponsible people or some juvenile hackers?

Consequently, the hacker became one of the key conceptual actors of the digitalizing culture of the 1980s. Steven Levy's *Hackers* (1984) had depicted these computer pioneers as "heroes of the computer revolution" who were on a quest against software imperfections, inspired by a general desire to improve the world:

> Hackers believe that essential lessons can be learned about the systems—about the world—from taking things apart, seeing how they work, and using this knowledge to create new and even more interesting things. They resent any person, physical barrier, or law that tries to keep them from doing this.[221]

This idea included the message of free information and resistance of the authorities. However, "taking things apart" was transformed into a criminal activity, and in the public perception, "hacker" became a synonym for a computer criminal. The ARPANET hackings (1985), the Wily Hacker incident (1986), which included international espionage, the NASA incident by the Chaos Computer Club (1987), and the Pentagon break-in (1987) introduced the persona of a criminal hacker who exploits the security vulnerabilities in national network computers.[222] The 1985 ARPANET case has also been seen as one of the catalysts for the 1986 Computer Fraud and Abuse Act: just before Senator Hughes announced that his committee was starting work on such a law, the hacking case had been all over the news headlines.[223]

The reactions to Morris were various, and it would be impossible to recount them all here. In 1990, Peter Neumann gave a comprehensive account of the feelings and comments of the digital society when he wrote:

> With regard to the Internet Worm, seldom has the computer community been so divided by one incident. In the final analysis, there seem to be fairly widespread moderate sentiments that the Worm was a badly conceived experiment and should have never been attempted, but that Robert Tappan Morris's sentence was essentially fair—neither meting out excessive punishment nor failing to provide a deterrent to would-be-emulators. But many diverse positions have also been expressed. On one side are thoughts that RTM should have received an extensive jail term, or perhaps should have been barred from the computer profession for life, or that companies willing to employ him should be boycotted. On the other side are thoughts that RTM became a sacrificial lamb to his country in demonstrating a diverse collection of flaws that have long cried out for greater

recognition; or that he was an accidental whistle-blower whose most serious mistake was a programming error that enabled the Worm to replicate out of control *within* each penetrated system, contrary to what he had intended; or that the ARPANET was a sandbox anyway.[224]

The Morris worm pinpointed the technical flaws in existing computer networks, but soon computer ethics was also on the agenda. Computer crime and ethics had been discussed in relation to embezzlement and theft cases since the 1960s, but this situation represented something new.[225] According to several commentators, the hacker behind the worm had attacked the basis of an open society. The Morris worm incident, despite the huge volume of literature on the technical details of the worm, was deemed a human problem. One of the participators in the discussion, Eugene Spafford, noted that the problem was due to the fast pace of technological revolution. According to Spafford, although it had been totally acceptable in the 1960s that pioneering computer professionals were hacking and investigating computer systems, the situation had changed. Society, and increasingly also the business world, had become dependent on computing in general: "Many people's careers, property, and lives may be placed in jeopardy by acts of computer sabotage and mischief."[226]

Basically, the problem was not only what Morris did but where (and when) he did it. The Internet had risen to be a symbol of the central trends within computerization and the whole of information capitalism. As Ken Thompson warned in 1983, the computer world was no longer a playground for benevolent and eager enthusiasts but for all sorts of users who did not share the same value basis of computer community. In 1989, James H. Morris, a professor of computer science, gave a similar account of computerized society to those of Spafford, Thompson, and several other commentators:

> Along with the openness, diversity, and size come certain problems. People can bother you with junk mail, hackers can disrupt your computer systems with worms and viruses, people can get at information you would prefer to be private and even broadcast it if they choose. Like a big city, the academic networks are not under anyone's control. They carry any kind of communication without regard to its correctness, tastefulness or legality.[227]

Apparently, the problems listed were the downside of the open architecture and adaptability of the Internet. It is worth noting that in 1989, after the worm incident, the same questions that dominate contemporary discussions of information networks and the Internet were raised. In a way, the problem of computer viruses is also a problem of aesthetics, of cultural perception. As discussed in the

analysis of Joost Van Loon's work above, risks are media risks, making it irrelevant to distinguish between real risks and imaginary risks. Imaginary risks are also real on a certain level. Risks come in existence only through their mediatization, and this is always connected to a political agenda, which makes it worthwhile to analyze the a priori of such cultural perceptions of risk and accident. Actualized virus incidents, such as the Morris worm, are part of the logic of the virtual in that through media channels they are transformed into expectations, predictions, and thresholds: How about the next incident? When will it occur? Will it prove to be even more disastrous? What preventive actions should be taken? As Van Loon notes, politics filters risks from hazards. Material facts (whether concerning the existence of HIV or the computer virus) are translated into vocabularies of politics and statistics where "risks imply a specific form of knowledge of causal relationships between particular conditions, specific actions (decisions) and possible consequences."[228]

Certain key perceptions that still circulate as dominant were raised in 1988. (1) Viruses and worms are a threat to national security. (2) They are also a threat to international business. (3) The phenomenon was "Oedipalized" so that the virus-creating individual was put at the center of the problem; the father–son dialectics of this particular incident were brought to the forefront.[229] (4) The incident was controlled through a search for the origin, the programmer behind the worm. This demonstrates well how in my take on media ecology, the articulation of technological issues with, for example, politics is emphasized. Media ecology is not a self-sufficient and determined evolution of natural flows; it is a field of politics where politics do not concern merely human issues but always stretch toward technology and nature in ways Latour has described.[230] Politics also becomes a meta-issue of evaluating what sorts of actants we acknowledge as being involved, what sorts of processes are seen as pertinent, what sorts of scales we must address. Such an evaluation is part of the work of media ecological cartography, which engages with politics of interactions and networks.

The media perception was gradually followed by certain speech acts and the creation of practices that aimed at combating the problem. I have pinpointed above the general discursive framework in which the worm was incorporeally baptized, but the incident also had practical repercussions. The raised awareness spurred new research centers, associations, publications, and other contagions. In December 1988 the Computer Emergency Response Team (CERT) was founded to battle the known threats to computers and computer networks. The federal government, and in particular the Department of Defense's Advanced Research Project Agency (DARPA), wanted to repair the so-called security lapses that UNIX

machines had (as the Internet worm proved) and to educate users; this became a general theme and catchphrase for years in computer security discourse. [231]

In the United Kingdom the Computer Threat Research Association, with similar interests to CERT, was founded at the beginning of 1989. It was, however, unsuccessful and was quickly replaced with the British Computer Virus Research Centre (BCVRC). The new body was designed to collect and catalog computer viruses and analyze their structures to help combat the growing problem. It is worth noting that in Hamburg the Virus Epidemic Center was already active in the summer of 1988, with the pioneer computer virus researcher Klaus Brunstein as its head. Its idea was also to test new viruses and produce so-called hygienic software programs to combat the digital infectors. [232]

The year 1990 saw the rise of a European Institute for Computer Antivirus Research (EICAR), which was a nonprofit organization aiming to professionalize the scientific battle against malware. It was founded "to support and coordinate the European efforts in the fields of research, control and fight against malicious computer program codes, especially of computer viruses and related security threats to automated systems as part of general computer and data security." [233] EICAR was designed to act according to the interests of researchers, governments, and also the corporate/commercial field and private users.

In general, the official reaction toward hackerism and computer crime was harsh. Jurisdictional matters came to dominate the incorporeal events acting upon self-reproductive code. The 1986 Computer Fraud and Abuse Act was unanimously supported in the Senate, but the following years saw few convictions. [234] However, the FBI SunDevil operation at the turn of the decade and the Computer Fraud and Abuse Task Force founded in 1987 in Chicago were indications of this new atmosphere, which refused to tolerate "electronic vandalism." In terms of the notion of hackerism, the busts and raids at the end of the 1980s and beginning of the 1990s demonstrated that hackers were no longer understood as eager computer enthusiasts but as computer criminals. SunDevil culminated in a raid and the confiscation of 23,000 diskettes and 40 computers. [235] The cyberpunk author Bruce Sterling noted in his *The Hacker Crackdown* that the operation was not meant to be an attack on system intruders and hackers in the traditional sense but on credit card frauds and telephone code abuses. The operation carried political objectives and sent a message to the public and the hacker community: electronic crime would be dealt with by tough measures. [236]

In a way, these actions marked a certain professionalization of the field: computer viruses and worms became among the most contagious threats feared by digital culture, which spawned a huge number of papers, essays, books, institu-

tions, and antivirus software programs. However, it was the antivirus field alone that professionalized: by the end of the 1980s and during the 1990s viruses were no longer simply toys for computer scientists and eager young hackers—such as Rich Skrenta—but part of a multimillion-dollar business of computer crime and crime prevention. Manuel DeLanda has made a similar point: as hackers used system crashing to expose flaws in computer systems, so their modern viral counterparts have become "a potential form of terrorism." Whereas previously the hacker ethic included the channeling of energy into mapping the potentials of the computer culture, after 1988 the horizons of hackers and organized computer crime had conjoined.[237] Of course, the change is not so clear-cut, and experimental practices were not altogether sucked into a web of crime. Yet, computer abuse did increase: during the early 1990s viruses proliferated, with new clubs, organizations, and programs dedicated to manufacturing them. The media ecology or machinic phylum that spurred the self-replicating machines of von Neumann, Core Wars, Creeper, and other "benign" virus programs gave birth also to a number of viruses with the specific intent to cause havoc. This is the culture of "panic computing", the paranoid fear of contamination, disease, and touch that circumscribes the late twentieth-century network culture.[238]

COMPUTER VIRUSES AND NETWORK SOCIETY

The Morris worm incident touched primarily the UNIX environment. The UNIX operating system, created at the Bell Laboratories with the C programming language, morphed quickly into an open pedagogical platform. U.S. legislation did not allow the commercialization of the operating system, and universities could use it without charge. As UNIX came equipped with C, it was from the start optimized for various experimental tasks and reconfiguration. It was used for practical hands-on research into new protocols, data structures, and architectures, and it played a key role in the development of network platforms from the late 1970s on. Every university could turn it into a utility it specifically needed: "flexibility" was the key word, and security something set aside. As Paul Ceruzzi points out, it was relatively easy to "write programs that acted like a virus, programs that could replicate themselves by producing executable code as output."[239] UNIX was designed for research purposes in universities, with specific emphasis on the ease of file sharing. This increased the vulnerability of the system to viruses and malicious hackers. Whereas UNIX was no platform for mass society, as the

Morris worm incident demonstrated, IBM-compatible PCs, Macintosh desktops, Amigas, and Ataris represented a new wave, the first powerful home computers available to ordinary users. These systems also generated a corresponding number of problems. Relatively cheap prices made them available to a larger number of users and programmers, but PCs with the MS-DOS operating system had no form of inbuilt security, which made MS-DOS "a near-perfect platform for virus propagation."[240] Hence, around 1992, some 1,300 virus strains had been detected, and every month saw 38 new IBM PC viruses. The problem was about to explode. A table from a 2001 F-Secure white paper illustrates this explosion:

Virus type	Widespread	Replication media	Typical time needed to produce a new generation	Typical time to become widespread worldwide
Boot viruses	1988–1995	Diskettes	Weeks	>1 year
16-bit file viruses	1988–1995	Program files	Weeks	>1 year
Macroviruses	1995–	Document files	Days	1 month
E-mail worms	1999–	E-mail messages	Hours	24 h
Pure worms	2001–	TCP/IP connections	Minutes	Hours

Source: F-Secure white paper, 2001, © F-Secure Corporation. Used with permission.

Boot viruses were relatively slow infectors, taking more than a year to spread across the globe. However, as network connectivity and file sharing increased steadily during the 1980s and the early 1990s, viral infections, too, were on the rise. This demonstrates well the material infrastructures of globalization, which accelerated with the Internet connections and protocols of the 1990s. In addition to being a phenomenon of spatial ties and connections between localities, globalization is a temporality, which reflects a time-based understanding of global flows. It took more than a year for an automated dataflow to become worldwide in the late 1980s, but with highly efficient worms tuned to the TCP/IP protocol it takes only a few hours in the twenty-first century. Even though the real network viruses, e-mail worms, and pure worms have been a phenomenon of recent years,

widespread network infection became a discussion topic soon after the Morris worm incident. The latter half of the 1990s, approximately from 1995 to 2000, saw an actual revolution in viruses and worms, with a rising number of local area networks in companies, the Internet boom on the way, and the huge popularity of e-mailing. As the F-Secure paper notes, these technologies enabled new ways of communicating, but, at the same time, they opened up new channels of infection as well.[241] The key security threats of computer culture had been hacking, system breaking, and fraud, but now viruses and worms started to take to the stage. Viral activity shows mathematical patterns of epidemics that feed on themselves. This is where *demos*, the people, referred no longer just to people in the human sense, but also to nonhuman actors such as programs and operating systems.

Of course, in terms of numbers of infections, network viruses were not a problem in the early 1990s. Most viruses were still using the boot sectors of floppies to spread their code.[242] So, if I focus here on the 1990s and the relationship between network society and viruses, this is done on a conceptual, or an archaeological–virtual, level. As Brian Massumi notes, this level is one where the perspective is not on historical actualities as such, but on the immanent layer of the archive.[243] Archive as a mode of operation (not so much a physical place) is not only an a priori of actualized actions but an immanent principle of realization. Every actualized historical event feeds back to the archive.

Networks were imagined as key modes of operation of modernization at least from the nineteenth century on, as Armand Mattelart argues, referring to Saint-Simon's philosophy of networks as well as the ideas of "worldism" that saw underwater cable networks and universal post offices connecting the planet into one sphere.[244] Patrice Flichy argued more specifically that "communication" had been the central socio-technical utopia since the 1960s and that communication and community are the central archaeological values still prevalent in today's Internet.[245] As shown above, communication became a vector of epidemic viral overflow, and during the 1990s a communications utopia was captured as part of the commercialization of the Internet in a way that placed "communication" and "community" among the key business concepts of the network economy (think of the Nokia-slogan "Connecting People"). Kevin Kelly expressed his admiration for the communicatory turn in *Wired*, the flag bearer of the new network economy:

> Information's critical rearrangement is the widespread, relentless act of connecting every-
> thing to everything else. We are now engaged in a grand scheme to augment, amplify,
> enhance, and extend the relationships and communications between all beings and all
> objects. That is why the Network Economy is a big deal.[246]

Kelly was not the only apostle of network capitalism. Bill Gates foretold in 1995 how digital networking would revolutionize the business world via improvements in productivity through such technologies as web publishing, video conferencing, and e-mail. "Corporations will redesign their nervous systems to rely on the networks that reach every member of the organization and beyond into the world of suppliers, consultants and customers."[247] According to Gates, the Internet especially was to provide "friction-free capitalism" in a fashion articulated by institutional economics. To quote Gates: "We'll find ourselves in a new world of low-friction, low-overhead capitalism, in which market information will be plentiful and transaction costs low. It will be a shopper's heaven."[248] During the 1990s the hacker ethic ideals of liberation of the human mind were, with the commercial popularity of the Internet (from 1995), turned into aspirations of liberation of human potential via consumption. Similarly, the Free/Libre/Open Source Software (FLOSS) of recent years can be seen as being partially captured by those trends of information capitalism that aim to reduce maintenance and transaction costs.

Nicholas Negroponte offered a similar view of the future.[249] According to Negroponte's frequently cited ideas, the world was changing from atoms to bits. Thus, in the world to come, businesses would be dependent on digital information, selling bits not things. In Negroponte's prophetic and optimistic vision, the future world of information would be a world of expressing one's selfhood and interacting with intelligent technological environments. To paraphrase *Being Digital*, the information highway will provide a global marketplace where people and machines interact, also without friction, in a wonderland of never-ending digital consumption.[250]

The idea of informational, networked capitalism stems from the 1960s and 1970s and the novel theories of postindustrial production. Peter Drucker released his *The Age of Discontinuity* (1969), Alvin Toffler his *Future Shock* (1970), and Daniel Bell his *The Coming of Post-Industrial Society* (1973), and all gave influential definitions of what the new economy would be like and what role information and networking would play in that rising society. Information was seen as the key that would unlock the new economy, and the shift to information technology was comparable to the prior move from agrarian society to industrial-based production mechanisms, as Jon Marshall summarizes it. In this, knowledge workers were beginning to be regarded as the "creative innovators or manipulators of symbols",[251] who were also expected to handle protocols of worldwide action, flexibility, and noise tolerance.

Against this background, worms and viruses were (particularly from the end of the 1980s) understood as enemies of the new economy. In the informa-

tional circuits of corporate environments, viruses and other outside programs interrupted the "normal flow of operation", which, of course, took away from productive working hours: several hours to contact technical support, scan the machines, remove possible infections, and guarantee that no further machines were infected.[252]

In the EICAR conference of 1995, Urs Gattiker acknowledged the problem that viruses present for the information highway and for the opportunities of networking businesses on the Internet. Broken vehicles and unsafe drivers were crowding the information highway:

> For managers and policy makers alike the flourishing InfoBahn (information highway) is making it difficult to ensure a safe and natural progression of use of this technology. Everyone is anxious to capitalize on this new frontier. Growth has been incredibly rapid and those organizations who have not already established an InfoBahn presence may miss golden business opportunities. With the rapid computerization of information and data, however, protecting privacy and safety/security of data subjects and information systems becomes crucial while simultaneously maintaining the viability and accessibility of information. The freedom to acquire information will be facilitated by the hybridization of the telephone, television and the computer. Data collection will become easier with each evolution of technology. Data subjects will become information.[253]

In the U.S. context, the information highway and cyberspace were at the same time constructed as the new "American dream"—a politically and economically crucially important project of the 1990s, as expressed, for example, in the High Performance Computing Act of 1991.[254] The 1993 National Information Infrastucture program prepared by Al Gore launched the term "Information Superhighway", fueling the hype further. In Europe, the 1994 Bangemann report "Europe and the Global Information Society" emphasized similar issues, and these two projects spurred several national strategies around the globe that aimed to benefit from the seemingly revolutionary flow of information (network) technologies.[255]

Instances of noncommunication, such as viruses, meant disruptions within the circuits of this new sphere of economics and politics based on digital technologies. As information became money, "computer viruses can make your bank sick", as *Bankers Monthly* wrote in 1988.[256] Capitalism was becoming *information* capitalism based on the handling and transmission of information. Production was increasingly tied to information networks instead of physical regions, and information in itself, in the form of entertainment, news services, communication services, etc., was the "end product" of production machinery.[257]

The increasing concern with viruses was also due to the absolute number of viruses, which was constantly on the rise. According to an F-Secure chart, the few PC viruses of 1986–1988 multiplied into 180 spotted in 1990, 2,450 in 1993, and 3,550 in 1995. In 2006 F-Secure estimated a number of 185,000 distinct computer viruses.[258] The annual Virus Bulletin conferences aimed to spread information and combat the growing problem. In 1992, at the second international meeting, Fridrik Skulason summarized the situation at the beginning of the 1990s: more viruses with less development effort required, more anti-antiviruses, and more people writing viruses while cooperating more intensely—and still the viruses were getting less media attention. Skulason pointed out that although new virus construction kits enabled even average users to write their own malicious software, these new viruses were badly written.[259] Virus writing became "popular", with allusions to the cyberpunk literature genre of the 1980s. This also turned into a prominent subculture, in the classical sense Dick Hebdige refers to: manifestations of *style* acted as a distinctive factor and a marker.[260] Virus writing was seen as cool and dangerous, as the names of the virus-writing clans testify. Phalcon/Skism, Rabid, Younster Against McAfee (YAM), NuKE, Crazysoft, Demoralized Youth, and Funky Pack of Cyber Punks were among the most famous. One of the best-known virus writers called himself the Dark Avenger. Dark Avenger was the first to design virus *vaporware*, the Self Mutating Engine, in 1991. According to one estimate, it was able to produce four billion different forms of viruses. It was followed later that year by the Virus Creation Laboratory and the Phalcon/Skism Mass-Produced Code Generator.[261] This organizational phenomenon can be seen as partly overlapping the wider "script kiddies" problem, a term used for inexperienced young programmers or crackers who use premade script for vandalism without understanding much about the actual basics of such programs. The scene mushroomed with the popularization of the Internet in 1995.[262]

The huge number of viruses "in the wild" also spread more effectively. New virus clans shared information via bulletin board systems. In a way these can be understood as continuing the functions of the underground press. The magazines included *PHRACK* (from 1985 on), *Legion of Doom: Hackers Technical Journal*, *Phreakers/Hackers Underground Network*, and *The Activist Times*. Maybe the best known is *2600 The Hacker Quarterly*, published since 1984.[263] These magazines gathered together subcultures and interest communities keen on technology and hacking.[264]

A new phenomenon was the selling of virus collections. Although some individuals and virus writers tried to earn an (illegal) buck that way, the U.S. government was also involved. According to some sources, the Treasury Department ran

a bulletin board where it was possible to download viral code. The bulletin board was closed down in 1993.[265] This was ironic given how often professionals within the field, as well as the media in general, emphasized the role of Eastern Europe and the former Iron Curtain countries in producing viruses. Viruses came from somewhere "out there." Of course, this picture was not altogether false—Bulgarian programmers, for example, were active in constructing viral programs.[266]

In 1994 the Virus Bulletin conference addressed again the alarming rate of virus production. Vesselin Bontchev, an esteemed antivirus researcher, noted that the number of viruses was increasing and the quality of viruses was also better. Sure, there were lots and lots of viruses with sloppy code made by amateurs, but at the same time the new *polymorphous* viruses were making the job of virus scanners harder. Polymorphous viruses were, in a way, intelligent viruses: they changed their appearance each time they infected a new object. Virus-specific scanners were able to identify programs by unique viral signatures, a form of digital fingerprint. Polymorph viruses were, however, shape shifters that encrypted the virus body differently with each infection.[267]

New programming techniques and construction kits encouraged new antivirus techniques. For example, heuristics and generic detection programs were techniques widely discussed in antivirus conferences and publications. These were "intelligent protective programs" to face the new and cunning viruses. Earlier antivirus software concentrated on identifying and removing already known viruses; the new programs were supposed to be able to determine from the general characteristics of a piece of code whether it was an example of a virus. Heuristic programs were double-edged swords, for they were known also to "identify" normal programs as viruses. This in general reflects the shifting boundaries and ambiguities between so-called *normal* computing and *abnormal* viral computing.[268] This is a core contextual issue in software criticism: who defines what is software, what is legitimate software, and how it is used, where, by whom, etc.?[269] A good recent example of such a gray area of computing is the suggestion for "parasitic computing", which builds upon Internet communication protocols and taps into server processes that are idle. Different from breaking into a computer and from virus software, such processes share characteristics with cluster computing projects such as the SETI program. Yet, even though it is not a security threat, parasitic computing could delay scheduled network processes.[270]

Generic identification relied on behavior monitoring and integrity checking, which meant searching for suspicious actions within the computer system. These activity monitors were able to detect new virus programs, which increased the number of viruses they could find to billions. Being memory-resident and preven-

tive, these programs were supposed to act as blockers, preventing the execution of abnormal operations. These intelligent programs also generated references to "artificial intelligence" and "artificial life" and the use of neural network models in computing.[271] These topics will be addressed in Chapter 3.

As noted earlier, the first antivirus companies, and antivirus programs, were born around 1986–1987. In a way, this was paradoxical. Viruses were not a serious threat, more a peculiarity, a fact that caused antivirus vendors justification problems:

> By early 1988 a small but lucrative industry was specializing in securing computers from attacks by viruses. Computer specialists offered their services as security consultants or sold dedicated computer software designed to track down and kill viruses. By 1988, despite Brain and Leligh, despite the two Macintosh viruses [Macmag and Scores] and a score of other isolated virus incidents, there was little real evidence of the oft-hyped unstoppable plague of computer bugs, but it is understandable that writers of anti-viral software and others in the new security industry should have exaggerated the threat. They were like burglar alarm salesmen without any burglars about. They had to emphasize the potential of viruses; they needed to convince customers and the press that a storm of viruses was gathering, to be unleashed on defenseless computer users in the next weeks or months, or in the coming year.[272]

The first antivirus programs included Ross Greenberg's Flu Shot and Data Physician by Digital Dispatch Inc. Others were Vaccine and Antidote.[273] One has to note that most of these early companies were small, independent entrepreneurs who sold their programs for a nominal price of 5–10 dollars. Some programs were even freeware or shareware. Dr. Solomon's Anti-Virus Toolkit at the end of 1988 was, however, among the more commercially established attempts to provide digital safety.[274]

Small or big, these companies gained from the general virus hype or hysteria. The 1988 *Time* feature on computer viruses was excellent in creating an atmosphere of fear, but other examples can be cited. *Computers & Security* wrote in its editorial in 1987 that "a computer virus can be deadly." The editorial introduced a case where a computer virus had crashed a continuous-process industry's computer system, "causing hundreds of thousands of dollars of damage."[275] As usual in such examples, all companies mentioned are anonymous, which makes it impossible to confirm the actual events. This type of atmosphere of fear fueled the new industry of computer security and antivirus companies, to paraphrase a *Computerworld* article. As the number of viruses and worms grew, and as people became more conscious of the problem, the antivirus industry benefited. There

was even continuous discussion of whether viruses were a scam by antivirus companies to "prime their markets."[276]

Similar accusations have been numerous across the years. Rod Parkin presented "20 myths about viruses" in 1993, in which he included such claims as "all viruses are destructive", "viruses are the most significant threat to businesses today", "all viruses are clever, sophisticated programs", "viruses are only found in pirated software or games", "viruses only come from disreputable sources or companies", and "virus researchers are all kind-hearted, reclusive philanthropists." Parkin, representing the Midland Bank view, was in any case propagating the notion that viruses are a real threat. [277]

At the 1994 and 1995 EICAR conferences, the criticism of antiviral companies and certain media preoccupations was even more intense. Ilkka Keso compared antivirus vendors to arms dealers, who want to sell their products by whatever means. Most antivirus tests were claimed by Keso to be "worthless" and even "purposefully misleading." Another paper attacked the "cult of anti-virus testing", claiming that a big part of the business is dishonest, too involved in competition to produce trustworthy results, and that the whole testing of products is still in its infancy: most of the antivirus software tests were claimed to be misleading.[278]

The criticism was spot on in the sense that the industry was used to employing strong metaphors and rhetoric. Ross Greenberg, for example, warned against the threat of viruses in *Byte* (1989), noting that the problem increases as more computers are networked. Millions of dollars had already been lost, and there was more to come, which is why Greenberg advised readers to "protect your micro-computers, use common sense and as many preventive measures you can. Don't be fooled into thinking you can beat the threat."[279] This warning and implicit advice to buy antivirus software should be read against the background that Greenberg was then the owner and CEO of Software Concepts Design; that is, he was in the industry himself! The evaluation of software and digital culture in general was carried out from a business perspective, which had been the case since the 1980s.

Similar issues were expressed even more intensely in commercial advertisements. Companies secured the usefulness of their antivirus programs by articulating future threats of viruses that would multiply exponentially:

> PCs are threatened by a growing virus problem. In the last few years the number of PC viruses has grown from less than one hundred to over two thousand. Systems are continually being attacked by newly emerging viruses. Although the files on these computers can sometimes be repaired after an attack, the computers may not be prepared for further attacks. *The only defense* against the threat of further infections is the installation of a virus protection program containing a memory-resident monitor.[280]

Although the brochure referred to more or less generally agreed details on the growing number of viruses, the idea that this antivirus program was the *only solution* is dubious. A similar tone is used in the brochure for the ThunderBYTE PC Immunizer, which presents worst-case scenarios similar to a disaster movie, with human lives in jeopardy, companies crashing, and files being erased and disks being formatted—all as a result of computer viruses![281]

A concrete example of the media hype surrounding malicious programs was the Michelangelo virus incident in 1992. Although several previous viruses had been in the media spotlight, causing exaggerated reactions, Michelangelo crystallized several key themes of the viral and antiviral phenomenon of the 1990s. The virus was very beneficial for the antivirus companies. The viral spread across media circuits started well before Michelangelo activated. One commentator, part of the antivirus business, estimated that some 5 million computers would be hit and destroyed on March 6, the birthday of the artist Michelangelo. As *The Wall Street Journal* wrote on the day the virus was activated: "The world will find out today whether Michelangelo is a genuine plague or just a digital common cold. But already Michelangelo-mania qualifies as the greatest high-tech hysteria to grip the nation since the Skylab fell out of the sky in 1979."[282] In a way, Michelangelo—like viruses and worms in general—became a symbol for technological failure replacing the earlier symbolical status of physical accidents, as with satellites or space shuttles. Even though only 5,000–10,000 machines went down, the hype and the fear were enormous. Thus, as an apt example, the Michelangelo virus scare was fought with special "Michelangelo Limited Edition" scanners to detect the virus.

The connection between media panics and capitalism was noted in 1992. Commentators asked whether the incident was exaggerated, and whether the antiviral software producers had in fact released the virus. Others found positive aspects in the hype, emphasizing that this form of media attention raised the security consciousness of companies and individuals and that it was precisely this forewarning that caused the failure of the virus.[283]

In any event, the virus incident illustrated how deeply viruses and the antivirus business were connected. In other words, viruses were not just disruptors of the flows of information money; they were also captured as a part of it. This idea stems from a conception of capitalism as an apparatus of capture, a machine of appropriation. Buying antivirus products meant buying off fear, which increasingly served as an essential element of consumer capitalism (something that was, of course, already part of the industrial capitalism of the nineteenth century, expressed through so-called future management in the form of insurance

products that objectified risks and security into sold products).[284] This feedback loop, a reterritorialization of the deterritorialized flows of self-reproductive code, is illustrative of the idea of *viral capitalism*—another key element in the media ecology of viruses (consisting of viral information technology, viral media, and viral organization of capitalism). This anxiety was captured as part of the capitalist machinery of production.

CODA: VIRAL CAPITALISM

In a way, it seems as if capitalism invents such accidents and risks to keep itself busy. This idea that "if it's not broken, break it" provides, then, an interesting way to approach the functioning of so-called information capitalism. Dangers and risks produce excellent needs and products in the consumer market, which aims to provide tools for controlling the uncertainties and anxieties of everyday life.[285] The previous themes can be synthesized under the notion of viral capitalism, which stems from an idea of capitalism as capable of continuous modulation and heterogenesis. The "object" virus actually stems from the abstract machinery of virality guiding processes and interactions on various cultural levels, such as software. Technology is merely an index of this immanent logic that spreads across scales of culture (from aesthetics to capitalism, from media to politics). The role capitalism plays here is based on its power to conjoin social and technological machines and make them resonate.[286] The virus as a software object is an index of the (capitalist) drive toward virality as a mode of operation based on contagion, mutation, and colonization of various networks.

The power of capitalism resides in its capability to appropriate the outside as a part of itself. In a sense, capitalism incorporates the ability to subsume heterogenesis as part of its production machinery, and heterogeneity is turned as part of the capital itself. In its functioning, capitalism is a continuing abstract machine of the new, inventing itself all the time, refusing to tie itself to any transcendent point (even though the actual workings of capital do constantly stop at some intervals of profit-oriented points, such as companies, corporations, and monopolies).[287]

Of course, similar trends occurred in the cultural history of diseases long before viruses. As Nancy Tomes notes in her history of germs in America, the fear of microbes was, from the 1880s onward, turned into a lucrative business, with special goods and services designed for hygiene. This meant, for example, "safeguards against the dangers of sewer gas and polluted water, such as special toilet

attachments and household water filters",[288] and on to antiseptic floor coverings and wall paint as well as sanitary dish drainers and fly traps. Hence, commodity interests were very active long before the media ecology of capitalist network culture.

Massumi argues that in information age capitalism, it is the circulation of things that counts, replacing their mere production as the key energetic principle of surplus value. This amounts to a change also in the commodity's status where it becomes a self-organizing and living entity—a form of self-reproductive object. "The commodity has become a form of capital with its own motor of exchange (fashion, style, 'self-improvement') and cycle of realization (image accumulation/ image shedding (…)). Its value is now defined more by the desire it arouses than by the amount of labor that goes into it."[289] The commodity works as a virus— and the virus as part of the commodity circuit.

In their *Empire*, Michael Hardt and Antonio Negri elaborate the idea of viral contagions of power and business. Their main point—following Deleuze's and Guattari's *Anti-Oedipus* and *A Thousand Plateaus*—works through the notion of Empire but as an immanent channeling. We live in a world not only of overcoding despotic imperial regimes, but of a global body of capitalism that catalyzes the continuing processual nature of informational culture. Capitalism and Empire are more accurately axiomatic than transcendent. For Hardt and Negri, the capitalist axiomatic works through an ontology of relationships, which is "a set of equations and relationships that determines and combines variables and coefficients immediately and equally across various terrains without reference to prior and fixed definitions or terms. The primary characteristic of such an axiomatic is that relations are prior to their terms."[290] Hence, there is no transcendent justification for the existence of the capitalist "laws" or "principles"; they are the ground on which the self-organizing functioning of the system is positioned. As a form of organization, capitalism presupposes nothing but itself as a logic of relations and a power of renewing itself. To my understanding, for Hardt and Negri the Empire is not a substance of any kind, but a logic of capture and of translation.

Luciana Parisi has made important remarks concerning the basis of information capitalism and the problems with Hardt and Negri. According to Parisi, the Empire becomes too easily a transcendent apparatus of power opposed to the creative virtualities of the multitude, which leads to a dualism of death and life, organic and inorganic. Instead, she proposes an endosymbiotic conception of capitalism, where it "exposes a machinic composition of molecular bodies involving continual and differential degrees of variation between bodies that capture and bodies that are captured."[291] Hence, she proposes an ongoing nonlinear symbiosis

instead of a dualism. Capitalism, despite functioning as an apparatus of capture, does not proceed in a rigid manner of linear capture but proliferates differences in its wake. As Massumi writes, the rationality of neoliberalism works through a type of pragmatics, not perhaps so much through grounding principles or normative laws. Its cultivation of the metastable systems of markets and affects resides in its focus not on truth but on how the future (the unknown) can be managed on the basis of the data of the past (statistics). What matters is how to keep things running.[292]

Parisi notes the novel forms capitalism takes in societies of control. Instead of clinging to molar formations and operating as exclusions of, for instance, spatial form, control modulation attaches to the differential moment that moves between states.[293] Parisi's stance approaches what I call viral capitalism in her take on seeing (bio)information capitalism as not interested in homeostasis and balance but in cultivating a "metastable equilibrium of parallel networks of communication incorporating all variables of communication."[294] In other words, it clings to the intervals and the emerging web of relationships. Parisi offers, then, a more accurate view of the working of contemporary capitalism than Hardt and Negri in that her take, the idea of symbiosis, is more fully developed and multifarious.

In this sense, the capitalist media ecology of network culture is much more complex and differentiated than it at first seems. Drawing on Fernand Braudel and Manuel DeLanda, Parisi refers to the evolution of antimarkets as a coevolution of the market system. Whereas markets are "constituted by heterogeneous components, ecosystems whose parts always exceed the whole"[295] and which are always in an open state of becoming, antimarkets act as a capitalist apparatus of capture that centralizes and creates monopolies. Heterogenesis turns into accumulation of capital in a few singular nodes of a network, something that resonates with the contemporary network theory of Albert-László Barabási. Viral networks are actually characterized by accumulation of importance to a few key hubs that distribute connections to a vast number of nodes of lesser importance.

What Parisi accentuates is that capitalism should be seen as an intertwining of such various tendencies that create a "complex environment of heterogeneous forces of production, populations of institutions, markets, corporations and bureaucratic agencies."[296] Capitalism is not a self-identical machine that could reproduce a stable preexisting body; it is not a closed system, but part of a wider ecology open to a "microphysical environment."[297] What is important to underline is the constant shifting between hierarchies and meshworks in this system. Capitalism—and this applies well to the viral capitalism I have been describing—does not function as a meshwork, even if market systems in an ideal case would

follow such a logic of self-organization according to demands and productions.[298] Instead, capitalism is hierarchical in the sense that in the last instance it fundamentally turns flows toward a body of capitalism. The heterogenesis it promotes is subjugated to a process of capitalization and profit making, underlining the difference from a more radical machine of deterritorialization. It is able to convert and conjugate contradictory, minoritarian, disrupting, and even potentially revolutionary constellations to itself—and yet such a system is not a transcendent apparatus but itself also bound within immanent relations. Prevention of malicious software conjugates with the flow of informational capital but is not reducible to overcoding capitalism.

It would interesting to analyze how concretely certain business models take advantage of the viral phenomena, but I end the chapter merely with a broader notion of how flexible global capitalism lives at the heart of the antivirus discourse, as Stefan Helmreich notes.[299] Computers and antivirus protection are modeled on discourses that emphasize adaptation, flexibility, agility, and adjustability.[300] These features have been emphasized since the early 1990s, with the introduction of polymorphous viruses, which are able to create numerous variations of themselves, rendering them potentially invisible to traditional virus scanners. What is interesting is how this tension between morphing viruses and antivirus discourse developed into an information commodity spiral.

Whereas "normal" viruses were identified by a specific code string when scanned, the polymorph code reacted on itself to produce huge numbers of chameleon-like variations. The self-encrypting procedure introduced random bytes into the code so that the overall "appearance" of the program was constantly changing. With early self-encrypting programs this was more rigid, as they included a small piece of decryption code at the beginning of the program that easily gave away the whole virus. Later, the sophisticated polymorphs were harder but not impossible to discover. The production of such disguising code was automated with special polymorphic engines that worked to add random code to viruses: a difference engine of sorts. This procedure, however, left a stamp of the engine on the virus that again made it easier to identify. In any case, the camouflaging did not alter the actual functioning of the parasitic code and the potential payloads.[301] Normal scanners had constant trouble pinpointing viral code, which led to the use of heuristic scanners, as mentioned above. The most interesting part is how this ontology of relations between morphing viruses and the development of continuously more intelligent antivirus programs resonated in another scale as part of the abstract machine of capitalism. The morphing power of capitalism was able to tap directly into this creative tension between new viruses and ever-renewing protection programs.

To sum this up from a media ecological perspective, the idea of capitalism as a (computer) virus designates the functioning of the system. IF "computer" is understood as the technical machine operating the decoding of flows of the abstract machine of capitalism, THEN is not the virus conceptually at the center of this social machine as well? This parallel relies on Deleuze's idea of how every social machine finds it equivalent in its technical machines: thermodynamic machines for the nineteenth century, cybernetic machines for the late twentieth century.[302] Yet, whereas Deleuze sees viruses as the active danger of the cybernetic machine, we can complexify this scheme. Just as, for instance, Matthew Fuller and Lev Manovich have analyzed the media ecologies and (aesthetic) software objects of the network culture,[303] we can here add viruses, worms, and the like as integral parts of such a system and claim that viruses as cybernetic objects and processes resonate with the social machine of the early twenty-first century. The term "ecology" does not refer here to naturalizing the functioning of a capitalist logic of profit and commodification (even though naturalizing its functioning has been a key tactic capitalism has used to justify its existence). Instead, media ecological and ecosophical analysis is attuned to exposing the complexities of matter and politics that characterize capitalist logic.

Although viruses are a logical part of the computer system in that they use the normal operating and programming procedures of computers—interrupt calls, for example—they are also to be understood as essential parts of the logic of capitalism. "Like a missionary or a vampire, capital touches what is foreign and makes it proper",[304] write Hardt and Negri, and we might add that similar to a virus that inserts its own jump routine at the beginning of an infected program to ride along its functioning, capital rides on the powers of the virtual, taps into them, modulates such contagious routines. Digital capitalist culture also seems to be the first system that has really succeeded in converting its own accidents to its own profit. The noise of the network machine is folded back (reterritorialized) into its circuits in a manner that suits the logic of the risk society and second-order cybernetics.

The next chapter concentrates on the body politic of digital network culture: what aesthetico-political implications does this concept of a virus that refers to a realm of biology possess, and what forms of (in)corporeal and tactical meanings did the technologized media culture of the 1980s create for this specific class of software? What types of objects and processes are allowed to flower and what mischief is weeded out? The cultural history of digital diseases is not restricted to technical computer architecture, but also touches more general notions of body and life—and *the biopolitics of digital life*.

NOTES

1. Shain 1994, 4.
2. Gerrold 1975, 175.
3. Freud 1995, 739.
4. Editorial, *Virus Bulletin*, July 1989, 2.
5. See Gerrold 1975. Brunner 1976. Ryan 1985. These novels are analyzed in Parikka 2007.
6. Shain 1994, 5.
7. *Oxford Dictionary of Computing* 1986, 335.
8. Vesselin Bontchev: "Are 'Good' Computer Viruses Still a Bad Idea?" *EICAR Conference Proceedings* 1994, 31.
9. See, e.g., the Wikipedia page for trusted computing. <http://en.wikipedia.org/wiki/Trusted_computing>.
10. Bauman 1995, 39.
11. Hughes 1989, 4.
12. Beniger 1997.
13. Gere 2002, 19–40.
14. Wiener 1961, 11.
15. See Shannon & Weaver 1949.
16. Davis 2000, 3–20. See also Pividal 1999.
17. Künzel & Bexte 1993, 113.
18. Wiener 1961, 12.
19. Bauman 1995, 7. Friedrich Kittler (1996) emphasizes that Leibniz came up with an "economy of signs" that had a big impact on communications media, first with Morse code and later with digital communications media.
20. Gere 2002, 121. N. Katherine Hayles (1999, 103) notes how the notions in statistical mechanics and information theory took on elements of a moral theory as well. Entropy functioned as a moral evil for Wiener, and communication—between humans or machines—was conceptualized as a battle against noise. Since then, control perspectives have been incorporated into various scales as part of the personal computer systems. See Suominen 2003, 227, passim. Cf. Salmi 2006. Moreover, so-called trusted computing has worked toward another hierarchization of computer systems.
21. Bauman 1995, 7.
22. Kittler 1993a, 242.
23. Pavel Lamacka: "Harmless and Useful Viruses Can Hardly Exist." *Virus Bulletin Conference Proceedings* 1995, 195.
24. See Lundemo 2003.
25. Cf. DeLanda 2003.
26. Peter V. Radatti: "Computer Viruses in Heterogenous Unix Networks." *Virus Bulletin Conference Proceedings*, September 1995, iv.
27. Edwards 1996.
28. Naval Historical Center, "The First Computer Bug." <http://www.history.navy.mil/photos/images/h96000/h96566kc.htm>. Järvinen 1991, 189.

29. See the "bug" page on the website of the Institute for Computational Engineering and Sciences, University of Texas at Austin. <http://www.ticam.utexas.edu/~organism/bug.html>.

30. Slade 1992.

31. Kevin Driscoll: "The Common Code Virus." *The Risks Digest*, vol. 6, issue 48, March 1988, < http://catless.ncl.ac.uk/Risks/> (accessed 6 March, 2007). Driscoll also describes the symptoms of this piece of code: "It had the effect of copying itself to the next memory location, which was then executed. (…) At the top of memory, the Program Counter rolled over to zero. Thus, in a matter of milliseconds, the entire memory contained just copies of this instruction (no memory protection in those days). This had an interesting symptom on the control panel. The normal random-like pattern of the address lights became the distinct binary counter pattern. Because every memory cell was overwritten by this process, it left no clues about its origin."

32. Apter 1966, 94.

33. Ferbrache 1992, 5.

34. "Two Old Viruses." *The Risks Digest*, vol. 6, issue 53, March 1988, < http://catless.ncl. ac.uk/Risks/>. A similar observation dates to 1973, which shows that several programmers thought about the same ideas. See "Old Viruses." *The Risks Digest*, vol. 6, issue 54, April 1988, < http:// catless.ncl.ac.uk/Risks/>. Other examples are "bacteria"—programs that have been listed as one of the oldest forms of programmed threats. A bacterium is another name for a rabbit program. It does not explicitly damage any files, and its only purpose is to reproduce exponentially. This, however, might have such serious consequences as taking up all the processor capacity, memory, or disk space, and consequently preventing the normal use of the computer. Thomas R. Peltier, "The Virus Threat", *Computer Fraud & Security Bulletin*, June 1993, 15.

35. John Walker: "The Animal Episode", 1996 (1985). <http://www.fourmilab.to/documents/univac/animal.html>. The link includes listings for the Animal and Pervade programs, as well as parts of a 1985 letter to *Scientific American* describing the program. See also Ferbrache 1992, 6. Cf. "Virus Precursor: Animal." *The Risks Digest*, vol. 6, issue 52, March 29, 1988, < http://catless. ncl.ac.uk/Risks/>.

36. See, e.g., Terry Winograd: "Breaking the Complexity Barrier Again." *SIGPLAN Proceedings of the 1973 Meeting on Programming Languages and Information Retrieval* 1974.

37. Slade 1992.

38. Ken Thompson: "Reflections of Trusting Trust." *Communications of the ACM*, vol. 27, August 1984, 761.

39. Gere 2002, 61.

40. A.K. Dewdney: "In the Game Called Core War Hostile Programs Engage in a Battle of Bits." *Scientific American*, vol. 250, May 1984, 19. Ross 1990. Hafner & Markoff 1991, 263–264. Robert Morris was the father of Robert Morris Jr., the creator of the 1988 Internet worm analyzed below.

41. "Darwin, A Game of Survival of the Fittest among Programs." A letter by V. Vissotsky et al. to C.A. Land, 1971, transcribed and online at <http://www.cs.dartmouth.edu/~doug/darwin.pdf>.

42. A.K. Dewdney: "In the Game Called Core War Hostile Programs Engage in a Battle of Bits." *Scientific American*, vol. 250, May 1984, 15.

43. Johnston 2007.

44. A.K. Dewdney: "In the Game Called Core War Hostile Programs Engage in a Battle of Bits." *Scientific American*, vol. 250, May 1984, 16.

45. Ibid., 18.

46. Ibid. See also Lundell 1989, 25–26. Cohen 1994, 4–7.

47. Dewdney referred to a spy thriller, *Softwar: La Guerre Douce* (1984), in which the Soviet Union buys a supercomputer from the West for weather forecasting purposes. The computer is loaded with a "software bomb" that "proceeds to subvert and destroy every piece of software it can find in the Soviet network." The novel does not depict, however, self-reproducing software but simply a version of a Trojan attack and a logic bomb. A.K. Dewdney: "A Core War Bestiary of Viruses, Worms and Other Threats to Computer Memories." *Scientific American*, vol. 252, March 1985, 14. See Breton & Beneich 1984.

48. In 1989 Dewdney emphasized that his Core Wars programs had no direct connection to the booming number of virus infections. Again stating that Core Wars programs were not hostile to programs outside the game, he referred to real computer viruses as acts of vandalism. Comparisons between his programs and these vandal programs were often, according to Dewdney, misconceptions cultured by journalists and the media in general. The misconceptions were not, however, hard to understand given the amount of fear and panic hostile computer viruses had created since the years of Core Wars and Dewdney's first column on the game in 1984. See "Of Worms, Viruses and Core War." *Scientific American*, vol. 260, March 1989.

49. See Speidel 2000.

50. See Parikka 2007.

51. The cultural historian Jaakko Suominen has named the era from roughly 1958 to 1973 as a time of "automation and integration", referring to the central trends in computing. According to Suominen, the general metaphors for technology were the automatic factory, the reactor, and the spaceship. Only computing professionals had firsthand experience of computers, and media representations constructed the main popular imagery. The primary applications and uses for computers were calculation, registration, control, prediction, and surveillance, and the problems experienced were intuitively connected: Will the machine replace the human? Do computers make mistakes? See Suominen 2003, 227. Cf. Saarikoski 2004, 411.

52. See Bagrit 1965.

53. "Bad Bits." *Scientific American*, vol. 242, February 1980, 63.

54. See Lance Hoffman: "Computers and Privacy: A Survey." *Computing Surveys*, vol. 1, 2, June 1969. Cf. Ceruzzi 1998, 118–121. Privacy concerns were, however, part of the TV culture of the 1960s. Sconce 2000, 144–147.

55. For example, the *NBC Evening News* on July 31, 1973, included a story under the headline "1984 Threat" describing the dangers inherent in the contemporary mass record-keeping boom in banks, loan companies, and census bureaus. Vanderbilt News Archive, <http://tvnews.vanderbilt.edu/>.

56. Bagrit 1965.

57. Alan F. Westin: "Legal Safeguards to Insure Privacy in a Computer Society." *Communications of the ACM*, vol. 10, issue 9, September 1967, 534. In 1988 Roger Clarke defined "dataveillance" as "the systematic use of personal data systems in the investigation or monitoring of the actions or communications of one or more persons." See "Information Technology and Dataveillance." *Communications of the ACM*, vol. 31, issue 5, May 1988, 499.

58. See Lance Hoffman: "Computers and Privacy: A Survey." *Computing Surveys*, vol. 1, issue 2, June 1969.

59. "We Solve the One Problem No Computer Can." *The Times*, February 24, 1972, 23.

60. "How the Human Factor Bugs Security." *The Times*, September 10, 1985, 22.

61. Dorothy E. Denning & Peter J. Denning: "Data Security." *Computer Surveys*, vol. 11, issue 3, September 1979, 227–228. See also Parker 1976. Bell & La Padula (1976) do, however, discuss computer sabotage in such terms as could include malicious programs as well. For an online collection of relevant security papers from the 1970s, see "History of Computer Security." <http://csrc.nist.gov/publications/history/index.html>.

62. Dorothy E. Denning & Peter J. Denning: "Data Security." *Computer Surveys*, vol. 11, issue 3, September 1979, 229.

63. See Wark 1994, 120.

64. Gerrold 1975, 175.

65. Harley, Slade, & Gattiker 2001, 663.

66. See, e.g., Fites, Johnston, & Kratz 1989. Trojan programs themselves had been active computer security problems since the 1960s. Denning 1991b, 288–289.

67. "Deterritorialization" refers to a process of moving between territories and contexts. For Deleuze and Guattari (1994, 67–68), these movements are, however, primary in relation to the nodes they connect. Territories do not refer only to geographical or physical entities, but also to mental, psychical, and cultural territories (ecologies in later Guattarian vocabulary). Thus, if the life of an animal can be conceived as a cycle of deterritorializations and reterritorializations from one place to another, so can the life of a human and human culture as well. See also Sasso & Villani 2003, 82–100. For example, a hammer, normally a tool (assemblage) in a territory/context of woodwork might deterritorialize in another context as a weapon. Similarly, concepts and discursive practices are able to change territories and acquire new meanings and uses while also carrying some of their old forces with them. In other words, deterritorialization carries assemblages toward new territories. Here, territories consist of milieus, organisms, and their relations and also of the creative rhythms that export them toward novel becomings: the territorial assemblage is not reducible to straightforward patterns of behavior. Assemblages are always territorial while also consisting of the double articulation of expressions (semiotic systems) and pragmatics (actions and passions). In the words of Deleuze and Guattari (1987, 504–505), assemblages are tetravalent as they consist of (1) content and expression and (2) territoriality and deterritorialization. Cultural concepts and practices can be understood through such processes of movement, where no capability, practice, or meaning is naturally and eternally determined; instead, they flow from some territories (contexts) to others. This means that the task of media ecology is an active mapping of such existing and virtual movements across territories. On remediation, see Bolter & Grusin 1999.

68. R. Stockton Gaines & Norman Z. Shapiro: "Some Security Principles and Their Application to Computer Security." *ACM SIGOPS Operating Systems Review*, vol. 12 issue 3, July 1978.

69. Mosco 2004, 137–138. Cf. Hardt & Negri 2000, 297–300.

70. McAfee & Haynes 1989, 15.

71. See Deleuze 1990, 240–247.

72. Brunner 1976.

73. Ryan 1985.

74. Denning 1991a, iii.

75. Maurice Wilkes: "Computer Security in the Business World." *Communications of the ACM*, vol. 33, issue 4, April 1990, 399.

76. Samuelson 1991, 482.

77. "However, the security experts of both government and private sector organizations with the biggest, most carefully guarded systems have failed to produce fully effective defensive measures to protect their systems against sabotage, infiltration, and virus infection. A major factor is that computer security must move away from its traditional role of providing only physical protection for data and equipment. This issue is causing great confusion among security professionals, who have been used to dealing in access controls and the protection of data from theft or overt manipulation by hostile people." McAfee & Haynes 1989, 14.

78. Deleuze 1990, 240–247.

79. Ceruzzi 1998, 77–78, 154–155. Not everyone agreed that the future of computers was about time sharing and networking. For example, Andrew Booth stressed that ideas of time sharing involve "nothing new" under the sun. "The Future of Automatic Digital Computers." *Communications of the ACM*, vol. 3, issue 6, June 1960, 339.

80. Lundell 1989, 39. Lundell also quotes Fred Cohen: "But in order for systems to allow sharing, there must be some information flow. It is therefore my major conclusion that the goals of sharing in a general-purpose, multilevel security system may be in such direct opposition to the goals of viral security as to make their reconciliation and coexistence impossible." See also Fites, Johnston, & Kratz 1989, 35.

81. Robert Kahn: "Networks for Advanced Computing." *Scientific American*, vol. 257, October 1987, 128.

82. Bagrit 1965, 33.

83. John F. Shoch & Jon A. Hupp: "The 'Worm' Programs—Early Experience with a Distributed Computation." *Communications of the ACM*, vol. 25, issue 3, March 1982, 179. Hafner & Markoff 1991, 280. Lundell 1989, 21. According to Lundell, the Creeper was a virus that got away, and a special Reaper program was designed to clean the network of Creeper programs.

84. See Hiltzik 1999, 209–210. Cf. Jeff Johnson et al.: "The Xerox Star: A Retrospective." *IEEE Computer*, September 1989, 11–29.

85. Robert Kahn: "Networks for Advanced Computing." *Scientific American*, vol. 257, October 1987.

86. See the Wikipedia page about ALOHAnet, <http://en.wikipedia.org/wiki/ALOHAnet>.

87. On ARPANET, see Abbate 2000. Flichy 2001. Packet switching means that information is not sent in a continuous stream, but in small parts, packets, that do not necessarily have to follow the same paths to reach the receiver. This leads to a more efficient utilization of network capacity.

88. See Hafner & Markoff 1991, 34–35, 110–111. Also Digital Equipment's (DEC's) corporate network Easynet was the target of hacker attacks. In Europe computer networks tended to be more government controlled throughout the 1980s. According to Hafner and Markoff, "Multics was one of the first time-sharing systems that paid real attention to security as an explicit design goal." Hafner and Markoff 1991, 265.

89. Cf. Harley, Slade, & Gattiker 2001, 189. In *Viruses Revealed!* they emphasize that even if the Shoch–Hupp worm was a reproductive worm, it did not have security-breaking intentions, nor did it try to hide itself. Ibid., 21. Often, antivirus researchers stress that even benevolent viruses are harmful as they tie up computing resources (memory), making it unavailable to the normal operations of the system. Cf. Fuller 2003, 131–132.

90. Spafford 1997, 263.

91. Fites, Johnston, & Kratz 1989, 5.

92. Quoted in Briggs & Burke 2002, 308–309, 21. The Computer Science Research Network (CSNET) was founded in 1979. The first key players in networking plans, especially in the United States, were universities and research institutes.

93. Bagrit 1965, 33. R. Stockton Gaines & Norman Z. Shapiro: "Some Security Principles and Their Application to Computer Security." *ACM SIGOPS Operating Systems Review*, vol. 12 issue 3, July 1978, 19–28. See also Halbach 1998.

94. Victor Vyssotsky, e-mail to author, June 2, 2005.

95. See Bürger 1988, 255–256. Fuller (2005, 93–96) sees standard objects in terms of continuous "ideally isolated systems" (A.N. Whitehead) that are designed as stable and ready for composition. Standard objects go through standards, handlers, testers, and so forth to enter a larger state of potential systematic connections, whether we are talking of freight containers or network objects.

96. "Virus on All Things Considered." *Risks Digest*, February 8, 1988, < http://catless.ncl.ac.uk/Risks/>. Cohen 1986, 83–95.

97. "Of Worms, Viruses and Core War." *Scientific American*, vol. 260, March 1989, 90.

98. See Lundell 1989, 41. See also Parker 1991a. The earlier forms of technological crime included phone phreaking in the 1970s.

99. See Trogemann 2005.

100. Ken Thompson: "Reflections on Trusting Trust." *Communications of the ACM*, vol. 27, issue 8, August 1984, 763. See also Ferbrache 1992, 9. Thompson was also one of the main designers of the UNIX system. Hafner & Markoff 1991, 267.

101. Ken Thompson: "Reflections on Trusting Trust." *Communications of the ACM*, vol. 27, issue 8, August 1984, 763.

102. Vanderbilt News Archive. "Computer Crime." *CBS Evening News*, March 3, 1983.

103. Cf. Galloway 2004, 178.

104. Donn B. Parker & Susan H. Nycum: "Computer Crime." *Communications of the ACM*, vol. 27, issue 4, April 1984, 313. See also Dorothy Denning & Peter Denning: "Data Security." *Computing Surveys*, vol. 11, issue 3, September 1979. These themes were, of course, not altogether new, as a computer security advertisement from *The Times* illustrates. It emphasizes the changes in security brought about by the increasing number of remote processing systems. *The Times*, February 24, 1972. A letter to the editor of *The Times* in 1974 makes the same point: "The fact is that these [computer] systems have developed significantly in scope over the years and vast files of information can now be handled; furthermore access to the information may now be obtained through remote terminals and central processors frequently cope nowadays with several programmes at one time." *The Times*, September 17, 1974, 20.

105. Willis H. Ware: "Information Systems Security and Privacy." *Communications of the ACM*, vol. 27, issue 4, April 1984, 315. (My italics.)

106. Maurice Wilkes: "Computer Security in the Business World." *Communications of the ACM*, vol. 33, issue 4, April 1990. See also Levy 1985, 417–418.

107. Hafner & Markoff 1991, 68.

108. As Doug McIlroy, one of the originators of the Darwin program remembers, 1983 was a crucial year: "In 1982, Vyssotsky, by then a fairly high executive managed to divert an investigation into 'inappropriate' use of company computers into a study of corporate computer security. That

was the year of the movie 'War Games,' which can be taken as the start of general awareness of security as a major computing concern." Doug McIlroy, e-mail to author, April 25, 2005.

109. Peter Denning: "Moral Clarity in the Computer Age." *Communications of the ACM*, vol. 26, issue 10, October 1983, 709–710. Denning 1991a, 441–443. "The 414 Gang." *Computer Fraud & Security Bulletin*, vol. 6, number 1, November 1983. In addition to the United States, Germany had an active hacking scene in the early 1980s. Clough & Mungo 1992, 164–165. On Kevin Mitnick, see, e.g., Hafner & Markoff 1991, 15–137. In general, security specialists commenting on the hacker image argued that the attitude of the press was too tolerant, leading to a romanticized view of hacking as innocent computer breaking by enthusiastic teenagers. These professionals themselves were already warning about the future risks in system breaking and hacking.

110. Haddon 1993, 129. See also Briggs & Burke 2002, 286–287. Suominen 2003.

111. "Elk Cloner." <http://www.skrenta.com/cloner/>. "A Threat from Malicious Software." *Time*, November 4, 1985. However, the *Oxford Dictionary of Computing* from 1986 (2nd edition), for example, includes neither "virus" nor "worm" as an entry.

112. Ferbrache 1992, 8–9. "Two Viruses." *The Risks Digest*, vol. 6, issue 71, April 26, 1988.

113. "A Threat from Malicious Software." *Time*, November 4, 1985.

114. "RE: Prize for Most Useful Computer Virus." *The Risks Digest*, vol. 12, issue 30, September 11, 1991. The viruses were written by Joe Dellinger as personal experiments. The virus did, however, spread via a game called Congo. See also Ferbrache 1992, 8–9. Ferbrache documents a third virus from the beginning of the decade. Apparently it did not have a name, and it was written for research purposes in 1980.

115. Ceruzzi 1998, 264.

116. Ibid.

117. Briggs & Burke 2002, 286–288. Suominen 2003, 227.

118. "Machine of the Year. The Computer Moves In." *Time*, January 3, 1983. On the history of home computing in Finland in the 1980s and early 1990s, see Saarikoski 2004.

119. Briggs & Burke 2002, 323–324.

120. "Machine of the Year. The Computer Moves In." *Time*, January 3, 1983.

121. Hoo-min D. Toong and Amar Gupta: "Personal Computers." *Scientific American*, vol. 247, December 1982, 89.

122. According to *Virus Bulletin*, "background operation" is a term applied to programs that run in multitask environments over which the user has no direct control. *Virus Bulletin* 1993, 327.

123. Bolz 1998. As Wendy Chun (2006, 3–4) aptly notes, even though the user is left with the illusion that "your computer sends and receives data at your request" networked computers are actually in continuous connection with each other via the Ethernet technology.

124. Kittler 1993a. Cf. Fuller 2003.

125. See the description of the Apple II machine in Levy 1985, 263–264.

126. "Computer Viruses—A Management Overview." *Virus Bulletin Conference Proceedings* 1992, v. Harley, Slade, & Gattiker (2001, 129) emphasize the same point: user-friendly programs and operating systems hide information from the user, for the system is more complex in its programming.

127. Lundell 1989, 36.

128. Spafford, Heaphy, & Ferbrache 1991, 319.

129. See Lundell 1989, 36. McAfee & Haynes 1989, 3, 9.

130. Harley, Slade, & Gattiker 2001, 85–86.

131. Data-Fellows, F-Prot, *Käsikirja*, n.d., 43.

132. Several computer virus activation routines seemed to take advantage of this upper hand they had over average users in almost a bullying tone. The Casino virus (1991) forced the user to gamble in a jackpot game. The stakes were the contents of the hard drive. Another example is the YAM.Math virus (1993), which denied execution of a program unless the user could give correct answers to addition and subtraction questions. These viruses—or, more accurately, these virus *payloads* triggered by activation routines—can be understood as expressing the uncontrollability, and even helplessness, that a user might experience with a computer or a computer virus.

133. "Personal Computers." *Scientific American*, vol. 247, December 1982, 92. Cassette players remained the most frequently used mass storage tool for several personal computers for a long time. Only in the late 1980s with, e.g., the Amiga 500 did disks become more popular in homes.

134. Ceruzzi 1998, 236–237.

135. Bürger 1988, 256.

136. Steve R. White, Jeffrey O. Kephart and David M. Chess: "Computer Viruses—A Global Perspective." International Virus Bulletin Conference Proceedings 1995,173. See also "Brain Virus Remembered." *The Risks Digest*, vol. 6, issue 75, May 1, 1988, < http://catless.ncl.ac.uk/Risks/>. The Stoned virus can be used as a similar example. Around 1989, 5.25-inch diskettes were the standard and Stoned could spread only using that platform. With the proliferation of 3.5-inch diskettes, Stoned began slowly to disappear. White, Kephart, & Chess: "Computer—A Global Perspective", 173. Several similar examples could be given, but this is enough to support my point: computer viruses and similar digital programs are inherently tied to certain socio-technological platforms. The 1980s was more or less an era of personal computing and the start of a networking era that was truly realized at the beginning of the 1990s and the so-called Internet era.

137. Lundell 1989, 45. It was first found on university computers, which is quite natural: universities were key nodes in diskette sharing.

138. Ibid.

139. Highland 1991b, 302.

140. Harley, Slade, & Gattiker 2001, 25, 337, 338. Slade 1992. Highland 1991a. See also "Brain Virus Shows Up in Hong Kong." *The Risks Digest*, vol. 7, issue 66, October 18, 1988, <http://catless.ncl.ac.uk/Risks/>. The spreading of Brain was slow. Even though the first reports came in 1986, it was still thought to be a new virus in 1988. This illustrates the low media coverage viruses received before 1988. See "New Virus Reported." *The Risks Digest*, vol. 6, issue 52, March 31, 1988. See also "Re: © Brain Virus in Risks Digest 6.52." *The Risks Digest*, vol. 6, issue 55, April 5, 1988, <http://catless.ncl.ac.uk/Risks/>. Also the Apple Macintosh, Commodore Amiga, and Atari ST had their viruses from early on. In 1987 nVIR was found in West Germany, having the honor of being the first Mac virus. One version of it also included a peculiar payload: it used the MacinTalk program to reproduce the words "Don't Panic!" Atari's Pirate Trap and Amiga's SCA viruses also appeared in 1987, the latter becoming infamous for its supposedly ironic message: "Something wonderful has happened Your AMIGA is alive!!!" Ferbrache 1992, 12. The variation across different nations and computing cultures should not be neglected: whereas PC viruses were at the center of media focus in the United States, Finland was more concerned with Amiga viruses. The SCA virus spread to Finland via importers and illegal pirate games. Saarikoski 2004, 363–364 "Outo tauti Amigassa." *Mikrobitti* 11, 1987. "Amigan virus jatkaa riehumistaan!" Mikrobitti 2, 1988. "Amigan virukset." *Mikrobitti* 4, 1988. "Onko Amigasi käynyt vieraissa?" *C–lehti* 3, 1989.

141. Data-Fellows, F-Prot, *Käsikirja* n.d., 44. See also Saarikoski 2004, 363. Ross 1990. "Data Viruses, Trojan Horses and Logic Bombs—How to Treat Them?" *Computer Fraud & Security Bulletin,* vol. 10, issue 6, 1988.

142. Ibid., 56. David Aubrey-Jones: "Diskettes: Risk and Security." *EICAR Conference Proceedings* 1994, 131.

143. See Helmreich 2000a. See also "'The Itch Syndrome.'" *Virus Bulletin*, October 1989. Some commentators saw not only pirate games but *all* games as part of the problem: "Unfamiliarity with the culture of the PC can (...) present problems. The ease of access and widespread use of PCs (many people own one at home) encourages the exchange and swapping of software (especially games) and experience. This is completely in contrast to the bureaucratic, centralized and heavily controlled culture of centralized computing. The capabilities of many modern PCs easily outstrip mainframe computers of a few years ago and the sense of power accorded to end-users may lead to almost fanatical extremes." Jean Hitchings: "Human Dimension of Computer Viruses." *Virus Bulletin Conference Proceedings* 1995, 26. On the history of the software industry, see Campbell-Kelly 2004. Campbell-Kelly, however, neglects virus and antivirus programs.

144. Harley, Slade, & Gattiker 2001, 341. See also Cohen 1991a, 389.

145. *Virus Bulletin* 1993, 26. See also "Computer Virus Spreads to Commercial Software." *InfoWorld*, March 21, 1988.

146. *Virus Bulletin* 1993, 27.

147. See Ken Thompson: "Reflections of Trusting Trust." *Communications of the ACM*, vol. 27, issue 8, August 1984, 761–763. Mark Day refers to this in the Risks Digest Forum in 1985: "On viruses, etc.: it is certainly the case that you only want software which is written by people you trust (and ENTIRELY by people you trust—see Ken Thompson's Turing Award Lecture for a further discussion of this). But is that different from needing to have bookkeepers and treasurers that you trust in order to avoid embezzlement? If bankers and national security types don't take steps to ensure that they have good software, then they certainly have a problem, but not a hopeless one. There have been previous proposals to have independent 'software certification agencies' to ensure software quality, but I don't know if they would really be able to solve this problem." "Viruses and Worms." *The Risks Digest*, vol. 1, issue 28, December 9, 1985.

148. Harvey, Slade, & Gattiker 2001, 355. A few years later the person responsible for the Trojan was sentenced in an Italian court.

149. "Machine of the Year. The Computer Moves In." *Time*, January 3, 1983.

150. "A Threat from Malicious Software." *Time*, November 4, 1985. Similarly, the Arf Arf Got You Trojan program received some media attention in 1985. *The Computer Fraud & Security Bulletin* told the story of a director at CBS who caught the program from a public Family Ledger bulletin board. In advice repeated ever since, commercial users were alerted to the new danger they were in: "The dangers to the commercial user are obvious. Operators of commercial systems should be instructed not to access bulletin boards from company equipment and under no circumstances should they even think of copying across public domain software." "Not Arf and Worm Programs." *Computer Fraud & Security Bulletin*, vol. 8, issue 1, November 1985, 11. See also "The Insidious Infection." *Infosystems*, vol. 32, issue 5, May 1985. The warnings were backed up by several virus reports during the following years.

151. Alan Solomon: "A Brief History of Viruses." *EICAR Conference Proceedings* 1994, 118. Slade 1992. Harvey, Slade, & Gattiker 2001, 346–347. Other 1987–1988 viruses included Stoned

and Jerusalem. Originating from the University of Wellington, New Zealand, the Stoned virus (1987) became the most widespread virus on the MS-DOS operating system. New versions of the virus were found around the world for several years after the first version. It became famous for its reference to the effects of the drug cannabis, printing "Your PC is Now Stoned" to screen. Stoned operated as a cunning virus that overwrote the master boot record (MBR) and stored the original MBR to another place on the disk. F-Prot *Päivitystiedote*, vol. 2, issue 4, June 1992. See also Alan Solomon: "A Brief History of Viruses." *EICAR Conference Proceedings* 1994, 118. Slade 1992. Harley, Slade, & Gattiker 2001, 603. The Jerusalem virus, also known as the PLO virus and the Israeli Time Bomb, was supposed to activate on May 13, 1988, the fortieth anniversary of the state of Israel—hence the reference to the PLO and the idea that the virus was a political act. It was discovered at the Hebrew University by Yisrael Radai, who worked at the university computer center. Actually the virus was the fourth part of a virus family called sURIV, and it originally contained a bug that caused the virus to reinfect repeatedly the same .exe files. Owing to this, the activation in 1988 was largely ineffective. It basically constipated itself. "An Israeli Virus." *The Risks Digest*, vol. 6, issue 6, January 1988. "Another PC Virus." *The Risks Digest*, vol. 6, issue 25, January 1988. Lundell 1989, 163.

152. Trond Lundemo (2003) analyzes the Cascade virus as a "physical objectivation of the word and letter, in a truly Mallarmean understanding of language", commenting on the changing nature of writing. Harley, Slade, & Gattiker 2001, 26.

153. "The Virus Reaches Israel." *The Risks Digest*, vol. 6, issue 12/January 1988.

154. Harley, Slade, & Gattiker 2001, 30. "Friendly Advice … [Datacrime]." *The Risks Digest*, vol. 9, issue 32, October 1989, <http://catless.ncl.ac.uk/Risks/>.

155. See Guillaume 1987.

156. Harley, Slade, & Gattiker 2001, 29. Fred Cohen, e-mail to author, November 4, 2003. According to a 1988 survey, computer security in general had a low priority in UK companies; at least one in four had no security policies at all. "Computer Security a 'Low Priority in UK Companies', Survey Reveals." *Computer Fraud & Security Bulletin*, vol. 10, issue 8, 1988, 12–14. The virus hunters John McAfee and Colin Haynes have offered a view on why it was so hard to admit that such a problem as a "digital virus" could exist. They argue that it is the *uncanniness* of the idea that causes the most problems: comprehending the notion of a digital disease is a cognitive problem. "Another danger stemming from human attitudes toward the virus problem is the natural tendency to downplay an issue that is so difficult to comprehend. Furthermore, if there is a temporary lull in the publicity surrounding viral outbreaks, we risk becoming complacent about the dangers of infection. We are dealing with a piece of computer software that has no morals, no thought processes that can be anticipated. It has been created by a human being, whose motivations can be investigated once known; however, once let loose, the virus inexorably pursues a single purpose—to seek computing environments in which it can reproduce itself as extensively as possible. The infection and replication processes are now happening automatically." McAfee & Haynes 1989, 16.

157. "Although monitoring and analytical programs have a place in the antiviral pantheon, this fact means that they, and, in fact, all other antiviral software, can never give 100% guaranteed protection. Without this early work, it is likely that some toilers in the antiviral vineyards would still be pursuing that elusive grail." Slade 1992.

158. Cohen 1984.

159. Cohen 1986, 1.

160. Fred Cohen, e-mail to author, November 4, 2003.

161. See Cohen 1986, 84. "Clearly, if there is no sharing, there can be no dissemination of information across subject boundaries, and a virus cannot spread outside a single subject."

162. Ibid., 85.

163. Cohen 1984.

164. Cohen 1986, 204.

165. Ibid., 207.

166. Ibid., 208–209. The fear of information falling into the "wrong hands" was a continuous concern. Apparently, one conference on computer security and viruses in 1988 was originally cancelled because the U.S. Department of Commerce thought the subject was too sensitive for open discussion. The conference was reorganized in 1989—in Canada. "First International Conference on Secure Information Systems." *The Risks Digest*, volume 6, issue 53, March 31, 1988.

167. Cohen 1986, 211.

168. Ibid., 177.

169. Ibid., 222. At the same time David Jefferson, an artificial life researcher, was active at the University of Southern California, providing Cohen with his support. Levy 1992, 254, 315.

170. von Gravenreuth 1995, 15.

171. Shain 1994, 4.

172. Mattelart 2003, 109, 115–116.

173. Shain 1994, 4.

174. See, e.g., Anderson & Shain 1994.

175. Beck 1986, 1988. Whereas accidents are actualized events, risks are to be seen as temporal expectations. Risks are probabilities and express the novel conceptions of time modernization has brought with it—a future that is uncertain, but remedied with (e.g., political) action. See Reith 2004. Nigel Clark (1997) offers an interesting and affirmative perspective on remediations of nature in the context of risk society in his text "Panic Ecology. Nature in the Age of Superconductivity."

176. Beck 2000, 213.

177. Van Loon 2002b.

178. Ibid., 159. See also Van Loon 2000.

179. However, the question is not one of a virtual reality, as cyber theorists often articulate this media cultural situation, but concerns the metaphysical notion of the reality of the virtual—where reality in every case (not merely in the media culture of the late twentieth century) is virtual. See Žižek 2004, 3–4.

180. Beck 2000, 221. Latour 1993. On virtuality, see also Deleuze & Parnet 1996, 179–185.

181. Hayles 1999, 131–159. See also Maturana & Varela 1980.

182. Heylighen & Joslyn 2001, 11.

183. Serres 1982, 68. Martin 1994, xvii.

184. Fred Cohen, e-mail to author, November 4, 2003. Harley, Slade, & Gattiker 2001, 24. See also "The Legend—Fred Cohen." *Alive*, vol. 1, issue 1. <http://www.cs.uta.fi/~cshema/public/vru/alive/alive.11>.

185. Järvinen 1990, 146–189. Fites, Johnston, & Kratz 1989, 133–145.

186. C:Cure Virus Buster leaflet. Virex for the PC leaflet. Vaccine Antivirus system for DOS leaflet. All undated.

187. "Virus Insurance from Lloyds of London" and "Control Risks Forms New Computer Security Company." *Computer Fraud & Security Bulletin*, vol. 11. issue 4, 1989. "Insuring Computer

Virus." *The Computer Law & Security Report*, vol. 6, issue 4, 1990. See also "The Computer Virus— A Threat Under Control or a Warning of Things to Come?" *The Computer Law & Security Report*, vol. 5, issue 6, 1990.

188. "Security." *Byte*, June 1989, 254.

189. Harley, Slade, & Gattiker 2001, 284–285.

190. Stephenson 1993, 371.

191. On risk management issues, see Harley, Slade, & Gattiker 2001, 172–300.

192. Mark Drew: "Distributed Computing—Business Risk or Risking the Business." *EICAR Conference Proceedings* 1994, 93. Drew continues: "The issue is also a *personal* issue, every individual is responsible and accountable and this is a key message that must be conveyed to staff, associates, partners, agents, suppliers, and collaborators." However, as Dorothy Denning highlighted in the end of the 1970s, each user was to be responsible for his or her safety in network environments. See "Secure Personal Computing in an Insecure Network." *Communications of the ACM*, vol. 22, issue 8, August 1979, 476–482.

193. Tozzi 1991.

194. "The Computer Virus—A Threat Under Control or a Warning of Things to Come?" *Computer Law & Security Report*, vol. 5, issue 6, 1990, 8.

195. Reijo Sulonen, interview with author, November 23, 2005.

196. Brunner 1976, 248.

197. Ibid., 249.

198. Bernd Fix, e-mail to author, November 7, 2005.

199. Ibid.

200. Clough & Mungo 1992, 80–82. Bürger 1988. The same year, 1987, the Vienna virus was found. Clough and Mungo describe this virus as raising much interest, being "certainly the hottest thing seen in 1987." Cf. Alan Solomon: "A Brief History of Viruses." *EICAR Conference Proceedings* 1994, 117.

201. "Dr. Pournelle vs. The Virus." *Byte*, July 1988, 199.

202. "Invasion of the Data Snatchers!" *Time*, September 26, 1988, 40.

203. Ibid., 41.

204. Ross 1990. This theme is continued in the next chapter. On *The Invasion of the Body Snatchers*, see, e.g., Ahonen 1999. Hardin 1997.

205. See John Markoff: "Computer Virus Cure May Be Worse Than Disease." *New York Times*, October 7, 1989.

206. McAfee & Haynes 1989, 15. Cf. "The Kid Put Us Out of Action." *Time*, November 14, 1988. Earlier in 1988, *Time* discussed an older virus, Brain, programmed in Pakistan. It was also a cover story. See "You Must Be Punished." *Time*, September 26, 1988.

207. See Chun 2006, 177.

208. Cf. Van Loon 2002b, 179. Harley, Slade, and Gattiker note that the Morris worm was probably the first mention people heard of such software programs: "News stories about the event appeared in the general media, and, for many years afterward, no news story about viruses failed to mention the Internet worm, regardless of the fact that it used technologies radically different from the other, more common, viruses." Harley, Slade, & Gattiker 2001, 29. On the intimate relationship between television and catastrophes, see Doane 2006.

209. Neumann 1991, 539. Eric C. Rosen: "Vulnerabilities of Network Control Protocols: An Example." *ACM SIGCOMM Computer Communication Review*, vol. 11, issue 3, July 1981.

210. "The Christmas Virus [End of the Season?]." *The Risks Digest*, vol. 6, issue 1, January 2, 1987. *Survivor's Guide to Computer Viruses* 1993, 28–29.

211. Abbate 2000, 219. The tension between open architecture and security demands has been noted by Severo Ornstein: "The primary purpose of the Internet is to foster the sharing of information, ideas, programs, data, etc., among its thousands of users. In designing any shared computer system, there is an inherent tension between demands for security and the desire for easy exchange of information. Unlike vital military, business, and financial networks, the Internet design has been deliberately biased toward increased capability, at the known and accepted cost of some loss in security." Ornstein 1991, 519. Although the Internet worm started the era of virus paranoia, it is part of a longer history of the Internet. This is also because Robert T. Morris was the son of Robert Morris, who had been a pioneer in the computer security and design community. Morris Sr. had even participated in the original work on the Core Wars game, a precursor of viruses!

212. "The 'Worm' Programs—Early Experience with a Distributed Computation." *Communications of the ACM*, vol. 25, issue 3, March 1982, 172–180.

213. Jon Rochlis and Mark Eichin: "With Microscope and Tweezers: The Worm from MIT's Perspective." *Communications of the ACM*. vol. 32, issue 6, June 1989, 692. Lundell 1989, 8–9. Harley, Slade, & Gattiker 2001, 347–352.

214. Apter 1966, 94.

215. Ted Eisenberg et al.: "The Cornell Commission: On Morris and the Worm." *Communications of the ACM*, vol. 32, issue 6, January 1989, 709. Harley, Slade, & Gattiker 2001, 351. Lundell 1989, 8–18. "Student Convicted on U.S. Computer Tampering Charge." *Wall Street Journal*, January 23, 1990. "Student Indicted on Charge Linked to Computer Virus." *Wall Street Journal*, July 27, 1989.

216. Clark 1997, 79.

217. Guillaume 1987, 60.

218. Ibid., 64.

219. Vanderbilt News Archive Abstracts. <http://tvnews.vanderbilt.edu/>.

220. Guillaume 1987, 59.

221. Levy 1985, 40.

222. On these incidents, see Clifford Stoll: "Stalking the Wily Hacker." *Communications of the ACM*, vol. 31, issue 5, May 1988, 484–497. Klaus Brunnstein: "Computer Espionage: 3 'Wily Hackers' Arrested." *The Risks Digest*, vol. 8, issue 35, March 2, 1989, <http://catless.ncl.ac.uk/Risks/>. Jon Jacky: "Yet Another 'Hackers Break Milnet' Story, Some Interesting Twists." *The Risks Digest*, vol. 5, issue 40, September 28, 1987, <http://catless.ncl.ac.uk/Risks/>. Morris was even named as "the ultimate hacker." See Harold Joseph Higland: "The Arpanet Virus Attack." *Computer Fraud & Security Bulletin*, vol. 11, issue 5, 1989. See also Hafner & Markoff 1991, where they discuss Kevin Mitnick, the Wily Hacker incident, and Robert Morris Jr. Hackers are also discussed in Chapter 2.

223. Tuomi 1987, 134. See also "A bill to amend title 18, United States Code, to provide additional penalties for fraud and related activities in connection with access devices and computers, and for other purposes." (1986) <http://thomas.loc.gov/cgi-bin/bdquery/z?d099:HR04718:@@@L=2=m>. For the underground point of view, the reader might want to see the

Computer Underground Digest archive from 1990 (<http://www.soci.niu.edu/~cudigest/>) and the Dutch *Hack-Tic* archive from 1989 (<http://www.hacktic.nl/index.html>).

224. Peter Neumann: "Inside Risks: Insecurity about Security?" *Communications of the ACM*, vol. 33, issue 8, August 1990, 170. On discussion and comments concerning the worm, see vol. 32, issue 6 (June 1989) of the *Communications of the ACM*. See also Bryan Kocher: "A Hygiene Lesson." *Communications of the ACM*, vol. 32, issue 1, January 1989, 3 & 6. Peter Denning: "Sending a Signal." *Communications of the ACM*, vol. 33, issue 8, August 1990, 486–488. Lundell 1989, 1–18. See also the *Risks Digest*, especially vols. 7–9, for an extensive discussion of and reactions to the incident. From vol. 7, issue 69 on, the archives offer an interesting, almost real-time account of the worm incident. See, e.g., "Virus on the Arpanet—Milnet." *The Risks Digest*, vol. 7. issue 69, November 3, 1988, <http://catless.ncl.ac.uk/Risks/>. *The Computer Law and Security Report* saw that the prosecution of Morris would send the right message to the hacker community. The report recognized hacking as a growing international problem. "Virus Hits Major U.S. Computer Network." *Computer Law & Security Report*, vol. 4, issue 5, 1989. In general, see Hafner & Markoff 1991, 253–346.

225. On early computer crime, see Parker 1976.

226. Eugene Spafford: "Crisis and Aftermath." *Communications of the ACM*, vol. 32, issue 6, June 1989, 686.

227. James H. Morris: "Our Global City." *Communications of the ACM*, vol. 32, issue 6, June 1989, 448–450.

228. Van Loon 2000, 166. See also Van Loon 2002b. Biologization is seen as having an important role within computer virus discourse. Some commentators have warned against the "medicalization" that blurs the causal fact that humans make malicious software: "Viruses, worms, Trojan horses, pest programs, and logic bombs are extremely dangerous forms of computer and networks contaminants. They represent a serious threat to the viability of computer usage in an increasingly fragile world. Describing them using biological analogies is deceptive, however, since computer viruses are man-made and theoretically can be cured by convincing people of the seriousness of their use." Parker 1991b, 521.

229. Cf. Van Loon 2002b, 161–162.

230. See Latour 1993, 2004.

231. "Computer Emergency Response Team (CERT)." *The Risks Digest*, vol. 8, issue 14, January 24, 1989, <http://catless.ncl.ac.uk/Risks/>. Ferbrache 1992, s.19. Scherlis et al. 1991. On ethical discussions at the end of the 1980s, see Denning 1991a, 505–511.

232. Ferbrache 1992, 23. Cf. Longley 1994b, 620–621. On the Hamburg Research Center, see *Risks Digest*, vol. 6, issue 83, May 1988, <http://catless.ncl.ac.uk/Risks/>

233. <http://www.eicar.org/constitution.htm>. It is also worth noting the founding of the *Virus Bulletin* journal, which is still active in the field. <http://www.virusbtn.com/>.

234. In Britain, the Computer Misuse Act of 1990 made malicious virus writing illegal. The first conviction was in 1995, when Chris Pile (the Black Baron) was found guilty of hacking and planting viruses. See "British Man Pleads Guilty on Malicious Virus Writing." *Computer Underground Digest*, vol. 7, issue 43, May 28, 1995, <http://venus.soci.niu.edu/~cudigest/CUDS7/cud743>.

235. Ferbrache 1992, 28. On the 1986 Computer Fraud and Abuse Act, see U.S. Code Collection, title 18, part 1, chapter 47, section 1001. <http://www4.law.cornell.edu/uscode/18/1001.html>.

236. Sterling 1994, 153–165. For hacker discussions of the operation and related issues, see Computer Underground Digest archives. <http://www.soci.niu.edu/~cudigest/other/backiss.html>.

237. DeLanda 1991, 227–228. One must, however, note that the computer underground participated in restricting the spread of malicious viruses. See "Z-modem Virus Alert." *Computer Underground Digest*, vol. 2, issue 19, December 31, 1990.

238. Lupton 1994.

239. Ceruzzi 1998, 284. Mackenzie 2006, 85. Also the Digital Equipment Corporation's internal network, Easynet, dating from 1984, was built to support simplicity, uniformity, and ease of use, making it susceptible to hacker attacks. See Hafner & Markoff 1991, 111.

240. Edward Wilding: "Computer Viruses—A Management Overview." *Virus Bulletin Conference Proceedings* 1992, v.

241. F-Secure white paper 2001. Concerns about e-mail communication had already been raised in 1984. See Willis Ware: "Information Systems Security and Privacy." *Communications of the ACM*, vol. 27, issue 4, April 1984, 315–321.

242. See Slade 2004.

243. Massumi 1992, 46.

244. Mattelart 2003, 40–43.

245. Flichy 2001.

246. Kevin Kelly: "New Rules for the New Economy." *Wired*, volume 5, issue 9, September 1997, <http://www.wired.com/wired/archive/5.09/newrules.html>. *Scientific American* wrote in 1986 of this turn within information society: "The triumph of the integrated circuit has been paralleled by the spread of networking at a higher level. In the not very distant past telecommunication was something that took place only between two people. Now the owner of a personal computer can draw information from data bases around the country, and computers communicate directly with one another without human involvement. The information explosion has triggered a communications explosion." John S. Mayo: "Materials for Information and Communication." *Scientific American*, vol. 255, October 1986, 52.

247. Gates 1996, 153.

248. Ibid., 181.

249. Negroponte 1995.

250. This is what Manuel Castells refers to as the "faceless capitalist collective, made up of financial flows operated by electronic networks." Castells 1996, 474.

251. Marshall 2003.

252. Dmitry O. Gryaznow: "Scanners of the Year 2000: Heuristics." *Eicar Conference Proceedings* 1995, T-7.

253. Urs E. Gattiker: "The Information Highway: Opportunities and Challenges for Organizations." *Eicar Conference Proceedings* 1995, P1-14.

254. See <http://assembler.law.cornell.edu/usc-cgi/get_external.cgi?type=pubL&target=102-194>. Cf. <http://www.pff.org/issues-pubs/futureinsights/fi1.2magnacarta.html>.

255. For info on the NII, see <http://clinton1.nara.gov/White_House/EOP/OVP/html/nii1.html>. The Bangemann Report can be found on the web. <http://europa.eu.int/ISPO/infosoc/backg/bangeman.html>.

256. Beth Ellyn Rosenthal: "Computer Viruses Can Make Your Bank Sick." *Bankers Monthly*, October 1988, 55–58.

116 Fear and Security: From Bugs to Worms

257. Hardt & Negri 2000, 298.

258. F-Secure, The Number of PC Viruses 1986–2006 Chart, 2006.

259. Fridrik Skulason: "Virus Trends." *Virus Bulletin Conference Proceedings* 1992, i. See also Edward Wilding: "Computer Viruses—A Management Overview." *Virus Bulletin Conference Proceedings* 1992, v–xiii.

260. See Hebdige 1985.

261. Alan Solomon: "A Brief History of Viruses." *EICAR Conference Proceedings* 1994, 125. Solomon: "The Computer Virus Underground." *Virus Bulletin Conference Proceedings* 1994, 1–10. See also Clough & Mungo 1992.

262. I am grateful to Matthew Fuller for pointing this out. See also the Wikipedia page at <http://en.wikipedia.org/wiki/Script_kiddie>.

263. Clough & Mungo 1992, 58–59. See also the 2600 website at <http://www.2600.com/>.

264. As Alexander Galloway notes, this enthusiasm to get things working finely and aesthetically related to anticommercialism and even more so *pro-protocolism*: "Protocol, by definition, is *open source*, the term given to a technology that makes public the source code used in its creation. That is to say, protocol is nothing but an elaborate instruction list of how a given technology should work, from the inside out, from the top to the bottom." Galloway 2004, 171.

265. Ibid. Todor Todorov's Virus Exchange bulletin board was one of the first well-known systems distributing viruses. See Vesselin Bontchev: "Future Trends in Virus Writing." *Virus Bulletin Conference Proceedings* 1994, 78. F-Prot also reported several Finnish bulletin board systems spreading viruses. See, e.g., F-Prot, *Päivitystiedote*, vol. 2, issue 4, June 1992. For a detailed account on virus construction kits, see F-Prot, *Päivitystiedote*, vol. 2, issue 7, January 1993.

266. Pavel Baudis: "Viruses behind the ex-Iron Curtain." *Virus Bulletin Conference Proceedings* 1994, 157–164. Clough & Mungo 1992, 106–135. Cf. David S. Bennahum: "Heart of Darkness." *Wired* vol. 5, issue 11, November 1997. <http://www.wired.com/wired/archive/5.11/heartof.html>. Eastern European viruses included Yankee Doodle and Cascade. It is worth noting that several of these viruses, written in the early 1990s, in the midst of political turmoil, were in a way also nationalist and political. For example, in Bohemia the 17th November 1989 virus included a message "Viruses against political extremes, for freedom and parliamentary democracy."

267. Vesselin Bontchev: "Future Trends in Virus Writing." *Virus Bulletin Conference Proceedings* 1994, 70. Harley, Slade, & Gattiker 2001, 129–131. See also Steve Gibson: "Polymorphic Viruses Escape Detection but Get Our Attention." *Infoworld*, April 20, 1992.

268. Cf. Sampson 2004.

269. On software criticism, see Fuller 2003.

270. Albert-László Barabási, Vincent W. Freeh, Hawoong Jeong, & Jay B. Brockman: "Parasitic Computing." *Nature*, vol. 412, August 30, 2001, 894–897.

271. Harley, Slade, & Gattiker 2001, 152–153. Glenn Coates & David Leigh: "Virus Detection—'The Brainy Way.'" *Virus Bulletin Conference Proceedings* 1995, 211–216. Richard Zwienenberg: "Heuristic Scanners: Artificial Intelligence?" *Virus Bulletin Conference Proceedings* 1995, 203–210. David J. Stang: "Computer Viruses and Artificial Intelligence." *Virus Bulletin Conference Proceedings* 1995, 235–246. See also Frans Veldman: "Combating Viruses Heuristically." *Virus Bulletin Conference Proceedings* 1993, 67–75. On the interconnections of viruses and antivirus programmers, see Frans Veldman: "Virus Writing Is High-Tech War." *EICAR Conference Proceedings* 1994, 151–156.

272. Clough & Mungo 1992, 90.

273. Ibid. Harold Highland: "Data Physician—A Virus Protection Program." *Computers & Security*, vol. 6, issue 1, February 1987, 73–79

274. Alan Solomon: "A Brief History of Viruses." *EICAR Conference Proceedings* 1994, 119–120. Cf. "Good Virus Protection Comes Cheap, Test Shows." *Network World*, October 21, 1991. For a review of Anti-Virus Toolkit, see *Byte*, July 1989, 88IS-3.

275. Editorial, *Computers & Security*, vol. 6, issue 1, February 1987, 1–3.

276. Michael Alexander: "Health Insurance for Computers." *Computerworld*, April 23, 1990. Aki Korhonen: "Jenkkilä." *Mikrobitti*, vol. 1, 1991.

277. Rod Parkin: "Is Anti-Virus Software Really Necessary?" *Virus Bulletin Conference Proceedings* 1993, 57–65. Cf. "Computer Virus Cure May Be Worse Than Disease." *New York Times*, October 7, 1989.

278. Ilkka Keso: "View from Large Corporation: Anti-Virus Tests" and "Cloaked Business." *EICAR Conference Proceedings* 1994, supplementary papers. Kari Laine: "The Cult of Anti-Virus Testing." *EICAR Conference Proceedings* 1994, 65–87. Cf. Sara Gordon: "Why Computer Viruses Are Not—and Never Were—a Problem." *EICAR Conference Proceedings* 1994, 167–182.

279. Ross M. Greenberg: "Know Thy Viral Enemy." *Byte*, June 1989, 280. Cf. "Editorial. Crying 'Wolf!'" *Virus Bulletin*, September 1990. *Virus Bulletin* takes a critical stance on this exaggeration of the virus phenomenon. This illustrates that one should not see the industry as corrupt and one-sided. For example, *Virus Bulletin* (at least the volumes for 1989–1995) tries to avoid discussions that are too rhetorical and ideological, focusing more on technical details.

280. Brochure for VIREX antivirus program from the early 1990s. (My italics.)

281. ThunderBYTE PC Immunizer brochure from the early 1990s. Electronic Systems and Special Services (ESsaSS). An Information security brochure from Computer Security Engineers (CSE) offered a central narrative of the security dilemma in information society with personal computing: "Traditionally, *Materials, Capital* and *People* have been considered the three means of production. However, it is now clear that *Information* must be added to this troika. Without its information intact, no corporation, private or public, is able to survive in modern society. Maybe for a few hours, a few days or even a few weeks, but certainly not for any longer period of time. Despite this fact, most managers regard information as a commodity, which is just there to be used as required. They do not generally consider security threats to their information base." The ad continues by referring to "statistical information" that has shown the dangers in malware for companies: "95% of companies hit by a computer calamity no longer exists 5 years after the incident, whereas only about 80% of these companies would be expected to be out of business after 5 years anyway. Thus, in about 15% of the cases, the computer calamity can be said to be the decisive factor causing the business to close." Such examples can be contrasted to an F-Prot antivirus software brochure from the early 1990s that uses more neutral language and a down-to-earth approach.

282. Michael W. Miller: "High-Tech Hysteria Grips U.S.; Skylab? No, Michelangelo." *The Wall Street Journal* (Eastern Edition), March 6, 1992. Cf. "Ding! Whrrrrrrrrrrrr. Crash!" *Time*, March 16, 1992. "Virus Barely Causes Sniffle in Computers." *New York Times*, March 7, 1992. See also Alan Solomon: "A Brief History of Viruses." *EICAR Conference Proceedings* 1994, 126.

283. Bernad P. Zajac: "The Michelangelo Virus—Was It a Failure?" *Computer Law & Security Report*, vol. 8, issue 3, 1992. See also the discussions and reports at Risk Forum. <http://catless. ncl.ac.uk/php/risks/search.php>. The virus also made TV news headlines. The virus was discussed

before and after the activation date on the NBC and CBS evening news programs. See <http://tvnews.vanderbilt.edu/>.

284. Massumi 1993, 12.

285. See Murphie & Potts 2003, 186–187, 190–191. See also Bauman 1993, 204–205. See a hacker's point of view on the virus: "Viruses—Facts and Myths." *Computer Underground Digest*, vol. 4, issue 49, October 7, 1992. Cf. "Re: CuD 4.49—Viruses—Facts and Myths (1)", Computer Underground Digest, October 25, 1992, <http://www.soci.niu.edu/~cudigest/>.

286. Ansell-Pearson 1997, 145–147.

287. Deleuze & Guattari 1983, 223–250; 1987, 20. See also Goodchild 1996, 97–98. DeLanda 1998.

288. Tomes 1998, 11.

289. Massumi 1992, 200.

290. Hardt & Negri 2000, 326–327.

291. Parisi 2004a, 144.

292. Massumi 2005.

293. Parisi 2004a, 134.

294. Ibid.

295. Ibid., 140.

296. Ibid.

297. Ibid.

298. DeLanda 1998. See also Herbert Simon's (1969, 84–118) interesting theories of how complex dynamic systems are constituted of hierarchical parts.

299. Helmreich 2000a. The antivirus researchers noted the possibilities in business models based on updating: "When new viruses are discovered, anti-virus software is updated to deal with them on a cycle of weeks or months. Anti-virus vendors generally offer monthly updates, and in a typical corporate environment new updates are installed every one to six months. Because it takes a typical new virus many months, or even a few years, to become widespread, this is reasonable. The recent rise of macroviruses, which can become widespread in just a few months, has put some downward pressure on these time-scales, but not changed their general magnitude. It is still feasible to deal with new viruses through a largely manual process: a customer finding a new virus sends it in to a vendor, the vendor analyses it by hand and returns detection and repair information to the customer, and other customers get the information over the next months, in their regular updates." David Chess: "The Future of Viruses on the Internet." *Virus Bulletin Conference Proceedings* 1997, <http://www.research.ibm.com/antivirus/SciPapers/Chess/Future.html>.

300. See Martin 1994.

301. Harley, Slade, & Gattiker 2001, 129–131. Ludwig 1993, 47. In a more experimental fashion, Mark Ludwig tried to create a polymorphing virus with "genetic memory" that could help it evolve more efficient variations. The Darwinian Genetic Mutation Engine was supposed to experiment and remember the successful variations, which would be passed on to later versions of a normal DOS virus. See Ludwig 1993.

302. Deleuze 1990, 244.

303. See Manovich 2001. Fuller 2003, 2005. See also Chun 2006. Mackenzie 2006.

304. Hardt & Negri 2000, 226.

BODY: BIOPOLITICS OF DIGITAL SYSTEMS

Rigorously speaking, there is never silence. The white noise is always there. If health is defined by silence, health does not exist. Health remains the couple message-noise. Systems work because they do not work. Nonfunctioning remains essential for functioning. And that can be formalized. Given two stations and a channel. They exchange messages. If the relation succeeds, if it is perfect, optimum, and immediate; it disappears as a relation. If it is there, if it exists, that means that it failed. It is only mediation. Relation is nonrelation. And that is what the parasite is. The channel carries the flow, but it cannot disappear as a channel, and it brakes (breaks) the flow, more or less. But perfect, successful, optimum communication no longer includes any mediation. And the canal disappears into immediacy. There would be no spaces of transformation anywhere. There are channels, and thus there must be noise.[1]

—*Michel Serres (1980)*

PROLOGUE: HOW ARE BODIES FORMED?

The previous chapter touched on the notions of security within the digital media culture of the late twentieth century. The purpose of the chapter was to demonstrate not what computer viruses are (in essence) but how they "became" the form of malicious software they are perceived to be. The genealogy of digital worms and viruses led us to the software program projects of the early pioneers in the 1950s and 1960s in Bell Laboratories, MIT, and other research facilities. As computers and networking became more central to national infrastructures and international commerce, viruses and worms were incorporeally transformed into menaces of the information society. They were no longer those innocent and fascinating almost-alive programs but started to represent a danger to society at large. The new security standards of digital culture tried to weed out the experimentality of the hacker mentality that also spawned experimental software such as self-reproducing programs. Of course, virus writing also became a form of vandalism, with no other intent than to cause havoc. Still, we can dig deeper

into the political and economic connections that the discourses and practices of computer diseases exemplify. Although I touched mainly on the issue of the viral logic of the capitalist abstract machine and the assemblage of the viral object, such metastable system qualities could be seen as also characterizing, for example, issues of post-Fordist labor practices, where self-organization, the emphasis on communication and interaction, and free movement of the workforce are key modes of operation.[2] What also was deliberately untouched, but plays a huge role in the discourse concerning computer viruses, is the concept itself: computer *virus* and *worm*. As we know, these are concepts that have become familiar through biology, where, for example, the virus has a history of its own. Deterritorialized from the Latin word for a slimy, repulsive substance, poison but also virility, viruses entered modern medicine and hygiene during the eighteenth and nineteenth centuries as minuscule, submicroscopic, infectious agents. "Virus" was actually at first only used to denote an *X* factor, the unknown cause. As a result of advances in the technologies of microscopes, filtering, and analysis, viruses were gradually identified as parasites of living organisms that themselves occupied a curious twilight zone between life and death with their singular structure of protein cover over nucleic acid (genetic material).[3] Viruses also acted as key objects for twentieth-century biochemistry and genetics research.

Computer viruses are often explained *as if* they were biological viruses. If biological viruses are thought of as submicroscopic actors that can multiply only via living host cells, without a metabolism of their own and consisting of a "pure information" core of DNA or RNA, then digital viruses are often explained from the territory of such an explanation.[4] Computer viruses are, then, seen conceptually as secondary to biological viruses. They are placed in a spatial grid of representation where their characteristics are viewed as metaphorically transported from the discourse of biology.[5]

In addition, the discourse of computer viruses mobilizes a whole field of references to biology and nature. CPUs are referred to as brains; system networks are environments; computers get infected and sick; and these diseases are countered with vaccines. Consequently, as the perception of biological viruses has never been "innocent", outside the power/knowledge relations of society, technological viruses are perceived, valorized, and signified similarly in complex fields of culture. Technological objects are embedded in assemblages of desire, where the technological machines are part of social assemblages—synthetic compositions of heterogeneous flows, symbiotic by nature.[6] Here, the fact that the technology and design of digital culture has "borrowed" from biology (and vice versa) does not fall entirely under the notion of "metaphorics" but can be approached also

as a more fundamental becoming-biological of digital culture. For example, the intensive qualities of software (how it functions, acts, and reacts in relation to other software, operation systems, and protocols) are not reducible to discourses but present materially specific technical affects as well. Using biologically attuned models and modes of analysis (such as ecology) does not have to be seen as succumbing to easy-going metaphorics. Instead, as the early designers of digital culture themselves thought, nature and biology have presented such complex and inspiring ways of seeing objects, couplings, and processes that they are worth deterritorializing to novel uses. This does not mean that technology is biological and evolves naturally. Quite the contrary. Several ideas of complexity and systems are not restricted to specific substances but are worth translating into new uses as long as this work of translation is carried out conscious of the limitations their use might have.

Viruses also touch the theme of the body, but as we know by now, viruses and worms are not restricted to biological bodies: the electrical, silicon bodies of computers and computerized culture have them as well. In addition, these bodies are part of the societal body of the late twentieth century, placing them in an isomorphic relation to the general cultural condition branded by the presence of the viral, as we will see. This chapter focuses on the biological figurations and bodily metamorphoses this phenomenon is embedded in. Computer viruses appeared to the popular consciousness around the same time as AIDS and the HIV. As in the AIDS discourse, the connotations, articulations, and contexts of digital contagions have political implications and consequences, with disease and health acting not just as medical concepts but also as a structuration of the power of digital culture. As "life" and the living body became crucial components of the fields of power and knowledge during the nineteenth century, in a similar vein the digital body and "computer life" became objects of keen societal interest in the latter half of the twentieth century.[7] My point in this chapter is that not only the biological body and the care of the biological self but also the technological body and the care of the technological subject are brought to the fore in the cybernetic society of control: a biopower looking over the life of digital media ecology.

But, first, what is a body? In my argumentation I follow in the footsteps of Gilles Deleuze, Friedrich Nietzsche, and Baruch Spinoza, who argue that a body is not something inherently human. The world is filled with different types of bodies. To quote Deleuze: "What is the body? We do not define it by saying that it is a field of forces, a nutrient medium fought over by a plurality of forces. For, in fact, there is no medium, no field of forces or battle. There is no quantity

of reality, all reality is a quantity of force."[8] For Deleuze and Nietzsche, cultural analysis is "lowered" to the level of forces that make up the bodies that are perceived. In other words, there are no bodies on which forces act, but the bodies are themselves constituted within the acting of forces on each other. Forces as physical and social terms form the world through engagements and synthesis. Such a concentration on the molecular elements of the world, instead of already stratified molar entities, allows one to see culture as continually in process, not obeying any teleological or historical scheme, but constantly tied to constellations (or assemblages) of power and knowledge, as Foucault put it. It is the task of an archaeological analysis to excavate such constellations and show their nonlinear and open-ended nature.[9]

There are different types of bodies and different classifications for bodies. For Deleuze and Spinoza, bodies are defined not by the class or genus they inhabit (chemical, biological, geographical, social, political, technological, etc.) but by the compositions they form with other bodies and the relations of motion and rest. This ethological view of the world suggests that everything forms on a plane of immanence and is thus capable of affecting others on the same plane. Therefore it is quite natural (sic!) that culture is always "impure", as the biological notion of a virus spreading to the technological sphere suggests. Cultural notions and concepts act on a plane of immanence where no thing is separable from its relations with the outside, the world: the naturality of the artificial and the artificiality of the natural.[10] Culture is a constant process of the folding of the inside with the outside, an ongoing structuring, just as Maturana and Varela understood the ontology of autopoietic machines, or Gilbert Simondon the active individuating capabilities of any metastable system, "natural" or "artificial."[11] In ethological cultural analysis, more important than classes and categorizations are capabilities and affordances: what is cultural entity capable of, what are its potentials, and how is it related to other entities?

Of course, such foldings and connections have always been highly regulated. Paths between the insides and outsides of the body are part of the power architectures of a culture, of maintaining cultural hierarchies, based on inscriptions of "health." Naturally, disturbances are consequently understood through images of disease, of dangerous mixings, of leaking bodies, as in sickness or the mystified menstrual cycle of the female sex.[12] The biological body and the body politic are in an intimate isomorphic relationship with each other, revealing how the epidemia "works on the social bond; it may reinforce, transform or undo it."[13]

This theme is genealogically embedded in the intimate relationship the human form has had, first, with the city and, then, with other forms of media

ecology. The imagery of the body politic was tied to a *longue durée* of the social order of the state as a body. The ruler is the head, merchants the stomach, soldiers the executing organs (hands), and peasants the feet. The analogies were used by Greek philosophers such as Plato to question the proper modes of state, to differentiate between a healthy polis and a "feverish" one. In medieval times, the figure of the body politic was used in order-word manner to evoke unity: the world is a hierarchical whole, similar to an organism with its governing head. Whether secular empire or the religious *corpus mysticum et politicum* of the papal Church, order equaled hierarchy, which equaled health of the body. For instance, in John of Salisbury's *Policraticus* (1159) the head is the prince, the heart equals the senate, and the soul is analogous to the clergy. In a similar manner, the body politic analogy worked in matters material, such as the organization of the city. This interfacing of the body and the city acted as a power apparatus for channeling bodies into proper Christians and half-humans, such as Jews.[14]

Later the body politic was appropriated as an integral part of the corpus thinking of modernity, with, for example, the theories of sovereignty and state of early modernity. With Leviathan we have a new formation (yet a continuation of the Christian body politic) where the (standard male) individual body is part of the body politic. Leviathan was no longer, however, the expression of transcendent religious unity, but an artificial body, established through contract.[15] Instead of becoming a dead metaphor, the idea of an organic and unified body was used continuously through a mobilization of health and disease. Referring to the natural state of a body in contrast to disease and sickness proved to be a strong and strategically useful image even after the religious connotations had vanished. In Leviathan, perhaps the figures of sickness, part of the artificial man of the state (*civitas*), are now seen not as metaphysical evils but as dissonances that have to be taken care of, managed, and channeled into health? Sickness of the body politic as a practical problem?

Consequently, it would appear apt to locate the origins of biopower at the beginning of modernity with the connection of the living body of people with the abstract bodies of the state (and cities). The practical task with the image of body politic was to establish unity (and weed out multiplicity, translated as disease). With modern technological media and transnational political networks this situation has further complicated. Whereas early modernity functioned through the city, the state, and the body politic that guaranteed order alongside such lines, the post-state era of networks has been obliged to find alternatives to this form of ordering. Human bodies are no longer the sole issue; also important are the bodies and biopolitics of subhuman molecules (genes, for example) and nonhuman actors

(objects and processes in digital network ecology, such as viruses). This can be also thought of as the move from disciplinary societies to societies of control. Where discipline functioned through the distribution of bodies in space—the biopower of the body politic of cities and states—the control society focuses increasingly on algorithmic codes and passwords and the modulation of cybernetic patterns.[16] What we have with network societies and the third nature of telecommunications is a new mode of digital biopower that focuses on "the massive and dynamic inter-relation of processes and objects, beings and things, patterns and matter"[17] that form the contemporary media ecology.

On a discursive level, the themes are constantly remediated, and the gene-alogy of healthy media ecologies spans from early modernity all the way to the end of the twentieth century. Since the discoveries of William Harvey in the early seventeenth century concerning blood circulation, movement and circula-tion have been general standards also for a healthy body and a flourishing city. As Sennett notes, Harvey's discoveries were soon translated into discourses and designs of public spaces and urban media ecology where free movement equaled health. A healthy body in a healthy society was understood through the paradigm of flow.[18] Hence, the biopolitics of bodies acted through the medium of the city, and even though the focus has slowly moved toward underlining the healthy flow of networks, the patterns are very similar. The age of technical networks as key organizational models can be seen emerging at the end of nineteenth century, and hence the rise of network capitalism dates much further back than the age of computers. As Schivelbusch notes, the new vectors of movement represented by the railroads, steamships, and the telegraph enabled the flood of interfacing media as organisms of flow, where circulation (of people, goods, and information) guaranteed a healthy balance. A commentator from 1895 emphasized the impor-tance of roads, railways, and waterways as "the arteries through which this blood is conducted, while telegraphs and telephones may be compared to the nerves which feel out and determine the course of that circulation, which is a condi-tion of national prosperity."[19] The paradigm of a healthy body is remediated into the age of networks and computing, where obstacles to the flow of information are instances of disease and imbalance that resonate with the early articulations between the biology of blood circulation, rising capitalist economic theories, and city planning. This archaeological trait connects to the previous chapter's analysis of viral capitalism.

The media ecology of cities and human bodies is now supplemented with the global city of networks. This is created and conceptualized as a global body of network flows through the veins of the digital version of a circulatory system.

Recent years have seen a heightened interest in the topic of terrorists moving in the pathways of such global networks both on a macro physical level (the saddening examples of airplanes, for instance) and on the micro levels of digital communication (the Internet). Such complex systems of global scale have made the problem of identification of malicious flows extremely difficult, which has further emphasized the need to find effective control mechanisms to filter the circulatory systems. Whereas in the more or less binary cold war global system the enemy was easily located and spatialized, the multifarious nature of the network society finds its enemies within itself, dispersed, heterogeneously distributed. This expresses the biopolitics of the digital body, where the pathogenic networks are countermeasured with network organization.[20]

My argument here is oriented toward the *formation,* the *emergence* of bodies, the forming of the body digital and the computer (network) as the central diagram or abstract machine of network culture. What types of forces define the borders and thresholds of this digital body? What forms into normality, what into abnormality? What stays inside, what is demarcated outside? How is disease differentiated from health? In other words, what would be a better way to approach health than through the breakdown of this presumed unity? The chapter focuses on such creations of positions within a body politic of digital systems—how the viral is expressed in the figures of users, misusers, and vandals. The issue of viruses highlighted also the ensuing question concerning bodies, openness and closedness, and the figurations used to stabilize the interactions of digital systems.

Bodies are thus always political in the sense that they are "force-arrangements of chemical, biological and social bodies."[21] Bodies are organizations (the question of substance is here bracketed). This implies the very important idea that no particular body is pure; all are made up of heterogeneous parts. In other words, an inspection of a technological or computer body means analyzing a whole congregation of bodies (human, technical, social, natural) that are attached together under this specific force. A parliament of things, of uncanny quasi-objects, as Latour might put it.[22] In this sense, the concept of the body is close to the definition of an assemblage; health is a process and a network, as Andrew Goffey elaborates, referring to Deleuze.[23] Power aims to seal off this processuality and to form hierarchies and stable nodes that connect the flow of lines, yet networks gain their force only from the connections they establish. In this sense, understanding immunities is vital; do we conceptualize the self and immunity as a field of military operations, or do we try to move in the direction of networks as flexible, autonomous systems, as Francisco Varela outlines?

DIAGRAMS OF CONTAGION

Viruses (and this applies equally to biological and digital ones) have been understood since the nineteenth century as (system) anomalies, foreign elements invading otherwise solid bodies. As Joost Van Loon writes: "Viruses make us ill because they are replicating themselves; like waste, they are virulent abjects of modernity."[24] In a similar vein, the novel *The Adolescence of P-1* portrays viruses as something comparable to "communists" and "cancer"—all three symptoms of the anomalous and the point where the biological, the political, and the technological seem to coalesce. First it was the Russians, then the viruses that had to be kept out. "If Simpson had any idea that he had Russians in his computer, he'd scream."[25]

Luca Lampo from the net art group *[epidemiC]* emphasizes the importance of this construction of the anomalous and connects it to a mental history of fear of the other:

> We feel that "The Virus" is the "stranger", the "other", in our machine, a sort of digital sans papier—uncontrollable diversity. Once Hollywood, like Empire, finished killing "Indians" and the "Soviet Russians", the Hollywood propaganda machine had to build other anti-Empire monsters to keep alive the social imaginary of 2001: aliens, meteors, epidemic (…) so many monsters. Now the "virus" equals damage, it is easier to sell the idea of a "full spectrum" anti-virus product that would "kill them all", with no distinctions. Instead, our work says that there are many types of viruses: good, evil, entertaining, boring, elegant, political, furious, beautiful, and very beautiful. "There are no good viruses", anti-virus producers say.[26]

So, the concept of a virus, which (especially since AIDS has come to be understood as caused by a virus) has been a complex mesh of overlapping meanings and pejorative uses, is far from neutral and is often used as a political weapon. But how did biological viruses spread to digital bodies of electricity and silicon? A brief answer would suggest via language—just as HIV spread from being a medical concept to being a general cultural entity. HIV infects cultural categories, and "AIDS is a disease, an industry, a career, a universal signifier that invites us to share a concern over our being in the world, and even invites us to condemn the evil that has brought it into our world."[27] Of course, it was already much before AIDS that diseases and catastrophes spread also as media phenomena. A perfect early example is the 1755 Lisbon earthquake, the first worldwide (at least Europewide) media event that horrified people as a pictorial but also literary catastrophe. For decades it was recounted in numerous pamphlets and letters, such as the letter that was turned into a public media story and reprinted in various countries: "An

Account of the late dreadful earthquake and fire, which destroyed the city of Lisbon, the metropolis of Portugal: In a letter from a merchant resident there, to his friend in England."[28]

Diseases and catastrophes are not merely linguistic representations but more fundamentally *events*.[29] The event of AIDS, the event of a computer virus infection synthesizes into a machinic assemblage and includes various types of flows from incorporeal acts of judgment (You are sick! What did you do to deserve this? Practice safe hex as a digital version of safe sex!) to corporeal movements and interactions of bodies (whether the flesh of humans or the metamorphosis of computer codes). Another way to describe the issue is to talk of the incorporeal act with which the technological machinations, bits of code that self-reproduce are named "viruses",— an event which summons a plethora of cultural and historical meanings and stratifications. As a judge might have the power with an incorporeal act to transform an innocent person into a guilty one,[30] so the media, computer scientists, and security specialists are among the key groups that have "pronounced" the virality of these programs, turning them into malicious menaces to, and diseases of, organized society.

In her essay "Illness As Metaphor" (1978), Susan Sontag demonstrates the power of articulations. Tuberculosis and cancer, to take two central diseases of the last centuries, are perceived and signified not as mere clinical constructs but as more complex machinations. Tuberculosis, along with hysteria, was articulated together with Romantic ideals of feminine subjects, suffering ideal bodies, for whom life was too much. Tuberculosis was an artistic disease, taking over the lungs, the part of the human body most associated with the idealistic ether of creativity. It was also an illness of the poor—"of thin garments, thin bodies, unheated rooms, poor hygiene, inadequate food."[31] In contrast, cancer was something low, degrading, and middle class, usually striking the "lower parts" of the body: colon, bladder, rectum, breast, cervix, prostate, testicles. What Sontag has succeeded in demonstrating is the synthetic, machinic nature of diseases (to transform the issue into Deleuzian vocabulary): diseases are assemblages, heterogeneous articulations of bodily metamorphoses (viruses and bacteria acting on the molecular level), societal reactions (disease control, medications, hospitals, various other institutions, border control), and order-words (seeing language primarily as ordering and commanding, instead of communicating). Diseases are a mobilization, a synthesis of a whole arsenal of cultural institutions, metaphors, articulations, and references.

In "Aids and Its Metaphors" (1989), Sontag addresses computer viruses. Analyzing the rise of "virus culture" during the 1980s, Sontag notes how informa-

tion also seems to have been exposed to viral diseases. Sontag illustrates how these notions are metaphors drawn from virology that "reinforce the sense of omnipresence of AIDS."[32] Computer culture draws from biology, and viral infections in general are increasingly depicted in the language of computers. Both discourses present a malicious actor, the virus, as taking over the host cell or program in order to make more replicas of itself.[33]

The post–World War II years were marked by a relaxation toward issues of microorganisms, with antibiotics in particular as the new wonder cure. This created a certain discursive atmosphere of contagion-free health, prosperity, and confidence about the future, which, of course, was much needed in most countries after the turmoil of the war.[34] In the United States, the surgeon general announced that contagious diseases were a thing of the past and that they represented no severe threat in the future.[35] Yet, since the 1970s and especially the 1980s, we have faced a new threat in the form of viruses (as well as drug-resistant strains of disease) as the key disease of postnational world order (which on a political level gained ground after the end of the 1980s).

Hence, Sontag is right in claiming that the late twentieth century, especially from the 1980s on, transformed itself into a virus culture. "It is a modern plague: the first great pandemic of the second half of the twentieth century. The flat, clinical-sounding name given to the disease by epidemiologists—acquired immune deficiency syndrome—has been shortened to the chilling acronym AIDS",[36] wrote *Scientific American* in 1987. Just as nuclear war was the central fear of the cold war era, so the anonymous face of a virus became the central driver of anxiety in the years just before and especially after the fall of communism and the binary setting of world order. A perfect disease of the network society: a virus. The fear of atomic apocalypse turned into a seemingly post-ideological world of biological danger. This change is accurately evident in Terry Gilliam's remake of Chris Marker's movie *La Jetée* (1962). Whereas Marker's experimental audiovisual essay from the middle of the cold war depicted a world of postnuclear apocalypse, Gilliam's *Twelve Monkeys* (1995) focused on the danger of viral bioterror—a theme that has evolved into a continuously repeated general warning, not least as a result of the fear of international terrorism since 9/11.[37] Yet, as Eugene Thacker argues, such intertwinings of the viral and the network are taken as diagrammatic, where "the diagram provides a cross-section, a transversal (similar to the transverse cross-sections used on frozen cadavers in digital anatomy). Diagrams cut across separate organs and organ systems, they cut across institutions, governments, social classes, technical paradigms, and cultural forms."[38] Diagrams are thus seen in terms of abstract machines, defined earlier, which do not represent

but form the reality, organize and distribute singularities. They are immanently placed on the social field and pilot the concrete social machines. In other terms, diagrams can be seen as the presentation of power (*pouvoir*) in a formation, where forces are taken in their Spinozan manner as capacities to affect and be affected.[39] Here, the concept of diagrams can help us to understand how concrete machinations, such as in medicine or technology or network security, are intertwined on a level of abstract machines, diagrammatically and immanently linked on a social field. Diagrams select elements and assemblages and make them spread and resonate over their original contexts of birth. In other words, even though the virus appeared on the field of society and science at the end of the nineteenth century, it became diagrammatically distributed over the whole of society from the end of the 1950s on.

Viruses were sporadically analyzed as cultural symbols in the 1990s. These earlier analyses addressed their subject mostly as a phenomenon of metaphoricity, in the manner of the "linguistic turn" of cultural theory in the 1980s. For instance, Jeffrey Weinstock writes about the paranoia of contagion in his article "Virus Culture" (1997). According to Weinstock, notions of infection, contagion, and viruses (biological, digital, and metaphorical) have become symptomatic of Western media culture, especially American society. Alongside AIDS discourse, he analyzes computer viruses and the cyberpunk literature genre of the 1980s, which present new constellations of the natural and technological. William Gibson's 1984 best-selling novel *Neuromancer*, in particular, introduced the theme of the virus. Yet, Weinstock argues, the issue of the viral should not be taken at face value; it should be *evaluated* as a functional element of society and politics. Viruses work through the logic of paranoia, the expected infection that creates "an aura of fear." The virus is transformed from microorganisms into an infection on the macroscopic level of society, where the disease is fought via isolation, splintering, and blaming.[40]

Hence, as Weinstock and Sontag argue, virus culture not only is about biological viruses, or even computer viruses, but concerns a whole cultural condition, affecting fictional and factual accounts of inside and outside, of boundaries and crossings—a diagram. In addition to biological bodies, HIV spreads in digital games, computer programs, and media representations. As noted in the previous chapter, virality diagrams media technologies according to its own logic of contagion where viruses are not merely the represented object of media but a description of the how media works. In a more journalistic vein, Douglas Rushkoff's best-seller *Media Virus!* from the mid-1990s introduced the idea of how the media and popular culture in general act virally, transmitting messages that "attach" to

people, invert habits of thought, and reproduce themselves. An example of such a viral media object in Rushkoff's sense could be the AIDS computer game, created by a Japanese software firm at the beginning of the 1990s. The game is an AIDS simulation, from the moment of infection to death.[41] "AIDS" designates not just a certain disease, or immunodeficiency syndrome, but also a strong cultural symbol, adopted in various contexts, deterritorializing and reterritorializing across a range of cultural phenomena, not least owing to the media technological logic of network digitality based on the ease of copying and transmitting information. In a way, the virus incorporates in its logic of reproduction the very basic elements that we find structuring computing and digital culture, that is, reproduction (copy) and transmission (communication).

There is no direct and linear cause–effect pattern from AIDS to computer viruses. The AIDS discourse was not the sole reason viruses became an issue in computer discourse and other cultural platforms. Instead, the phenomenon should be approached as a feedback system where causalities are multidirectional. AIDS sparked the use of viral concepts, but at the same time various events and processes in different cultural contexts, for example, the rise of self-reproductive software or the economic emphasis on global vectors of movement of people, goods, and money, all contributed to the rising concern over the viral qualities of culture. AIDS, however, can be used as a vector that leads us to the operations of this larger abstract machine, functioning over various platforms and scales.

Although the first AIDS cases in the United States date back approximately to the beginning of the 1980s, HIV as a cause of the syndrome was discovered around 1983 and has been discussed widely since 1984.[42] This did not stop the one-sided arguments that it was mostly a problem of homosexuals, drug addicts, and other "marginal elements." *Scientific American* wrote in 1985 how

> (t)he groups at highest risk for infection have become increasingly well defined; they include homosexual and bisexual men, abusers of injected drugs, the sexual partners of people in AIDS risk groups, and children born to mothers at risk. (…) The fact that the disease shows no sign of spreading beyond those groups, except to predictable targets such as women who are artificially inseminated with sperm from infected donors, indicates that the virus is ordinarily transmitted through the blood or through sexual intercourse.[43]

With these types of articulations the virus became a new symbol of terror, spreading through the intimate touch of bodily fluids and blood. It was repeatedly claimed that the virus and the immunodeficiency syndrome were mostly something that homosexuals and drug addicts had to deal with. Anal sex and

needle sharing were the causes for the infection of society.[44] Of course, it was very
hard for the popular media to top the statements by such people as Jesse Helms,
Norman Podhoretz, Pat Buchanan, and, for example, Jerry Falwell, who became
famous for his "analysis" that "AIDS is God's judgment on a society that does not
live by His rules."[45]

The Times speculated in 1985 in the United Kingdom that in the best case
"the AIDS figures will fall significantly when the susceptible pool of promiscuous
homosexuals has been used up through death or mutation of lifestyle."[46] However,
a few years later the emphasis was different. Slowly it was realized that this partic-
ular virus could not be thought of as affecting solely the marginalized groups of
homosexuals, drug addicts, or Haitians (as the cliché was); rather, "the toughest
virus of all"[47] was spreading to society at large:

> In a moral sense any disease that affects some people affects all people. Yet it has been
> possible for mainstream members of industrial societies to feel safely (even smugly)
> distant from the groups that have been the main victims of AIDS: male homosexuals,
> intravenous-drug abusers, Haitians, some black Africans and hemophiliacs. That security
> blanket has been now stripped away. Three major health authorities assert that AIDS is
> everyone's problem.[48]

HIV proves to be an interesting case, as it can be seen as one of the key formal
models of epidemics in nonscalar networks. As the sciences of complexity have
argued in recent years, the question is primarily a mathematical one: homosexuals
merely exhibited a vastly connected subculture where a parasite could easily spread
at an enormous pace owing to the high interconnectedness and intensive sex life
of certain key hubs. As was soon realized, the question was one not of sexual
orientation but of formal models in nonscalar systems. Everything boils down to
a problematics of vectors where a node has enough connecting links for a parasite
to take advantage of the network, whether social or technological. According to
scientists of complexity, all viral phenomena can be described as exhibiting an
uneven topological formation where only a few links connect to a wide array of
other links and consequently act as hubs of a new form of epidemic. As network
theories have during recent years argued, the abstract forms of epidemics from sex
habits and viral vectors of HIV to computer viruses and viral marketing all act
under similar formal patterns of reproduction.[49]

Here, mathematics or biology is not removed from politics. My point with
these examples is to recall the interconnected (and in a broad sense political)
issues inherent in diseases. When Sontag writes that with epidemics of large
proportions demands "are made to subject people to 'tests', to isolate the ill and

those suspected of being ill or of transmitting illness, and to erect barriers against the real or imaginary contamination of foreigners",[50] I read this as illustrating a key cultural historical trait. Efforts to isolate the agents of the disease as well as the affected individuals and groups mean actions on the level of the body politic as well, emphasizing that the issue is not only metamorphic but also isomorphic (or diagrammatic). With articulations concerning divisions between the healthy and the diseased, the boundaries between wished and unwished actions, between promoted and forbidden ways of being are created: cybernetics all over again.[51]

AIDS was not the only level on which this virus culture expressed itself, even though it occupied a central place within the diagram. HIV was merely the perfect objectification of the viral diagram, where several cultural traits of AIDS infection were transported into foreign territories as well. The virus became a vector of change, expressing the novel bodily ontologies of not only biological entities but also technological, media, and cinematic ones. In addition to biological bodies, digital bodies and organs had to be protected. The computer as a (presumably) rational machine offered, at least until the end of the 1980s, a perfect fantasy object for the clean body, as Christine Boyer notes: "The computer seems to be our age's clean, innocent machine, promising a synthetic world born from mathematics in a pure state, not yet tainted by the dark disciplinary devices of our all-too-human making."[52] The clean body of modernization found its imaginary ideal in the computer organism. Just as the body biologic (and hence politic) was, from the end of the nineteenth century, the object of constant attacks by minuscule viruses and bacteria, so the computer soon had its own share of white noise and dirt.

The trope of the disastrous killer virus originates from 1960s fiction. Alistair MacLean's *The Satan Bug* (1962) used the theme of techno-scientific viruses in its plot, and Michael Crichton's novel *The Andromeda Strain* (filmed in 1971) can be seen as one of the key points in the history of virus culture. The successful sci-fi thriller depicted a virus-like substance from outer space arriving on earth with a U.S. army satellite.[53] In the novel, the virus wipes out a small village and demonstrates its lethalness. The story focuses on the constellation of modern science and a form of mapping of the scientific way of thinking. The virus is revealed to be an alien life form and not just an anomaly, thus raising the issue of perspective: even if it is deadly from the human perspective, it can be a symptom of life in a different horizon. The novel also questions the autonomy of the human body: even if one tries to clean out all bacteria, dirt, and waste from the body, still there is no clean and pure core within the body and the self. The human creates dirt from itself and is in constant contact with a "dirty" outside, making us inherently

connected to our surroundings. Dirt and noise become the defining factor of health and borders.

Such articulations were at least partially a consequence of the heightened status of virology from the 1950s. Early twentieth-century virology bore the stamp of conflicting views and definitions, but the field found a consensus after World War II. Hence the 1950s saw the founding of such key journals as *Advances in Virus Research* (1953), *Virology* (1955), *Voprosy Virusologii* (1956), *Acta Virologica* (1957), *Progress in Medical Virology* (1958), and *Perspectives in Virology* (1959), without forgetting the key textbook by Salvador Luria, *General Virology*, from the early 1950s.[54] In addition, Luria, Max Delbrück, and Alfred D. Hershey were awarded the Nobel Prize in 1969 for their work on viruses, which presented these actors not merely as foreign intruders but as similar units to genes. They proposed thinking of viruses, too, as "bits of heredity in search of a chromosome."[55] Soon viruses as a cultural topic were quick to infiltrate other parts of Western media culture.

The assemblage of virus culture has its *phylogenetic lines* deep in the biological understanding of modernization, established during the nineteenth century. Its ontogenetic lines, on the other hand, connect this biological phenomenon to other contexts, linking together various elements. Hence, technological and media viruses appeared approximately at the same time as the killer viruses from space, and in this vein I would consider, for example, David Cronenberg's films cultural symptoms that deal with the virality of late twentieth-century culture, not so far removed from the nineteenth-century germ and membrane theories, but this time in media technological contexts. Where Mark Seltzer in his *Bodies and Machines* provided an inspiring account of the human–technology assemblage of the nineteenth century, and Tim Armstrong highlighted the complex intertwinings of the subject with early twentieth-century modernism in his *Modernism, Technology and the Body: A Cultural History*, Cronenberg presents a powerful cinematic diagram of the body and the machine of the postindustrial media era.[56] The body being punctured, opened, and denied its autonomy is a continuous theme in his work, which, particularly from the 1980s on, resonated with the cultural fear of viruses that cross insides and outsides and puncture the biological body and at the same time the somatic body politic.[57] His earlier work in the 1970s was occupied with strange infectious diseases and mass hysteria that spreads like a virus—underlining how the incorporeal is intimately tied to material vectors of infection. In *Scanners* (1981) thinking becomes a projectile that proceeds via the telephone network in an aggressive manner reminiscent of a malicious computer program.

Yet, with Cronenberg, the viral condition is not privileged as part of distributed networks or computers. Broadcast media, too, can act virally and infect. In *Videodrome* (1983) the male protagonist, Max Renn (James Woods), involves himself in a weird play of S/M fantasies and hallucinations, enacted by a video channel that programs people's brains. The television screen and the signals it emits penetrate the viewer's body. The self becomes an other (*j'est un autre*)—this time not on the couch of a psychoanalyst but on the couch before the television. In a key scene, Renn's stomach opens up to reveal a videotape inserted inside him. Although it would be possible to analyze Cronenberg's film as expressing certain themes of the mental history of technological fear, especially the fear of the impact of television, it can also be seen as part of the virus culture of the 1980s: the (male) self is opened up and his bodily boundaries and sense of identity are truly put into question via this encounter with technological forces of televisual transmission, expressed nicely in the evil Professor O'Blivion's (Jack Creley) McLuhanian line "the television screen is the retina of the mind's eye. Therefore the television screen is part of the physical structure of the brain." The body has been infected with elements outside its (presumed) boundaries, and increasingly these elements are technological and audiovisual. Contagious media. This is part of the viral condition, as Jean Baudrillard has it, that dissolves the ontological borders of the modern boundaries between nature, technology, and Man.[58] Thus, when the body image—animal, male, female, technological, biological, chemical, alien, etc.—is discussed, we also discuss the body political, a more general issue of the abstract body of society. One has to note that cultural theory was in no way an outside observer of the phenomenon. Baudrillard or, for example, Deleuze and Guattari–inspired voices such as that of Rosi Braidotti were keen to use the concept of the virus as a marker of fluidity, becoming, and tactical resistance that tapped into the reservoir of its host, turning it to new contexts and uses. In media tactical terms, the concept was perhaps related to earlier situationist ideas of *détournement*, of using mainstream media products in novel assemblages. This theme is addressed at the end of Chapter 3 in terms of "viral philosophy."

Among filmmakers, Cronenberg was not alone in his viral condition; one can cite the complex bodily infections and transformations in films such as George Romero's *Crazies* (1973), the *Alien* series (first part 1979), *Species*, and *Outbreak* (both 1995), all indexes of a cultural motif that has been repeated in recent years. According to Jerry Aline Flieger, this refrain of viral culture sums up to a symptom of the "fragility of the human self" that is open to the forces of new technologies; the body is punctured with foreign forces, of which the viral is the perfect symbol.[59] The viral invasion marks the point of posthumanism after the figure of the cyborg: the body is not punctured by visible media technologies trespassing

on the human body but by swarming forces of subliminal nature to which the human body is merely a secondary carrier, a host, not the focal point.

Indeed, a whole panorama of 1980s science fiction works illustrate the vulnerability of the body and stable identity in the age of cybernetics. In Greg Bear's *Blood Music* (1985) a genetic research project ends up on the wrong tracks, unleashing an intelligent new life form that threatens to soften the whole globe into a jelly-like substance. These intelligent germs take over the human body, transforming it from the inside out:

> Something is happening inside me. They talk to each other with proteins and nucleic acids, through the fluids, through membranes. They tailor something—viruses, maybe— to carry long messages or personality traits or biologic, Plasmidlike structures. That makes sense. Those are some of the ways I programmed them. Maybe that's what your machine calls infection—all the new information in my blood.[60]

In *Blood Music* the human is transformed into an information entity, a computer-like processing machine, with viruses taking over, invading this "soft machine."[61] Similar themes are played out in Octavia Butler's *Clay's Ark* (1984), where in a manner reminiscent of *The Andromeda Strain* a spaceship imports a viral life form from outer space that acts as an invading parasite for human and animal hosts.[62] In addition, two novels from the beginning of the 1990s deepen the ties between the computer and the body, namely, Pat Cadigan's *Synners* (1991) and Neal Stephenson's *Snow Crash* (1992). Both novels also deal explicitly with computer viruses infecting human bodies through the mediation of cyberspace. In this manner they can be considered key novels of the computerized techno-scape of recent decades, alongside William Gibson's novels, such as *Neuromancer* (1984). As Gibson and cyberpunk problematized the dichotomy of (organic) nature versus (artificial) technology, Cadigan and Stephenson illustrate the same theme with viruses. For them, computer viruses are also biological viruses in that both consist of pure information. A computer virus moving in the cyberspace of digitality is able to infect a human being connected to the machine, which rein-forces the common ground these entities seem to have in a cybernetic culture: the naturality of the artificial and the artificiality of the natural. In *Synners* the virus causes strokes: "If it gets into the system and finds someone hooked in with the interface, it'll get them, too. You got that? A *contagious stroke*, a fucking *virus*, are you with me yet?"[63] In a similar fashion, in *Snow Crash* a "digital metavirus, in binary code, that can infect computers, or hackers, via the optic nerve"[64] causes havoc in a near-future mass-mediated computer society based on the universality of digital network media.

What these narratives present is a central theme of technological culture, that is, the fusion of body and machine, of nature and technology. If we understand science fiction scenarios as "public stages or arenas to negotiate technical innovation and identity politics",[65] then the virus truly seems to be a central cultural trope of the digital world. The virus is exemplified in these novels as the connection between two worlds long presumed to be disconnected. Viruses interface humans, technologies, and natures again. From a cultural historical perspective this, of course, is no surprise: the biological and the technological have always been intertwined.[66] More specifically, humans and machines found a common ground with the computer and systems theory projects of the 1950s and 1960s, well analyzed by N. Katherine Hayles. Digitality and formal information in general became the common language, the Esperanto, of the world, which enabled these cultural articulations of biological and technological systems.[67] Similar to digitality, viruses mediate between various assemblages, biology and technology being the most obvious one. This does not testify to the merging of biology and technology, but to the constant interaction, translation, and significance the fields had throughout the late twentieth century.

We could also talk about the abstract machine of this viral phenomena of the post–World War II era, a diagram that gives consistency to these seemingly disconnected cultural signs. *The Andromeda Strain* articulates themes of the biological virus, part of the germ theory of the nineteenth century, as well as the later HIV discourse of the 1980s; *Videodrome* touches on the idea of media as a virus; *Neuromancer*, *Synners*, and *Snowcrash* invest their cyberpunk energies in the virality of technology, inhabiting humans as protheses and data networks as computer viruses. In this context we must not forget the idea of cultural virality introduced with the discourse of the meme in the 1970s. Originating in Richard Dawkins's *The Selfish Gene* (1976), memes have been understood as "cultural genes" and self-propagating viral ideas that Susan Blackmore explicitly associated with computer viruses. In general, the computer and the Internet are fertile ecosystems for meme groups, as Blackmore argues, even though she emphasizes that the issue is not about technologies but about reproduction:

> All this talk of viruses makes me wonder just why we call some pieces of computer code a virus and others a computer program. Intrinsically, they are both just lines of code, bits of information or instructions. The word is, of course, taken directly by analogy from biological viruses and probably based on the same intuitions about the way these bits of code spread. The answer is not so much to do with the harm they do—indeed some really do very little—but to do with their function. They have none apart from their own replication.[68]

Thus, recent decades have seen a number of cultural strata inhabited by viruses, which underscores the centrality of this vector of trespassing bodies. In memetics, viruses are conceived as informational objects, a translation that problematically forgets their material ontology. Yet, reading the various expressions, it is interesting how various (several of them contradictory) expressions of the viral seem to contribute to a viral diagram of network culture that feeds on the notion of information as a question of immaterial organization. This theme is addressed in the next chapter. Here, in addition to the critique of too metaphorical or too simplified an understanding of the viral question, one can turn to mapping the modes of action the viral expresses. In *A Thousand Plateaus* Deleuze and Guattari write:

> there is no fixed order, and one stratum can serve directly as a substratum for another without the intermediaries one would expect there to be from the standpoint of stages and degrees (for example, microphysical sectors can serve as an immediate substratum for organic phenomena). Or the apparent order can be reversed, with cultural or technical phenomena providing a fertile soil, a good soup, for the development of insects, bacteria, germs, or even particles.[69]

This is an ethological point of view on moving bodies, where what matters are the relational movements and rests: Spinoza in network culture. The idea refers to an ontology of affects where entities are defined not by their species or classes but by the vectors and interactions they are capable of. The entities of the world are "packets of affects", potentials for action and passion in their relative environments.

As noted, one solution would be to understand this viral and bacterial colonization of the technological as a *metaphorization* of culture with viruses; another would be to use the idea of an abstract machine piloting this virality—a diagram as Thacker has it.[70] This notion is further supported by the analyses in the previous chapter, where I discussed the virality of capitalism and the network society. The abstract machine of virality and networks seems to inhabit and construct significant parts of the social, biological, and technological media ecologies of post–World War II culture.

The Order-Word of AIDS

Language and viruses seem to be intimately connected. Steven F. Kruger points out in his *Aids Narratives* how linguistics has a special place as a technique of contextualization: "Viral infection of cells is generally understood in terms of the

linguistic metaphor: as the introduction into a host of parasitic genetic information capable of using the cellular apparatus of transcription and translation to further the expression of its own genome, directing the synthesis of new viral nucleic acids and proteins, and hence new viruses."[71] Viruses represent invaders that try to take over the cellular processes of healthy organisms. This cultural imaginary was in a wonderful way visualized in the educational cartoon series from the 1980s "Il etait une fois la vie" (1986), which represented viruses and other nuisances of humans as mean-looking and evil-spirited hooligans.[72]

But it is not just that viruses are language; it has been proposed that language itself is also a virus. William S. Burroughs originally introduced this idea of the life of language as a proliferating self-copying machine destined to populate the world with pieces of itself. As Burrroughs writes in his characteristic style:

> My general theory since 1971 has been that the Word is literally a virus, and that it has not been recognized as such because it has achieved a state of relatively stable symbiosis with its human host; that is to say, the Word Virus (the Other Half) has established itself so firmly as an accepted part of the human organism that it can now sneer at gangster viruses like smallpox and turn them in to the Pasteur Institute. But the Word clearly bears the single identifying feature of virus: it is an organism with no internal function other than to replicate itself.[73]

With the general "textualization" or "informationalization" of the world during the latter half of the twentieth century, computer science and the sciences of life overlap: everything is regarded as a code. The human body is seen as coded (with DNA), and computer viruses are coded actors of the digital world. Kruger argues that computer *viruses* are not just a case of a metaphor being applied afterward to such programs but that they have from the beginning been designed to imitate biological viruses. Both need hosts, both are parasites by nature, and both aim to self-replicate, "though they depend on the function ('execution') of the 'host' programs they have infected in order to 'replicate.'"[74]

Another way to approach this would similarly take seriously the idea of the world as based on language—but language not as (merely) signifying but as *ordering*. In other words, what does it imply, in the light of Deleuze and Guattari's notion of language as an order-word, that we think of computer code as language? The pragmatics of language emphasize that it does not primarily operate as communication; it does not mediate in the transparent sense. Language has effects on the corporeal world, which makes it occultist by nature. Language enacts, effects, and affects, and does this not merely as a result of its semantic powers, but as an a-signifying machine of order-words.[75]

Language is already tied to its outside, the world, and the power relations operating in and between assemblages. Language is no autonomous entity with internal laws, but a rhizome operating within the world. In this way, all acts of language are acts of power: attempts to draw territories, define borders, impose operations. Order-words are assemblages of enunciation that mobilize and transform bodies and hence create new affects (actions and passions) for them.[76] The description seems to apply especially well to computer code, which exhibits this occult quality of doing what it says in the form of executing sentences. Code expresses immanently the affects it comprises. Of course, this "expression" (or "execution" of commands) is always done in relation to its surroundings, which in technical terms include an operating system. Yet, there is a specifically interesting quality in computer language resulting from its nonsemantic status. It does not "mean"; it functions and enacts changes, subjugating meaning to pragmatics.

Affects are principally capabilities for creating and receiving action—being part of larger assemblages. Of course, we have variations and we have minor linguistic practices that aim to stutter the majoritarian languages. For example, fictions of computer viruses from the 1970s and the 1980s have created novel openings that do not merely territorialize the viral function into a criminal act or a security problem. Fiction can hence act as a deterritorializing machine that triggers becomings, new modes of subjectivity functioning on the molecular level.[77] Here evolutions should be seen as symbiotic processes of cooperation and positive parasitism, instead of the neo-Darwinist ideas of warlike competition for scant resources.[78]

Most articulations of computer viruses work, however, to spatialize the energetics of the phenomenon. This spatial territorialization works as a political machine. As I discussed above, computer viruses became viruses only during the early 1980s, even if similar forms of programs had existed since the 1950s and 1960s. Computer viruses do not seem simply to be consciously modeled on their biological counterparts; the link is more profound. It is as if an abstract machine working diagrammatically makes them resonate. This way we would not have to resort to some conscious (human) actor that has created computer viruses (nor sneezed on computers, as the joke goes).[79] The idea of machinic synthesis expresses how the world is formed of connections of heterogeneous elements that then form functional entities. Abstract machines are the virtual element of concrete assemblages, fully residing in the real singularity of their plane of consistency. As Deleuze and Guattari note, they should not be confused with Platonic ideas, transcendent, universal, and eternal levels of possibility. Instead, they are dynamic levels of virtuality that are always changing according to the actualizations they

bring about. In other words, an abstract machine is immanent to the cultural assemblages it gives birth to; it can be considered an immanent movement from which concrete assemblages emerge. One way to grasp this would be to think of the concept as a tactical one that helps a cultural analyst to grasp how concrete assemblages are connected across a vast social field. Abstract machines distribute local themes on a much wider scale. In Chapter 1, I called the modern need for strict security expressed as notions of inside/outside, rationality, and cleanliness an abstract machine actualizing in several themes of modernization. Similarly, the mixing of biology and technology in the liminal figure of viruses is an expression of the abstract machine of virality of late twentieth-century culture.[80]

But, then, how do the crossings of biological and computer bodies and viruses concretely express themselves? What types of biological concepts does the computer discourse of the 1980s promote? This can be approached as an analysis of *topoi* (sg. *topos*). Topoi are "commonplace motives 'floating' within cultural traditions and simultaneously forming their storehouses of discursive formulas"[81] that can be used consciously in propaganda or persuasion or merely passively remediated in media cultural discourse, as Erkki Huhtamo defines them. The term is taken from the expert on Latin literature Ernst Curtius. Media archaeological topos research focuses on how certain key discursive structures are used recursively in various historical contexts with novel articulations and significatory chains. I am here conjoining the idea of language as pragmatics and order-words (commanding and channeling, not meaning) with the idea of topoi as historically recurring order-words that are used in various media spheres. It is specifically due to their historical recurrence that certain modes of ordering gain cultural plausibility and hence act as (seemingly) convincing modes of argumentation. The articulations work through the spatialization and metaphorization of phenomena to a certain grid of meanings—a specific way in which topoi are used as order-words. A multiplicity inherent in any cultural "object" is stratified according to various, changing modes of order-words, of which allegorization and metaphorization are examples.

McAfee and Haynes offer one such key topos of viruses infecting the "nervous system of the computer":

> A virus may attach itself to other software programs and hide in them. Or it may infiltrate the computer's operating system—the programming that acts as the computer's nervous system. The operating system regulates the flow of information and instructions to the central processing unit (the CPU), which is the equivalent of the brain. All computer operating systems—for example, MS-DOS, PC-DOS, UNIX, and others—are vulnerable, some more than others.[82]

This way of referring to computers as organisms and CPUs as brains stems from the 1950s. Here the computer is seen as directly analogous to a biological organism. Nervous systems are equivalent to operating systems, a peculiar analogy considering that most operating systems are software marketed for a certain price and in other ways connected to the capitalist economy. MS-DOS, PC-DOS, and UNIX represent the healthy backbone of the computer body, vulnerable to outside diseases. However, one has to note, to the credit of McAfee and Haynes, that they do also fight the virus hysteria when claiming that not every virus is harmful and that there are a number of different types of programs that are viral by nature and that can even be "used in positive ways to make software more versatile."[83]

There is, however, a more lurking danger inherent in networks, McAfee and Haynes warn. It is not enough to rule out the obvious dangers, such as malicious hackers, for the new diseases are more cunning than that. Infections are described as "intelligent agents" that are able to fool the user into trusting them: "The same precepts currently associated with the AIDS virus apply to computing—when you insert an unknown diskette or download from a network, you expose yourself to a long chain of potentially infectious contacts."[84]

This presents an interesting perspective on the history of computer crime. As I discussed in the previous chapter, computer security and crime control went through a change during the 1970s and 1980s. Computer security was no longer concentrated on controlling only the physical facilities where machines were actually placed; it had to work on the networks the computers were attached to. Networking itself created new types of threats. Phone phreakers, hackers, and electronic crime such as fraud and embezzlement were on the security agenda long before worms and viruses were judged to be malicious. With hackers (presumably dangerous to network society), the identification seemed to be more or less easy: they were still people, often marginalized as anxious teens that committed such acts. Software programs causing problems was a different case: could one state that the programs were doing the crimes? Or were the programmers responsible, as is usually emphasized? I argue that this difficulty in grasping the worm and virus programs as quasi-actors spurred the use of the AIDS analogy. Even McAfee and Haynes testify to this: "Programs with a will to destroy—an unseen inhuman enemy without motivation—comprise an alien concept that is difficult for those who are not knowledgeable about computer theory to accept as reality."[85]

The computer virus discourse did label and point out certain vectors of risk, malpractices, unethical acts, and suspicious groups that were put on the spot.[86] The so-called Israeli (or Jerusalem) virus of 1987 employed the power of the AIDS

discourse to weed out the reckless from the careful: "'It might do to computers what AIDS has done to sex,' said Bushinsky. 'The current free flow of information will stop. Everyone will be very careful who they come into contact with and with whom they share their information.'"[87] Peter Denning made the connection explicit with his explanation of the link between AIDS and the computer virus. Both are described as a parasitic retrovirus that uses other cells to self-reproduce and incorporate "itself into the genetic material of the cell that it attacks, causing the cell to alter its function; the reproductive processes of the cell spawn new copies of the retrovirus."[88]

In another, overlapping topos the blame was put on the individual. Computers do not have lives of their own; people create viruses, and the problem is thus a human–social phenomenon. This leads to *the user* being under the microscope, with an emphasis on the issues of proper and improper computing. At the same time, the emphasis is on illegitimate uses of software code and criminal ways of computing, and virus writers and hackers are one key *risk group* to be watched. But also the average user, and her ways of connecting to the world of computers and networks, becomes an issue of national and global interest: using pirate programs, connecting to suspicious bulletin board systems, visiting porn sites, and being careless and imprudent in her way of computing are things that put the body of the computer at risk. With the use of the AIDS threat, several, occasionally far-fetched, analogies were mobilized as part of the fight against malicious viruses, worms, and other threats lurking within digital networks. These issues of proper and inappropriate computing as well as different risk groups are analyzed below.

The battle against computer worms and viruses is fought against the whole history of diseases and our cultural perceptions and valorizations of health and sickness. And in this respect, all the viruses that have made direct references to AIDS and HIV and other diseases are perfect material to make people scared. This could be referred to even as a media affect-fear-blur, which is a mode of collective perception and *the capitalized accident form* that does not work on a well-argued rational basis but on the vagueness of the phenomenon, as Massumi notes. This is the low-level fear that saturates the media assemblages of capitalism.[89]

Programs were often directly named with AIDS references. In the early 1980s a virus-like program carried the name Cyberaids, probably the first of its type. Later came several similar cases. Sontag reports that the 1987 Leligh virus was also called PC AIDS, while in France the term *le sida informatique*, information AIDS, was in use early on.[90] The computer "virus" with a reference to AIDS that gained the most popular attention was actually not a virus but a Trojan horse—a

fact that did not stop allusions being made to HIV and computer viruses. The AIDS Information Diskette was mailed to tens of thousands of medical, commercial, and state organizations in Europe, Africa, and the United States, and was supposed to include facts on AIDS. Instead it trashed several computers and included a blackmail demand for 200 pounds to clean the system.[91] Later, the man responsible for this incident, a zoologist called Joseph Popp, was arrested and put into psychiatric care.

So, my point, before going into a deeper and more thorough analysis of bodily issues of digital virality, is that in the several virus incidents that have occurred over the years, especially since the mid-1980s, the HIV and general virus connection has been (at least) twofold. On a linguistic level viruses have been used as political tools, order-words, and topoi that draw far-reaching lines between what is proper computing and what is to banned. At the same time, they are part of an a-signifying field of a socio-technological media ecology, which lives on liminality, self-reproduction, complexity, and distributed networks. In this light Andrew Ross is right when he points out that media commentary has fueled the virus scare and media panic by using the rhetoric of AIDS with moral statements that draw on a general "paranoid style of American political culture."[92] Where I disagree with Ross is over his statement that because computer viruses and worms are human-made, they must be *meaningful*. For Ross these computer programs and the representations they produce tell the narratives of hacker subculture, the history of computer technology, the notion of ethics in computing, the role of media in contemporary society.[93] Of course, I will concentrate on such issues, but I want to make the point that not everything is *human*–social and not everything is reducible to representational analysis. *Meaning* is not the issue crucial to this media ecology of networking. Under, or between, these social representations operate other fields of a-signifying material. The material elements also participate in intensive differentiation and mixed semiotics where these materials (for example, software and the computer environment) are actively part of the politics of digital culture. In addition, software can be understood as an affective modality in that it intensely participates in various constellations from technology to politics.[94] As Latour has stressed, politics is not merely about people and the meanings they exchange. In this sense, Latour's definition of the social as interaction of heterogenesis that connects people, animals, molecules, technologies, economics, and politics is apt.[95] Consequently, the archives of a society are not merely linguistic or representational, but also visual by nature: media as a face machine.

EXCURSUS: FACIALITY

Everything needs to have a face of its own. Faces everywhere: white, black, male, female, young, old, for every identity. Identities everywhere—there is no lack of identity, but an overflow.

As Deleuze and Guattari write in *A Thousand Plateaus*, subjectification works through assigning faces to otherwise anonymous preindividual flows. Faciality is a marker system that places lines on a grid, makes them interact, gives them names and positions in a field of society: an address system. Faciality works as an abstract machine that assigns both the background (the white wall) and the position (the black hole) that are to subsume all the flows passing through a culture.[96] From a societal point of view, you need a face, an address, and a net password to exist. Not restricted to media culture, but powerfully captured as part of its power structures, faces are what capitalism needs, as Philip Goodchild writes:

> Oedipalized representation operates by giving people faces; a person is recorded on the socius and participates in society according to the appearance which he or she is given, and by which he or she is recognized. Capitalist culture is largely concerned with the investment of desire in the production, recording, and consumption of faces. The capitalist subject wishes to produce a face of his or her own, to be recognized and acclaimed; films, television, newspapers, and magazines operate less as 'media' than as machines for the production and recording of faces.[97]

Even though we are dealing here with decidedly very faceless flows of digital codes (subrepresentational, nonspatial, temporal), they are continuously coded to have a face.[98] Viruses, too, have faces. Virus scanners have since the late 1980s tried to identify viruses based, for example, on their code signatures:

```
C:\> VIRSCAN c:
© Copyright IBM Corporation 1989, 1990
Virus Scanner            Version 1.41
Starting virus scan on Sat Apr 07 22:51:45 1990
Scanning system memory for dangerous and/or well hidden resident viruses
Found signature in (C:\PROG\TARKIN.EXE) at offset 12650 (316AH)
8ED0BC000750B8C50050CBFC062E8C0631002E8C0639002E8C063D002E8C0641
008CC0
This file may be infected with the 1813 (Jerusalem) virus.
(Continuing Scan)[99]
```

Although virus code was fundamentally trying to stay invisible by, for example, hiding itself at the beginning or end of "normal" code, viral programs were soon visible on another scale of media. Incorporeal acts of signification assigned them their specific *meaning* as malicious software, marking them a place in the symbolic order of digital culture. Visual media intensified this act. The Morris worm became known through its connection with the face/name system—Robert Morris Jr. Similarly, recent viruses such as the Netsky and Sasser worms have to a large extent been visually perceived events.[100] The programs were written by a German teenager who wanted merely respect and fame; he did end up being a celebrity on a small scale, interviewed in various publications, although his Netsky worm made it to television before he did.[101] Yet it was the teenager Sven J. who gave the face to the algorithmic processes of Netsky and another young man who got his face in *Time* magazine for the Melissa virus—David Smith, "No John Dillinger."[102] To these we should not forget to add the maker of the I Love You virus, identified as the 23-year-old student from Manila Onel de Guzman. One curious example is the female virus writer Gigabyte, who wrote her Sharpei worm with Microsoft's C# programming language apparently to teach a lesson to sexists who think women cannot code. According to the 17-year-old Belgian, virus writers are not merely pimple-faced male teenagers, not merely the faces constantly repeated and circulated in media representations.[103]

The nonvisual nature of the algorithmic worm patterns has been no hindrance in presenting them. The Morris worm was dissected in true scientific style with "microscopes and tweezers" at the MIT laboratories. Yet, for the press, this proved to be a disappointment at first:

> The media was uniformly disappointed that the virus did nothing remotely visual. Several reporters also seemed pained that we were not moments away from World War III, or that there were not large numbers of companies and banks hooked up to "MIT's network" who were going to be really upset when Monday rolled around.[104]

This did not prevent the virus being visualized in symbolic terms, usually in cartoon style. The images often used easily recognizable elements from popular fiction, such as crime stories or science fiction. In addition, the whole Morris worm situation included "cinematic" elements in itself:

> At 4:22 a.m., once upon hearing of the virus going after yet another host in a "new" manner, Rochlis remarked "This really feels like the movie *Aliens*. So where's Sigourney Weaver?" Seeing the virus reach out to infect other machines seemed quite scary and beyond our control.[105]

Such articulations, or topoi, of viral incidents and "digital Godzillas" have been repeated ever since, depicting "killer viruses" that attack the protagonists (usually male heroes) who defend the innocent lay users—who are frequently described in "feminizing" terms referring to rape or other sexualized images of vulnerability.[106] The Morris worm incident became a paradigm that has been followed ever since: with new viruses we have the television talk shows and news reports, the security professionals assessing the threat, and so on. In addition to being a security threat to the Windows operating systems in particular, worms and viruses are increasingly becoming media incidents that spread with the aid of audiovisions and texts. This is, of course, a near-banal statement as the antivirus researchers themselves emphasize: even people who do not use computers are familiar with the concept of the computer virus through Hollywood movies such as *Independence Day* (1995) and *Hackers* (1995).[107] The faceless computing processes animating the expressive machines of the cybernetic era (that is, computers) also have a visual nature, although the microscopes of digital virology were not

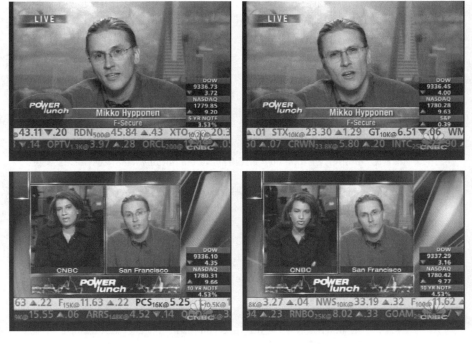

The F-Secure virus hunter Mikko Hyppönen in a CNBC Interview.
Virus researchers also have been made into media figures.
Image source: Mikko Hyppönen press photos <http://mikko.hypponen.com/photos/>.

able to dig into the actual contents of code within the computers, which forced them to adapt other, indirect techniques of visualization.

Faces, so many faces. If we follow Trond Lundemo's line of reasoning, this is due to the inherent nature of the algorithmic accident:

> The separate regimes of manual, electric and cybernetic machines have different ways of breaking down. Their malfunction may be hidden, sudden or gradual. The physical presence and the visibility of the film strip in cinema is contrasted by the invisibility of the digital code. The hidden erasure in the computer must for this reason be represented visually. The many different symptoms of the computer virus are such ways of visualisation, and a field that in itself deserves a comprehensive historiography. "I love you", "California", "Win a Holiday"—in a subject line of an e-mail, these messages are associated with a disaster.[108]

This is how accidentality and its ambiguous nature as chance and necessity are controlled and assigned a societal place. This is a very practical solution to the problem of lines of flight of deterritorializing miniprograms—a way to territorialize them and create an environment (a medium?) where they can be grasped again. Knowledge works through "the combinations of visible and articulable that are unique to each stratum or historical formulation."[109]

Digital Immunology

Faciality is one mode of capture among others. The meaning of the last short excursus was to demonstrate how temporal codes are continuously short-circuited into other media platforms.

In addition, the construction and upkeep of the territory of a healthy, integral body of society has been intimately tied to the medical discourses of each age, especially during modernization (as medicalization). In her innovative analysis of the cultural-medical landscape of the late twentieth-century United States, Emily Martin argues how flexibility and the notion of an adjustable immune system work as central cultural symptoms. Martin analyzes different ideas of the immune system and the body, ranging from the body as a police state and warlike scenarios to a softer version where the bodies of the self are fluid and in constant interaction with the environment. Martin connects these figures to a more general cultural trend of flexibility, an index of advanced capitalism. The new idea of an agile self, capable of responding to the various changes and pressures the environment produces, serves as "an ideal model of being in the world" and a sort of template

"for ideal forms of conducting business or making products."[110] Martin offers a wonderful analysis of the so-called postdiscipline societies of control, which is in resonance with Deleuze's ideas of the phenomenon. Martin sees immune systems thinking as a move from the rigid Fordist system of organization based on constraining and "immobilization of the body" toward a flexible system of differentiation. Yet, such a figuration of "agile, dancing, flexible" bodies is also subject to forms of containment that work more subtly via a temporal and moving modulation, not spatialization and containment. Such bodies of the post-Fordist order "cannot stop moving, they cannot grow stiff and rigid, or they will fall off the 'tightrope' of life and die."[111]

To paraphrase Andrew Goffey, the key ideas of Sir Frank MacFarlane Burnett in the 1940s and 1950s established immunology as the "science of self–nonself discrimination." In the second part of the twentieth century in particular, immunological thinking was occupied with "the nature of biological identity and the mechanisms of organic integrity." This is part of the biopolitical agenda, having to do with "the nature, maintenance and protection of populations: a delegation of the health of the body to a set of autonomous biological mechanisms, an interiorization of a social and political problematic parallel to the interiorization of the social repression of desire traced out by Gilles Deleuze and Felix Guattari in their *Anti-Oedipus*."[112] Such a rigid self–nonself model of immunology can also be understood as a war model based on the aggressive defense of territory. Instead of a network ontology of connectivity and open systems, we have closed interiorities, windowless monads communicating but closed to change. This also reveals how "nature" and "biological truths" are used to stop movement: biological concepts can also be used to highlight a phenomenon as a "matter of fact" that abides by law-like behavior. For example, neoliberal capitalism can be naturalized and biologized as a form of self-organization where we have to trust only that the capitalist system will be self-balancing and self-correcting. In contrast to such uses of biology, my take on media ecologies wants to denaturalize the ecologies of network culture: ecologies are not natural but historical, changing, and also in the future open to variations and further potentials.

I analyzed the risk discourse of the 1980s, and its emphasis on flexibility, tolerance of noise, and insecurity, in the previous chapter on security. Next, I want to further discuss the virus discourse of the 1980s and 1990s and analyze the articulations of "technological public health", "digital disease control", and the figures of immunity that go along with these issues. Of course, one has to note the variety of ways the image of the pristine body of the computer versus the infecting vectors of computer viruses are created. In some cases the notion of public health

and hygiene is the central reference point; in other cases more direct references to AIDS are played out. Some articulations see the split between the healthy body of a computer and the infectious virus as uncrossable; others see the border as more flexible. Whatever the case, immunological references within computing discourses and practices bring forth powerful mechanisms of naturalization that are used to present the borders between healthy and unhealthy processes of computing as fundamental.[113] Naturalization works here as a strategy of stratification, where fluid lines of flight are captured into condensations. Stratification works as a screening from the chaos: by producing repetitive action, habits, and cycles, a territory is formed. Easily, strata might turn to present themselves as transcendent: God, State, Nature, Self.[114] Their assembling of heterogeneous elements is thus forgotten, and they present themselves as solid unities.

The notion of malicious agents of disease and the need to maintain strict borders between inside and outside is a central tenet when discussing computer viruses. This pertains especially to the 1980s, the early years of computer worm and virus outbreaks. Viruses and worms are *by definition* seen as *outside* infiltrators trying to find ways to alter the healthy operations of a system. *Time* reported in 1985 on the threat of malicious software:

> Programs called "worms" are capable of altering a system's fundamental operations or shutting it down entirely. They delete specific portions of a computer's memory, thus creating a hole of missing information. Another type of software demon, called a "virus", instructs the host machine to summon its stored files. Each time the machine does so, the program copies itself onto the software. The computer's memory can soon turn into a mass of confusion.[115]

In a similar vein, the novel *When HARLIE Was One* (1972) fantasized a virus program that strikingly resembled its biological counterpart in that both were unhealthy pieces of vandal renegade code. In the novel, virus programs are described as "renegade genetic information", just like biological viruses of pure DNA. Both infect *normal* cells and *force* them to produce more viruses, as the novel narrates.[116] Just after the publication of the novel, in 1973, the movie *Westworld*, written and directed by Michael Crichton, used a similar idea of a computer disease. A computer-controlled robot entertainment world starts to malfunction and threatens the safety of the human visitors. The extremely complex robot figures are explained as having been built autonomously by other computers, which makes their operational principles too hard to grasp for the human designers. "Getting sick" is the term used to refer to program breakdowns of high-complexity systems.

So why these figures of disease and unhealthy code? The notions can be read against the background of how computer security itself was understood. As discussed in the previous chapter, the generally accepted definition has since the 1980s been that computer security means confidentiality, integrity, and availability. These imply a coherent, integrated, and solid understanding of a computer and a computer system or network. Viruses and worms are seen as malicious code that interrupts the normal functioning of the computer and its sequences, threatening the integrity of the computer body. Concretely, for instance, with boot viruses, this meant intercepting the interrupt processes of the operating system, for example the disk interrupt vector Int 13h. This interrupt call is the one that enables read, write, and format operations on a disk and is among the key calls for older DOS viruses at least. Tapping into this interrupt made it possible to control fundamental processes of a system. As a micropolitical order function, access control mechanisms are designed to keep the intruders (human and technological) outside systems and to stabilize the interrupt processes as predefined.[117]

Figures of a healthy computer body versus an infected one are also stratified with gender allusions. Stefan Helmreich notes how the language of computer virus discourse has sexualized the intrusion of a computer so that open and vulnerable systems at danger are feminine, whereas desirable computer systems are masculine, hard to break, and secure. A desperate e-mail message from the 1980s addressing the hacker incidents the company Digital Equipment Corporation confronted testifies to a view in which computers are part of the *polis* to be guarded. It articulates the gendered and sexual connotations of this digital city:

> We seem totally defenseless against these people. We have repeatedly rebuilt system after system and finally management has told the system support group to ignore the problem. As a good network citizen, I want to make sure someone at network security knows that we are being raped in broad daylight. These people freely walk into our systems and are taking restricted, confidential and proprietary information.[118]

The figure of the city provided a recurring topos. Bryan Kocher, the ACM President in 1989, addressed the need for a "hygiene lesson" taught by the then-recent Morris worm incident:

> Just as in human society, hygiene is critical to preventing the spread of disease in computer systems. Preventing disease requires setting and maintaining high standards of sanitation throughout society, from simple personal precautions (like washing your hands and not letting anyone know your password), to large investments (like water and sewage treatment plants or reliably tested and certified secure systems).[119]

Kocher equates computer security with the concept of hygiene, arguing that the parallels between digital viruses and sexually transmitted diseases "are painfully obvious." Kocher continues that computer diseases are, like biological diseases such as cholera, tied to specific contexts in which they flourish. Consequently, as the quotation above illustrates, hygiene measures are needed to ensure the safety of the polis.

In the same year, James Morris writes of "our global city", with all the positive and negative aspects of a modern metropolis. This exemplifies the idea I proposed at the start of this chapter: the practices and discourses of previous media ecologies, namely the city, are constantly remediated in these novel contexts of network ecology. As in the Middle Ages, the computerized version of the city faces the need for sanitation systems and other solutions to help address the growing side effects. "The global city" needed digital sanitation services:

> Along with the openness, diversity, and size come certain problems. People can bother you with junk mail, hackers can disrupt your computer systems with worms and viruses, people can get at information you would prefer to be private and even broadcast it if they choose. Like a big city, the academic networks are not under anyone's control. They carry any kind of communication without regard to its correctness, tastefulness, or legality.[120]

Morris is not so drastic in his demands for countermeasures, but he emphasizes that one must find the middle path between the total anarchic openness (of the Usenets) and hierarchically controlled data networks. What is also worthy of notice is that all these anxieties concerning junk mail, hackers, viruses, and worms causing trouble for the otherwise functioning highways of information, as they were called in the 1990s, are still prevalent in the publicly debated themes of the digital culture of the early twenty-first century. Junk mail still threatens to jam teleconnections, hackers are still regarded as the outlaws of the networks, and viruses and worms are more than ever those unpredictable miniprograms that threaten the purity and health of home computers, corporate connections, and the whole Internet.

Yet, it is difficult to maintain this sort of imagery of purity in the age of networking and the Internet, where the basic model of computing is connectionism. Computing is increasingly understood as meshworking rather than top-down control as in the mainframe era.[121] This is in tension with certain recurring views of computers as autonomous and healthy objects. As Helmreich notes, "Computers are imagined as pristine, autonomous entities that exist prior to their embedding in networks—an idea that echoes the liberal conception of society as made up of individuals who exist prior to the society of which they are a part, an

*Computer viruses are often ironically sexualized, as in this cartoon from a Finnish antivirus
advice book from 1990. Reproduced by permission from the publisher from
Virus-Tietokone sairastaa (Hyppönen & Turtiainen 1990, 20).*

ideology deeply written into U.S. political culture."[122] This view finds echoes from a neo-Darwinian stance, where individual cultural entities (as with Dawkins's meme theory) are subject to a constant battle for resources.

Bodies are mobilized and delineated with the use of notions of immunity, individual integrity, and the hostile outside. According to Emily Martin, interest in the immune system dates from the early 1970s, even if traces of the trope are found even earlier. Martin refers, for example, to a 1970s TV program *The Immortal* in which a hero is equipped with a special supercharged immune system. A decade later, AIDS as a disease of the immune system was, of course, an obvious spur to discourses on immunity and the border of self and other. Martin notes how the immune system became understood as a maintainer of this boundary, "often accompanied by a conception of the nonself world as foreign and hostile."[123] Dysfunctions of the autoimmune system were consequently described as states of civil war.[124] As Lily E. Kay notes, John von Neumann had spoken in the 1940s in terms of war when he conceptualized systems of self-reproduction. Such automata were fighting for scarce resources, engaging in a competition for *Lebensraum*.[125] Both the biological organism and the computer "body" have in recent decades been wrapped in a discourse of battle, defenders, and combatants.

Gibson's *Neuromancer*'s (1984) world of computing is a paradigmatic example of how the life of computers and the inside of cyberspace were pictured in the 1980s and 1990s. The novel's cyberspace, a sort of three-dimensional Internet, is a constant battlefield for jacked-in hackers, artificial intelligence programs, attack viruses, and defensive countermeasure programs called ICE (intrusion counter-measure electronics). *Neuromancer* is filled with sexualized images of battles and war, both inside and outside cyberspace. "Case triggered his second program. A carefully engineered virus attacked the code fabric screening primary custodial commands for the subbasement that housed the Sense/Net research materials."[126]

Neuromancer gave the digital culture of the 1980s a wide array of effective concepts and metaphors that played an important part in the symbolical design and signification of the new technologies of the personal computer and network society.[127] Viruses were part of this scene. As Paul Saffo notes, John Brunner's *Shockwave Rider* (1975) inspired a bunch of hackers, including the Internet worm programmer Robert T. Morris Jr., but it was the dark neon-lit figures of digital urbanity, speed, and cyberspace of Gibson who attracted a whole generation of wannabe cyberpunks to write viruses and hack systems. Is there a whole new generation of computer kids "learning their code of ethics from Gibson's novels"? was the worried question. Saffo writes: "Unambiguously illegal and harmful acts of computer piracy such as those alleged against David Mitnick (arrested after

a long and aggressive penetration of DEC's computers) would fit right into the *Neuromancer* story line."[128] Interestingly, some software pioneers have also hinted at the connection between early virus-like programs such as Darwin and the cold war security sentiments of the 1950s and 1960s.[129]

In 1988, the Morris worm was described as an attacker and invader that was bringing computers and institutions "to their knees", and the computer scientists at MIT were brave figures of hard-working defensive troops, who with little or no sleep persisted in a continuous battle, "attacking the virus."[130] In another context, the same Internet worm was described in similar terms, presenting the virus as a furious monster breaking in, as in a scene from a monster movie:

> The program kept pounding at Berkeley's electronic doors. Worse, when Lapsley tried to control the break-in attempts, he found that they came faster than he could kill them. And by this point, Berkeley machines being attacked were slowing down as the demonic intruder devoured more and more computer processing time. They were being over-whelmed. Computers started to crash or become catatonic. They would just sit there stalled, accepting no input. And even though the workstations were programmed to start running again automatically after crashing, as soon as they were up and running they were invaded again. The university was under attack by a computer virus.[131]

The topos of war is also used in *Virus! The Secret World of Computer Invaders That Breed and Destroy* (1989). To paraphrase the writer, Allan Lundell, military models have provided the reference points for most computer security systems. For example, password access can be described as analogous to a fence or a wall separating the inside from the outside.[132] This can be interpreted as a remediation of sorts. Of course, what has to be noted is that electronic warfare, the information bomb, is not a mere metaphor but refers to the actual ways war is being transformed with digital computers. War *is* to a large extent about softwar(e), where network technologies have to a great extent been the product of military funding, and hence the programs of network technologies are potential vectors of disruption, interruption, sabotage, and scrambling.[133] Even though I also engage continuously with something that seems to be textual analysis, the overall scheme is materially embodied in asignifying semiotics, where talking about bodies is not to be understood metaphorically. The whole of computer culture and network culture is about building, maintaining, and engaging with bodies of various sorts (from software to hardware, from protocols to operating systems). In a computer security context this means focusing on the questions of how bodies of software are defined, how they are contextualized in systems, how their boundaries are maintained, and how such bodies are transported and filtered.

In practice, digital immunology systems were developed in the early 1990s in various research centers in the United States. Stephanie Forrest (University of New Mexico) was one of the pioneers, alongside Jeffrey Kephart (IBM Thomas J. Watson Research Center, New York). For Forrest, the immunological model and the biologically inspired design were merely natural consequences of "the uncontrolled, dynamic, and open environments in which computers currently operate."[134] This biologization of computer security functioned as a symbiotic coevolution where the increasingly nonhierarchical computer operations and user procedures were followed by similar problems—which in their turn were "controlled" only via subtle and complex models of immune systems.

Nancy Forbes outlines the problematics of such a systematic yet flexible defense mechanism as having to find lasting definitions for the self as separate from the nonself (the white wall and the black holes). Protection systems are filters for intruders that function via detection, prevention, and elimination. Such systems are endowed with a memory, or an archive, for remembering previous attacks or infections and potentially for recognizing new ones.[135] In this version, reminiscent of Nietzschean thematics, memory is life and power works through inscription on the memory of a body.

Forrest's ideas of a digital immune system protecting the "self" of the computer are well summarized in the 1997 article in *Communications of the ACM* entitled "Computer Immunology." It offers a range of definitions and concepts that resonate with the general cultural understanding of the immune system, as analyzed by Martin, for example. For the writers, the immune system works as a layer of protection against "dangerous foreign pathogens, including bacteria, viruses, parasites, and toxins."[136] As in biological organisms, the immune system acts as a form of filter that kills hostile invaders, and in computer networks similar multilayered protection systems could detect and eliminate foreign particles and thus protect the integrity of the system. Hence, the immune system inhabits a certain twilight status between the system and its outside. This is further emphasized by autoimmune diseases (such as AIDS), where this protective membrane turns on the host organism or system. In addition, as Forbes notes, *digital immune system breakdown* has to be accounted for in the same way as lymphocytes attacking an organism's own cells.

Nonetheless, the computer immune system is proposed to be based on the distinction between "self" and "other." In computers, the biological "self" of internal cells and molecules is seen as "short sequences of system calls executed by privileged processes in a network operating system."[137] These processes are the *healthy signature* of the normal computer self, in contrast to the "abnormal

anomalies" of intruders and viruses trying to capture the processes (system interruptions). The individuality of the computer is maintained with a database of normal procedures that a computer can process without the need to suspect an infiltration of unhealthy code.[138] Interestingly, in 1995 IBM produced an "automated immune system" available commercially, indicating that digital safety had become something one could buy. This was in connection with IBM's multimillion-dollar research project that the company claimed "will lead to an automated immune system for computers patterned on biological processes."[139] Of course, on another level one could claim that the aspirations for trusted computing of the Trusted Computing Group, of the biggest corporate hardware and software manufacturers, work in such a direction of immunizing the computer platform against dubious programs but also against user control.

"Immunization" has also been used to refer to certain types of antivirus software and checksum procedures. The latter check for alterations in software before running it. In essence, this procedure also relies on an archival principle of comparing the program at hand with an archived, presumably healthy version and judging by this comparison whether the code is uninfected. This form of immunization, however, produced a huge number of problems in the ordinary execution of programs.[140] Such examples demonstrate well how the issue is far from metaphorical and engages more accurately with the importance of material definitions of digital bodies, their detection, filtering, and channeling: a border control mechanism of network systems, that is.

Lundell's *Virus! The Secret World of Computer Invaders That Breed and Destroy* discusses views of software adaptation, flexibility, and resilience. Vaccinations are explained as "small stresses to the body that prepare it to deal with greater stresses."[141] For computers, system-resident auditing software is proposed as an allegory. But there seem to be also additional parallels in terms such as "antigens", "free radicals", "inflammation", and "fever", as well as "white cells." These are understood by Lundell as "traveling internal checker programs":

> Basically a decentralized defense from within, white blood cells and macrophages travel through our veins and arteries looking for "unauthorized" visitors. In computers, roving "checker programs" could travel paths leading to all important parts of a system, disabling unauthorized or unrecognized programs, peripherals, terminals, and the like. These checker programs could refer to a log of authorized production program changes to determine whether a certain code should be permitted to execute or even whether it should be system-resident. In this way, unauthorized programs hidden within authorized programs (like viruses and Trojan horses) could be detected.[142]

Basically, what Lundell proposes is quite similar to the idea presented in the 1997 *Communications of the ACM* article on computer immunology. Both describe a process of immunity programs that are based on a database, or a log of authorized normal processes allowed to run. Programs without such clearance are to be treated as invaders and stopped. This is password control: instead of physical borders and spaces of confinement controlling movement, we have numerical access points that either grant access to a piece of information or reject it.[143]

In addition, this question of control is tied to archives as databases of authorized processes. In a conceptual way, AIDS is an archival danger—the possibility of erasure of the archives that define what is self and what is other, an erasure of memory. Similarly, erasure of computer memory threatens such distinctions. An erasure of memory would mean a complete program malfunction within the most important control components of a system:

> In our model of the computer immune system, for example, the virulence of a virus can crash its host or hosts very quickly. An attack on the computer's immune system could occur if a white blood cell checker program attacked other checker programs, should its integrity be infiltrated by a virus. The system could also crash should antibody-related destroyer programs attack legitimate processes, or if a control infinitely recursively called itself.[144]

Lundell emphasizes the decentralized nature of this self, although he refers to classical notions of "intruders", "us and them." In general, Lundell proposes a holistic approach to the computer world, in which a single body is always part of a larger whole, "where we in relation to the planet are like viruses in relation to our bodies."[145] This is a parasite ontology of sorts. Lundell's proposition of security and the immune system ordered as flexible, holistic entities resonates with Martin's analysis of the immune discourse in the era of advanced capitalism. Abstract processes (machines) express themselves also in corporeal cultural objects.

However, providing a definite definition of the self remains a theoretical and practical problem. In contrast to the binary warlike models, holistic flexibility proposes a softer form of memory and self: "There are many legitimate changes to self, like new users and new programs, and many paths of intrusion, and the periphery of a networked computer is less clearly defined than the periphery of an individual animal. Firewalls attempt to construct such a periphery, often with limited success."[146] This is basically the same problem that Fred Cohen was already engaged with in the 1980s: how to reconcile the need to restrict the paths of sharing and transitivity flow that are part and parcel of the vectors for spreading viruses with not succumbing to isolationism;[147] how to keep the "body

of the network" open but at the same time restrict unwelcome elements from entering the flows of information. The software problem connects to the abstract scale of network society, where the already mentioned homogeneous cold war system is turned into a heterogeneous state of paranoia, where any singular element could turn out to be hostile (whether we are talking about terrorists or viruses). Concerning the form of organization, these different scales are isomorphic: the immunology of individual human bodies, the protection of social and technological bodies.

The war model of the immune system is not the only truth inherent in the scientific and public discourse of the late twentieth century. As Martin notes, more subtle and flexible notions have also gained ground. Actually, the critique of a too-simple understanding of immunology stems from the work of another early key name in the history of science, Ludwig Fleck, and his book *Entwicklung einer wissenschaftlichen Tatsache: Einführung in die Lehre vom Denkstil und Denkkollektiv* (1935). For Fleck, an investigator of syphilis, the idea of infectious disease was

> based on the notion of the organism as a closed unit and of the hostile causative agents invading it. The causative agent produces a bad effect (*attack*). The organism responds with a reaction (*defense*). This results in a conflict, which is taken to be the essence of disease. The whole of immunology is permeated with such primitive images of war. The idea originated in the myth of disease-causing demons that attack man.[148]

For Fleck, this presupposition of organisms as self-contained and completely autonomous units is inadequate to grasp the complexity of the issue. Organisms are in constant interaction with their environments. With this emphasis, Fleck is close to second-order cybernetics and reflexive systems theory, which underline the interaction of an organism with its surroundings. For these approaches, the defining point of a living system is located not in any specific instance or substance but in the ambient point of connection between an inside and an outside. This is a circular organization of negative feedback that functions to maintain a sensitive balance. The interesting part in their autopoietic theory of systems is its focus on processuality: unities are based on relationships that maintain nodes. Unities exist because of continuous processes of self-reproduction. This implies also a move beyond subject–object relations and toward systems as events and processes. Relations between organisms and their environment are primary.[149] In another register this could also be called Spinozan immunology, based on affects and interactions of bodies on an immanent plane. So, the outside is already folded with the inside:

It is very doubtful whether an invasion in the old sense is possible, involving as it does an interference by completely foreign organisms in natural conditions. A completely foreign organism could find no receptors capable of reaction and thus could not generate a biological process. It is therefore better to speak of a complicated revolution within the complex life unit than of an invasion of it.[150]

Fleck's ideas are interesting as they try to steer away from binary models of self–other toward more complex ideas of systems. This is fruitful also in the analysis of conceptualizations of computer systems: instead of seeing viral code as pure noise, the other of normal computing, it actually meshes with the operations of computer systems as an interesting variation on themes of network computing. This is why accounts of self versus other that are too rigid are unsuitable for any complex system. This has led computer scientists to emphasize that computer immune systems have to be dynamically formed. Even though such systems have been thought to rely on distinguishing self from anomalies, the definition of anomalous behavior has been a difficult task. Databases of normal behavior (measured by allowed system calls) have to be continuously open to redefinition, and no scanning procedure is completely safe. Hence, instead of seeing the computer as clearly defined by its borders (whatever they might be), some computer scientists have pointed to the need for multilayered protection, distributed detection (no one central database and control of anomalies), and open-ended detection of "previously unseen foreign material."[151] This highlights how the border of the computer (as drawn by discourses of the immune system) is not a natural, clear-cut entity but is continuously under construction and negotiation.

As Donna Haraway reminds us, bodies are not transcendently existing autonomous natural entities but are actively created in symbolic, technical, and political fields. The self is not a preexisting identity to which an immune system is assigned; selves are actually created through immune systems. Within discourses of the immune system, bodies and boundaries are drawn with the aid of concepts of the normal and the pathological. The immune system is a program of coding, of territorialization, that actively *assigns* elements to classes of self and other. It territorializes objects on the scale of familiar or foreign, being more an active apparatus of selection than a merely passive surface of recognition.[152]

In immune system discourse this means that those elements represented as foreign to the self of an immune protection layer cannot be totally foreign after all. The immune system uses the same language to identify the elements that approach it; in a way, it "sees" them or "mirrors" them internally.[153] In other words, the outside is constantly *folded* within the inside, an idea that problematizes the

strict separation of inside and outside. This is a model based not on representation but on an active creation of a territory (which is always in a potential state of becoming, of de- and reterritorialization). Territories are formed of couplings with their outsides that are not a qualitatively different domain, but a continuity, a different attribute of the same reality. At times, as we know, the territorial movement turns on itself, as with autoimmune diseases. Instead of self and other being viewed as substances, they should be viewed as processes dependent on each other. The borders of any system are continuously differentiated and metastable, meaning that they are the product of assembly but also continuously open to reassembly.

The question is a rather fundamental one: Who and in what types of networks of power and knowledge defines what is normal functioning of a computer and what is a disease? The genealogy of incorporeal events raises its head again. A temporal perspective on individuation reminds us how crucial it is to step out of the rigid self–nonself model of immunology into a more flexible understanding of connectivity that relies not so much on the Hegelian moves of identity–nonidentity as on a plane of differentiation, of complexification and folding.[154] Interestingly, the security genealogy analyzed in the previous chapter is often based on exactly such an ontology of self and nonself, of presumably stable and clear-cut identities of hostile software and healthy, legal products. In this sense, the formation of security concerns regarding "malicious software" can also be understood through the thematics of digital biopolitics. Of course, as the next chapter shows, there are alternative genealogies within this history of computer organisms, ones that connect to issues of artificial life, for example. The issue is to avoid dualistic accounts and underscore the complex nature of this assemblage or, in general, this media ecology where relations are perhaps endosymbiotic—various types of actors from bacteria to humans and technology constituting "a heterogeneous biosphere of evolution."[155]

Interestingly, such approaches have also been introduced in the computer design context. Terry Winograd and Fernando Flores's *Understanding Computers and Cognition* from the 1980s introduced important new ideas concerning, first, the embodied boundaries of computer systems and, second, postrepresentational approaches to understanding the interactions of such systems. In the wake of Heideggerian notions of technology, they underlined the issue of breakdowns as key technological features. Heidegger argued in *Sein und Zeit* at the end of the 1920s how breakdowns, accidents, provide a fundamental ontological point regarding tools.[156] Winograd and Flores translated this insight to computer systems discourse and design. Breakdowns are interrupted moments of "habitual, standard, comfortable 'being-in-the-world.'"[157] For Heidegger, the hammer presents itself as such only in its state of unreadiness-to-hand, which can be translated as the state

of breaking down. The normal processes of (technological) life are interrupted, and this intermediary presents itself. Of course, computers are not hammers, even though both can, perhaps, be defined not by their object-nature but by the processes and networks they engage in (assemblages, as Deleuze and Guattari would say). Winograd and Flores note how computers are actually networks of equipment that demand the cooperation of various parts from human arms and hands to keyboards, screens, and devices, not forgetting all the internal processes of the machine. Only a breakdown in some relationship in this web reveals the complexity of the machine working under our noses.[158] Computer design could, then, take into account such potentials for accidents and incorporate them affirmatively into systems. This emphasis on computer design in the mid-1980s provided in this light an interesting account where accidents were integrated into computer systems planning, and where computer systems were not mere pristine bodies but interacting and intertwining bodies of a symbiotic kind. This focus on breakdowns leads to an understanding of the interconnected nature of computers as networks and assemblages, where accidents are, always, internal to the functioning of the machine—an ontology of failures constitutes the mode of being-in-the-world.

THE CARE OF THE SELF: RESPONSIBLE COMPUTING

The media ecology of networking has gone through various processes of purification. The discourse of digital immunology has consisted of practices, concepts, and metamorphoses where certain computer operations were defined as normal and healthy and others went through the incorporeal transformation to *pathogens* of the computer world. Viruses and worms are embedded in the same program codes, operating system characteristics, and protocol filters as are the "normal" programs that one is able to buy at stores or download from BBS systems or websites, yet they seem to be curious anomalies. Viruses are most often christened as malicious software, whereas "bots", "crawlers", and "spiders" are considered legitimate background processes.[159] Another good example are port scanners that can be used to map network traffic and scan for potential security holes. Yet, they are also perceived as illegitimate tools for hackers searching for potential entry points to systems. This tension was made visible in Knowbotic Research's Minds of Concern project that allowed the scanning of activists' sites. The project was withdrawn from the New York Museum of Modern Art owing to its twilighting between legitimate (security) use and illegitimate scanning.[160]

Hygiene has also functioned in the digital sphere as a demarcation between health and disease. Computer hygiene has included of a range of practices, demands, advice, and precautions that have been directed at combating the ever-growing problem of "digital cholera", "computer AIDS", or whatever disease reference is used. Protective computer programs were one obvious solution, which has been analyzed above in several contexts. But the notion of the user and her way of interacting with the computer also became an important theme that was put under the microscope. Computer security management included backing-up, distrusting strangers, and a bunch of other procedures that seemed everyday but were part of a general construction of a safe user. "The best defense against this contemporary threat is user awareness and safe computing habits",[161] and "[w]e must all help in keeping each other 'virus free.'"[162]

Personal computers were only on their way to conquering the offices and homes of the Western world during the 1980s. The whole idea of using computers in everyday life was new. Whereas earlier computer use had been the privilege of a few people in universities, banks, insurance companies, and so forth, now they were marketed as essential tools for everyone, from children to adults. Earlier the television had received similar attention, and the entrance of the TV into living rooms was also buffered with careful advice on how the viewer should behave.

One central term used was "computer literacy", a concept applied in various ways. The idea was that computing was revolutionizing not just the basics of work but also the very symbolic structure of society. "Knowledge work" with computers represented a new form of labor that did not simply follow earlier forms of production. Knowledge workers did not represent a uniform class, nor did work with computers have to be bound by nationality. Instead, "the language" of computers enabled new forms of productive action that were not "work" according to the old standards of the industrial era but yet represented the core of the knowledge economy and its thrust toward communication, cultural and social knowledge, and what has been referred to as, for example, "immaterial labor."[163]

Just as the earlier national movements for literacy aimed to make the whole population into responsible citizens through the use of literature, something that Kittler analyzed in his *Discourse Networks 1800/1900*,[164] so computer literacy was proposed to be the next step in civilizing oneself to become a proper citizen of the coming digital culture. Computers were becoming essential to society:

> What then is computer literacy? It is not learning to manipulate a word processor, a spread-sheet or a modern user interface; those are paper-and-pencil skills. Computer literacy is not even learning to program. That can always be learned, in ways no more uplifting than

learning grammar instead of writing. Computer literacy is a contact with the activity of computing deep enough to make the computational equivalent of reading and writing fluent and enjoyable. As in all the arts, a romance with the material must be well under way. If we value the lifelong learning of arts and letters as a springboard for personal and societal growth, should any less effort be spent to make computing a part of our lives?[165]

In Britain, the BBC sponsored a Computer Literacy Project with a television program encouraging people to engage with computers. Similar projects spread during the 1980s in other European countries as well.[166]

Computer education was intimately tied to a perception of the new dangers of network society. As users were taught proper computing, the issue of the improper or even illegal use of computers came also to the fore. Earlier computer cultures (that is, the culture of mainframes during the 1950s–1970s) were hierarchical in the sense that only a few assigned people had access to computing facilities, but the culture of personal computing changed this. Computing became dehierarchized, noncentralized, and distributed, something that one could do on one's own without any mediating authorities: the dream of interactive computing. This, of course, was the main reason the counterculture became interested in personal computing: no more passive operators of mainframes but active users of personalized production machines.[167] In the heydays of the 1980s, everyone was supposed to become an individual media producer armed with her own personal computer. One has only to recollect Timothy Leary's enthusiastic accounts of computers as instances of personal freedom. In 1984 Leary wrote how the "intoxicating power of interactive software is that it eliminates dependence on the enormous bureaucracy of knowledge professionals that flourished in the industrial age."[168] However peculiar Leary's public image might have been, his statements were in many ways in sync with the general utopia of digital culture.

The new freedom was accompanied by a new *responsibility* the user was expected to practice. For example, in business contexts, individuals were held responsible and accountable for all of their actions, a message that was to "be conveyed to staff, associates, partners, agents, suppliers, and collaborators."[169] To paraphrase a commentator from 1986, even if computer data were much less sensitive to disclosure, they were more sensitive to being modified. The new media technologies of digitality demanded a new form of attention in the business environment:

> So it is important that management spell out for the users what all of its expectations are. It is important that those expectations include the responsibility on the part of all the users *to report to management anything strange that they may observe in the expected behavior, use, or content of the system.* Any variances from those expectations should be reported.[170]

The individual was subjected to a wide range of guides and demands that were to make her into a proper user of the computer, a responsible citizen (later *netizen*) of the prospering digital culture. The consuming individual became important to maintaining the flows of capital. Computers and the flow of information were no longer restricted to big organizations with their centralized computing facilities but became an issue of the individual user and the household. The new responsibility of the user was expressed in an advertisement in *Byte* magazine's January 1985 issue. The picture shows an anonymous person, a female, in front of a computer monitor. Her eyes are framed out of the picture, and the text says, "She's temporary. The damage is permanent", hinting that users are the ones making mistakes, not technology. "It can happen to you—because a leading cause of data loss is human error. If you employ people and computers, you're vulnerable." The human being is the weak link in the human–computer symbiosis planned already by Joseph Licklider in 1960. He noted the same thing: even if the nerve channels of human beings have many parallel levels, basically we humans are "noisy, narrow-band devices" who are a lot slower and less accurate than computing machineries.[171] Humans were not to be trusted in a culture of digitality, which was "becoming increasingly dependent on the accurate and timely distribution of information."[172]

A similar point is made in an earlier advertisement from *Scientific American* in 1981. This refers to computer crimes, picturing a police line-up with three middle-aged formally dressed men (clearly referring to businesspersons) and an IBM computer. The text says, "The computer didn't do it", which, again, puts the blame on the weakness of the human being. The advert promises that IBM continues its search for new safeguards and security measures, while outlining the whole theme of risk society: "True, there's probably no such thing as total security. But with proper precautions computers can be more than just safe places to keep information. They may well be the safest."

These are 1980s examples of a "care of the self" that has acted as a key technique of subjectification in Western cultural history. For Michel Foucault, this notion means the techniques with which the individual made herself into a true subject via self-observation. Care for the self thus refers to a range of norms, practices, regulations, and recommendations through which the subject made herself a genuine subject. It can be understood as placing oneself in relation to oneself, meaning a range of actions and thoughts through which one regulates one's being.[173] In early modern secularizing Europe, health became one of the key responsibilities of the individual body, where simultaneously this paradigm of the self was turned into an issue of society: a healthy body equals a healthy society in the biopower thought of the seventeenth century, as Richard Sennett notes.[174]

"She's temporary. The damage is permanent." Byte, January 1985.
Used with permission, © Byte. Courtesy CMP Technology.

"The computer didn't do it." Scientific American, September 1981.
Used with permission, © IBM Corporate Archives.

Concretely, the idea that germs cause disease (an idea we owe to Louis Pasteur and Robert Koch, among others) was by 1900 turned into a whole arsenal of techniques of hygiene and disease prevention through individual and collective responsibility. As the historian Nancy Tomes notes, the "golden era" of the American public health movement introduced such practices as municipal sewerage systems, water purification, garbage collection, and food inspection. Similarly, the campaigns taught the individual body that "microscopic living particles were the agents of contagion, that sick bodies shed germs into the environment, and that disease spread by seemingly innocuous behaviors such as coughing, sneezing and spitting, sharing common drinking cups, or failing to wash hands",[175] which were all to be battled with techniques of hygiene and purity (or civilization, as Freud translated it). Of course, whereas the early bacterial anxiety was very much concerned with the home (and hence the female as the key person responsible for the household), the digital bug anxiety was targeted on the home computer and the virtual tele-environment of communications it was entangled with.

Such procedures of caring power merged intimately with the idea of government and governmentality, which valued the actions and meanings of bodies as being of central interest to the state. Human beings were to be assigned into assemblies of practical rationalities and functionalities that were useful from the point of view of the state. These technologies of the self or "self-steering mechanisms" were powerful tools in enforcing certain ways of life—public and private—to control the mass of society. They can also be understood as intellectual techniques, comprising acts of reading, memory, writing, and numeracy, none of which is an expression of an inherent human capability but instead an end result of a long and meticulous process of rehearsal and pedagogical attention.[176] This is a molding of the body-matter, of life.

So, when a professional in computer science and computer crime lists in 1991 that computer security includes "[i]ncreased awareness and motivation training for new computer users and for the population of future computer users, teaching them to be cautious, for example, to avoid putting untrusted software into their computers as they would avoid putting tainted food into their bodies",[177] this conjures up a process of building proper subjects, subjectification (*assujetissement*), a key component of societal life in general. Who would want to distribute digital diseases that originate from dubious sources and in the process become labeled as a virus distributor, a vector of infection: "Just like with biological viruses, subject behavior has a significant effect on the probability of infection. By altering the habits of users and examining how most virus infections occur, it is possible to

educate staff on the risk which their different actions carry, and thus minimise the risk of virus infection."[178]

Similar advice was plentiful, given out in antivirus guidebooks, popular news articles, and scientific accounts of computing. The whole of digital culture and computer usage was a paradoxical intertwining of the utmost optimism of a digital networked future in a postindustrial world of leisure and self-improvement and fear and anxiety of surveillance, computer accidents, and malicious use. The idea was to *educate* users into understanding that "if you do not follow the rules, the promised future will not come." In other words, perhaps fear and anxiety were functional within this atmosphere of digital optimism. For what was essential was that a range of countermeasures were on offer to fight the dark side of digitality. The user was not left on her own, even if it was constantly emphasized by authorities and experts in computing that a user should know what her actions led to. The issue was discussed at the end of the 1970s in the context of computing in insecure networks, where every user was presumed to be responsible for her own security, achieved through her own actions and care.[179] This was managed through techniques of soft power—power through attraction rather than coercion, an elemental way that control works in contemporary network societies.[180] For example, "health" and "security" were such vague attractors that provided much of the wanted effects and acted as efficient order-words. In general, such discursive actions were entwined with the assembling of the Western information society from the early 1980s on.

So there is an interesting paradox in the computer (security) discourse of the 1980s. Personal computers were supposed to be "about freedom and simplicity, not bureaucracy" as mainframes with their access controls, passwords, and authorizations were.[181] Yet, security and hierarchies were simultaneously touted as indispensable safeguards. On the one hand, we have all those voices that embrace the new liberties of nonhierarchical computing; on the other hand, these articulations emphasize the need to "be clean", to keep a constant eye on the behavior of the system. In other words, there is a paranoid machine operating at the heart of the liberal discourse that demands that users fulfill their responsibilities as key nodes in the digital networked economy and prescribes constant self-control and self-supervision to ensure the functioning of the system.[182] To be accurate, the paranoid machine is not an Orwellian big brother of surveillance from above; it functions as a sensitive piloting, controlling, and guiding of desire on the level of psyche. This is basically how subjectification works in the age of cybernetic machines of control: through soft power of attraction and self-improvement.

On a popular level, aimed at home users directly, *Byte* advised them in 1988 to "be secure, not sorry." According to the story, there are three types of people causing trouble with computers: those who are intent on harming other people, those who are careless, and those who have not been trained properly. Although accidents and system failures are an obvious cause of computer problems, it is fundamentally the user who is at the center of this problem.[183] Contributing to the discourse of the responsible user, another *Byte* story instructed the user to keep her PC healthy.[184] Even though the focus was on such physical threats as dust, excessive heat and cold, and power-line surges and spikes, the overall rhetoric of the story emphasized the computer as something that the user is in an intimate relationship with and that needs constant maintenance and care to function properly. It is as if the personal computer, where the emphasis is on the word *personal*, was something almost part of our living bodies, needing constant attention.[185]

Software, too, requires care. Jerry Pournelle advised in *Byte* in 1988 that users should keep an eye on where they get their computer programs, hinting that there is no such thing as free software: "If you don't put strange programs in your system, you can't get strange results. That 'free' copy of a program you got from a bulletin board may be more costly than you think. You're not even safe getting pirated software from a friend; even if there have been no signs of infection, some virus programs don't wake up for a long time."[186] These are classic warnings where unsuspecting users are cautioned of the dangers of reckless network use. Bulletin board systems, the first incarnations of the network society to come, were seen in a similar light to websites in the 1990s as potential sources of virus infection. Guidebooks listed ABCs for avoiding viruses and conducting "safe hex." "Do not copy programs", "do not bring program disks from home to work", "do not boot your computer from an unknown disk", "check all disks before using them", "check all downloaded software before using it"—these and a range of similar recommendations were used to guide the user to proper PC habits.[187] The best way was to identify the potential infiltrator *before* it crept into your computer and, if this failed, at least identify the infector before it activated its routines. After possible infections, users were often advised to *quarantine* potentially infected systems and avoid contact via networks, disk sharing, and e-mail to other systems and users.[188]

After the Israeli/Jerusalem virus incident of 1988, experts raised the issue of *decency in computing*, which was presented as analogous to sexual decency: "The computer community is grateful for stopping the process of unauthorized copying of software that reached incredible use lately. Exactly like AIDS, that generated the safe sex phenomenon, the computerized virus is about to generate

the phenomenon of decent use only of software."[189] Such order-words were addressed to the general public, yet they worked within the computer scientist and antivirus community as well. The mission of the *Virus Bulletin* journal, for instance, was to provide the user with safety tips and information on viruses.[190] In the Virus Bulletin conference of 1992, user education was underscored. Three main principles were given: (1) do not take chances; (2) if you pass on software or data, make sure it is not infected; (3) if you receive some software or data, protect yourself by checking it.[191] Even if no reference to biological sexual diseases was intended, the constant discussion of AIDS, HIV, safe sex, and personal responsibilities in intimate contacts was implicitly present. A management overview from the same year (1992) recognizes similar problems and brings the issues of education and risk management to the fore. What are introduced are "hygiene rules" for computers. Free software and shareware programs downloaded with modems from bulletin boards are labeled as high-risk software. Hygiene is implied to be the same thing as computer products *bought* from the market.[192]

Viruses and worms draw the line between healthy capitalist consumer products and clandestine software programs distributed as shareware or even freeware. The idea goes something like this: products that go through quality assurance procedures acquire in the process extra costs that are transferred to the consumer. Thus, the product might be similar to one that is available for free or for a small price, but buying one from "a reputable manufacturer" guarantees the product's cleanliness. In other words, cleanliness and hygiene are what the consumer pays for! This demonstrates how consumer products succeed in their role as "anxiety relievers." Capitalism involves a myriad machines producing fear complemented and reinforced by machines producing consumer products. The desire to consume as a way to fight fear and anxiety is at the very heart of digital culture and, in our case, the discourse of such digital contagions as worms and viruses.

In addition, such tools as backups, PC audits, regular checks for viruses, personal responsibility for reporting viruses, avoiding ignorance and arrogance, and increased security awareness in general are mentioned as steps toward a safer computing culture in corporate systems. What catches my eye is the need to control not only the physical actions of users but also their attitudes toward viruses and security. "People are the biggest problem" was the constant theme of computer security from the time lay users started mingling with computers— "The computer didn't do it" syndrome mentioned above. It was also acknowledged that computer viruses are similar to biological viruses (especially venereally transmitted ones), at least in one respect. Both cause shame and embarrassment: "An individual who suspects from the behavior of his PC that a virus is present

may well have a guilty conscience. If so, he or she may try to clean up that PC before anyone else notices, and may fail to tell anyone that other PCs could be infected."[193] As most viruses were thought to spread through using or copying pirated software or otherwise illegal software (porn files, for example), an infection would imply these illegal or at least embarrassing actions had taken place. Years later, in 2001, similar ideas were used in emphasizing the ambiguous status of computer viruses as invasions of intimacy: "Even when the virus involved is not particularly dangerous and can be removed easily, victims still feel a sense of invasion and discomfort at having been attacked by an unknown assailant. 'I wish I could get my hands on that guy who did this to me,' is a common cry. This fact is important: even viruses which do nothing more than spread are seen as dangerous and intrusive."[194]

The gendered sexual connotations of such articulations were addressed above, but this was also referred to as the "itch syndrome." People with diseases have been stigmatized throughout Western history, and computer users with diseases received similar responses. As the modern presupposition goes, individuals are responsible for their own bodies and thus for their own diseases, making diseased people victims only of their own being. Often, people with AIDS or cancer are blamed for being sick just because of their own weakness, low self-esteem, or whatever self-inflicted reason. Cancer, more specifically, has been articulated as a disease of the repressed (a disease of the middle classes), who do not seem to find a proper way to express their inner feelings and drives.[195] As Sontag notes, before the nineteenth century disease was often seen as a dire consequence of bad behavior and lack of morals, but the modern view of medicine changed this. However, the focus on the individual intensified. Disease was no longer punishment but a form of self-expression, a symptom of repressed character: "Passion moves inward, striking and blighting the deepest cellular recesses."[196]

The itch syndrome was at first especially prevalent in the business environment. Going public about computer problems might have bad consequences for the public image and reliability of any business. Viruses, or other forms of computer problem, were seen primarily as embarrassing.[197] This "veil of secrecy" multiplied the growing problem: few wanted to go public with their computer virus problems. This, in general, represented one of the biggest problems in computer security research: when a large proportion of the virus outbreaks in computers go unnoticed and unreported, how can we track such incidents down? As Sarah Gordon noted in 1994, the "it's not me" syndrome resulted in a failure to report virus and worm incidents and other problems with software. The virus, as a sign of disease, was stigmatizing.[198]

Of course, some antivirus researchers were anxious that people would not regard viruses as filthy diseases:

> Users will get a lot more relaxed about viruses. We've long since passed the stage where a virus is regarded as a loathsome disease, to be kept secret. But we're increasingly seeing people who regard a virus on their system with about the same degree of casualness as a bit of fluff on their jacket. Sure, they'll wipe it off, but there's no real need to worry about it happening again. This is perhaps a bit too relaxed attitude, but what can you expect if a user keeps on getting hit by viruses, and nothing terrible ever seems to result.[199]

Such articulations demonstrate how "computer hygiene" as a media ecological theme involves not only technical instructions, innocent recommendations for users, or even allegories of biology but a whole assemblage of corporeal and incorporeal countermeasures connected to power/knowledge relationships in society. Security policies and risk assessments are part and parcel of this ongoing process of defining the approved uses of computers. The similarities of computer virus warnings to messages from the U.S. surgeon general are striking: "Practice digital hygiene yourself. Don't exchange programs with anyone whose computer habits are not up to your own standards. Refuse to use software if the manufacturer's seal has been broken!"[200] Hence, the calls for "Centers for Computer Disease Control" were not far-fetched, and the need for such an organization was discussed during 1988.[201]

Destructive and unlicensed software has been consistently defined and outlined as an "undesirable" risk—a category often including games and pornography, too. Hence, risk reduction security policies were introduced at the end of the 1980s to keep the users of digital culture on the right track. Often written in the form of a checklist,[202] these instructions were aimed at "domesticating" users into the digital capitalist order of commercial computing. This was accentuated in the 1990s with the discourse of information highways, which associated the connections of the new digital culture with the older road networks of previous industrial culture.[203] In the culture of automobile transportation, driving conduct was an essential part of the functioning of the system. No drunk driving, no speeding, no irresponsible behavior as these might result in casualties and risking of the whole network. Information highways were controlled with restrictions, recommendations, norms, and other forms of order-words that channeled behavior. But who were the bandits, the drunk drivers, and the irresponsible vandals of these nascent digital networks?

THE BODY OF THE VIRUS WRITER: IRRESPONSIBLE VANDALISM

I end this chapter by analyzing the other side of these hygiene measures of digital culture. This is part of the ongoing double articulation within the media ecology of networking: outlining black holes on white walls. During the 1980s and early 1990s, a special focus was placed on the importance of the individual user as a node in the flow of information. I have analyzed how this linked with digital capitalism and the utopia of connectivity. But in addition to the legitimate users, the other side, the malicious outlaws who created viruses and showed disrespect for the common values of digital utopia, were under the microscope. Here I want to show how the writers and distributors of viruses were stratified as part of a field of digital security that ranged from psychological categorizations to pejorative references to international cold war politics.

This individual categorization proves to be another recurring *topos* in the media archaeological sense. The late nineteenth-century media technologies were described as neutral, and the people using them were seen to make the difference. Take wireless in the United States, for example. You had the robber barons who were seen as corrupt men taking advantage of technology for their own ends, but you also had the inventor heroes, the romantic self-made men such as Samuel Morse, Thomas Edison, and Alexander Graham Bell, who took technology into good hands.[204] The same scenario was repeated with computer technologies: computers and software were frequently seen as neutral, whereas it was the people inventing, applying, and using the media that blew life into the machines.

The problem with psychological accounts has been their highly reductionist nature in their focus on the individual, atomistic aspects of culture. Of course, this is part and parcel of how power functions in Western societies. Modern power individualizes and turns cultural assemblages into the language of the individual, as with crime. As Foucault suggested, crime was transformed during the nineteenth century into an expression of the state of mind of the criminal, implying the need to cure the criminal of his or her deviant, sick psychical state and lead him or her back into the approved practices of culture. In accordance with this, the twentieth century became increasingly obsessed with methods and practices of confession and inspection, which presumed a primary layer of truth behind the appearance (of a madman, of a psychically sick person, of a criminal, of a sexual "pervert", and so on). The confessional mechanism had its origins, according to Foucault, in the Middle Ages, but the juridico-medical apparatuses of power and knowledge of the twentieth century took full advantage of it. The confessions

and truths were disconnected from the religious themes of sin, redemption, and universal truth and localized to a more secular plane of controlling the body, the psyche, and life. Processes of medicalization attracted these methods of cultural hermeneutics, which are not to be confused with or restricted to the project of philosophical hermeneutics, to concrete practices where the truths were used to mould bodies, identities, and collectivities.[205]

The psychologization of culture assumes the self-identical individual, the indivisible, to be the atomic basic unit of society. Society is implicitly taken to be made up of a conglomeration of these individuals, some naturally healthy, others gone wrong and in need of correction. This view is strongly normative, assuming beforehand that there are such natural units as individuals divisible into mental classes, ranging from healthy, rational, autonomic, and social to addicted, irrational, and nonsocial. This notion blocks us from seeing the constructed nature of these assemblages. It prevents us from seeing the heterogeneous parts of which such natural-seeming entities as individual actors are made. Culture is not about the interaction of individual, self-enclosed actors; it consists of a wide range of different types of flows, which are synthesized in the process of machinic production. This is also an ecological perspective on cultural analysis.

Virus writers and malicious hackers were, then, also translated into psychological categories, states of mind (gone awry). Instead of seeing these as representations of hackers and virus writers, I analyze these imagings as *orderings* that connect to the issues of fear production analyzed in the previous chapter. As noted above, viruses were perceived, valorized, and signified in various technocapitalist-media assemblages, which reduced their multiplicity to that of malicious software. Similarly, the wide subculture of hacking (and virus writing) has been reduced and stabilized as part of a general category of "vandalism." The issue has been objectified via the media assemblage in particular, with its production of images of the actors of digital culture.[206] We can analyze this again as the working of the abstract machine of facialization. The professional antivirus and security industry was also eager to amplify such articulations:

Every virus writer that I have met has admitted to the *cowardly* and *craven* nature of their activities. It somehow reflects upon all of us that *human nature can sink so low* as to transfer some of its own baser instincts for destruction into an environment which is arguably the most thrilling development since the invention of the wheel. (...) The dedicated virus writer may therefore become *obsessive* and shun any other activities which may take him away from his obsession. This lack of social interaction makes them withdrawn and uncommunicative as well as leading to a general tendency to *social inadequacy.*[207]

Thus, it seems that the descriptions of disease within the body of the computer are extended to the *people* related to underground programming subcultures and practices—as either coders or distributors. The disease of the computer is seen as emanating from a (mentally) sick person. As socio-technical phenomena, computer viruses are articulated as an effect of a more fundamental level of psychology, where, as computer security professionals write, "the history of computer virus programs is a small part of the history of people's attempts to do undesirable things with computers"[208]

Or, as in another case, virus writers are seen as men who cannot find anything more interesting to do and who do not even seem to enjoy girls[209]—a pejorative allusion to virus writers as men-oriented perverts! The viral as the queer machine? Yet again such minor articulations are part of constructing the normal, straight digital culture through linguistic acts, incorporeal events. This, in general, is an interesting phenomenon. The example above is not the only text in which these pejorative allusions are made. On the contrary, this machinery of "Oedipalizing the hacker" or virus writer has been a constant theme throughout the spreading of the personal computer in the United States and other Western societies in the 1980s and since. The various hacker incidents of the 1980s, the *War Games* movie of 1982, and the Morris worm of 1988 helped such articulations to be amplified and to gain credit.[210]

The Leligh virus of 1987 was described as having been developed by "someone with 'a very, very sick mind.'"[211] *The Computer Virus Crisis* book (1989) calls these people psychotic vandals and terrorists, while also acknowledging that one might be enticed to spread viruses for the pure intellectual challenge.[212] The negative aspects of these people are highlighted visually with an image of a dubious-looking older man handing diskettes with worms to a young boy. The reference to pedophilic "candy-men" is obvious, again sexualizing the distribution of diseased software, but a striking resemblance is that the person is pictured looking like Fidel Castro, even with a cigar hanging from his lips! Castro has been one of the strongest icons and symbols of the communist threat to the American dream, now connected to the world of computer crime as well. This articulation turns out to be a more general fear of Soviet infiltration when reinforced with John McAfee and Colin Haynes's fear that "[c]omputer viruses give the Soviets, or any other potentially hostile power, a whole new approach to defense."[213] One must remember that at the end of the 1980s, the Soviet threat was still prevalent from the American perspective, despite the "glasnost" politics of Mikhail Gorbachev since 1985. So, a pedophile-communist virus writer was perhaps the most hair-raising articulation one could think of!

The image was originally a poster distributed at a security conference in 1986 held by the National Computer Security Center. Reproduced with permission from The Computer Virus Crisis! (Fites, Johnston, Kratz 1989, 81).

After the cold war tension had subsided, other types of threats were used to underline the morally indefensible actions of such people. Virus writers became terrorists at the end of the 1990s:

> virus writing is evil and cannot be justified in any circumstances. It follows that prosecution of virus writers is something which should be universally accepted as appropriate action. Virus writing needs to be recognized as a criminal act by international conventions and virus writers should always be subject to extradition. *Just like murderers and terrorists*, virus writers should find no escape across national boundaries.[214]

As terrorists, communists, and pedophiles, virus writers were the "dark side of network culture." They were seen as frustrated, vengeful maniacs destined to hurt people. Virus writers might have a "grudge against big business, the government, or against computing community establishment as a whole",[215] which was seen as similar to the mentally unstable person shooting innocent people with a sniper gun, an image familiar from the popular media and some real incidents, particularly in the United States. The most dangerous ones were the loners, who were seen as alienated from social contacts, again suggesting connections with the sociopath of popular fiction. Social intercourse was replaced for these people with electronic interaction, which deprived them of "real and healthy" contacts with society.

The implications are harsh, and they underline again the unhealthy, psychopathic side of virus writing. Although McAfee and Haynes do see variations within the concept of hackers and hacking, the "bad" sides are described with strong metaphors and concepts and implications of (mental) disorder. Digital disease equals mental disease, the implication goes. One has to note that this anxiety about digitality depriving people of a healthy social life was not a topic within the virus discourse alone. The developing digital culture of the 1980s was in general anxious about the people connected to these machines that proved to be addictive and emotionally binding— something very different from the traditional view of computers as rational machines. Computer and video games, for example, were seen as possible addictive nuisances of this growing cultural field.[216]

Hence, it is a striking fact that since the 1980s, both people engaged with computers and drug addicts have been labeled under the rubric "users."[217] As addictive stuff, computer culture was filled with anxieties. In this light, computer worms and viruses have not been the only digital problems the media has channeled. Perhaps viruses and worms were not so much exceptional instances of fear of computers, but a metonym of digital culture in general, referring to the fears and worries over the increasing, almost parasitic, presence of these new media

technologies in everyday life?[218] As Deborah Lupton has argued, computers were in themselves ambiguous cultural products extended between seduction or a potential for "sensuous pleasure" and a threat of invasion and contamination. And, of course, earlier youth cultural phenomena such as rock in the 1950s and 1960s had experienced similar overreactions and media panics, suggesting that such discourses were not merely about the new media technologies (whether the audio technologies that spread rock music or the computers and viruses or television) but also about the youth that had to be protected. Such media panics can also be analyzed as recurring media archaeological topoi. Yet, in addition, the archaeology of hackers spans from the early wireless amateurs of the beginning of the twentieth century, when such boy tinkerers became paradigmatic celebrated subjects of new technology. With several similar discursive elements, these boys represented the "rise of the boy inventor-hero as a popular cultural archetype",[219] as Susan Douglas writes in her history of American broadcasting. Such heroes were described in terms that made them reminiscent of such prankish fiction boy protagonists as Tom Swift, which eased the anxiety around the possible misuses of communication technology: boys will be boys.[220]

However, boys were not just boys, but part of a multiplicity of cultural flows. People using computers are always participating in larger and more abstract assemblages of cultural techniques. "Boys" or "vandals" writing worms and people otherwise part of the viral media ecology of the late twentieth century cannot just be reduced to their all-too-human psyches. They must be seen as interlocked in a field much larger than themselves, of which my book is one cartographic attempt. Viruses, worms, virus writers, hackers, and other actors are expressive of the ecology of flows that constitutes them. Digital technologies, the discursive networks of the desire for network programming and self-spreading software, the long genealogy of the Western conception of security, the linguistic order-words of health and disease, and so forth—all these accompany the whole phenomenon.

Of course, this and similar analyses that avoid reductionist accounts have had difficulty gaining ground in the public representations of worms and viruses. Instead, within the public discourse, the blame has been put on the *persons* responsible for computer worms and viruses. "Punish virus spreaders", an angry letter in *Byte* (1989) demanded at a time when the public anxiety over malicious software was growing strong:

> How long will it be before a virus infects a computer system at a hospital, a police department, or a military installation? (...) Viruses and other forms of computer tampering are not just a threat to the free flow of information. (...) They have the potential to

inflict enormous harm, and the people who are responsible for them should be subject to criminal prosecution. They are engaging in malicious destruction of property as surely as if they had walked into someone's office and tossed a match into a file cabinet. It's only a matter of time before something much more serious happens as a result of their antics.[221]

The change from beginning of the decade was huge. Levy and his book *Hackers* were probably in a key position in terms of producing the image of hackers and hacking as expressions of the hacker ethic. These people working at MIT in the 1960s, tinkering as hobbyists on the West Coast during the 1970s, and resisting authorities throughout the United States were perceived by Levy to be idealistic and exemplary figurations of a spirit of freedom and liberating computing. His version of the hacker ethic consisted of a number of slogans:

1. Access to computers—and anything which might teach you something about the way the world works—should be unlimited and total.
2. All information should be free.
3. Mistrust authority—Promote decentralization.
4. Hackers should be judged by their hacking, not bogus criteria such as degrees, age, race, or position.
5. You can create art and beauty on a computer.
6. Computers can change your life for the better.[222]

With the emphasis on such descriptions, Levy constructed his narrative of hackers as open-minded tinkerers and *bricoleurs* who have the one sole aim of finding the ultimate hack. Computers and programming were pictured as ends in themselves, as well as positive addictions and expressions of a life committed to technology. As Levy writes, for these pioneer hackers the aim was to make systems work better and at the same time to resist corporate bureaucratic forces, symbolized by IBM. Dysfunctional and irrational systems were obstacles that hackers were obsessed with crossing.[223] Taking things apart to inspect the workings of a system was in their blood, even if this was done without malicious intent. This does not contradict the fact that "intentional system crashes" were part of the repertoire of hackers at MIT:

> The faith that the ITS (Incompatible Timesharing System) had in users was best shown in its handling of the problem of intentional system crashes. Formerly, a hacker rite of passage would be breaking into a time-sharing system and causing such digital mayhem— maybe by overwhelming the registers with looping calculations—that the system would "crash." Go completely dead. After a while a hacker would grow out of that destructive

mode, but it happened often enough to be a considerable problem for people who had to work on the system. The more safeguards the system had against this, the bigger the challenge would be for some random hacker to bring the thing to its knees.[224]

Is the germ of viral vandalism and digital disease already present in these explorations of innovative computer wizards of the counterculture of the 1960s and 1970s? In general, this form of thinking became more common during the 1980s, when the media and certain public officials dealing with digital security were trying to find causalities and explanations behind the growing number of computer crimes.[225] The act of systems crashing was incorporeally turned from experimental hacking into an index of vandalism. Various types of recurring code, self-reproductive programs, and parasitic routines were outlawed. Of course, such tactics have been kept alive in net art, where the forkbomb script is one such example that closely touches on the earlier phenomenon of illegal code. The routine consists of a simple program that copies itself endlessly to constipate the system (much like the rabbit routine decades earlier). Alex McLean's version of the program won the software art prize at the Transmediale festive in Berlin in 2002, and the hacker-artist Jaromil wrote his own piece for UNIX systems, consisting of only 13 characters: ":(){ :|:& };:". Such pieces could perhaps be seen as underlining the potentials of the user/programmer in a world where operating systems constantly restrict potentials of action and "hide" them behind graphical user interfaces or protected-mode computing.[226]

Hackers were moved from being at the core of computerization to the outskirts of the digital utopia. They were seen as unlawful system breakers, as the computer game Hacker from the mid-1980s suggested. Activision's Hacker advertised itself with the slogan "Makes you feel like you've unlocked someone else's computer system!" The game was judged to be "socially irresponsible", which demonstrated the transformed understanding of the term.[227] Such individuals as Kevin Mitnick, Craig Neidorf, and Robert Morris Jr. became indexical names of the anonymous dangers lurking in the networks. Similar to how Melissa, Nimda, I Love You, and other viruses and worms facialized the danger of connection at the end of the 1990s and beginning of the twenty-first century, hackers' proper names were the digital outlaws that represented a threat to the otherwise normalizing digital culture of the 1980s.

Helen Nissenbaum provides an enlightening account of the ontology of cyberspace and the changing meanings of hackers in recent decades. According to Nissenbaum, the earlier hacker ideals, a hacker ethic, were, of course, cherished throughout the 1980s and 1990s by writers such as John Perry Barlow, Howard

Rheingold, and Nicholas Negroponte, all of whom celebrated the Internet as the new frontier of "great freedoms and liberty." Their views were adapted as part of the capitalist mythology of the superhighway of digital networks, illustrated in the United States by Al Gore's visions.[228] This normalized version of the hacker ethic did not, then, prove to be a threat to, but only a fulfillment of, the neoliberal ideas of freedom and connectivity.

But hacker demonization also served specific government and business interests, according to Nissenbaum. It was deemed necessary to "control the definition of normalcy in the new world order of computer-mediated action and transaction; the good citizen is everything that the hacker is not."[229] In addition, to paraphrase Nissenbaum, the fear of hackers provided excellent support for further expenditures on security, vigilance, and punishment, consequently illustrating exactly the same pattern as with viruses some years later. As I argued in the previous chapter, the fear of viruses was turned into a digital business that allowed people to "buy off digital fear" with antivirus software and other consumer products.

Nissenbaum refers also to Andrew Ross's insights into how AIDS is part and parcel of the discourse of digital fear. Ross notes similar things to those I have sketched above, namely that AIDS was used as a powerful tool to spawn fear and anxiety, or even hysteria, among the growing digital population. Hacker counterculture was something that was linked to sickness and disease. The pejorative references to computer AIDS, the need for "hygiene lessons", and sick software were extended to a certain social group, the hackers. So whereas such writers as Hugo Cornwall in his *Hacker's Handbook* offered a view of hackers as merely harmless pranksters, the officials were engaging in overkill actions, exemplified by the FBI's Operation Sundevil of the early 1990s.

What Ross, writing in 1991, in the midst of the hacker and virus hysteria (as he names it), emphasizes is that the virus crisis had, of course, increased sales of antivirus software while also exposing the weak points in computer and Internet systems. In addition, the notion of the paranoid machine emerges again:

> Virus-conscious fear and loathing have clearly fed into the paranoid climate of privatization that increasingly defines social identities in the new post-Fordist order. The result—a psychosocial closing of the ranks around fortified private spheres—runs directly counter to the ethic that we might think of as residing at the architectural heart of information technology. In its basic assembly structure, information technology involves processing, copying, replication, and simulation, and therefore does not recognize the concept of private information property. What is now under threat is the rationality of shareware culture, ushered in as the achievement of the hacker counterculture that pioneered the personal computer revolution in the early 1970s against the grain of corporate planning.[230]

Hence, this "privatization" of the digital sphere was something completely contrary to the hacker values that had been cultivated since the 1950s and 1960s, first in computer laboratories in universities, then among a wider public active in networking computing. Of course, this imaginary of the Internet[231] did not disappear altogether. It was incorporated into the productive machinery of digital capitalism, which really came to life in the 1990s with the popular Internet. The more idealistic visions of freeware and shareware cultures, as well as open source software, were marginalized, and the pejorative descriptions of hackers as adolescent criminals, digital vandals, and computer outlaws functioned to support this shift of cultural emphasis.

Economic "realism" and hacker idealism had been on a crash course, at least since the 1980s, when the new mass market for computers started to grow. The nature of production of digital culture changed, which immanently connected also to the idea of hackers and independent programmers. With the "maturing of software production" standardization, controlled production teams and professionally managed distribution chains guaranteed the positions of such larger companies as Microsoft as the key players. The standardized software houses were legitimized as the "right" producers of digital culture, whereas various alternative actors and distribution mechanisms were marked as secondary in the eyes of the user majority. Whereas the pioneer programmers of computer labs and university research facilities in the 1950s–1970s saw software as a branch of scientific knowledge, the 1980s commercial industry of personal computers soon turned its back on these original ideas of free ownership of code. Software became shielded by copyright jurisdiction. The idea of software as *consumer ware* actualized on a mass scale during the 1980s, when it became desirable to own software and to make money through selling it in large quantities, or, more precisely, selling the right to use software. From then on, software was *licensed* for use.[232]

The whole of this chapter has revolved around the idea of the body politic and the body digital of the computer culture since the 1980s. Viruses, worms, hackers, and other dubious elements have been perceived, signified, and valorized as cracks in the integrity of the organized society of (American) digital culture, expressed in the metaphors of sickness and disease, as well as the practices of safe computing and digital hygiene. In this sense, it is only natural that perhaps the greatest imagined threat to the body politic of U.S. society in the twentieth century, communism and the Eastern bloc, is intertwined in the discursive field of digital threats:

As the sources of viruses multiply—from pirate boards, construction sets, manic Thai programmers, Russian and Bulgarian computer freaks—access becomes much simpler.

> In the future everyone will be able to plant a virus on his "worst enemy": disgruntled
> employees, industrial saboteurs, blackmailers, electronic vandals. We may no longer
> be able to trust technology. A computer program could, without warning, become an
> uncontrollable force, triggered by a date, an event or a timer.[233]

The issue of digital vandalism was not limited to being an internal problem of
the United States. Enemies of the state were not just lurking within the internal
ranks; their origin was "out there", namely in the Eastern bloc, the face of other-
ness for American society ever since World War II and the McCarthy period. As
noted above, analogies to the communist persecutions of the 1950s were part of
the virus discourse of the 1980s—the perfect example being the *Time* article of
1988 "The Invasion of the Data Snatchers", not forgetting the pedophilic Fidel
Castro figure mentioned above.

The danger from behind the Iron Curtain remained even though the cold war
situation improved. The face of communism changed into fears of anarchism, "an
uncontrollable force" without any rational motives. The so-called ideological divi-
sion between East and West collapsed, but the fear of "Russians and Bulgarians"
remained in the form of viruses. This represented a battle against the threatening
digital diseases of computer networks—post-ideological micropolitics of a sort.[234]

Possibly the most frequently discussed issue was not a single virus but a person:
Dark Avenger from Bulgaria. He was responsible for a number of harmful viruses
as well as the infamous Self Mutating Engine, which made viruses polymorphous,
that is, harder to detect with traditional scanners.[235] Dark Avenger was, of course,
known in antivirus circles, but he was raised to an almost mythic position in 1997
by the *Wired* magazine story "Heart of Darkness", another reference to the world
of fiction, this time the Joseph Conrad novel of the same name from 1902. In
Conrad's text, the narration takes us to Africa, the heart of darkness of colonial
powers of the nineteenth century. *Wired* took the reader to the "heart of darkness"
of digital culture, the "ground zero of the global epidemic"—Eastern Europe, in
other words.

The virus and its creator became indexes of evil software. The code of the Dark
Avenger virus attached to .com and .exe files, activating its payload of hard disk
erasure every sixteenth boot. The code included also a signature, which assigned
the credits to Dark Avenger, city of Sofia, 1988–1989.

> The computer, self-destructing, would eventually crash, some precious part of its operating
> system missing, smothered under Dark Avenger's relentless output. Programs passed along
> in schools, offices, homes—from one disk to the next they carried the infection along,
> and in 1991, an international epidemic was diagnosed. One-hundred sixty documented

Bulgarian viruses existed in the wild, and an estimated 10 percent of all infections in the United States came from Bulgaria, most commonly from the Dark Avenger. Dataquest polled 600 large North American companies and Federal agencies early that year, and reported that 9 percent had experienced computer virus outbreaks. Nine months later, it found the number had risen to 63 percent. Anecdotal stories, of companies losing millions in sales and productivity due to virus attacks, became commonplace. The press seized upon the threat. The war drums of fear beat first in Europe, closer to the epicenter. Papers carried lurid pieces describing the havoc it wreaked. The tattoo was quickly amplified in the U.S. "Bulgarians Linked to Computer Virus", read a headline in *The New York Times*.[236]

Of course, there were concrete contexts behind this Bulgarian virus "threat." In the 1970s the Eastern bloc advocated copying Western, mainly American, computers instead of continuing their own development projects. This was accentuated after 1985 with an emphasis on "total computer literacy." This meant that computer courses became obligatory in school curricula. Thus, as the schools received their clones of Apple and PC computers and the students were taught high-tech programming skills, a sort of a digital intelligentsia was born in the Eastern bloc, including Bulgaria. However, as *Wired* reported, people did not find a sufficient number of things to do with computers:

In the late '80s, students in Bulgaria had access to more computers than their peers in any other Eastern European country. They did what young people do when they first meet machines—they played, they explored, they programmed. The Bulgarians were busy building a digital culture of their own, feasting off the fruits of Marxism-Leninism. And then, one forbidden fruit came to be known. In 1988, the Bulgarian computer-hobbyist magazine, *Computer For You*, founded in 1985, translated a German article about viruses into Bulgarian. It was a simple article, just an introduction to computer viruses. But it helped spread the idea. Several months later, the first pernicious homespun code appeared.[237]

In Soviet Russia, the situation was similar: plenty of programmers with no possibilities to channel their energies. The society was not computerized, far from it, which spawned a digital underground of experienced but frustrated programmers.[238] The situation seems to have been essentially similar in other Eastern countries such as Czechoslovakia. Computerization around the change of the decade 1989–1990 brought computers into the country, which was followed by an increase in various types of programs, including viruses. In Czechoslovakia, political viruses were frequent during the changes occurring in the early 1990s.[239]

But from the Western perspective, "Iron Curtain viruses" were the dark digital continent, the illness of network capitalism, just as communism had served as

the ideal face of evil for decades, suggesting the opposite of free market–driven Western consumer societies. To return to the first pages of this chapter, this was already what the novel *The Adolescence of P-1* suggested in the 1970s: viruses are the "communists" and the "cancer"—all three symptoms of the anomaly. With the breakup of the Soviet Union, a new type of security threat was created. Instead of the relatively stable cold war system between two main protagonists, public anxiety was turned toward subnational anarchic elements, global crime, terrorists—and malicious software as part of the other security threats. These are not merely unfounded representations and prejudices; recent years have seen virus-like code and other malicious software used as part of global crime and terrorist actions. For example, bots as a class of autonomous software programs are seen as the latest key threat to the Internet; they can collect passwords and other important personal information, participate in automated fraud by deceiving per-click revenue streams, and act as powerful denial of service weapon swarms that aim at, for example, "extortion and taking out rival businesses."[240]

Yet, malicious code quickly found its "legitimate" economic and political use. The virus was the stranger and the other in this machine producing Western anxieties, as Luca Lampo suggested: Soviet Russians and other monsters were replaced in the Hollywood machine with new enemies such as aliens, meteors, and epidemics.[241] The new spread of nongovernmental post–cold war threats provided fuel for entertainment productions, security agencies, and demands for increased funds in national and international security.

"Disease is politics, and always has been, whether it was syphilis in the old days, and even herpes",[242] notes the film director David Cronenberg, who has studied and used the theme of contagion throughout his films, in a manner that makes it pertinent to consider his products as symptomatic of the virus culture of the late twentieth century. As an intimate part of disease, order is also politics, where the polis/organism is formed through the demarcating battle over health and disease. Balance is what everyone seems to want, but how such a state of homeostasis is defined is a different matter.[243]

This construction of anomalies and monsters has had deep political and economic connections, best exemplified in the notion of viral capitalism introduced in the previous chapter. The viruses of the body politic, a surplus of digital globalization, generated the need to rethink the situation at the end of the 1980s and the change of the global economic system. With the collapse of the Soviet bloc, global politics reached a novel situation where the enemies were no longer represented by nation-states but increasingly by subnational, transnational, and international actors. Networks facilitated new modes of nonhierarchical organi-

zation, even though they were also adopted by the ruling economic and military elites as their mode of operation. Especially interesting are the ideas put forth by Tiziana Terranova in her analysis of the politics of the information age, where networks are not merely modus operandi of human politics and organization but also an active participant in themselves.[244] The network is in itself a dynamic space, an emergent phenomenon, that manifests its presence in terms of such "anomalies" as viruses, worms, and hackers. Yet, the anomalies are very much part of the novel political constitution of the hybrid politics of the network culture.

However, if this chapter has placed a great deal of emphasis on the incorporeal articulations of bodies politic, digital, and biological, several scientists and writers have been convinced that the connection between biology and computers is more profound. This can be thought of as expressing a form of contagious ecology of software that characterizes the genealogy of network dynamics. In other words, a constant theme since the beginning of the 1990s, with roots deep in the cultural history of Western modernity, has been the idea of computer worms and viruses as a form of life, not just devastation and destruction. In this vein, the often neglected context of computer viruses is to be found within the cultural history of artificial life.[245] This chapter proceeded with the question of how bodies are formed and kept intact; we next move even deeper into the machinic phylum of network culture and the biological paradigm of computing[246] to ask the question of how life is sustained and controlled in the context of digital culture. This also sharpens the focus on the biopolitics of digital life that we have been adopting.

NOTES

1. Serres 1982, 78–79.
2. See Terranova 2004.
3. Magner 2002, 290–293.
4. For definitions, see, e.g., the *Oxford English Dictionary*.
5. On the representational and the spatial grid, cf. Terranova 2004, 8–9, 35.
6. Deleuze & Parnet 1996, 84–85. Cf. Parisi 2004b. See also Parikka 2005c.
7. On biopower in the nineteenth century, see Foucault 2000a. On control societies, see Deleuze 1990, 240–247. Galloway 2004.
8. Deleuze 1986, 39–40. Cf. Olkowski 1999, 44–47.
9. Goodchild 1996, 28–30. Deleuze 1986, 1–8. Foucault 2002.
10. Deleuze 1988, 122–130.

11. See Maturana & Varela 1980, 135. Of course, Maturana and Varela's stance contains troubling notions, such as the definition of the autopoietic machine as *unity*. Organization equals unity for them, even though the process of creation of unities is composed of production, transformation, and destruction of components, underlining the dynamics of this process. Heterogenesis is in danger of turning into homogeneity. It would be interesting to discuss the distinction between their autopoietic model of organization and the process of emergence, but this is a question that I, owing to a lack of space, must bracket at this point.

12. Turner 2003.

13. Guillaume 1987, 59.

14. Sennett 1994, 23–24, 156. For a brief overview, see "Analogy of the Body Politic." In: *Dictionary of the History of Ideas*. <http://etext.virginia.edu/cgi-local/DHI/dhi.cgi?id=dv1-11>.

15. Agamben 1998, 125. Elizabeth Grosz (1995, 106–107) points out how the figure of the body politic is coded in masculine form and maintains a standard nature–culture division.

16. Deleuze 1990, 240–247. Cf. Mayer & Weingart 2004b, 28–30.

17. Fuller 2005, 2. On cities and the media ecology of cyberspace, see Boyer 1996.

18. Sennett 1994, 255–261.

19. Quoted in Marvin 1988, 141. Schivelbusch 1977, 171–174.

20. Thacker 2004. Cf. Bardini 2006.

21. Protevi 2001, 3.

22. See, e.g., Latour 2004.

23. Goffey 2003, 1.

24. Van Loon 2002b, 123.

25. Ryan 1985, 147.

26. Lampo 2002.

27. Van Loon 2002b, 141.

28. Quoted in Salmi 1995, 199.

29. Colwell 1996.

30. Cf. Deleuze & Guattari 1987, 66, 504. Wise 1997, 63.

31. Sontag 2002, 15.

32. Ibid., 155.

33. Ross 1991, 77.

34. See Tomes 1998, xi–xiv.

35. Ibid., 17.

36. Robert Gallo: "The AIDS Virus." *Scientific American*, vol. 256, January 1987, 39.

37. I am grateful to Malte Hagener for pointing out this example.

38. Thacker 2005.

39. Sasso & Villani 2003, 107–113. In addition, in diagrams there is also the potential for lines of flight, deterritorializations, which act as singularities of resistance that can open up diagrams toward the outside.

40. Weinstock 1997.

41. Rushkoff 1996. R. Rivas: "The AIDS game." *World Press Review*, vol. 9, 1993.

42. See, e.g., "Double Agent." *Scientific American*, vol. 251, July 1984. "AIDS: In the Blood." *Scientific American*, vol. 251, September 1984. "AIDS Update." *Scientific American*, vol. 252, April 1985. "Knowing the Face of the Enemy." *Time*, April 30, 1984.

43. Jeffrey Laurence: "The Immune System in AIDS." *Scientific American*, vol. 253, December 1985, 70. See also Duncan Fallowell: "AIDS Is Here." *The Times*, July 27, 1983, which illustrates certain first reactions and representations of AIDS.

44. "Just How Does AIDS Spread?" *Time*, December 1988. Similar sorts of prejudices against the poor, immigrants, and nonwhites were already part of the early twentieth-century discourse of the germ contagion. Tomes 1998, 11.

45. Sontag 2002, 147.

46. Duncan Fallowell: "AIDS: The Facts, the Fears, the Future." *The Times*, March 6, 1985. The article discusses heterosexual AIDS, but sees it only as an African problem: "In America the number of AIDS cases among heterosexuals unassociated with any of the risk categories is nil—as it is in Britain." See also Patton 2002, 129–130.

47. "The Toughest Virus of All." *Time*, November 3, 1986.

48. "The AIDS Pandemic." *Scientific American*, vol. 256, January 1987.

49. Barabási 2003, 123–142.

50. Sontag 2002, 166.

51. See Patton 2002, x. Kruger 1996, 42–61.

52. Boyer 1996, 37–38.

53. Crichton 1998. Actually, one of the early theories for AIDS, too, was that it came from outer space on a meteorite or a returning spaceship! See Fallowell: "AIDS is Here." For an analysis of killer virus novels as emblematic of the bodily crisis in late capitalism, see Dougherty 2001.

54. Van Helvoort 1996, 142.

55. "50, 100 & 150 Years Ago." *Scientific American*, April 2005, 18. Quoted in Bardini 2006, fn. 6. See also, e.g., "Reconstruction of a Virus in Laboratory Opens the Question: What Is Life?" *New York Times*, October 30, 1955. "Mutation Agent Held Clue to Life." *New York Times*, January 26, 1960. Yet, in a way, this virus culture is part of the scientific landscape of the nineteenth century and its notion of the germ theory, which supposes that diseases are caused by microorganisms. As Laura Otis (1999, 7) shows in her inspiring analysis in *Membranes*, this theory was also part of the masculine and imperialist assemblage of the century, resonating with socio-political themes of colonialism. The outside, with its bacteria and other dangerous entities, was to be fenced out to maintain the pristine individual body, analogous to the body politic of the Western white colonialist powers. The cultural fear of penetration (a very masculine fear) has long roots in the nineteenth century, which has led to two persisting cultural prejudices, to paraphrase Otis: first, the tendency to think of female sexuality as "passive penetrability" and, second, to value the intactness of the hymen—where its rupture means the fall into "the realm of the passive, the penetrated, and the impure."

56. Seltzer 1992. Armstrong 1998.

57. See John Protevi's (2001, 101) analysis of AIDS, where the virus becomes an invader that without respect renegotiates the borders of the outside and the inside and the frail wall of fold that separates them: "Body is seen as an interiority encased by a protective barrier, a frontier. According to the oppositional cultural imaginary, the ideally seamless mucuous membrane walls are in fact fragile, prone to tiny invisible tears, opening the inside to an outside that should stay outside. The response to this factual degeneration from ideal separation is to police the borders of the somatic body politic. The messages we all know by now: separate inside and outside. Avoid mixing the famous bodily fluids. The truth about AIDS is a liminology, a discourse on borders: keep your fluids to yourself! Don't bring foreign blood inside!"

58. See Bukatman 1993, 78–93. Concerning *Videodrome*, Rosi Braidotti writes aptly, "What makes *Videodrome* a classic is that it addresses the issue of the physicality and the corresponding malleability of the male body, while it also shows to what extent the body is constructed, thus striking an anti-humanist note." Braidotti 2002, 249. Braidotti notes that this becoming is at the same time very conventional, only repeating several sexist and even humiliating images of women.

59. Flieger 2003, 396.

60. Bear 2001, 77.

61. See Bukatman 1993, 268–272. Hayles 1999, 252–256.

62. Butler 1985.

63. Cadigan 2001, 309. Gibson's *Neuromancer* had introduced the idea of computer programs causing cerebral damage to people jacked into the matrix. While the virus programs were a form of attack software, ICE programs were antivirus viruses, designed to protect the data banks and resources of large institutions. These were visualized in the 1995 *Johnny Mnemonic* movie, written by William Gibson and directed by Robert Longo.

64. Stephenson 1993, 378. On postmodernism and Stephenson's *Snow Crash*, see Porush 1994. See also Hayles 1999, 251.

65. Harrasser 2002, 822.

66. See, e.g., Channell 1991. On bodies in cyberpunk literature of the 1980s, see McCarron 1996. On bodies and technology in contemporary culture, see Balsamo 1996.

67. Hayles 1999. Cf. Gere 2002, 47–74.

68. Blackmore 2000, 21. Cf. "The Guru Trap or What Computer Viruses Can Tell Us about Saddam Hussein." *Computer Underground Digest*, vol. 3, issue 31, August 23, 1991, < http://venus.soci.niu.edu/~cudigest/CUDS3/cud331.txt>.

69. Deleuze & Guattari 1987, 69.

70. See Thacker 2005.

71. Kruger 1996, 11. Cf. Sontag 2002.

72. "Il etait une fois … l'homme" (1978) focused on explaining the evolution of the human being to children.

73. Burroughs 1985, 48. Cf. Bukatman 1993, 76–77.

74. Kruger 1996, 17. This all quite easily implies that there is something called "healthy code" that is desirable, original, and legitimate. Healthy code makes healthy bodies. One commentator from 1989 went so far as to claim that computer viruses are an offspring of malicious thoughts: "The evolution of the computer is also yoked to our evolution as a species, and to our understanding of health, illness, and well-being. And one of the things we are discovering is that disease, as a life process, is profound, especially when we consider that we are now creating and releasing diseases designed to afflict our very own brainchild. With computer viruses, our thoughts, especially destructive ones, can easily be turned into action." Lundell 1989, xii.

75. Massumi 1992, 41.

76. See Deleuze & Guattari 1987, 80–81.

77. "Science fiction has gone through a whole evolution taking it from animal, vegetable, and mineral becomings to becomings of bacteria, viruses, molecules, and things imperceptible." Deleuze & Guattari 1987, 248.

78. See Speidel 2000. Cf. Parisi 2004a.

79. Denning 1991a, xi.

80. Deleuze & Guattari 1987, 510–514. Goodchild 1996, 51, 217. This abstract machine also relates closely to Latour's (1993) notion of the modern constitution, which *tried* to separate nature from society, man from technology. As noted above, this distinction has leaked ever since its creation, and the idea of *computer* worms and viruses is part of this leakage.

81. Huhtamo 1995. Cf. Huhtamo 1997. Ernst Robert Curtius introduced the term "topos" in his *Europäische Literatur und lateinisches Mittelalter* (1948), which focused on topics in rhetoric.

82. McAfee & Haynes 1989, 1.

83. Ibid., 4.

84. Ibid., 14–15.

85. Ibid., 15. On quasi-objects, see Latour 1993, 51–55.

86. AIDS references such as this imply that there are similar key risk groups within computing to those in culture in general. If homosexuals, drug users, Haitians, and black people were defined as such groups in the 1980s, what were such groups within the computer virus discourse? Often these are not stated aloud—the power of the analogy is based on its vagueness. The risk groups, those unsuspected but therefore so dangerous sources, could be represented by anyone. Curiously, here computer viruses connect to the articulations of AIDS. As Cindy Patton notes, the tropes of bisexual men and heterosexuals who occasionally pass through homosexual vectors were seen during the mid-1980s as figures of terror, untrustworthy elements within the otherwise safe middle-class cities and suburbs—trespassing borders, like viruses. Patton 2002, 68–69.

87. "An Israeli Virus." *The Risks Digest Forum*, vol. 6, issue 6, January 7, 1988, <http://catless.ncl.ac.uk/Risks/>.

88. "Computer Viruses and RETROVIRUSES." *The Risks Digest Forum*, vol. 7, issue 27, July 23, 1988, <http://catless.ncl.ac.uk/Risks/>.

89. "The media affect-fear-blur is the direct *collective* perception of the contemporary condition of possibility of being human: the capitalized accident-form. It is the direct collective apprehension of capitalism's powers of existence. It is vague by nature. It is nothing as sharp as panic. Not as localized as hysteria. It doesn't have a particular object, so it's not a phobia. But it's not exactly an anxiety either; it is even fuzzier than that. It is *low-level fear*. A kind of background radiation saturating existence (commodity consummation/consumption)." Massumi 1993, 24.

90. Sontag 2002, 155. Kruger 1996, 21.

91. "AIDS Computer Virus." *The Risks Digest*, vol. 13, issue 1, January 3, 1992. See also "The Trojan Horse Named 'AIDS.'" *The Risks Digest*, vol. 9, issue 55, December 16, 1989. "The Trojan Horse Named 'AIDS' Revisited." *The Risks Digest*, vol. 9, issue 65, February 2, 1990. Harley, Slade, & Gattiker 2001, 31.

92. Ross 1991, 76.

93. Ibid., 79.

94. Cf. Parisi 2004b.

95. See Latour 2005.

96. Deleuze & Guattari 1987, 167–171.

97. Goodchild 1996, 107.

98. As Friedrich Kittler (1990, 369–370) emphasizes, technical media works on very different codes irreducible to anthropological bodies or the handwritten texts of hermeneutic meaning.

99. Järvinen 1990, 153.

100. See Joost Van Loon's analysis of the virtuality of the viral object: "The first step in the formation of the virus as a virtual object is that it has to be visualized—either iconically or indexically. Second, it has to be signified, that is, endowed with the specific meaning through which the objectification can be anchored into the symbolic order, and become a discursive object, engendering a discursive formation. Third, it has to be valorized; the virtual object must not only be endowed with meanings, this endowment must be attributed a particular value in terms of its significance within the wider emergent discursive formation. Objectification, therefore, is nothing but the singular decoding and encoding of a territory, a re-organization of particles and forces, not simply in terms of 'knowledge', for example as in the Foucauldean (1970) notion of 'episteme', but first and foremost in practices and technologies of enpresenting." Van Loon 2002a, 117.

101. Sven Stillich & Dirk Liedtke: "Die Wurm von der Wümme." *Stern* 16.6.2004, <http://www.stern.de/computer-technik/internet/index.html?id=525454&nv=ct_cb&eid=501069>.

102. See Jon Katz, "Who Are These Kids?" *Time*, vol. 155, May 15, 2000.

103. See "Girl Power's Point of Virus Written in Microsoft's C#." Computeruser.com, March 4, 2002. <http://www.computeruser.com/news/02/03/04/news3.html>.

104. Jon A. Rochlis and Mark W. Eichin: "With Microscope and Tweezers: The Worm from MIT's Perspective." *Communications of the ACM*, vol. 32, issue 6, June 1989, 695.

105. Ibid., 694. Interestingly, in another context the very same Morris worm was described using themes familiar from classic horror and science fiction films, with the worm playing the role of the abhorred monster, a digital Godzilla. Hafner & Markoff 1991, 254.

106. Helmreich 2000a, 477. See, e.g., Parker 1976, 85–106, where computer intrusion is described as rape. On diagrams and imaging of biological viruses, see Weingart 2004.

107. Theriault 1999. Cf. Chun 2006, 177.

108. Lundemo 2003, 15.

109. Deleuze 1998, 51.

110. Martin 1994, 245.

111. Ibid., 248. Deleuze 1990, 240–247.

112. Goffey 2003, 3.

113. See Stephanie Forres, Steven A. Hofmeyr, and Anil Somayaji: "Computer Immunology." *Communications of the ACM*, vol. 40, issue 10, October 1997. *Virus Bulletin* 1993, 107.

114. See Deleuze & Guattari 1987, 502–505. Goodchild 1996, 68–69.

115. "A Threat from Malicious Software." *Time*, November 4, 1985.

116. Gerrold 1975, 175.

117. See, e.g., Longley 1994a and 1994b. See also Patrick Wood: "Safe and Secure?" *Byte*, May 1989, 254. *Byte* lists computer security concerns in four subtopics: preventing unauthorized access, preventing data compromise, preventing service denial, and preserving system integrity.

118. Quoted in Hafner & Markoff 1991, 120.

119. Bryan Kocher: "A Hygiene Lesson." *Communications of the ACM*, vol. 32, issue 1, January 1989, 3.

120. James H. Morris: "Our Global City." *Communications of the ACM*, vol. 32, issue 6, June 1989, 661.

121. Cf. DeLanda 2003.

122. Helmreich 2000a, 477.

123. Martin 1994, 53.

124. Ibid., 62. See, e.g., Jeffrey Laurence: "The Immune System in AIDS." *Scientific American*, vol. 253, December 1985, 70. "How is it that by damaging a single link the AIDS virus causes the immune system as a whole to unravel? The answer lies in the complex web of interactions among the different classes of blood cells that take part in immunity. The immune system is a flexible but highly specific defense mechanism that kills microorganisms and the cells they infect, destroys malignant cells and removes debris. It distinguishes such threats from normal tissue by recognizing antigens, or foreign molecules, and mounting a response that varies with the nature of the antigen."

125. Kay 2000, 112.

126. Gibson 1984, 63.

127. See Wendy Chun's (2006, 37–76) apt critique of the spatialization of cyberspace in the wake of Gibson.

128. Paul Saffo: "Consensual Realities in Cyberspace." *Communications of the ACM*, vol. 32, issue 6, June 1989, 664–665. Published also in Denning 1991a, 416–420. See also Ferbrache 1992, 10–11. Cf. Harrasser 2002.

129. Vic Vissotsky, e-mail to author, June 2, 2005. Cf. Kittler 1999, 243. In addition, in another novel, *Softwar/La Guerre douce* (1985), the United States donates a Trojan-infested computer to the Russians, hoping to penetrate their defense networks.

130. Jon A. Rochlis and Mark W. Eichin: "With Microscope and Tweezers: The Worm from MIT's Perspective." *Communications of the ACM*, vol. 32, issue 6, June 1989, 692–694.

131. Hafner & Markoff 1991, 254.

132. Lundell 1989, 113.

133. These ideas connect to Friedrich Kittler's emphasis on the interconnections of war and media. See Kittler 1999, 243. See also Virilio & Kittler 1999.

134. Forbes 2004, 104.

135. Ibid., 105.

136. Stephanie Forrest, Steven A. Hofmeyr, and Anil Somayaji: "Computer Immunology." *Communications of the ACM*, vol. 40, issue 10, October 1997, 88. Immunology against computer viruses was discussed in 1987 in connection with the Christmas Tree worm. See "The Christmas Card Caper, (Hopefully) Concluded." *The Risks Digest*, vol. 5, issue 81, December 21, 1987. <http://catless.ncl.ac.uk/Risks/5.81.html#subj1.1>

137. Stephanie Forrest, Steven A. Hofmeyr, and Anil Somayaji: "Computer Immunology." *Communications of the ACM*, vol. 40, issue 10, October 1997, 92.

138. See "A Database of Normal Patterns." *Communications of the ACM*, vol. 40, issue 10, October 1997, 95. See also "Computer Immune Systems." <http://www.cs.unm.edu/~immsec/>.

139. "The IBM Virus Antidote." *Computer Fraud & Security Bulletin*, October 1995, 6.

140. *Virus Bulletin* 1993, 107.

141. Lundell 1989, 114.

142. Ibid., 115. In 1988, a hard drive write-protect application was introduced as a form of immunology against viruses. See "Write-Protection for Hard Disks." *The Risks Digest*, vol. 61, issue 73, April 29, 1988. <http://catless.ncl.ac.uk/Risks/6.73.html#subj5.1>. Examples of sophisticated techniques of observation were checksums, designed to look for changes within programs. This way the program was in theory able to perceive whether a virus had changed the structure of a program. The problem was that checksums were effective only against known viral strains, not new

ones. In essence, virus writers were also able to find out where the checksums were located in a program. They were then replaced with ones that simulated the normal routines of that checksum. On checksums, see, e.g., McAfee & Haynes 1989, 144. Heuristics was a widely discussed antivirus technique in the early 1990s, trying to find solutions to the problem of the constantly increasing number of new virus strains. See Frans Veldman's papers "Combating Viruses Heuristically." *Virus Bulletin Conference Proceedings* 1993, 67–76. "Why Do We Need Heuristics?" *Virus Bulletin Conference Proceedings* 1995, xi–xvi. The "problems of virus detection" are also discussed in David J. Stang: "Computer Viruses and Artificial Intelligence." *Virus Bulletin Conference Proceedings* 1995, 235–246.

143. Deleuze 1990, 240–247.

144. Lundell 1989, 118–119.

145. Ibid., 119.

146. Stephanie Forrest, Steven A. Hofmeyr, and Anil Somayaji: "Computer Immunology." *Communications of the ACM*, vol. 40, issue 10, October 1997, 90.

147. Cohen 1986, 5–8.

148. Fleck 1979, 59. See also Martin 1994, 108–110.

149. Maturana & Varela 1980, 9, 81.

150. Fleck 1979, 61. Actually, Francisco Varela wrote about the immune system, together with M. Anspach, in 1994. Mackenzie 1996, 23. Mackenzie draws much of his analysis from Haraway's "The Biopolitics of Postmodern Bodies: Constitutions of Self in Immune System Discourse." (1991, 203–230.)

151. Stephanie Forrest, Steven A. Hofmeyr, and Anil Somayaji: "Computer Immunology." *Communications of the ACM*, vol. 40, issue 10, October 1997, 91.

152. See Haraway 1991, 204–208. Haraway rests on A.N. Whitehead's notions of a process ontology, which aims to think beyond the subject–predicate determination of Western thought. These ideas are also apt concerning immunology and interaction of bodies. On Whitehead, see Halewood 2005.

153. Mackenzie 1996, 22–26.

154. Cf. Goffey 2003.

155. Parisi 2004a, 141.

156. See Heidegger 1996, §16.

157. Winograd & Flores 1986, 77.

158. Ibid., 36–37.

159. Sampson 2005. See also Galloway 2004 for a protological view of network genealogy.

160. See "Museum's Hack Piece Pulled." *Wired*, May 15, 2002. <http://www.wired.com/news/culture/0,1284,52546,00.html>.

161. Brothers 1991, 365. Cf. "Health Insurance for Computers." *Computerworld*, April 23, 1990.

162. Rod Parkin: "Is Anti-Virus Software Really Necessary?" *Virus Bulletin Conference Proceedings* 1993, 59.

163. For an analysis of knowledge work in network culture, see Terranova 2004.

164. Kittler 1990.

165. Alan Kay: "Computer Software." *Scientific American*, vol. 251, September 1984, 47.

166. Saarikoski 2004, 89, 145.

167. On the archaeology of interactivity, see Huhtamo 1996.

168. Leary 1992, 43. Originally published in 1984 in *Digital Deli*, edited by Steve Ditlea (1984). Of course, the computer "revolution" did not happen overnight and has been a much slower process than many commentators of the 1970s and 1980s assumed.

169. Mark Drew: "Distributed Computing—Business Risk or Risking the Business." *EICAR Conference Proceedings* 1994, 93.

170. William Murray: "Good Security Practice for Personal Computers." *Symposium on Applied Computing Proceedings of the Northeast ACM Symposium on Personal Computer Security*, September 1986, 11. (My italics.)

171. Licklider 1960.

172. Shain 1994, 4.

173. Foucault has analyzed these in relation to the antique in his *The History of Sexuality*, volumes II and III (*The Use of Pleasure* and *Care of the Self*). See Foucault 2000b.

174. Sennett 1994, 261.

175. Tomes 1998, 6–7.

176. Kittler 1990.

177. Parker 1991a, 552.

178. *Virus Bulletin* 1993, 72.

179. Dorothy E. Denning: "Secure Personal Computing in an Insecure Network." *Communications of the ACM*, vol. 22, issue 8, August 1979, 476–482.

180. See Mattelart 2003, 130–131.

181. Martin Kochanski: "How Safe Is It?" *Byte*, June 1989, 257.

182. "Just like with biologic viruses, subject behaviour has a significant effect on the probability of infection. By altering the habits of the users, and examining how most virus infections occur, it is possible to educate staff on the risk which their different actions carry, and thus minimise the risk of virus infection." *Virus Bulletin* 1993, 72.

183. Wayne Rash Jr.: "Be Secure, Not Sorry." *Byte*, October 1988. See also Peter Stephenson: "Personal and Private. How Much Security Is Enough?" *Byte*, June 1989. Stephenson emphasizes that in the end, the user is the one choosing the right measures to protect her data: "You can encrypt the data on your hard disk, prevent access to the data in the first place, and watch active files for viral contamination that could damage or compromise data. Which of these approaches (or combinations thereof) you select will depend on how secure your data needs to be and how open your computer is to outside intrusion." (p. 285.)

184. Gene B. Williams: "Keep Your PC Healthy." *Byte*, Fall 1988.

185. Deborah Lupton has made similar remarks. Analyzing the computer virus phenomenon in 1994 she notes how the virus anxiety in part stems from our intimacy with computer technology. Drawing on cyborg theory, Lupton writes about the erotic nature of our interaction with digital machines. The figure of the cyborg can be seen as a cultural symbol of the late twentieth century: ideal, clean, seamless, invulnerable, and hygienic, as Lupton lists. This figure represents perhaps exactly those qualities that are under threat in the intimate computer technology and AIDS culture of recent decades. This *fin de millennium* is one of the anxieties concerning bodies and sexualities, limits and borders. Just as biological bodies were dwelling in this ambiguous state of pleasure and terror, so the signs of computing and our relationships with computers were marked by a tension between the intimacy with our personal computers and the fears of what was lurking inside those

machines. Thus, the user was in a constant state of paranoid self-surveillance: "Panic computing extends the boundaries of the erotic Self, requiring even greater vigilance, surveillance and personal control to protect against invasion from both biological and computer viruses. Furthermore, panic computing problematizes the capacity of cyberspace to offer liberating, guiltless, safe and infection-free erotic pleasure." (Lupton 1994, 564.)

186. Jerry Pournell: "Dr. Pournelle vs. The Virus." *Byte*, July 1988, 199.

187. See, e.g., Järvinen 1990, 74–77. Hyppönen & Turtiainen 1990, 39–40. Harley, Slade, & Gattiker 2001, 284–300. *Virus Bulletin* 1993, 91.

188. Harley, Slade, & Gattiker 2001, 297–299.

189. Fites, Johnston, & Kratz 1989, 124.

190. *Virus Bulletin* editorial, July 1989.

191. "A Virus-Free Corporate Culture." *Virus Bulletin Conference Proceedings*, September 1992, 30.

192. "It is safer to use only programs from reputable manufacturers. A reputable manufacturer will implement anti-virus security procedures on its development computers to ensure that no virus is embedded in a program at that stage. There have been cases of manufacturers distributing infected copies of software; these incidents have reinforced the need for strict QA (Quality Assurance) procedures." "Computer Viruses—A Management Overview." *Virus Bulletin Conference Proceedings*, September 1992, xi. The article mentions the idea of a "dirty PC" used to try new software, play games, etc. It is physically isolated from network connections to avoid company files from being smothered.

193. "A Virus-Free Corporate Culture." *Virus Bulletin Conference Proceedings*, September 1992, 32.

194. Paul Ducklin/Sophos: "Is Virus Writing Really That Bad?" *Anti-Virus Asia Researchers (AVAR) Conference*, 2001.

195. Martin 1994, 134–135. Sontag 2002, 23.

196. Sontag 2002, 47.

197. "The 'Itch Syndrome.'" *Virus Bulletin*, October 1989, 2. See also Parker 1976, 16. Sontag (2002, 10–26) describes the trope of cancer as something that one might consider keeping to herself.

198. Sarah Gordon: "Why Computer Viruses Are Not—and Never Were—a Problem." *EICAR Conference Proceedings* 1994, 173.

199. Alan Solomon: "A Brief History of Viruses." *EICAR Conference Proceedings* 1994, 129.

200. "Peter J. Denning on Terminology." *The Risks Digest Forum*, vol. 7, issue 4, June 6, 1988, <http://catless.ncl.ac.uk/Risks/>

201. "Computer Viral Center for Disease Control?" *The Risks Digest*, vol. 6, issue 70, April 26, 1988, <http://catless.ncl.ac.uk/Risks/>. "Re: Computer Viral Center for Disease Control?" *The Risks Digest*, vol. 6, issue 72, April 27, 1988.

202. See, e.g., Fites, Johnston, & Kratz 1989, 87–93. Hyppönen & Turtiainen 1990, 40. Järvinen 1990, 91–93. *Virus Bulletin* 1993, 91.

203. On the NII (National Information Infrastructure), see <http://clinton1.nara.gov/White_House/EOP/OVP/html/nii1.html>.

204. See Douglas 1989, xxv. On topos and media archaeology, see Huhtamo 1997.

205. See Foucault 1976.

206. Cf. Van Loon 2002a.

207. Jim Bates: "Catching the Virus Writer." *Virus Bulletin Conference Proceedings*, September 1995, 2–4. (My italics.)

208. Fites, Johnston, & Kratz 1989, 17. Cf. Sontag 2002, 47. Cf. Van Loon 2002b, 162–163.

209. See the "Russian's official answer." In: "More on 'Little Black Book of Comp. Viruses.'" *Computer Underground Digest*, vol. 4, issue 55, November 4, 1992.

210. Of course, not every antivirus researcher has been so one-eyed in her analyses; one example has been Sarah Gordon, active for years in the antivirus research community. To quote Gordon from the mid-1990s: "The virus writer has been characterized by some as bad, evil, depraved, maniac; terrorist, technopathic, genius gone mad, sociopath. This image has been heightened not only by the media, but by some of the actions of the virus writers themselves. Public communications from the writers, in the form of echo-mail messages, often seem to indicate they are intent on doing as much damage as humanly possible. Their electronic publications have in the past reinforced this, and the very fact that they release viruses may seem to confirm it: these people are bad." However, as Gordon continues: "this is a gross oversimplification of the situation, and (…) the virus writing aspect of these individuals is not sufficient to characterize them into one group simply labelled 'unethical people.'" Sarah Gordon: "The Generic Virus Writer." *Virus Bulletin Conference Proceedings* 1994, 122. See Sarah Gordon's web page at <http://www.badguys.org/>.

211. "Case History of a Virus Attack." *Computer Fraud & Security Bulletin*, vol. 10, issue 4, 1988, 6. In a different way, *Viruses Revealed* disparages virus writers, saying that their code is sloppy and most often their viruses do not work. See Harley, Slade, & Gattiker 2001, 62–63.

212. Fites, Johnston, & Kratz 1989, 77, 121.

213. McAfee & Haynes 1989, 188.

214. Alistair Kelman, quoted in Paul Ducklin/Sophos: "Is Virus Writing Really That Bad?" *Anti-Virus Asia Researchers (AVAR) Conference*, 2001 (orig. 1997), 3.

215. McAfee & Haynes 1989, 39.

216. Games were sources of new forms of addiction, habits, and patterns of culture, and hence also a threat to Western culture. As Jerry Bruckner and Gary Garcia's 1982 hit song "Pac-Man Fever" satirized: "I gotta pocket full of quarters, And I'm headed to the arcade. I don't have a lot of money, But I'm bringing everything I've made. I've gotta callus on my finger, And my shoulder's hurtin' too. I'm gonna eat 'em all up, Just as soon as they turn blue. 'Cause I've got Pac-Man Fever, Pac-Man Fever, It's driving me crazy, driving me crazy, I've got Pac-Man Fever, Pac-Man Fever, I'm going out of my mind, going out of my mind." See the Buckner and Garcia official site for "Pac-Man Fever" at <http://www.bucknergarcia.com/>. I am grateful to Jaakko Suominen for originally pointing me to this example.

217. Huhtamo 1996, 194.

218. Lupton 1994, 566.

219. Douglas 1989, 190.

220. Ibid., 207–215.

221. "Punish Virus Spreaders." *Byte*, July 1989, 40.

222. Levy 1985, 40–45.

223. Ibid., passim.

224. Ibid., 127. Cf. Parker 1976, 48. Professor Sulonen, who studied in Brown University and worked with the Xerox Palo Alto labs in the 1970s, recalled similar types of examples of tactical systems crashing. Reijo Sulonen, phone interview with author, November 23, 2005.

225. According to some commentators, 1984 was when "hacker" was for the first time used as a pejorative term to refer to computer vandals. Nissenbaum 2004, 206. Cf. Hafner & Markoff 1991, 10–12. Yet, already in the mid-1970s, the term had been used for a teleoperating computer criminal. See Parker 1976, 107–117.

226. "Runme.org" website. <http://www.runme.org/feature/read/+forkbombsh/+47/>. See Kittler's article on protected mode (1993b).

227. "Irresponsible Computer 'Game.'" *The Risks Digest*, vol. 1, issue 23, November 18, 1985. <http://catless.ncl.ac.uk/Risks/1.23.html#subj4.1>.

228. Nissenbaum 2004, 201. See, e.g., the High-Performance Computing Act of 1991. <http:// assembler.law.cornell.edu/uscode/html/uscode15/usc_sec_15_00005501----000-notes.html>. See also, e.g., Negroponte 1995. For an enlightening discussion of the term "hacker" by hackers themselves, see The Computer Underground Digest discussions from the 1990s on, archived online at <http://www.soci.niu.edu/~cudigest/other/backiss.html>.

229. Nissenbaum 2004, 199–200.

230. Ross 1991, 80.

231. Flichy 2001.

232. Campbell-Kelly 2004. Following Lazzarato (2004, 197–199), Microsoft's power resides not in exploiting its workers (as the traditional Marxian explanation would suggest) but in creating a clientele and organizing the social field of production in a linear fashion: producers versus consumers (where consumers represent the huge majority of people). It is on this social field that alternative modes of production are easily called "suspicious."

233. Clough & Mungo 1992, 223.

234. See Terranova 2004, 154, passim.

235. Harley, Slade, & Gattiker 2001, 35.

236. David S. Bennahum: "Heart of Darkness." *Wired*, vol. 5, issue 11, November 1997. <http://www.wired.com/wired/archive/5.11/heartof.html>. Cf. "Bulgarians Linked to Computer Virus." *New York Times*, December 21, 1990.

237. David S. Bennahum: "Heart of Darkness." *Wired*, vol. 5, issue 11, November 1997. <http://www.wired.com/wired/archive/5.11/heartof.html?pg=2&topic=>. Cf. Dmitry O. Gryaznov: "Russia: A Computer Virus Jungle?" *Virus Bulletin Conference Proceedings* 1993, 149–150.

238. Dmitry O. Gryaznov: "Russia: A Computer Virus Jungle?" *Virus Bulletin Conference Proceedings* 1993.

239. Pavel Baudis: "Viruses behind the ex-Iron Curtain." *Virus Bulletin Conference Proceedings* 1994, 158. For example, the 17th November 1989 (Pojer) virus included the message: "Viruses against political extremes, for freedom and parliamentary democracy." This illustrates how viruses have been understood also as media tools, perfect for efficient distribution of messages. In the United States, the MacMag Peace virus functioned in the same way, promoting a message of peace across the globe. Such viruses in the Eastern bloc countries can perhaps be analyzed using the notion of tactical media. See Lovink 2003, 254–274.

240. Scott Berinato: "Attack of the Bots." *Wired*, vol. 14, issue 11, November 2006. <http:// www.wired.com/wired/archive/14.11/botnet.html>.

241. Lampo 2002.

242. Lukas Barr: "Long Live the New Flesh. An Interview with David Cronenberg." <http:// industrycentral.net/director_interviews/DC01.HTM>.

243. Sontag 2002, 77.

244. Terranova 2004. Hardt & Negri 2000. Castells 1996. See also Lovink 2003.

245. "One of the most fascinating aspects of the entire software/medicine analogy is the amazing degree to which it holds. Modern computer systems and software are now complex enough to support a crude simulation of life-cycle processes." Steve Gibson: "Computer Viruses Express Themselves in Many Ways." *Infoworld*, April 18, 1988.

246. See Terranova 2004, 98–100.

CHAPTER 3

LIFE: VIRAL ECOLOGIES

This ability to reproduce is, of course, the most important and distinctive feature of viruses. For the first time in the history of technology, mankind has created an artificial device that is capable of reproducing itself and, without further human intervention, pursue a course of action than can cause harm, even if the original programmer had no such intention.[1]

—*John McAfee & Colin Haynes (1989)*

At the center of these problems one finds that of error. For, at the most basic level of life, the processes of coding and decoding give way to a chance occurrence that, before becoming a disease, a deficiency, or a monstrosity, is something like a disturbance in the informative system, something like a "mistake." In this sense, life—and this is its radical feature—is that which is capable of error. And perhaps it is this datum or rather this contingency which must be asked to account for the fact that the question of anomaly permeates the whole of biology. And it must also be asked to account for the mutations and evolutive processes to which they lead.[2]

—*Michel Foucault (1985)*

PROLOGUE: THE LIFE OF INFORMATION

The media archaeological roots of self-reproducing technology and the fear of technological automata reach far back, much further than has been presented earlier. The interesting thing is how certain themes come to dominate both the biological and the technological interests of knowledge. As the epigraph taken from Foucault notes, anomaly rose to be a key theme in biology (but also in technology) during the cybernetic (late twentieth-century) phase of life sciences. Self-reproduction, duration, and distributed processes had, however, already characterized both spheres in the nineteenth century. The end of the nineteenth century is especially worth noting in our context. Charles Darwin, in particular, introduced radical ideas of time and development in the context of the animal kingdom, but evolution was perceived to be part of the technological sphere as well: near the end of the nineteenth century, not only animals were described

as having evolved but technology as well. Lieutenant-General A. Lane-Fox Pitt-Rivers became famous for his collection of tools and his arguments concerning the evolution of such artificial organisms.[3] For Pitt-Rivers, material culture (he was, for instance, interested in the genealogy of weaponry) worked through similar patterns to organic evolution. Even more famous have been the views—marked by an astute sense of satire—of Samuel Butler and his novel *Erewhon*, a novel about "nowhere", yet read as "now-here"—a conception of time and history also as untimely, open to becomings bypassing linearity.[4]

Although the narrative of *Erewhon*, first published in 1872, is loyal to the genre of utopia novels, it also presents themes that attach it to an epistemic field that is pertinent to our digital perspective as well. Whereas Darwin opened up history both as an evolutionary past and as a potentially open future, Butler's fantasies map a certain event of technological evolution that presents keys to understanding the intertwining of technology and biology.

In the novel a Western traveler stumbles upon an isolated tribe where all pieces of advanced technology are restricted to museums. As it turns out, the tribe has consciously refrained from technology owing to a fear of the evolution of machines. Even the protagonist's watch is confiscated and put into the museum next to other freaks of technological nature:

> It was filled with cases containing all manner of curiosities—such as skeletons, stuffed birds and animals, carvings in stone (whereof I saw several that were like those on the saddle, only smaller), but the greater part of the room was occupied by broken machinery of all descriptions. The larger specimens had a case to themselves, and tickets with writing on them in a character, which I could not understand. There were fragments of steam engines, all broken and rusted; among them I saw a cylinder and a piston, a broken fly-wheel, and part of a crank, which was laid on the ground by their side. Again, there was a very old carriage whose wheels in spite of rust and decay, I could see, had been designed originally for iron rails. Indeed, there were fragments of a great many of our own most advanced inventions; but they seemed all to be several hundred years old, and to be placed where they were, not for instruction, but curiosity. As I said before, all were marred and broken.[5]

The sudden change in Erewhon's history was due to a book, *The Book of Machines*, that argued that machines were to be regarded as living and vital entities that evolve. *The Book of Machines* contains a thorough exposition of this peculiar stance toward technology. Written by a "hypothetic", a scholar of the College of Unreason (another ridiculed absurdity of the novel), the treatise functions to demonstrate that machines are capable of reproduction and evolution. For the writer, machines are cities or societies; that is, they are not to be understood as

single entities but as complex organizations of parts that communicate. Machines are inherently interconnected, similar to nature, through complex structures of kinship, filiation, and symbiosis. Hence, we find the surprisingly common theme of the late nineteenth century of interfacing nature and technology, perhaps the strongest outgrowth planted by the Romantic age. The knowledge of the evolutionary patterns of animal and plant life provides the necessary understanding to see where technological progress is headed. But, as the writer notes, there can be no evolution without reproduction:

> Surely if a machine is able to reproduce another machine systematically, we may say that it has a reproductive system. What is a reproductive system, if it be not a system for reproduction? And how few of the machines are there by other machines? But it is man that makes them do so. Yes; but is it not insects that make many of the plants reproductive, and would not whole families of plants die out if their fertilisation was not effected by a class of agents utterly foreign to themselves? Does any one say that the red clover has no reproductive system because the humble bee (and the humble bee only) must aid and abet it before it can reproduce? No one. The humble bee is a part of the reproductive system of the clover. Each one of ourselves has sprung from minute animalcules whose entity was entirely distinct from our own, and which acted after their kind with no thought or heed of what we might think about it. These little creatures are part of our own reproductive system; then why not we part of that of the machines?[6]

With Butler and his *Erewhon*, we have imaginary reproducing machines a hundred years before digitalized self-reproduction. In this sense *Erewhon* acts as a passage between the age of industrial machines and the era of viral ecologies. This early expression of fear of dynamic material and evolutionary science can be expressed in terms of a parable that connects to another form of figuration of artificial life in a contemporary media context. Produced during the early years of the artificial life boom, the hit movie *Jurassic Park* (1993)—again written by Michael Crichton, the writer of the first "virus novel", *The Andromeda Strain*, and the writer and director of *Westworld*—shows a prefabricated artificial ecology that runs out of control and demonstrates how dynamic living systems can be. The laboratory-grown dinosaurs exhibit out-of-bounds behavior in relation to the prefabricated amusement park ecology they are placed in. The life of such partially artificially created creatures overflows the closed ecologies, showing how unpredictable the organism–environment coupling can be. Actually, this theme of systems spreading outside their (designed) borders is a one of recent decades that connects audiovisual expressions from *Blade Runner* (with replicants leaving their designated habitat) to *Tron* (with the malicious master program aiming to control the world outside it as well) and on to the various movies on biological

contagions. Similar concerns to those articulated already in *Erewhon's* world of metastable, distributed technological systems that overflow their intended design contexts have been distributed across the wider field of genetics and computer artificial life. Here, again, such "noise" functions as the surplus of technological rationality.

Only during the course of the twentieth century did such ideas of evolving technologies gain more consistency and start to form the abstract machine, or diagram, that characterizes the media ecology of network culture. Of course, automated self-perpetuating technologies of the clock and, for example, the cinematic image had already characterized the late nineteenth-century fear of automation, acting as a form of premeditating probeheads for contemporary technologies of self-reproduction. In the midst of novel technological creatures, Butler's ideas expressed a new field of reproduction that works as a machinic assemblage, as Luciana Parisi notes. Here, techno-cultural reproduction is not tied to the hierarchical principle of reproductive intelligence but proceeds as a complex field of connectivity: "[T]here is no centre of reproduction, but only a continuously scattered connection of machines of reproduction, related and mixed with each other. For example, the egg of a butterfly becomes a caterpillar, which then becomes a chrysalis, which then produces a new butterfly. (…) The butterfly is a machine that affords the egg ways to make another egg: a machinic production."[7] It is important to note that this model of evolution is based on ideas of symbiosis and affirmative parasitism. The neo-Darwinian model, which has been widely embraced in biology as well as in computer culture, rests on seeing competition as the key force. We need, however, more affirmative models that take into account anomalous symbiotic phenomena. Lynn Margulis has been the key person in introducing these ideas into the biological field, and similar ideas need to be addressed in respect to digital network culture.[8]

Computers have become the general pilots for a whole range of cultural entities and activities from intelligence to life. In this regard, it is not surprising that computers have also been figured as living entities, ecosystems of a sort. At least since the 1940s, information has been at the heart of the Western scientific understanding of life. For example, in his famous "What Is Life" (1944), Erwin Schrödinger depicted living systems as being born, on the basic level, of a "code-script", information that guides the development of systems from birth to adulthood. Genetics adopted this idea of information as the key to hereditary traits, and James Watson and Francis Crick's discoveries concerning the structure of DNA rested on similar allusions to the informatics of life in general. Later, computers played a crucial part in the Human Genome Project, which in a way mapped the

alphabet, or the information codes, of human life as we know it. Digital archives became the ultimate cultural memory banks of humanity, deposits of the very stuff we humans were made of.[9] Similarly, software tools are increasingly used to help "biologists understand how nature operates."[10]

The Universal Turing Machine of the late twentieth century acts in various contexts as the storage model for life. In the words of François Jacob, a Nobel Prize winner from 1965 who continued the project of the physico-chemical conceptualization of living organisms:

> (M)odern biology belongs to the new age of mechanism. The program is a model borrowed from electronic computers. It equates the genetic material of an egg with the magnetic tape of a computer. It evokes a series of operations to be carried out, the rigidity of their sequence and their underlying purpose.[11]

His colleague Jacques Monod proceeded along similar lines in this atmosphere of novel, open-ended biology: no more Hegelian thematics of dialectical laws governing living systems; instead we should turn to another figure of the nineteenth century, namely, George Boole and his algebra, to find a novel ground for a biology with a cybernetic quality.[12] From the 1950s on, life and information became entangled and understood through the negative entropy principle: life means resistance to the disordering force of entropy, a temporary organization against disorder.[13] Hence, life was not a specific substance but information and organization, which opened the way to designing technical patterns of organization that resisted entropy. This marked the first steps of artificial life, ALife, research. Thus, it should be noted up front that the fields of artificial life, computer science, and, for example, cybernetics, which seem to have conflated the biological and the technological during recent decades, were expressions of the historically specific understanding of life as information, a mode of organization. Here, the question of structure (understood as material substance) was deemed crucial, and it became a key cultural theme in various contexts throughout the latter part of the twentieth century.

Incidental to our topic, such a plane of technological biology also affected the nascent field of virology. As part of the techniques of vision and conceptualization, biological viruses had since the late nineteenth century also been seen as technological parasites, and technological models and tools were increasingly used to understand their patterns of reproduction and virality. For instance, with Jacob and Monod there was a constant feedback loop between concepts such as bacteria, phages, information, circuits, and switches that tied the spheres of biology and

information science intimately together.[14] As cybernetics incorporated biology as an essential part of its self-understanding and practices, so biology was cybernetized. The intimate cooperation between mathematicians, biologists, and researchers in physics and computer science worked toward finding convenient crossing-points between the disciplines.[15] Of course, as Alex Galloway notes, this informationalization of life was already a part of the episteme of the nineteenth century, with Bertillon's system of criminal phrenology, Muybridge and the quantification of human movement, and similar systems of measuring and objectifying life into tables, paragraphs, and diagrams.[16] In this sense, the discourse network of 1900 analyzed by Kittler can be seen as a general diagram of abstraction and automation: instead of "hallucinating meaning" in writing, as in the discourse network of 1800, we have machines that write for us, Boolean algebra that thinks for us, and the media technologies of inscription that record life (with its noise). Cultural practices such as writing become autonomized from human subjects and automated as isolated (countable) functions, as in the psychophysics of Hermann Ebbinghaus.[17]

The previous chapter focused on something we intuitively think of as an essential part of life, that is, the body as a mode of organization. As discussed there, the concepts of body and virality provided the central thematics for a cultural history of disease in the late twentieth century. In this sense, bodies and diseases were not just entities of the biological sphere but taken in their diagrammatic dimension as notions that span the whole social field. Moreover, the world of technology and digital culture connected with this sphere to develop an understanding of the contemporary culture of computers. This provided elements for a media ecology that essentially relies on a certain metaphoric and metamorphotic basis deterritorialized by biology and ecology.

Paradoxically, there is nothing natural about nature, and similarly the digital culture of bodies and viruses is not to be understood as a deterministic system of laws. Instead, as discussed, it has been a culture of bifurcations and contingencies, of potentialities as virtualities, of a constant struggle for meaning and articulation, and of a general battle to find stable states of order, healthiness, and control with which sickness and disease could be easily deciphered. AIDS as the central disease (syndrome) of the 1980s provided key elements for this, leading to the use of such concepts as "safe hex", "responsibility in use", "digital hygienics", and "computer hygiene", which posited a certain ideal horizon of a natural, healthy culture of computing.

This positing worked through certain micropolitical maneuvers. The conceptual elements were turned into recommendations for action for the users, analyzed above as a form of care for the digital self. Two central figures emerged: the

promoted idea of a responsible user who practiced digital hygiene and safe hex, and the feared and loathed irresponsible virus-writing vandal who was understood as part of the genealogy of the hacker—in itself an ambiguous figure of digital culture. These discourses, in addition to elements from Chapter 1 such as viral capitalism, networking, and risk society, are, bit by bit, pieces of which the diagram or media ecology of viral digital culture consists.

This chapter deepens the understanding of "the biology of digital culture" by addressing the discussions of computer viruses as forms of artificial life. From the early 1990s, in particular, such articulations gained ground, partly because a specific field of ALife, analysis of artificial processes of life, was established at the end of the 1980s—in 1987 in Los Alamos to be precise. Of course, viruses and the informationalization of life sciences were discussed not merely in scientific circles but also in various cultural products, such as the aspiring literary genre of late modernity called "killer virus novels."[18]

In fact, a whole range of practices and discourses of artificial life emerged at the end of the 1980s and the 1990s. Artificial life was not merely an academic endeavor; ideas of complexity, self-reproduction, evolution, and adaptability were widespread within the emerging media culture. The early models and ideas of ecology and self-organization stem from the end of the nineteenth century, when Eduard Suess coined the term, which Vladimir Vernadsky inserted into an ecological context in the 1920s. As Charlie Gere sums up the more recent history of the term, from the 1960s on the ecology movement took advantage of and also produced these new scientific and cultural ideas, and at the same time digital culture was stamped with the label of its own form of ecology. Maturana and Varela's idea of autopoiesis emphasized the interaction of an organism with its surroundings; Edward Lorenz used computers to model atmospheric events in the 1960s; John Conway's Game of Life from the 1970s used the idea of a cellular automaton to exhibit the potential for complexity to emerge from a simple set of states; Benoit Mandelbrot introduced the fractal ontology of the world, an idea made possible by the simulation power of computers.[19] These ideas, which are close to systems theory and second-order cybernetics, for example, were also in use from the 1980s on in a range of robot projects, installations, and software programs that mixed engineering with artistic ambitions in an attempt to produce entwinings of nature and technology that challenged many traditional ideas concerning life.[20]

The paradigm of artificial life rested on techno-cultural presumptions, well summarized by N. Katherine Hayles as a threefold agenda. First, wetware research refers to the creation of artificial biological life in, for example, test tubes. Second,

hardware artificial life means a focus on embodied life forms such as robots. Third, software artificial life is focused on computer programs that exhibit "emergent or evolutionary processes." For Hayles, all share a "bottom-up" agenda of research:

> In the software branch, with which I am concerned here, the idea is to begin with a few simple local rules and then, through structures that are highly recursive, allow complexity to emerge spontaneously. Emergence implies that properties or programs appear on their own, often developing in ways not anticipated by the person who created the simulation. Structures that lead to emergence typically involve complex feedback loops in which the outputs of a system are repeatedly fed back as input. As the recursive looping continues, small deviations can quickly become magnified, leading to the complex interactions and unpredictable evolutions associated with emergence.[21]

Hayles makes the important remark that the gap between self-reproductive software and living organisms has remained wide, and has often been obscured by certain narrative strategies. Similarly, computer viruses have been, especially since the beginning of the 1990s, described in various contexts as forms of life. In addition to mapping these articulations, I present a genealogy of network virality and ALife, starting from the origins of computer culture with John von Neumann and Norbert Wiener, demonstrating that with these pioneers ideas of self-production and technological life were already prevalent. As I pursue this cartography of explicit articulations, I develop another, more implicit idea. Perhaps computer viruses are a symptom, a sign of the very basis of network culture, which in general has the same functional capabilities as viruses, namely, self-reproduction (copying), networking, and communication? Perhaps viruses are just what digital network culture is all about?[22]

In this chapter, I embark on a diagrammatic mission that focuses on the material workings of a viral ecology traversing network culture. In this, I return to the question of media ecology with the aim not so much to draw analogies between technology and nature as to find and create concepts that help us understand the processes of digital culture. "Ecology" does not function as an innocently representative or descriptive tool but as a diagrammatic aid and a pilot.[23] Diagrams channel and create; they do not represent.

Chapter 3, "Life", offers, then, a counternarrative, a countermemory, to Chapter 1, "Fear and Security." In a way I am writing here an alternative account of computer viruses that emphasizes the active and countermemorizing methodology of media archaeology. This amounts to finding cracks, openings, and anomalies within the usual narratives of computing and offering a surprising view of viruses and worms. Just as the research on computer viruses as artificial life

is connected to a certain experimental ethos of science, media archaeology is an experimental way of questioning in terms of its methodology of problematizing the already known.[24] If the cultural history of computer worms and viruses can be mapped from the viewpoint of how they became malicious in the cultural contexts of the digital culture of the 1980s, so their history can be written from the viewpoint of experimentality and networking. In this, viruses and worms do not remain anomalous objects of malicious nature but actually stand at the center of our cultural condition of network societies. What follows is a genealogy of the incorporeal and corporeal forces that affirm the nonorganic life of reproductive, semi-autonomous software.

THE BENEVOLENT VIRAL MACHINE

During the early 1990s, viruses and worms became everyday inhabitants of the media ecology of network culture. After the 1988 Morris worm incident, viruses became a widely recognized (and at times overestimated) danger. This led to a boom in the antivirus market, with new companies offering their security programs for safe computing. Of course, the recurring overkill statements of viral dangers did not guarantee safety, something that was then already widely criticized.[25] At the same time, however, as discussed in Chapter 1, virus writers organized themselves into clans and bulletin board systems to spread viruses, even wrapping in commercial issues. Viruses were sold on special bulletin boards that acted as trading houses for such miniprograms.[26] At the same time, the research community turned from novel ideas in out-of-control (metastable) computing and distributed programs toward an emphasis on security. As the ideas spread from research laboratories to "the wild", self-reproductive code was quickly turned into a new constellation of malicious software.[27]

The early 1990s also witnessed a certain trait within computer virus discourse that was soon forgotten. For a few years, several researchers participated in practices and discussions concerning ideas of computer viruses as a form of artificial life, a theme that was, of course, virtually present for decades within computer science, yet one that actualized only then. Although it is possible to see these themes merely as a subplot within the dominant understanding of viruses as malicious software, I want to argue that perhaps this apparently marginal trait can highlight crucial issues of the whole phenomenon. The issue focuses on the nature of the informational machine of networking—which, to follow Tiziana

Terranova, can be hypothesized as "an active and turbulent space" that makes "the Internet a space suitable to the spread of contagion and transversal propagation of movement (from computer viruses to ideas and affects)."[28]

Such turbulences were stirred up by researcher Mark Ludwig when he published his *Little Black Book of Computer Viruses* in 1991. Although merely a re-presentation of new media (computer viruses) on an older media form (the book), the event saw Ludwig and his publisher, American Eagle Publishing, labeled as vandals—all owing to the small fact that he had printed working viral code on the pages of a scientific book. According to some researchers, even if the virus code was "old and silly", the book was still harmful, and such actions could not be justi-fied. Even if, for some, Ludwig had the right to publish such information, others suggested that most people within the antivirus community probably viewed the book "with considerable distaste." According to such views, *The Little Black Book of Computer Viruses* was making people's lives more difficult, something that was referred to as "digital suicide", poisoning oneself. [29] The book quickly joined the long genealogy of Black Books containing clandestine pieces of information. In contrast to a few years of more liberal discussion of ALife and benevolent viruses, the responses grew strict as the 1990s proceeded. Hence, several unorthodox views concerning viruses, among them those of Cohen and Ludwig, were quickly and acrimoniously attacked.[30]

Of course, Ludwig himself was quite aware of the possible stir the book would cause. In the foreword to the book he described his task as a commitment to *truth*. Consciously or not, Ludwig was using the basic hacker motto "Information wants to free", which avers that no information should be kept secret. Publishing virus code was an attempt to help people fight malicious viruses:

> I am convinced that computer viruses are not evil and that programmers have a right to create them, posses them and experiment with them. That kind of a stand is going to offend a lot of people, no matter how it is presented. Even a purely technical treatment of viruses which simply discussed how to write them and provided some examples would be offensive. The mere thought of a million well armed hackers out there is enough to drive some bureaucrats mad. These books go beyond a technical treatment, though, to defend the idea that viruses can be useful, interesting, and just plain fun. That is bound to prove even more offensive. Still, the truth is the truth, and it needs to be spoken, even if it is offensive. Morals and ethics cannot be determined by a majority vote, any more than they can be determined by the barrel of a gun or a loud mouth. Might does not make right.[31]

Such ideas were already part of the hacker culture of the 1980s. As, for example, Bernd Fix recollects of his years with the Chaos Computer Club in the

mid-1980s, the aim was to explore what could be done with computer technology. This amounted to a protective ethos that aimed to write viruses in order to come up with efficient antivirus tools against potentially malicious virus writers. Hence the first antivirus tools were developed by hackers and, in particular, the Chaos Computer Club, proving the practical side of experimenting with viral programming.[32] In addition, the mid-1990s saw these issues of experimentality, artificial life, and computer viruses discussed in, for example, the electronic magazine *Alive*, published online in 1994–1995 by Suzana Stojakovic-Celustka. The magazine set itself the task of finding new methods of digital protection, but topped with a keen interest in looking at fundamental questions such as "What can be 'alive' in a computer environment?"[33]

What interests me is this ethos of experimentality as a way of working within computer architecture. Traditionally, it can be connected with hacker ethics, but it can also be connected to such experimenters as Ludwig who aimed to connect programming issues with law and social institutions. This amounts to a certain sphere of micropolitics and aesthetics of digital code, where open source and anticommercialism connect with the aim of finding new protocols or an "elaborate instruction list of how a given technology should work, from the inside out, from the top to the bottom."[34] The aspiration to evade the control of hierarchical institutions becomes a novel model of soft control, or power, that turns to finding the internal limits of an organizational platform such as networked computers.

Yet, *out of control* became an organizational form of viral capitalism in the 1990s, as the title of a book by Kevin Kelly expressed.[35] Out of control actually meant a new form of subtle control over complex systems modeled on the principles of living autopoietic systems. As discussed above, software turned commercial during the 1980s and network computing for businesses was being increasingly touted as the next frontier, the new Gold Rush. Of course, Ludwig was in no way anomalous in his opinions. The old hacker spirit was being kept alive alongside the commercialization of the Internet, as expressed in the "Declaration of Independence of Cyberspace" by John Perry Barlow in the mid-1990s:

> Governments of the Industrial World, you weary giants of flesh and steel, I come from Cyberspace, the new home of Mind. On behalf of the future, I ask you of the past to leave us alone. You are not welcome among us. You have no sovereignty where we gather. / We have no elected government, nor are we likely to have one, so I address you with no greater authority than that with which liberty itself always speaks. I declare the global social space we are building to be naturally independent of the tyrannies you seek to impose on us. You have no moral right to rule us nor do you possess any methods of enforcement we have true reason to fear.[36]

The cyberspace of the mind was injected with a "virus of liberty" underlining the infectious logic of network computing: "In China, Germany, France, Russia, Singapore, Italy and the United States, you are trying to ward off the virus of liberty by erecting guard posts at the frontiers of Cyberspace. These may keep out the contagion for a small time, but they will not work in a world that will soon be blanketed in bit-bearing media."[37] The aspiration to create a new social space of liberty and freedom of expression and thought continued as a general theme of this hacker culture of the Internet age. What has to be underlined is the American basis of this new social contract, articulated both in Ludwig's book and in Barlow's declaration. Barlow's definitions and references fitted in well with the rhetoric of the "original" American dream of freedom, corrupted by big politics and commercial corporations.[38] This combination of freedom and communitarian utopia was, however, logically connected to the utopia of frictionless capitalism, which also demanded decentralization, globalization, harmonization, and empowerment, to borrow key words proposed by Nicholas Negroponte.[39]

However, if *The Little Black Book of Computer Viruses* is to be judged as a book on politics, it it is one written in program code. It lists different types of viruses from simple .com infectors to sophisticated boot-sector viruses, offering hex code and assembly language listings for five viruses. The point in the listings and Ludwig's message is that even though viruses and other programs can have malicious variations and can be used for destructive goals, as with military viruses, computer viruses are not destructive *per se*. In other words, it is not their destructiveness or any malicious payload that defines them as viruses. Instead, viruses are copy-machines that can use the machine to increase their own life span. This makes computer viruses actually "self-reproducing automata", underlining the genealogy of the idea and practices from John von Neumann's cellular automaton theory.[40]

The notion of computer viruses as a form of artificial life was taken up again with Ludwig's sequel to *The Little Black Book of Computer Viruses*, called *Computer Viruses, Artificial Life and Evolution* (1993). Even though it was obvious that digital organisms were not the same as carbon-based life, it remained reasonable to ask whether other traits of life were present in computer viruses. In this, Ludwig proposed to follow the criteria put forth by artificial life researchers before him, looking for the basic characteristics of life in general:

1. The ability to reproduce and the method of reproduction.
2. The concept of emergent behavior.
3. The possession of metabolism.

4. The ability to function under perturbations of the environment and interact with the environment.
5. The ability to evolve.[41]

The virus as artificial life was a theme discussed during the early 1980s in Fred Cohen's pioneer work on computer viruses. In his 1986 doctoral thesis in particular, Cohen articulated the view that viruses could be conceived as exhibiting formal characteristics of reproduction and evolution, both fundamental properties of life.[42] This aspect of Cohen's work was neglected, and such themes were more or less marginal until a special field of research into artificial life gained was consolidated in 1987 (yet it remained marginal within the field of science). The first workshop was organized by Christopher Langton in Los Alamos and more or less settled the agenda for this the highly transdisciplinary field of questioning, which ranged from computer life to ecological dynamics, on to synthetic biology and theories of self-organization.[43] Curiously, Langton invited A.K. Dewdney to give a demonstration of the Core Wars game but did not extend the invitation to Fred Cohen, who was explicitly engaged in viral programming.[44] Despite this downplaying of the viral in early ALife contexts, a few years later the stage was set for such writers as Eugene Spafford to question, in 1990, whether computer viruses were a form of artificial life.

For several critics, the lesson from studying computer viruses was the realization of the danger inherent in such miniprograms. Systems that were somewhat alive were never totally controlled, which also exposed society at large to risk. On a programming level, this referred to ideas of floating code and self-recurring programs experimented with in speculative software research. Such code experiments in, for instance, genetic algorithms and programming were designed to incorporate variations, recombinations, and mutations into the modeled systems.[45] Computational efficiency was, however, continuously limited by the inability securely to control such dynamic systems. The problem with most accounts of evolution in computer culture discourse is that they rest on neo-Darwinian assumptions of what evolution is. These warlike models of competition and selfishness are not able to take into account the possibility that network culture and its software are fundamentally parasitic and symbiotic.[46] This is the problem with Ludwig's and several others' cautions concerning viruses, although Cohen can be seen as working toward ideas of symbiosis on the software level.

Of course, the idea of viruses as artificial life was not taken at face value. Even Mark Ludwig ended up being skeptical. Although viruses had gained some degree of autonomy in environments that were not explicitly designed to foster them,

thus showing capabilities of adaptation and emergence behavior, they had in several senses failed the "test of life." [47] Their evolutionary patterns had remained short and, in many ways, viruses continued to be very determined by the program code originally inserted into them, thus also being dependent on the programmers, the human interface. Ludwig designed his own version of the polymorph virus with a form of genetic memory. This way the virus was equipped with potential evolutionary capacity as it could remember the useful variations it went through. It did not, however, work as an evolutionary unit, partly because the actual computer systems were (and are still) too unstable to admit radical mutations. Mutating code did not work in these carefully structured computer operating systems.

Yet, such analytical accounts do not contradict what I am implying. More interesting than strict accounts of whether computer viruses and worms are alive (the question of Being) are the problematics of what life in computer discourse and ecology could mean and the ethos of experimentality connected to this questioning. Computer viruses and worms might not be alive in the formal sense of the word, but still they are acting and affecting pieces of code, resulting in both representations of *unheimlich* life and concrete, nondiscursive effects on a global scale. [48] The question of living computer programs has not been a mere theoretical daydream; it connects with the interesting topic of benevolent viruses, which was picked up at the start of the 1990s and dropped some years later. It had a life span as short as the topic of artificial life in viral computing. Some might argue that despite the superficial resemblances of these ideas, the two discourses were not connected, but I suggest quite the opposite. [49] The idea of benevolent and useful viruses was very much part of the idea of viral life, and these ideas have a common, though neglected, history.

The connecting node can again be found in Fred Cohen's work. As stated above, Cohen had an early interest in artificial life, when he explicitly figured computer architecture as a form of ecology. Computer organisms, such as viruses, could not be understood outside the context of their natural habitat, which concretely meant the Universal Turing Machine architecture. This led to the important conceptualization of (artificial) life as coupling:

The essence of a life form is not simply the environment that supports life, nor simply a form which, given the proper environment, will live. The essence of a living system is the coupling of form with environment. The environment is the context, and the form is the content. If we consider them together, we consider the nature of life. [50]

The formality of the Turing machine presents itself as the ontological technical principle of contemporary digital culture. The idea of algorithmic coding

and a machine that is able to process those algorithms forms the basis of this idea, formulated by Cohen in the early 1980s. This Universal Turing Machine is equivalent to digital computers, which are able to code heterogeneous units of information into discrete symbols and process them effectively in their logical circuits.[51] In this sense, the mathematicians of the early twentieth century (Church, Gödel, Turing) were in a key position to define the future of computing machines as *abstract machines* in the technical sense of the term. Logical sequences that controlled a machine's functions were not essentially part of its material form, but algorithmic, that is, formal. What mattered were the blueprints for how specific machines were *organized*; thus the emphasis was on the formal relationships of parts, not so much the specific material of the parts. This was already the key assumption of artificial life projects.[52]

What Cohen adds to this schema of computers is a viral twist: first, viruses share the formal characteristics of the Turing universe, but, second, viruses include a potential for new forms of evolutionary principles of computing, an evolved version of the Turing machine, which Cohen depicts as the Universal Viral Machine. In other words, this represents a turn to the *virulence* of virus programs, not their payloads. Given that viruses are bits of code that by definition function only to infect, self-reproduce, and activate from time to time, it is no wonder that several computer scientists have been unable to view them as passive material (crude technological components). Instead, they have been viewed as something acting, spreading, as if living. Rather than just an articulation on the level of cultural imaginary, this is a fundamental description of the machinic processes of these programs and of digital culture in general. What Cohen established—and this might be his lasting contribution, even if one does not want to downplay his achievements in computer science—was the realization that digital culture was on the verge of a paradigm shift from the culture of Universal Turing Machines to an ecology of Universal Viral Machines, which was no longer restricted to the noisy capabilities of the people designing the algorithms. Such evolutionary concepts of computing provided a model for a digital culture that increasingly relied on capabilities of self-reproductive, distributed, semi-autonomous actors. To quote Cohen's all-too-neglected words encapsulating the media ecology of networking digital culture:

> Since we have shown that an arbitrary machine can be embedded with a virus (Theorem 6), we will now choose a particular class of machines to embed to get a class of viruses with the property that the successive members of the viral set generated from any particular member of the set, contain subsequences which are (in Turing's notation) the successive iterations of the "Universal Computing Machine." The successive members are called "evolutions" of the previous members, and thus any number that can be "computed" by

a TM [Turing Machine], can be "evolved" by a virus. We therefore conclude that "viruses" are at least as powerful class of computing machines as TMs, and that there is a "Universal Viral Machine" which can evolve any "computable" number.[53]

In other words, as with Ludwig, viruses were to be understood as powerful mechanisms of computing, not purely as malicious pieces of software, even though malicious subroutines could be part of a virus sequence. Security against malicious software (and the people using it to wage war) was only one component of computer viruses, expressed in the difference between the quasi-code of

```
subroutine infect-executable:=
{loop:file = get-random-executable-file;
if first-line-of-file = 01234567 then goto loop;
compress file;
prepend compression-virus to file;
}
```

and

```
subroutine trigger-pulled:=
{return true if some condition holds}
main-program:=
{infect-executable;
if trigger-pulled then do-damage;
goto next;}
```

In plain English, the activities of viruses are not reducible to the potential damage malicious software is capable of inflicting on national and international bodies of organizational order (cf. Chapter 1). Even if Cohen's point, or general aim, was obviously to find models and procedures for secure computing—to maintain the flow of information in a society—this task was accompanied by something of a more fundamental nature. The viral routines were not confined to damage; they enabled the idea of benevolent viruses, too. For example, the "compression virus" could function as an autonomous maintenance unit to save disk space.[54] In 1994 Cohen introduced other such viral programs that for the sake of political correctness were called "live programs", or LPs: software distribution LPs could maintain and update network databases; other LPs could be used to implement distributed databases because of their built-in parallel processing capabilities; and LPs could also, as noted before, perform such maintenance operations as "hunting down" and killing temporary files.[55]

Hence, the virus was not merely a problematic noisy infiltrator in the channels of communication; it was also a potentially benevolent power of viral computing

and "friendly contagions." Tony Sampson has described this new phase of network ecology well:

> The viral ecosystem is an alternative to Turing–von Neumann capability. Key to this system is a benevolent virus, which epitomises the ethic of open culture. Drawing upon a biological analogy, benevolent viral computing reproduces in order to accomplish its goals; the computing environment evolving rather than being 'designed every step of the way.' (…) The viral ecosystem demonstrates how the spread of viruses can purposely evolve through the computational space using the shared processing power of all host machines. Information enters the host machine via infection and a translator program alerts the user. The benevolent virus passes through the host machine with any additional modifications made by the infected user.[56]

What Sampson underlines, and what I find an illustrating emphasis, is that such ideas are basically grounding steps for a certain form of viral ecosystem of digital culture in which worms and viruses are to be regarded not as necessarily malicious but as potentially powerful processes of computing. Such ideas have been advanced more concretely in genetic algorithm applications that breed new processes and routines for computer systems.

The general understanding that with virus-like programs we are dealing with malicious software is in fact partly dependent on projected fears of artificial life, but, as hinted above, this thematics of life risks turning the original emphasis on its head. What if we do not take these warnings about and definitions of worms and viruses as malicious at their face value, but look for alternative definitions, such as Cohen's or Ludwig's, or practices such as genetic algorithms or cellular automata? What if we take these more or less marginal ideas as the starting point in the countermapping of an alternative, a supplementary, understanding of viruses and the cultural history of digital culture in general? Even if such ideas gained explicit consistency at the end of the 1980s and beginning of the 1990s, their lineages span back through the early experiments with network computing of the 1960s and 1970s all the way to the computing pioneers of the 1940s and 1950s.

In short, viruses and worms are perhaps not anomalous objects of digital dirt; they reveal characteristics of a specific digital ecology and actually can provide an essential viewpoint on our network culture. Interestingly, and implicitly, this discourse of viral ALife articulates the patiently developed understanding of the new networked media spaces as environments and ecologies, thus also reflecting general trends of computing and digital culture. In this, viruses are not the outside of network culture but express its very defining modes of operating.

CELLULAR AUTOMATA AND SIMULATED ECOLOGIES

If our digital culture starts with Turing and von Neumann, so does the culture(/ing) of digital viruses. The Turing machine principle included virtually the whole sphere of Universal Virus Machines that were self-reproductive automatized calculating processes, not far from the idea of later genetic algorithms and other forms of evolutionary calculation. As Fred Cohen noted at one point, although ironically, the Morris worm of 1988 was perhaps to be understood as the most powerful high-speed computation event ever![57] In an e-mail in 2005 Cohen stressed the same notion: "The point is that viruses are general purpose computing mechanisms and, as such, could be useful for reliable, high performance, resilient, distributed computing."[58] Parasitic power can, then, be understood as springing from an experiment in massive parallel computing that uses thousands of computers on the Internet to further its patterns, as with the Internet worm. Such viruses and worms "in the wild" have frequently been the focus of researchers, but one must notice that often worm and virus programs have been tested only in restricted conditions. In this sense, several worms and viruses discussed here are "laboratory viruses", or, as was the case with von Neumann's "viruses", they were merely formal models, mathematical patterns.

As von Neumann thought in the aftermath of World War II, designing computers was designing organs and organisms, that is, machines that could function independently as natural beings. The relationship between nature and technology was, however, complex:

> Natural organisms are, as a rule, much more complicated and subtle, and therefore much less well understood in detail, than are artificial automata. Nevertheless, some regularities which we observe in the organization of the former may be quite instructive in our thinking and planning of the latter; and conversely, a good deal of our experiences and difficulties with our artificial automata can be to some extent projected on our interpretations of natural organisms.[59]

Nature has been the ultimate imaginary reference point for digital culture ever since. Of course, the cybernetic and computer science and systems theory projects had very down-to-earth, pragmatic aims of developing efficient tools for simulating and controlling complex environments. Herbert Simon's ideas from the 1960s of how artificial systems reflect the complexity of their surroundings, just as ants reflect their habitat, gives a good idea of how control management was conceptualized during the latter half of the twentieth century. Simon sees the artifact as interfacing an inner environment with its outside, the surroundings.

Simon also gives a special place to digital computers as systems of imitation and simulation.[60] Computers catalyzed and channeled the complexity of the larger social field, and specific computer routines such as virality were also an interfacing with the complexity of the surrounding social field.

Yet, applications and systems are to be seen as events beyond their predefined goals, and as introducing interesting ideas in complexity, becoming, and virality. This is a point I want to open up from the perspective of media ecologies. As Elisabeth Grosz notes, we are obliged to think of such ecologies not in terms of holistic balance, of unity, but as a mutual production of partners that interact. To emphasize the *ecological* aspect, this should not be understood as a representation or a mirroring, nor even perhaps as the metaphorization of technology via nature, but as a connecting where neither partner to the union precedes the other and both enter into a symbiotic emerging, a conjunction of flows. Hence, instead of ecological balance, we have a "disunified series of systems, a series of disparate flows, energies, events, or entities, bringing together or drawing apart their more or less temporary alignments."[61]

Technological and biological constellations of power and knowledge are continuously intertwined and connected via feedback loops. Such circuitry has, of course, happened on the level of language, and also in concrete design projects and plans that have touched not merely the specialized field of computing labs but also, through various intermediaries, the everyday life of contemporary computerized societies around the globe, laying a sort of digital ecology on the other ecologies (natural, societal, industrial, economical, psychical, etc.). In other words, computer ecology refers here to a need to include complexity as part of the designs of network culture, where "ecology" does not remain a linguistic metaphor but becomes a more fundamental concept to elaborate the topological nature of network culture. Such couplings have also been continuously used as economic strategies underlining the "naturalness" of certain trends of cybernetic media culture (an extrapolation of the past into the future).[62] If we recognize the politics and the economic value in this use of biological concepts, this coupling can be further discussed in terms of ethology. What matter primarily are the intensive movements that define how, for example, cybernetic systems work, how certain potentials are captured (domesticated) for capitalist profit making, and how alternative models of coupling are restricted and labeled as dangerous and as an expression of vandalism. This ethological touch can be developed into a becoming-animal of computer culture, a mutual becoming—not imitating but diagramming, capturing affects and relations from another sphere and contracting them into a technological mode of composition.[63] In the history of computing,

"learning" from biological intensities of life has been a continuous theme, and the conscious coupling done in laboratories and computer science departments has not been only about metaphorics but also about capturing the potentials and affects living entities express.

In the history of computing, couplings of biology and technology have been articulated on various levels. As regularly pointed out, the contemporary culture of digital computers owes a lot to von Neumann's design of computer architecture. This von Neumann model is to be understood primarily as a general-purpose stored-program machine that is also reprogrammable. The central processing unit is separated from the memory (and the input/output functions), and the presence of storage memory allows instructions to be handled as data. Thus we have an organism of sorts, understood as a hierarchical set of "organs" that function in collaboration, relating to processing, memory, control, and user interaction. Paradoxically, this is something that has been exploited by computer viruses as well: because instructions were stored in the form of data, viruses also could "take over" the instruction routines handling the functions and operations of the computer. Whereas earlier computer programming meant mechanically altering the hardware—hardwiring the computer—with von Neumann came the idea that one could store these connections in the form of informational patterns. This made it possible for a computer program to interrupt and alter the data and processes of other programs.[64]

Despite this focus on designing organs and organisms, von Neumann should not be taken as a rigid proponent of classical artificial intelligence. Instead, or in addition, he was very much engaged with issues of parallel and evolutionary computing, distributed information processing, and neural nets, which became the central trends of digital culture only some years after his work. Although, particularly from the end of the 1940s, he was interested in mapping analogies between technology and the human neural system, von Neumann was not a naïve proponent of the analogy between the brain and the computer or of any other simple form of artificial intelligence. As George Dyson writes, von Neumann was actually preoccupied not so much with the question of thinking machines as with designing computers that could *learn to reproduce*.[65]

Von Neumann engaged deeply with automaton theory, where automaton refers to "any system that processes information as part of a self-regulating mechanism."[66] Automata capable of reproduction included logical control mechanisms (modeled on the McCulloch–Pitts theory of neurons), the necessary channels for communication between the original automaton and the one under construction, and muscles to enable the creation. This kinetic model of automata was,

however, soon discarded, as it proved to be too complex for actual construction: a physical automaton was dependent on its environment for a continuous supply of resources, and providing it with such an ecology proved to be too cumbersome. Von Neumann turned to developing *cellular* automata, formal models of reproductive systems with "crystalline regularities."[67] One of the models for formal self-reproductive patterns was the very primitive living organism the bacteriophage.[68] This is an amusing analogy when we remember that the early "bacteria" programs in mainframe computers have been listed as among the oldest forms of programmed threats.[69] Of course, these programs got their name because of their ability to clog the computer's memory and disk space via extensive reproduction (and, in fact, were an earlier form of the forkbomb).

Von Neumann was also very interested in virology. Just after World War II he turned to viruses as the key minimal organisms, interesting because of their ability for orientation, reproduction, and mutation. For von Neumann, such minuscule subcellular actors were links between information processing and life sciences, particularly because of their ability to reproduce.[70] In general, virus research had raised novel perspectives concerning the "informatics of life." These were of keen interest to researchers in molecular biology but also to the wider public, as a headline from *The New York Times* in 1955 demonstrates: "Reconstruction of a Virus in Laboratory Opens the Question: What Is Life?"[71] This research is interesting both as an archaeological trait of studies of artificial life and as part of the interconnection of living organisms and synthetic systems. Lily E. Kay notes how "viruses and genes were becoming agents of information storage and transfer"[72] during the 1950s, and it is merely a small conceptual step from such articulations to designing computer viruses.

Von Neumann himself did not publish anything on the topic of cellular automata. He engaged with the issue around 1946 and discussed his ideas in Princeton and at the Hixon symposium in Pasadena, California, a couple of years later, under the topic of "The Logic of Analogue Nets and Automata." In December 1949 von Neumann addressed the issue at the University of Illinois in five lectures entitled "The Theory and Organization of Complicated Automata." The issue of cellular automata was then continued in an incomplete manuscript, "The Theory of Automata: Construction, Reproduction, Homogeneity", originally from 1952–1953 but published posthumously in the 1960s.[73] Hence, it is clear that von Neumann did not achieve any clear results, even less "products", from his ideas; rather, they remained sketches that resonate with issues especially prevalent decades later. Such models were, however, influential in the field of molecular genetics, where in general cybernetic system theories they functioned

as effective catalyzers of genetic research and, for instance, the discovery of the structure of DNA by Watson and Crick.[74]

Von Neumann's ideas of cellular automata were distributed by John Kemeny in *Scientific American* in his 1955 article "Man Viewed as a Machine." It was mutually arranged that he would write an article based on von Neumann's Vanuxem lectures at Princeton University in 1953.[75] Drawing a history from Turing's machines to von Neumann, Kemeny emphasized the idea of reproduction that von Neumann added to previous models of logic machines. Cellular automata are such reproduction machines that spread according to their internal logic and self-organizing movements. Of course, the model was basically quite simple: a space divided into cubical cells, occupied by "entities" or "actors" that interact according to the logic of the nervous system. The state of a cell is determined by its current state and its relationship with neighboring cells. The whole automaton changes, then, in cycles: "The neurons and transmission cells are either quiescent or they can send out an impulse if properly stimulated. The muscle cells receive commands from the neurons through the transmission cells, and react either by 'killing' some undesired part (i.e., making it inert) or by transforming some inert cell in the environment to a machine part of a specified kind."[76]

A more extensive selection of von Neumann's work on automata was collected and edited by Arthur Burks in 1966 in his *Theory of Self-Reproducing Automata*. The work reveals that von Neumann was actually thinking of five different forms of self-reproductive behavior: kinematic, cellular, continuous, probabilistic, and one based on the excitation–threshold–fatigue model. In general, as he noted at the beginning of his 1949 lectures entitled "Theory and Organization of Complicated Automata", computing machines were a *variety* of artificial automata,[77] implying, of course, that whereas automata were a mathematical and formal problem, computers were more intimately tied to practical engineering work. What was evident was that even though von Neumann was working in the context of computers that were still more or less mere number crunchers, such ideas already went some way toward understanding computers as potential simulation machines that could function as a form of ecology, that is, at least partially autonomously. This is underlined by the construction of visual aids to facilitate the understanding of the complex nature of such operations. Instead of a linear, one-dimensional calculation we have now a two-dimensional diagram of computing events that would be hard to grasp without visual tools to think with. What we have with such reproducing machines are "nerve cells", "muscle cells", and a tail that contains the instructions for producing offspring, as John Kemeny explains.[78] It is as if the whole computing process had come alive with parts that

Figure 27. Universal constructor.

The von Neumann universal constructor is one example of how automata are diagrammatized as two-dimensional figures. Source: Burks 1970, 44. Image used with permission, © Arthur W. Burks.

refer to processes of the living world. Of course, the visual nature of such operations was emphasized in subsequent developments of cellular automata to which I return shortly. At the center were the new diagrams of machinic life, successors of the circuit diagrams of Gottlob Frege's *Begriffsschrift*. Writing had turned into a two-dimensional coordinate system, a technological diagram.

Thus, what we have with such cellular automata is a model for parallel processing computing that, once put into action, could potentially go on forever. But how does such a checkerboard structure with organism-like creatures, or neurons, provide us with a precedent for computer viruses? Instead of seeing

cellular automata as a direct ancestor of contemporary viruses, it forms a point of orientation within the history of digital culture that leads to the material and incorporeal network structure of the contemporary media condition. In other words, even if the classic von Neumann computer architecture is often seen as the paradigmatic technological model of computer culture, we might further emphasize the role of this abstract model of parallel processing, of replicatory self-organizing systems. True, researchers have since engaged in searching for the origins of artificial life theories of complexity in the 1950s, and von Neumann's models of self-reproducing automata are clearly paradigmatic in this sense.[79] Yet, I want to push this recognition further and argue for the centrality of ALife ideas of complexity and self-organization and connectivity concerning the *whole* digital culture of networking of recent decades. Von Neumann believed that the development of automaton theory would be in connection with developments in probability theory, thermodynamics, and information theory, suggesting that the field of inquiry into automata would have to deal also with new paradigms of thinking and logic for computing machinery. As Arthur Burks notes, von Neumann thought that there were "qualitatively new principles involved in systems of great complexity" and he searched "for these principles in the phenomenon of self-reproduction, which clearly depends on complexity."[80] Such aspirations found further resonance after some decades with theories of complexity, artificial life, and network cultures, which were increasingly understood as ecologies.

Other ideas of computational ecologies of complex nature emerged during the 1950s. Among them Nils Barricelli's 1953 experiments with ideas of symbiogenesis applied to computers stand out. The Princeton Institute of Advanced Studies again provided the perfect playground for such artificial ecologies and digital creatures, as it did for several other key computer projects of post–World War II America. Barricelli's project stands out as being more than a mathematical formula as it engaged in actual experimental work with the institute's computer, whereas von Neumann himself always refrained from practical engineering work with computers. Although he was interested in symbiogenesis as a biological phenomenon, Barricelli proceeded to deterritorialize it from its basis in plasmatic life. Konstantin Merezhkovsky had defined symbiogenesis at the beginning of the century, giving the original impetus for ideas that look at evolution as mergings of distinct entities into symbiotic forms. Competition as the basic form of evolution was thus challenged by cooperation, as Lynn Margulis emphasized later during the twentieth century.[81]

Barricelli approached the process of symbiogenetic evolution not as tied to a specific substance but as a certain general pattern that could be tested in any

phylum as well. The computer memory offered Barricelli a platform to engage in experiments with processes that could be speeded up. George Dyson describes Barricelli's computer program in the following manner:

> Working directly in binary machine instruction code, Barricelli constructed a cyclical universe of 512 cells, each cell occupied by a number (or the absence of a number) encoded by 8 bits. Simple rules that Barricelli referred to as "norms" governed the propagation of numbers (or "genes"), a new generation appearing as if by metamorphosis after the execution of a certain number of cycles by the central arithmetic unit of the machine.[82]

The reproduction of genes was tied to the other genes, which effectively made the cells into an interconnected whole. "Connectedness" and "interdependence" were the key terms in Barricelli's own ecology of computer symbiogenesis, which provided him with interesting results concerning the interactions and complexity of such a system. Of specific interest to us are the parasites, of course. At first, the parasites threatened the balance of the system by reproducing too actively, and Barricelli inhibited this reproduction using a specific norm that allowed parasites to reproduce only once per generation. This led to the parasites becoming either harmless or even useful symbiotic genes.

Instead of seeing his tests focusing on biological phenomena as *representations* of potential lineages of natural processes, he underscored their simulationary aspects: "They are not models, not any more than living organisms are models. They are a particular class of self-reproducing structures already defined."[83] What we have here is an affirmation of the computer as a simulation machine that is not to be understood merely as a *tool* to research the real world outside it. Instead, the computer was in Barricelli's experiments enacted as an ecology of its own type, not subordinate to any other transcendent reality but a world of its own, connected immanently to its outside. Whether the organisms within the computer were living according to a comprehensive definition of the term is irrelevant; what is important is that they were real in their own environment. It is unnecessary for our purposes to point out the possible problems with Barricelli's ideas from a biological viewpoint. Again, what is important is that he designed a system with organisms and parasites that would be able to reproduce and evolve within a computer environment—something that cannot be neglected when mapping the genealogy of computer worms and viruses.

Barricelli's ecosystem was supported by the logic circuits and vacuum tubes of the computer designed by von Neumann specifically for scientific work. Von Neumann probably never got the chance to know about these practical implementations of computational ecology, as he left Princeton in 1954 and died just a

few years later. Computer scientists and biologists neglected Barricelli's work, and only during the 1990s did Barricelli acquire the status he deserves as one of the pioneers in artificial life.[84]

What is, of course, paradoxical is that the IAS (Institute for Advanced Study) computer, like computers of that time in general, was designed for weapons research, in particular computations concerning atomic weapons. At the same time, it was used to interface nature and technology in novel ways, for instance, with calculations concerning weather phenomena, and in creating such artificial ecologies as Barricelli's experiments. Technologies of death could also be used to create new modes of life.

Thus, important military simulations and computational ecologies produced new types of assemblages. The 1950s saw the first artificial intelligence applications in the form of simulations and tests with human–machine interfaces. RAND Corporation, founded in 1946, was a defense department think tank dedicated to interdisciplinary forecasting of social trends and to which we owe several of the key innovations in networking. It received its own version of von Neumann's IAS computer in 1952 and an IBM 701 in 1953.[85]

RAND's two computers were used for simulation purposes. One of the chief architects was Allen Newell, the 1975 Turing award winner, who emphasized the potential of such simulatory practices: computers were clearly more than large calculators and were capable of maintaining complex symbolic processes.[86] Computers were already during the 1950s occasionally seen as self-organizing systems. Particularly interesting is the report from 1959 by Beatrice and Sydney Rome on the Leviathan system,[87] developed at the System Development Corporation (a spin-off from the RAND thinktank).[88] Leviathan was a system for organization analysis that simulated social events and flows of information. It was to be based on adaptability and not only on common determinate preprogrammed systems of sequential logical steps: "It appears reasonably certain that neither classical symbolic logic nor existing mathematical formulations of social processes are adequate at present to provide analytical predictive control over such multi-level processes."[89] The system is a good expression of the post–World War II era emphasis on systematic analysis and simulation of social, economic, and military scenarios.

Leviathan was a self-organizing system that integrated humans in cybernetic fashion as part of the circuits. In my view, it presents an even more interesting scenario of human–computer interaction than Wiener's cybernetics in that the Leviathan model is directly conceived as a form of media ecology. In a way, the model was not planned as a computational enhancement of, for example, decision making but as a more thorough platform or an environment. Of course,

its purpose was very functionally defined: to find efficient models of hierarchical organizational interaction. More interesting was the way this research was conducted and the presupposition expressed that organizations are multilayered and dynamic systems, built from the bottom up, "in analogy to the organization of molecules into cells, of cells into organs, of organs into animals."[90] The IBM 709 was in this regard analogous to the molecular and animal kingdom and also to "large social groups", which were analyzed in terms of their functions, coalitions, policies, and importantly flow of information, where the temporal dynamics of the system was emphasized. In the system, social actions were described in terms of interactive computer processes—computerized agents:

> Our program, then, begins with a design for an automaton that will be made to operate in a computer. Circuits will be so imposed on the computer that their performance will be analogous to the operations of human agents in real social groups. Next, we shall cut the computer free from its ordinarily employed ability to accomplish mathematical computations. (…) The patterns and entailments of the specific activations will be controlled so that they will be isomorphic with significant aspects of individual human actions. (…) The micro-processes in the computer resemble the microfunctioning of real agents under social constraints."[91]

As George Dyson notes, the project became "an extensive experiment in communication and information handling",[92] introducing novel concepts of organization. These were inherently learning systems, a concept that was later adapted as a key phrase of information capitalist culture in general, alongside "flexibility." We could reasonably argue that this has been an aspiration in systems design ever since these projects of cybernetics and systems theory. Adaptive computer systems have been discussed, then, at least since the end of the 1950s.[93] Illustrative in this sense was Oliver Selfridge's Pandemonium project, which was modeled to receive and analyze Morse code. As Dyson notes, Selfridge's project from the end of the 1950s was based on Darwinian principles of information evolution. It was also modeled as a parallel processor, which Selfridge saw as a more "natural" manner of handling information. The Pandemonium platform was inhabited by a semi-autonomous code of processing demons:

> At the bottom the data demons serve merely to store and pass on the data. At the next level the computational demons or sub-demons perform certain more or less complicated computations on the data and pass the results of these up to the next level, the cognitive demons who weigh all the evidence, as it were. Each cognitive demon computes a shriek, and from all the shrieks the highest level demon of all, the decision demon, merely selects the loudest.[94]

Pandemonium predated contemporary probabilistic choice tools by decades. Even though it was too heavy or "wasteful" in its own time, Pandemonium clearly exhibited system tendencies that actualized on a large scale only decades later, in the 1980s. Manuel DeLanda sees Pandemonium as an early form of computational ecology that one can find in autonomous weapons systems and also in global computer networks. Intelligence is distributed to local actors, which "barter, bid, and compete" for resources and consequently create complex interactional patterns. Such interactions of computer demons can be seen as societies reminiscent of natural ecologies, similar to insect societies.[95] In Pandemonium, a special place was reserved for "natural selection", which was supposed to allow the system to evolve in a self-organized manner, independent of its designers. The successful demons were fed back to the system for evaluation so that the overall scheme for a specific task was kept optimal. The idea was to create "organisms" and "processes" that survived and were thus fit for replication: "Therefore, instead of having but one Pandemonium we might have some crowd of them, all fairly similarly constructed, and employ natural selection on the crowd of them. Eliminate the relatively poor and encourage the rest to generate new machines in their own images."[96] Obviously such projects were very keen on using Darwinian ideas and phrases.

In other words, we have already, since the 1950s, an important amount of research into computer architecture that is based on self-organization and replication, complexity, and a certain simulacrum of algorithmic nature. Cybernetic research was in a key position with a keen interest in systems that displayed traits of growth, learning, and self-reproduction. Patterns of differentiation were planned for complex artificial systems, which were intended to be *learning* systems, open to their surroundings (instead of merely *developing* systems, closed to information coming from outside).[97]

Norbert Wiener included a chapter with the title "On Learning and Self-Reproducing Machines" in the second edition of his influential *Cybernetics* book. Wiener writes in 1961 about living systems as having the power to learn and to reproduce:

> These properties, different as they appear, are intimately related to one another. An animal that learns is one which is capable of being transformed by its past environment into a different being and is therefore adjustable to its environment within its individual lifetime. An animal that multiplies is able to create other animals in its own likeness at least approximately, although not so completely in its own likeness that they cannot vary in the course of time.[98]

The issues of learning and reproduction in machines were also central to his 1964 book *God and Golem, Inc.* Wiener saw that such oxymorons, of *machines* recreating themselves and even learning, provided a serious threat to the established (religious) worldview of man at the center of the universe. Taking as his cue religious metaphysical themes such as "man creates man in his own image", Wiener asked a key question of the late twentieth century: "What is the image of a machine? Can this image, as embodied in one machine, bring a machine of general sort, not yet committed to a particular specific identity, to reproduce the original machine, either absolutely or under some change that may be construed as a variation?"[99] This question addressed the very ontological premises of machines but also their connection with humans. The Turing machine seemed to offer such a platform for these ponderings, in a similar way to how novel biological theories of evolution increasingly addressed symbiosis and nonlinear evolution. Even Wiener himself tackled the issue of virality and parasitism in evolution.[100] In addition, such ideas were incorporated into experimental projects, an apt example being adaptation machines that learn, a project at MIT in the early 1970s.[101] As Alex Galloway notes, Wiener's ideas of life saw it as resisting the second law of thermodynamics, which states that the world is governed by entropy. Life works through creating consistencies that (temporarily) resist entropy. Galloway emphasizes that Wiener's radical significance is in the way he includes machines in this diagram: technologically created "organisms", too, can resist entropy and hence are by this definition something akin to living beings.[102] Of course, cybernetics in general was occupied with such an agenda, as, for example, Michael J. Apter's study *Cybernetics and Development* from 1966 demonstrates.[103]

So, what we have are two interconnecting themes, here only separated to provide analytical aids to my argument. On the one hand, we have projects and designs that mapped the computer as a simulation platform or a cybernetic environment where artificial agents were promoted to be active participants in the self-organization of such ecological platforms. What Wiener engaged with was the production of the design blueprints, or at least ideas, for such agents. Repeating the topos of the digital culture design of interfacing nature with technology, Wiener studies animal behavior and characteristics to organize them into digital environments. Why were Wiener and so many other computer pioneers preoccupied with nature and animals? The key explanation in my opinion lies in the realization that they are the perfect examples and models for complex systems, adaptive behavior, collective functioning, ecological coupling, and self-reproduction, all themes that were incorporated into the third nature of the network culture.[104]

All in all, such perspectives reveal that seeing computers as rigid rationalization machines misses several points. This whole chapter revolves around the intertwining genealogy of computer worms and viruses, artificial life logics of complexity, and the network culture; such ideas did perhaps, on a wider scale, actualize during the 1980s, but they had a reality already in the 1950s. Thus, we do not have a clear-cut break between an early computer culture of hierarchical computer platforms and a self-organizing logic of network cultures. I will stick with the general analytical distinction that whereas computer culture followed in its early decades a certain logic of classical top-down programmed artificial intelligence, the shift toward complexity theories, network paradigms, and a specific logic of bottom-up artificial life happened during the 1960s and 1970s. Nonetheless, what are interesting are the mediators—for example, computer projects, design blueprints, or other texts—that partly incorporate certain ideas of artificial life, worms and viruses, or network computing "before their time."

I mapped earlier the lineages of security concerns and the creation of a particular class of "malicious software"; I also want to "accidentalize", or "eventualize", such a genealogy. Here the move from history to archaeology and genealogy is to be underlined: we are not looking for origins and natural filiations. Instead, we are looking for events, perhaps even *lost* ones, that raise the issue of *Herkunft*, descent. Following Foucault, genealogy does not mean deciphering continuities behind appearances, as the past is not present as any lived reality but only in fragments of the archive, as monuments. Genealogy as a method of cultural analysis activates, then, the need for a rethinking of archaeological events as constituent of our present being, but also as a potential way to look for new modes of being. Genealogy becomes a way to underline the Nietzschean will-to-knowledge that underlies any apparently innocent truth or natural state of being. Truth is posited, not found:

> to follow the complex course of descent is to maintain passing events in their proper dispersion; it is to identify the accidents, the minute deviations—or conversely, the complete reversals—the errors, the false appraisals, and the faulty calculations that gave birth to those things that continue to exist and have value for us; it is to discover that truth or being do not lie at the root of what we know and what we are, but the exteriority of accidents.[105]

Foucault proposes an alternative mode of thought that does not believe in the linear evolution of a species (or concepts and diagrams). At the beginning, there is no unity, identity, or principle that governs later actualizations, but an accident, singularity, and event. Such an "ecology of thought" is something that suits the

purpose of this book perfectly: seeing that the category of "malicious software" is merely in itself an accidental creature opens up the possibility for alternative, minor conceptualizations of virus-like and worm-like programs. Hence, in this sense, these are not strictly taken as *tentative forms* of contemporary viruses— there is no continuous lineage flowing from the past to the future. This does not contradict my thesis that such programs stand at the center of the media condition of digital culture: instead of presuming a lineage from the computer ecologies and virus-like programs of the 1950s and 1960s to the viruses of 1980s, we short-circuit the discourses of computer worms and viruses with such projects of earlier decades. Thus we actively create a new circuit that produces novel historical connections. In this way we are able to channel the accident of malicious software as part of an accidental ontology, that is, not an eternal category for the identity of a virus program but in a substantial way an incorporeal event through which the multiplicity of the phenomenon has been stabilized.

ORGANISMS OF DISTRIBUTED NETWORKS

Leibniz had already imagined a machine that allows numbers themselves to do the counting, and such peculiar images were addressed again with automatization and computerization. These automata illustrate a key theme of the twentieth century, earlier than computers. Automated machines had been a source of amazement since the eighteenth century, the early years of industrialization. The Vaucanson duck and other automata incorporated the idea of simulation of life, and hence the beginnings of artificial life, in their uncanny self-movement and coordination of systematic activities. In factory production, such characteristics became everyday life.[106] Manuel DeLanda sees this automatization of tasks from the human to the machine as the crucial moment in the birth of software, locating the focal point in Jacquard's loom and subsequently Babbage's interests in analytical machines and the transformation of control from humans to machines. Jacquard's loom incorporated data (but not control) as part of its card program system. This idea was used for decades with tabulators and calculators, but the principle of the Turing machine included the idea that control structures, the instructions for handling data, could also be represented as data. As DeLanda notes in his genealogy of distributed system intelligence, in the 1950s Turing emphasized the movement of control from hardware to software with the idea that computer tasks can be distributed into subprograms (although still at that

point subjugated to the master program). The ideas of computer science were, then, closely related to, for example, Herbert Simon's theories of the design of complex artificial systems from the 1960s.[107]

In 1922 *Scientific American* prophesied how "strips of paper", that is, machines programmed with perforated punch cards, would be taking control: "The time is coming when workmen will be largely supplanted by such strips of paper; when a walk through a factory will disclose hundreds of machines in operation with a mere handful of attendants fussing about. *In some uncanny way, things will seem to be running themselves.*"[108] Years later, such uncanny technological quasi-objects seemed to be multiplying, and the latter half of the twentieth century was repeatedly characterized as an age of automation. Whereas above we tuned into the ecological basis and simulation projects of early computing, now it is worth retuning into the uncanny "objects" that "seem to be running themselves." In this light it is interesting to review, for example, the Darwin and Core Wars projects briefly analyzed in Chapter 1. As we learned there, Darwin was an early game-like program designed at the AT&T Bell laboratories in the early 1960s. The game's digital organisms fought for the memory space of the computer, each trying to win the habitat for itself. Despite such "hostile" implications, the game can also be viewed as a model of a digital ecology. The game was played inside the computer: whereas a conventional game might use its game board as a mere tool for human-to-human interaction, Darwin allowed the platform to take on a life of its own.[109]

As one of the programmers, Vic Vyssotsky, recalls, the question was whether such self-reproducing organisms could be built: "I wasn't thinking in terms of 'viruses' or 'Trojan Horses' or 'worms' or whatever; I was just idly curious about what the most simple and effective ways would be of designing programs whose only function would be to make copies of themselves."[110] The patterns were, on a local level, simple: programs in Darwin tried (1) to replicate in unoccupied parts of the game arena (a restricted part of the memory) and (2) to destroy other species by attacking their memory locations. Vyssotsky, Doug McIllroy, and Robert Morris used a biologically loaded vocabulary of "species" and "organisms" to describe the game, which leads one to think of mini-ecologies of digital nature. The organisms were constrained by simple rules that kept the programs bounded within the arena but that also allowed cooperation and synergy in the game: "[An organism] may employ any desired computational procedures, may look at any cell in the arena, including cells occupied by members of other species. A player is entitled to make the members of his species communicate or cooperate in any desired fashion, or he may make them ignore each other."[111]

As mentioned in Chapter 1, Darwin was picked up again after years of silence in the early 1980s. The Core Wars game of A.K. Dewdney used similar premises for its operations. Again, the emphasis was on the novel ecology of semi-autonomous actors: "It is unlike almost all other computer games in that people do not play at all! The contending programs are written by people, of course, but once a battle is under way the creator of a program can do nothing but watch helplessly as the product of hours spent in design and implementation either lives or dies on the screen."[112] The feeling of impotence when confronted by such events is also something that has become a recurring topos when describing the experience of a virus attack.

With Core Wars and Darwin we see a culmination of the early interests in such programs that exhibit autonomous behavior within a computer environment. Although computers had, of course, been designed from the beginning as automation machines, their automatism was limited as the programmer or operator had to control and interact with the processes of early mainframe computers. In this context, such autonomous processes were undoubtedly inspiring: computers and programs that act nearly autonomously, cooperate among themselves, and even reproduce. There was even the slight chance of an unplanned spread of these epidemics, as Vyssotsky recalls: "At that time there was of course nothing like the internet, but the various computation centers of Bell Labs were networked together for load-balancing, and the Bell Labs operating system BE SYS was used by many other organizations, shipped out on mag[netic] tape, and the last thing we wanted was to have one of our beasties accidentally wind up on a distribution tape of BE SYS."[113]

Such ideas were not restricted to Darwin but followed from very simple realizations. The "`Move(program counter) program counter+1`" command made the computer follow a repetitious process to fill up its memory and was used as a clean-up utility in early core memory computers such as the IBM 1620 (released in 1959).[114] Similar recursive processes were innovated in the form of rabbit programs that turned the linear structure of batch processing computers into loop structures. The instructions were sent back to the beginning of the jobstream queue, which caused "constipation."[115] Of course, such commands could be perpetual motion machines only on a fictional Turing machine, where the tape would be imagined as infinite. Nevertheless, the idea of a computer recursively processing its own output seems fascinating: computer software parasiting its "host."

As a challenge to the traditional metaphysical view of inert material, these technological organisms seemed to have a potential life of their own—"beasties", as Vyssotsky called them. Referring to the computer culture of the 1960s, the 1983 Turing award winner, Ken Thompson, recalls a set of programs called "life":

A computer program would have a set of species, they would interact with other species, they would live, die, reproduce, etc. based on these interactions. Species would eat species, species would kill species for no reason. Species would gang up and kill species. Species would compete for reproduction, etc. We thought of it as an aquarium full of things that tried to survive for a long time.[116]

According to Thompson, such self-reproducing programs were tested in computer departments and labs in the early 1960s. Thompson also recalls Darwin as a program based on similar ideas to "life": for the young programmers, it was "easy and straight forward."[117] Von Neumann's ideas of cellular automata of self-reproduction were also actively on the agenda of computer programmers during the 1960s and 1970s.[118] In particular, another program called Life has often been mentioned in connection with viruses.

Von Neumann's cellular automata were at one point even designed as the basis for a concrete Cellular Automata Machine, representing interest in the idea of such multiprocessing grids. Among the most important and famous proponents of research into cellular automata has been Stephen Wolfram, also working at the Institute for Advanced Study in Princeton, whose project, started in the 1980s, has been to show how the world in general is an ontological grid based on the logic of cellular automata. These have been used as calculatory principles "drawing" complex patterns that, according to Wolfram, are nature's own patterns, found, for example, in mussel shells.[119] Such projects are a good example of how complex calculatory simulation machines such as cellular automata have, since the 1960s and 1970s, been seen also as the essence of nature and the world. If genes have been informationalized, so has the chemico-physical basis of the world.

We will, however, take a more modest approach and focus on computer structures and simulations. As mentioned, another Life program, or Game of Life as it has also been called, is seen as influential in this respect. John Conway was working as a mathematician at the University of Cambridge in the late 1960s when he remodeled the von Neumann cellular automata into "a game" where the cells could have only two states: dead or alive, on or off. Game of Life was "played" on a checkerboard structure, where the aim was to inspect the possibilities of growing complex structures using basic building principles. Conway was also after the principles of universal computation, but we can focus on the more concretely defined implications of this work and the attention it has received. Hence, the two important aspects of this computer project were that it was "one of the earliest attempts to simulate something resembling life on a computer"[120] and its practical experience with interacting, complex computational structures.

Self-reproduction had a key role in the Game of Life and other early cellular automata. Such games were designed in the 1960s and 1970s to simulate patterns of proliferation and growth, and molecular biologists such as Manfred Eigen used similar ideas with a special emphasis on introducing errors, mutations, and randomness into the games.[121] Whereas Eigen was after evolution, Conway's aim, and the aim of others such as computer scientist Tommaso Toffoli, was to show how such simple principles could yield to processes and phenomena that were self-reproducing and self-sustaining.[122] The keen interest was in automating certain computational processes: even if programmers were responsible for coding the basic behavior of the cells and the grid, the aim was to let the cells interact in a way that would make the structure into a second-order phenomenon, able to sustain its own being without external help.

From von Neumann's cellular automata on, such ideas represented the aim to see nature as a computational process and to analyze (and synthesize) such phenomena of *global computation*. Relying on ideas of population thinking, global computation has meant modeling computational ecologies as a form of evolutionary phenomena. Evolution, however, has been viewed on the basis of populations not individuals, meaning that evolution and other Darwinist phenomena happen on the statistically approachable level of "global" populations. Cellular automata, as one form of such biological global computation, are thought of as using such basic computational models of evolution in their systems. Local and simple rules governing relationships of cells produce widespread global results that span the whole of the (cellular automaton) system. Such ideas developed during the late twentieth century represent attempts to capture computational procedures of population biology, or as Terranova differentiates this form of cellular automata computation from linearly biased models: "Biological computation envisages an abstract computational diagram able to simulate (and hence capture) the productive capacities of multitudes of discrete and interacting elements. The most productive challenge of (cellular automaton) systems to the sequential computer lies in the fact that they do not start with the easily controllable linearity of a tape, but with the multiplicity of a population."[123]

If we look at Conway's work from another perspective, his aim can be seen to reside in creating a self-replicating machine.[124] The main focus was perhaps not on the cells but on the interactions between them that created the replication process. This emergent phenomenon implied that replication was something inherently part of the world, and hence, in particular, part of the simulatory computer environment! Although labeled as part of "recreational mathematics", it was recognized also as part of the history of mathematical organisms and simulations: "Because

of its analogies with the rise, fall, and alterations of a society of living organisms, it belongs to a growing class of what are called 'simulation games'—games that resemble real-life processes",[125] as Martin Gardner described Conway's brainchild in his famous "Mathematical Games" column in 1970.

Whereas Conway focused on "cells" and their interaction as the basic pattern of automata, another experiment at the MIT Artificial Intelligence laboratory referred already in 1973 to "worms." Michael Beeler wrote a memo on his mathematical tests of a pattern called "Paterson's worm", which was named after Michael Paterson and John Conway's original ideas concerning the mathematical modeling of a prehistoric worm that follows innate rules regarding its movements and actions. Paleontologists had traced the fossils of such worms; mathematicians tried to bring them back to life as simulations:

> Early in 1971, Michael Paterson mentioned to me a mathematical idealization of the prehistoric worm. He and John Conway had been interested in a worm constrained to eat food only along the grid lines of graph paper. Take, for instance, quadrille paper, and let a "worm egg" hatch at an intersection in an arbitrarily large grid of food. The worms starts eating in some direction, say east (E). When it has traveled one unit of distance, it arrives at a new intersection. Its behavior at this (and every following) intersection is determined by a set of fixed, innate rules. Each rule is of the form, "if the intersection has distribution D of eaten and uneaten segments, then leave the node via (uneaten) grid segment G."[126]

What interests me here primarily is how, again, the biological—in this case the paleontological organism—is interfaced with informational patterns. This was von Neumann's idea of creating computational "organisms", and the same idea was used in Michael Apter's (1966) notions of simulating developing organisms on a computer. Apter used in his examples the sea urchin and the zygote, among others.[127] Nature in its complexity and efficiency also proved to be an ideal partner to be interfaced in these computer projects of the end of the twentieth century. As the organizational and processual requirements of society and thus communication networks grew more complex, solutions were sought from the highly intriguing organizational patterns of animals and their milieus. As Evelyn Fox Keller writes, discussing the intermingling of cybernetics and life sciences on the post–World War II agenda: "Can it be any surprise, then, that in the bootstrap process of modeling organisms and machines, each upon the other, not only do organisms and machines come increasingly to resemble each other but that, as they do, the meaning of both terms undergoes some rather critical changes?"[128]

In other words, these pilot projects of digital organisms and interaction can be seen as part of the agenda that focused on creating new informational milieus.

Network projects and the creation of distributed interactions, in particular, can be seen as occupying the crucial position, especially from the viewpoint of contemporary globalized Internet culture.

Of course, John Conway's game was still based on such simplicity that he could use a single Digital PDP-7 computer for his experiments on life.[129] These processes were not network organisms *per se*, even though such experiments paved the way for the distributed programs to come. Yet, in general, the growing efficiency of computers that could process more complex simulations was a key requirement for such tests. Even though one should be careful not to put too much weight on the rhetoric of information revolutions, George Dyson's notes on the changing face of computing power during the 1960s and 1970s are interesting. Dyson writes how the microprocessor boom of the 1970s led to a huge number of new numerical symbio-organisms—that is, new programs and new code. Dyson's choice of words takes careful advantage of the ecological implications. Even though we are used to talking about the history of computers as focused on people making computers and code and using them (whether it is the focus on the inventors and geniuses behind the machines or the recent emphasis on users in cultural studies of technology), it is possible to take an even more complex view and look at the big picture as one formed of parasites, symbionts, and dependency, just as in any "natural" ecology. To follow Dyson, most software can thus be seen as parasitic/symbiotic as it depends on the "host metabolism", or the structuration to which it is coupled. Concretely Dyson refers to the new operating systems:

> By the 1960s complex numerical symbioorganisms known as operating systems had evolved, bringing with them entire ecologies of symbionts, parasites, and coevolving hosts. The most successful operating systems, such as OS/360, MS-DOS, and UNIX, succeeded in transforming and expanding the digital universe to better propagate themselves. It took five thousand programmer-years of effort to write and debug the OS/360 code; the parasites and symbionts sprouted up overnight.[130]

On the one hand, Dyson problematically sees cybernetic systems as autonomously natural without taking into account the other side of the coin. Cybernetic systems are based on control, modulation, cultivation, and updating, instead of being straight-forwardly emergent.[131] If we speak of emergence, it has to be in relation to the continuous efforts where technological systems are articulated as part of national and international politics, economic interests, and so forth: a continuous double movement between the actors contributing their share to the movement of the whole system and the system on its "global" level feeding back to the

actors. Naturally, Dyson is not writing about computer worms and viruses as we understand them—but that is the core of the issue: to rethink what we mean by parasites and to see whether actually our whole computer infrastructure is based on such patterns of symbiosis and interdependence. Whereas Dyson focuses on the operating systems, I want to stress the importance of networking and the techniques and processes related to it. Instead of automatically emerging, they were developed as part of national politics of the post–World War II era. Although it is customary to start with ARPANET (1969), it is equally important to contextualize it in general within the national (and later international) trend toward new networks of communication. Ralph Smith used the rhetoric of information highways as early as 1970 in his article in *The Nation*, followed by his 1972 book *The Wired Nation—Cable TV: The Electronic Communication Highway*: "In the 1960s, the nation provided large federal subsidies for a new interstate highway system to facilitate and modernize the flow of automatic traffic in the United States. In the 1970s it should make a similar national commitment for an electronic highway system, to facilitate the exchange of information and ideas."[132] Indeed, as Alex Galloway notes, the building of the Dwight D. Eisenhower System of Interstate & Defense Highways, or the interstate highway system, begun in 1956, represented the first intentional distributed network system and was probably a perfect model for informational networks.[133]

Such views concentrating on the communicatory sphere of "information and ideas" were not individual utopias but at the very core of discussions concerning post-Fordist society. Ralph Smith was channeling ideas that were actually from a 1969 report he produced with the Electronics Industry Association, which emphasized cable TV as the main infrastructure for the information society of the future. As Vincent Mosco paraphrases the report: "The EIA called for the development of a national cable system that, at the start, would provide electronic delivery of mail, access from the home to the world's libraries, comprehensive video surveillance to curtail crime ('within a community, streets and stores can be kept under surveillance from a central source'), and electronic shopping and banking. These are familiar themes in the forecasts about the Internet."[134] This highlights the fact that even though the emphasis has been put on computer networks, it was very unclear perhaps until the 1980s what types of technological solutions would actualize these aspirations toward networking. In a sense, this underlines the fact that the network utopias of the late twentieth century are very much "social" in the sense that they do not originate from technology in itself but from an assemblage of technology + affects + representations + politics + histories of various forms.[135]

But as we are dealing with computer organisms, the focus on ARPANET and computer networks in general is well founded. ARPANET and other local networks from the 1970s on saw a new batch of digital organisms and practices that form the genealogical framework for contemporary network software—which are parasitical by definition. In this sense it is no accident (except in the Virilian sense of the word) that the first viruses and worms were utility and test programs of the early network projects. Networking meant new paradigms for programming, as well as providing a fertile platform for novel ideas of digital ontology. Viruses and worms were a functional element within this new trend of computing, such as the Creeper virus in 1970, designed for the Tenex operating system. Creeper was able to use modem connections to infiltrate remote systems. It was, however, a utility program.[136] To quote a bunch of the key architects of the Internet and ARPANET, looking back at the early applications of the 1970s:

> In addition to email, file transfer, and remote login, other applications were proposed in the early days of the Internet, including packet-based voice communication (the precursor of Internet telephony), various models of file and disk sharing, and early "worm" programs illustrating the concept of agents (and viruses). The Internet was not designed for just one application but as a general infrastructure on which new applications could be conceived, exemplified later by the emergence of the Web.[137]

The principles of networking inherent in such computer projects promoted new ways of thinking about the design of computer organisms. As part of the slow turn toward post-Fordist themes of information society, organizations were increasingly depicted as distributed systems. Even though the 1980s and 1990s in particular were labeled with such ideas of adaptability, evolution, and complexity in business, technological, and social organizations, this sort of "swarm intelligence" was already part of the socio-technological diagram of networking. A perfect example is the idea of packet switching, which was pioneered with ARPANET. It introduced local intelligence to communications: instead of being controlled from above from a centralized, hierarchical position, network communications distributed the control into small packets that found their own way from sender to recipient. In a way, such packets, and the distributed routing algorithms, included the idea of autonomy and local intelligence of bottom-up systems, and the network in general was formed into a distributed communications system.[138] Nowadays, as Wendy Chun notes, your networked Mac or Windows machine actually wanders all the time in interaction with other networked machines despite the illusion that the user is in control of her machine.[139] This reflects how the actions, affects, and

events of the Internet do not take place solely on the level of the human being but also between protocol, software, and hardware processes.

Manuel DeLanda describes this shift as a formation of a novel type of a "mechanosphere" of interconnected computational societies that are modeled as ecological systems. With packet switching we have, according to DeLanda, a novel class of actors, "independent software objects, or demons that roam across the networks." He sees these semi-autonomous programs as catalysts for the networks' self-organization, a key component of adaptable and distributed networks.[140]

Packet-switching computer networks were not too common at first, the pioneers being ARPANET and the MERIT network, a research network in Michigan.[141] Models of networking were ideated by networked thinktanks and university labs, especially MIT and UCLA. RAND Corporation, too, was active, and it produced in the early 1960s an important paper concerning the diagrams of networking: Paul Baran's "On Distributed Communications" (1964). Although, as Charlie Gere stresses, the Internet was not solely a development that originated from Baran's paper, the paper addressed several key organizational and logistical

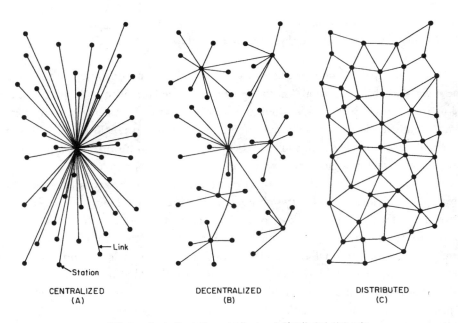

FIG. I — Centralized, Decentralized and Distributed Networks

Baran's network models. © RAND Corporation. Used with permission.

traits of complex networking.[142] The redundant communication model of distrib-
uted networks provided not only the hoped-for counterforce in case of an enemy
nuclear attack but also interesting patterns of communication that rested on local
intelligence and nonhuman adaptation. To quote Baran's paper:

> This simple simultaneous learning and forgetting mechanism implemented independ-
> ently at each node causes the entire network to suggest the appearance of an adaptive
> system responding to gross changes of environment in several respects, without human
> intervention. For example, consider self-adaptation to station location. A station, Able,
> normally transmitted from one location in the network, as shown in Fig. 12(a). If Able
> moved to the location shown in Fig. 12(b), all he need do to announce his new location
> is to transmit a few seconds of dummy traffic. The network will quickly learn the new
> location and direct traffic toward Able at his new location. The links could also be cut
> and altered, yet the network would relearn. Each node sees its environment through
> myopic eyes by only having links and link status information to a few neighbors. There is
> no central control; only a simple local routing policy is performed at each node, yet the
> overall system adapts.[143]

Since the early diagrams, the basic architecture of the Internet has been based
on data that is intelligent in the sense that it contains its own instructions for
moving, using networks to accomplish its operations. In this sense, we can justifi-
ably claim that the origins of semi-autonomous programs that include in them-
selves the instructions for moving reside in the schematics of network computing
in general. If the problems with computer security were intimately connected to
this new form of connectionism, so were the promises. As with automation during
the previous industrialization processes, the new autonomous network programs
promised to automate several repetitive and dull procedures, for example, the
updating of programs. John Walker's quiz program Animal, which was written in
Univac assembly language, demanded updates because of its sudden popularity.
Walker had to send magnetic tapes to people via ordinary mail, before he realized
how to change this. In January 1975 he wrote the Pervade addition to the Animal
program, which was based on autonomous processes: "When called, it created an
independent process which, while the host program was going about its business,
would examine all the directories accessible to its caller. If a directory did not
contain a copy of the program, or contained an older version, PERVADE would
copy the version being executed into that directory."[144]

The program was installed in San Francisco on a business computer, and later
it was added by Walker to company computers in Washington, D.C. Owing to a
small operating system characteristic of the Univac computers, Pervade managed
to send itself to "numerous installations of Univac computers." Apparently Walker

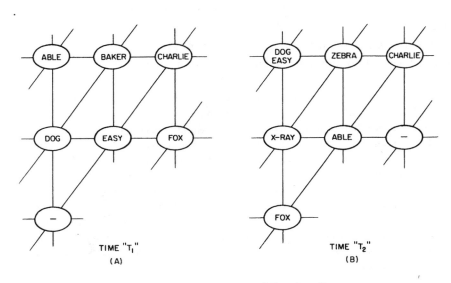

FIG. 12 – Adaptability to Change of User Location

Self-adaptation in Baran's model. © RAND *Corporation. Used with permission.*

wanted, in addition to the utility part, to use the program as a test of potential security problems in computers. Even though the computers were not connected via UNIX or worldwide networks, Pervade testified to the powers of self-spreading software. Although Animal was a "good citizen", as Walker describes it, in that it did not destroy data or programs, he was later very keen to underline the potential problems in having such distributed software: "A program which works exactly like ANIMAL with PERVADE is, in fact, much easier to implement under Unix today than on the Univac System in 1975. In fact, the technique will work on any system which allows multiple processes per user and shared directories. And with networks, things can happen much, much faster."[145]

To take another look at the tension between the corporeal elements and incorporeal effects of the Pervasive Animal (or "Pervade", as it has also been called): the corporeal coupling of distributed systems with semi-autonomous virus-like and worm-like programs developed into an interesting theme during the 1970s—yet, it was not surrounded with the order-words of vandalism, criminality, and the disgust reactions that were frequently expressed after the mid-1980s (incidentally, Walker's memoirs of his Pervasive Animal are from 1985). Self-reproductive software was approached through wholly different layers and practices: such programs

might have been amusing tests, programming challenges, mathematical puzzles, and also representatives of a new phase of digital culture, focused on distribution, adaptation, multiprocessing, and so forth.

The Palo Alto worm programs of the late 1970s and early 1980s resonate with Walker's miniprograms. Palo Alto was one of the highly esteemed institutes at the core of post–World War II computer research in the United States. Along with other similar organizations, many of them mentioned above, the computer and cybernetics research and development scene at Palo Alto was dominated by military and defense interests. For example, the ARPANET project was heavily influence by military funding and interests. Baran's famous 1964 paper was introduced with the notification: "This research is sponsored by the United States Air Force under Project RAND-Contract No. AF 49(638)-700 monitored by the Directorate of Development Plans, Deputy Chief of Staff, Research and Development, Hq USAF."[146] Hence, security interests have been at the core of cybernetics and computers ever since World War II: first, national defense interests, then, since the 1980s, increasingly also business and private interests.[147]

The Palo Alto worm tests probably cannot be reduced to merely part of the history of defense- and security-oriented computing. These programs of distributed computing—also called "vampire programs" in some contexts—spanned the more than 100 computers connected to the Palo Alto Ethernet local network and constituted in fact a "100-element multiprocessor in search of a program to run."[148] The worm programs were designed as connection makers, living on "the cooperation of many different machine users."[149] Although, as discussed in Chapter 1, the worm caused problems as a result of its semi-autonomous nature, it cannot be labeled as malicious software. In addition, it promised interesting prospects in terms of the networking paradigm. The Billboard worm was designed as message automation mechanism, distributing images and texts across a network. The Alarm Clock worm was, self-evidently, a worm-based alarm clock programmed to signal users at a prescribed time. And, among other applications, the Diagnostic worm was used to run diagnostics and maintenance on the Ethernet network.[150]

As noted by the Palo Alto experimenters, such ideas were already "suggested by the mechanisms used within the ARPANET or demonstrations built on top of that network."[151] The Creeper virus, and an enhanced version by Ray Tomlinson, the person often remembered as the inventor of e-mail, were examples of even earlier self-replicators. And it was not only the programs but also the ARPANET structure itself that was seen as a giant routing algorithm, "multimachine distributed computation", used for organizations, simulations, and communications of complex systems such as air space simulations.

Although Shoch and Hupp stress that these were among the trends of the 1970s and that many of the experiments in "distributed applications using the long-haul capabilities of the ARPANET"[152] had, if not waned, then remained as a mere promise, they do demonstrate several traits that connect with a whole new paradigm of computing, or science in general. In computer science, ideas of distributed programming and later, for example, neural network programming were gaining ground, becoming part and parcel of the new (nonlinear) order of digital culture. This was due to the growing complexities of the new networks of computation and communication. As computers were no longer, since the 1970s, calculation machines but "components in complex systems", where systems are built not from the top down but from "subsystems" and "packages", the basic idea of a programmer designing algorithms to carry out a task and achieve a goal had become outdated. The systems were used by various people and in various locations, and the computer world included cooperation both on the human level and on the program level. The emphasis moved to programming as integration, modification, and explanation of already existing programs. One needed to write the key modules of computing such as memory management, the user interface, and network communication only once and then work with those preexisting components, which, of course, nowadays is a more than familiar part of the standard computer culture. Designing distributed program environments for multiple users and programmers was a central requisite for the new organizational ideas.[153] Of course, contemporary Internet topology is not a direct consequence of the early ideas. As network theories have demonstrated, Baran's ideas of distributed networks do not resemble the nonscalar topology that defines most complex networks. The greatest difference lies in the paradoxical combination of distribution and hierarchy that such link structurations of nonscalar models exhibit. Instead of a democracy of nodes and connections, such systems are constituted of a few nodes that have a wide range of links and a majority with very few connections.[154] Interestingly, such a combination of hierarchy and complexity resonates well with the issue of viral capitalism as a machine of heterogenesis but subordinated to antiproduction (monopolies, the state).

One way to grasp the move toward distributed systems (and then toward scale free systems) would be to talk of a Kuhnian paradigm shift: hierarchical systems were toppled by subtle distributed systems in computer science, brain research, biology, human sciences, and so forth. Several critiques of distributed artificial life shifted during the 1980s toward valuing systems that were designed not as central data banks for intelligence but as learning systems that would interact with their surroundings. Before that, the opposition to such ideas from propo-

nents of "hard artificial intelligence" was severe. In a way, the turn participated in the longer genealogy of moving data and control routines from the human first to the machine and then to the distributed interaction between computers and their environments. Manuel DeLanda wrote of this as a paradigm shift from "conservative systems thinking" toward open systems. Instead of promoting models based on systems that are detached from their surroundings, DeLanda saw these novel systems theories underlining the dynamic aspects of flows of matter and energy, a reorientation that "allow[ed] us to discern phenomena that, a few decades ago, were, if they were noticed at all, dismissed as anomalies."[155]

This resonates with a shift of emphasis from top-down artificial intelligence paradigms in computing to seeing connectionism as a fruitful path to be followed in programming, something to which I referred above. "Complexity" and "connectionism" became the key words of digital culture from the 1980s on. The nonlinear processes of computing expressed the "new ideas of nature as a computer and of the computer as part of nature",[156] not reducible to analytic parts but instead functioning as an emergent whole. The general understanding (both in sciences and in humanities) of the world sees nonequilibrium states not as mere disturbances but as increasingly central in describing, for instance, the network culture. As Prigonine and Stengers noted in their early best-seller *Order out of Chaos* from the late 1970s, matter near equilibrium and dynamic states far from equilibrium were becoming useful in understanding how systems interact with their surroundings and envelop the potential for an open-ended becoming.[157]

Not restricted to a merely technical paradigm, the media ecology of networking can be described as a social machine of organization, perhaps one of *swarm intelligence*, to follow Hardt and Negri. The term "swarm", as used in artificial intelligence research (and ALife research, we might add), connects with notions derived from analyzing the collective behavior of ants, bees, and termites: multi-agent distributed systems. Dumb as individuals, their forces lie in the continuous interaction on a systematic level of emergence. Applying the model to contemporary network societies brings forth an even more complex system:

> The swarm model suggested by animal societies and developed by these researchers assumes that each of the agents or particles in the swarm is effectively the same and on its own not very creative. The swarms that we see emerging in the new network political organizations, in contrast, are composed of a multitude of different creative agents. This adds several more layers of complexity to the model. (…) What we need to understand, then, is the collective intelligence that can emerge from the communication and cooperation of such a varied multiplicity.[158]

In Hardt and Negri's take, swarm intelligence, which can be seen as one expression of the logic of networking and cooperative communication structures, becomes a key model for the logic of contemporary empire and multitude. This fits in well with the idea that on the level of abstract machines, or diagrams, such various fields of culture as technology (computing), biology, politics, and economics work in resonance and follow similar abstract patterns.[159] A becoming insect of digital culture.

ECOLOGIES OF COMPLEXITY AND NETWORKING

The early experiments with networking capabilities incorporate an interesting image of the computer scientist that does not adhere to the traditional view of a hierarchical systems engineer. When reading Shoch and Hupp's description of their work in particular, one is led to think of these experiments as minor, or nomad, science in the sense of Deleuze and Guattari. The issue is not one of imposing a form, a code, on the crude passive material of the computer. The programmer is not a demi-urge who feels the obligation to conjure up the otherwise nonexistent life of matter. Instead, we follow here a metallurgical notion of programming and technology that diverges from the basic hylomorphic models of materiality (which presuppose material to be passive and waiting for a god or a social constructionist to blow form and meaning into it).[160] Furthermore, material and energetic flows are differing in themselves and not only passively subject to the differences imposed by human-social categories.

As in metallurgy, the issue is one of following the flows of matter specific to the metal (or, in the case of programming, the computer architecture) at hand. Making tools of specific metal means adjusting oneself to the singularities and tendencies inherent in the metal and working *with* them, not *against* them. "Matter-flow can only be *followed*",[161] write Deleuze and Guattari, in a fashion that also fits well when we think of a more contemporaneous technology of networking and network programming. Digital platforms can be approached as affects and affordances of active matter, differentiation.

The flow of matter is a machinic phylum that the artisan follows. For Deleuze and Guattari, the artisan, the metallurgist, is an itinerant and ambulant following the flow, a nomad.[162] Instead of breaking the material flow (*hylē*) by slicing or detaching, one aims to extract elements of residual energy.[163] The material is itself intensive and full of potential, and the metallurgist merely taps into this field of

potentiality as a co-component. Similarly, we can think of the computer architecture (part of the more widespread and abstract media ecology) as a machinic phylum that has its own potential of flows, operations, logics, uses, and ways of functioning, all of which can be seen as tendencies. These tendencies are virtual in that they are real yet not actual. They are not determined as in the model of a Platonic heaven where ideas lie waiting, but they are only in the mode of becoming actual, of potentially actualizing with the interactions of a programmer. Thus the programmer works on such a phylum, working with its potential tendencies, sniffing and experimenting what can be done. The programmers working with the new phylum of network computing have, since the 1960s and especially the 1970s, been experimenting with the flows proper to a network of connected computers and the flows, protocols, and so on that are part of it. And as a part of this experimentation, viruses and worms have been followed as patterns inherent in this machinic phylum.

What has to be noted, however, is that we are dealing not merely with concrete projects and produced objects of programming but also with abstract models and diagrams. Just as cellular automata were mainly abstract models of cooperative computation that attracted the interest of mathematicians, computer scientists, and also hackers at various laboratories, viral sentences represented a field of interest that resonated with the work done in mathematical modeling, systems design, and software programming.

We can cite apt examples from the 1970s and later where certain publications—usually aimed at professional programmers but occasionally also for the hobbyist—acted as circulation channels. Such ideas of self-reproducing machines are probably to be interpreted as part of the enthusiasm surrounding cellular automata. Via the old format of paper publications, these ideas self-reproduced beyond the strict confines of media labs and computer science departments. Self-reproducing programs were addressed, for instance, by Paul Bratley and Jean Millo from the University of Montreal in the *Software—Practice and Experience* journal in 1972. Their aim of showing "that self-reproducing programs can be written in SNOBOL, LISP, FORTRAN and ALGOL 60"[164] programming languages was later taken up by *Byte* magazine with its program listing. Bratley and Millo's work was supported by the National Research Council of Canada, and neither it nor the *Byte* program included any hint of a malicious nature in its coverage of the topic. Instead, it contextualizes as part of the hobbyist circles interested in the common liminal zone of mathematical puzzles and computer "recreations" (with an explicit reference to a Pascal Users' Group newsletter from 1978). A program

that duplicates itself without any help was conceived as a fascinating idea—here an example of the version in the C program language:

```
Main () {
char q=042, n=012,
*a="main () {%cchar q=042,
        n=012,%c*a=%c%s%c;%cprintf(a,n,n,q,a,q,n,n);}%c";
printf (a,n,n,q,a,q,n,n);}¹⁶⁵
```

Around the turn of the decade, we find other, similar examples, of which Douglas Hofstadter's patterns are among the most interesting. A key name in research in computer intelligence, Hofstadter won the 1980 Pulitzer Prize for his *Gödel, Escher, Bach: An Eternal Golden Braid*, which is an intriguing puzzle of mathematical logic and word games. The book, which covers a varia of mathematical word games and the like, also addressed self-reproducing sentences and programs.[166] Instead of a merely noncontextualized interest in programming, as in the case, for example, of the *Byte* program code, Hofstadter creates a fascinating problematics of self-reference and replication that does not actually reduce to being a function of any particular technological system, although computers seem to provide the perfect structure for these ideas of copying and reproduction.

The ideas and sentences are puzzling examples of a media ecology, where user input is no longer needed and where the machines act on their own. The computer is no more a determinate linear machine, but a population calculator with potentially indeterminate results. In a curious posthumanist vein, the computer obtains a kind of a semi-agency. As Friedrich Kittler argues, technological subjects were born with the realization of conditional jump instructions, known also as the IF/THEN pairing of program code.[167] This implies the possibility of the program autonomously changing its mode of operation in the course of its action. In Kittler's schema, where computers have autonomized their read/write capabilities from human assistance, it also means the entrance of a new form of subjectivity on the level of society. So, no more "Turings" and "von Neumanns" or any other male designers as demi-urges of computer hardware and software, except as forefathers of a posthumanist digital culture of viral organisms? Via such ideas of autonomy and agency of computer programs, Cohen's aforementioned Universal Viral Machine fantasies, several artificial life projects of self-organization, and the above-analyzed programs of virus-like and worm-like quality find their common ground. Otherwise apparently different patterns are thus part of the same logic that pilots the network society. This is the important point to be noted: the ideas are not merely part of the digital network of

computers or computer science even though computers represent the perfect class of machines for this type of diagrammatic piloting.

The interest in reproduction is part of the *longue durée* of modernity and its media technologies; there is also a certain memetic tendency inherent especially in the media ecology that focuses on communications and copying. In this respect, it cannot be taken as a mere coincidence that the interest in memetics arose in the mid-1970s, when similar ideas were part of the experimental repertoire in mathematics and computer science. Richard Dawkins introduced in 1976 the idea that memes can serve as the equivalents of genes in terms of cultural reality. Genes were to be understood as enduring through "survival machines" of repetition and reproduction, and memes transferred the same idea to cultural transmission: "Examples of memes are tunes, ideas, catch-phrases, clothes, fashions, ways of making pots or of building arches",[168] that is, everything that reproduces and mediates itself. Dawkins's *The Selfish Gene* proposed, then, the ontologization of replicators; as Matthew Fuller notes, Dawkins's idea of replicators "can be understood as an abstract machine whose activity can be recognized across a range of material instantiations."[169] Tiziana Terranova makes an even stronger claim when underlining how the scientific knowledge and theories of genetic reproduction have been channeled and translated with the biological turn in computing "into actual working pieces of software, that are capable of producing their own emergent phenomena."[170] Dawkins is, then, essentially connected to the themes of biological computation prevalent during recent decades and a new form of incorporation of scientific knowledge into computers and networks. Of course, there are variations within biological computing between software meme processes and, for example, concrete biomemetic computing ("wet computing") experiments. Such distinctions were recalled by Katherine Hayles.[171]

As part of the genealogy of the informationalization of life and matter, the emphasis of memetics on patterns and mathematical models as primary in relation to the material actualizations deserves analysis. Whereas a move away from technologies, especially computer technologies, helps us to see the "big picture" in relation to the diagrammatic (abstract machine) piloting such ventures, we are at the same time led with memetic studies back into the world of media: as Susan Blackmore noted in 2000, media are the perfect meme machines. In Blackmore's take on the media history of the past 7,000 years, memes have tried to find the best vehicles for replication in terms of fidelity, fecundity, and longevity. Hence, the Sumerians in Mesopotamia with their techniques of writing are in this sense an important step, as are the monks of the Middle Ages with their industrious work of copying manuscripts, overtaken by the printing press. With moderniza-

tion we have technical media: the telegraph, the telephone, radio, and television, not forgetting the networks of roads, railroads, and shipping routes.[172]

Actually, Blackmore is focusing on modernization and the inherent capacity of modern media technologies: copying, reproduction, and communications. Her memetically inspired views of the media landscapes and histories are filtered through the copy machine of technical media that Walter Benjamin analyzed so well.[173] Yet, it is worth concerning ourselves with linking the Internet in particular to this picture. The Internet media technology is represented as a posthumanist copy machine par excellence, where it becomes obvious that the net does not necessarily need us. Of course, to paraphrase Blackmore, the net is still more or less made and maintained by us, but that is not a logical necessity with respect to the inherent workings of the network creatures:

> However, many changes lie ahead. Already there are free-floating programs which move around in cyberspace, called bots (short for robotic programs). The way forward in arti-ficial intelligence seems to be to build small and stupid units that together do clever things. We can imagine the Net becoming full of such autonomous stupid creatures that run about doing useful jobs. (...) At the moment, the only viruses or parasites are ones deliberately created by malicious (or just mischievous) human beings, but could bots mutate into viruses and start clogging up the system? Certainly, copying errors happen in any system and occasionally they lead to a product that proliferates. General evolutionary principles suggest that this may occur if the fantastic copying and storage system of the Net is maintained for long enough.[174]

So, the meme theory sees copying (and thus viruses as copy-machines) as integral part of the history of media technologies. Blackmore's media history should be read in relation to Dawkins's ideas from the 1970s, as well as the diagrammatic reference points of the network paradigm that surrounded those ideas. Both Blackmore's and Dawkins's ideas are highly problematic if they are viewed as cultural theories: the ontological status of the meme remains unclear, and it is in danger of being seen as a Platonic ideal object without materiality. In addition, the universality of the meme theory is insensitive to a more precise anal-ysis of, for example, media technologies and their history. We must continuously remember to analyze theories of the meme as situated expressions of the aspiring digital culture of the late twentieth century and to see the biased stance toward immateriality, virality, and, for example, universal communication as part of the abstract machine, which tries to produce such cultural assemblages. Despite such memetic tones, the functional assemblages were much more complex, and virality was articulated as continuously immanent in various material platforms.

Interestingly, Douglas Hofstadter also discussed meme theory in relation to virus-like sentences and self-replicating structures. A "metamagical theme", as his famous column in *Scientific American* following in the wake of Martin Gardner was called, virality was a memetic, mathematical, and hence a computational pattern.[175] No matter how idealistic such ideas of memes might have been, the computer and the network seemed to provide the fertile ground required for such viral patterns. In connection with the early ecologies of the 1950s, analyzed above, the computer seemed to be just the right testing ground for mathematical organisms, abstract structures of self-reproduction, and formal models of evolution. Hence, the mathematical interest in such sentence structures was easily transformed into computational experiments with programming languages and digital code. Of course, as argued earlier, several accounts of and experiments with virus-like software (for example, Core Wars) unfortunately rested on neo-Darwinian models of evolution, proposed also by Dawkins, where the symbiotic nature of software culture and network ecology was easily neglected.

The mainframe computer played a crucial part in the formation of theories and practices of classical artificial intelligence from the 1950s to the 1980s. The idea that the computer could also provide a fertile ground for more complex ecologies matured during the same period. Emergent and neural artificial intelligence, as well as the computational experiments in biology, contributed to this interlinking of the digital and the organic, although the genealogical lineages extend further back, as has been argued at the beginning of this chapter. Computing has certainly inspired biology and the research on intelligence and trends in computer science, but computers have been similarly interlocked in the biological diagram, the abstract machine interfacing computers and the computerized post-Fordist society with biology. This intertwining can be seen developing in a three-fold manner:

1. The manner how biological organisms are also information processors, computers;
2. How informational systems use biological materials (cells, enzymes, etc.) as part of their structure instead of silicon and/or are modeled on biological processes;
3. Using biology metaphorically, inspirationally or as a pathway for developing "in silico algorithms."[176]

Points 2 and 3 in particular strike me as interesting and apt in relation to the viral topic at hand, and the field of artificial life that has formed especially in the

wake of complexity theories, cellular automata, and the novel trends in computer science has underlined the loop nature of these ideas. Life was considered to be calculated, because "life in itself realizes forms of movement, forms of processing, that are computational in nature", as ALife scientist Claus Emmeche noted in 1991, continuing that "[i]f life is a machine, the machine itself can become living. The computer can be a path to life."[177]

A path to life for the scientists perhaps, but also a fertile platform for the various side-kicks of life, such as viruses and parasites, computers proved their powers not merely in laboratories. The advances in the processing power, memory capacity, and multifunctionality of computers were connected to their spread throughout Western societies from the beginning of the 1980s. This circulation was crucial in the interfacing of high-tech artificial life ideas and the everyday media ecology of Western computer culture. Just as self-reproducing programs had been part of early hobbyist experiments and high-profile computer lab tests, viruses and the exciting ideas that computers were somehow connected to life were increasingly pervading society.

On the scientific side, a look at the Santa Fe artificial life conferences provides a good sense of the range of ideas in professional circles. In the first conference, in 1987, the topics spanned from nanotechnologies and Hofstadter-inspired typo-genetics to behavior modeling, movement analysis, genetic algorithms, and on to several papers on the problem of artificial organisms in computational environments. Artificial bugs in artificial ecologies and adaptation and evolution seemed to be the ideal topics for such simulated organism–environment couplings, as in the presentation by Norman Packard.[178] Similar topics were addressed by Howard Pattee, who also warned of the dangers of overestimating the power of ALife research: ALife should be able to "evaluate its models by the strength of its theories of living systems, and by technological mimicry alone."[179] Simulated systems are not, according to the warning, realizations of the processes they follow but mere tools for thought.

In the following conference, in 1990, also in Santa Fe, the connections to viruses were even more intimate. The fear of viruses was forgotten, and evolution and computations had become a hot topic, with several papers on "learning and evolution", but also some directly addressing self-reproduction. Whereas Alva Ray Smith focused on self-reproduction from the point of view of the classical cellular automata configurations, Eugene Spafford, well known in antivirus research, addressed the topic head on: Are computer viruses a form of artificial life?[180]

Viruses and worms were examined in a microscope-and-tweezers style. Such necropsies had been a frequent theme in the professional and popular publications

since the end of the 1980s, so the interesting point is the context: the introduction to viral patterns of movement and spreading, logics of infection and structure were part of the research themes of the professional ALife researchers. Spafford was surprisingly positive about the affinities between viruses and ALife. According to Spafford, computer viruses do have a metabolism (they convert energy), they are functional parts of their environments, they exhibit growth, and they even seem to evolve through mutations—a fact that was disputed by Mark Ludwig, who argued, quite rightly, that contemporary computer systems were still too unstable to tolerate significant mutations. Yet, as noted above, Spafford declined to acknowledge the idea of viral ALife, partly for ethical reasons: they are often maliciously built and distributed—as part of unethical practices, poor science. In addition, Spafford gives of the following warning:

> More seriously, I would suggest that there is something to be learned from the study of computer viruses: the importance of the realization that experimentation with systems in some ways (almost) alive can be dangerous. Computer viruses have caused millions of dollars of damage and untold aggravation. Some of them have been written as harmless experiments, and others as malicious mischief. All have firmly rooted themselves in the pool of available computers and storage media, and they are likely to be frustrating users and harming systems for years to come.[181]

What we have here is actually a very tantalizing implicit observation of the media ecology of the late twentieth century. Spafford's position tells of conflicts of interpretation, where for some such programs are risks and errors (and hence connect to business interests), and for others this "noise" is an index of emergence. Mark Ludwig's ethos of hackerism, then, is in line with the efforts during the 1990s to bypass economic interests in the design of digital culture and commit oneself to a hacker ethos of experimentality. In a way, contrary to Spafford and others arguing in the same manner, such virus-like ideas and the hacker ethos of free information and experimentality were not adversarial to the principles of digital network computing. As Galloway aptly argues, hackerism and viruses are actually part and parcel of the protocological way of functioning of the networks of subtle smooth control.[182] For example, viruses as a specific logic of action use the bridges protocols build over heterogeneous machines, but they also "reveal" homogeneous platforms via high infection rates. Indeed, since the end of the 1980s, viruses have also been a part of "hacker art", especially in Italy with Tommaso Tozzi's pioneering Rebel! virus (1989) and the net art viruses of recent years by groups such as 0100101110101101.ORG and epidemiC. [183]

Such pieces of self-reproductive software can be seen as part of the tacit knowledge of an average hacker and a well-informed computer user in general. As Sherry Turkle has argued in her influential studies, computers have been changing our fundamental perceptions of intelligence and life at least since the early 1980s (the time of the wide distribution of computers in everyday culture). The platforms of complexity theories, evolution, genetic algorithms, and other experiments with artificial organisms were themselves also creating novel environments and thus perceptions of nonhuman actors and subjectivities. Although the psychoanalytically trained Turkle underlines the linguistic constructionism inherent in these perceptions and I want to emphasize the more complex affects, intertwinings, and interfacings of things considered living and computers, I find her point apt as it catches the basic tenet that ALife forces in its wake a redefinition of "what it means to call something alive."[184] ALife produces such uncanny objects that force new self-reflection concerning our concepts of life, technology, and culture.

Chris Langton is a perfect example of this interconnection of popular computer culture and high-tech artificial life theory. Langton was inspired by Conway's Game of Life in the late 1960s and was later piloted by a computer of his own, an Apple II (the computer with the friendly face and the one with the early viruses),[185] toward his own experiments. This serves as one of the key founding myths, as Turkle notes:

> A first element is that A-Life mobilizes people at the margins of established institutions who are empowered by personal computers. When he began his research, Langton was, after all, a college dropout with an Apple II. A second element is that A-Life is fueled by moments of epiphany. One night, when working alone in the Massachusetts General laboratory, Langton said that he felt a "presence." He believed it to be the Game of Life running unattended on a computer near his own. "You had the feeling that there was something very deep here in this artificial universe and its evolution through time", said Langton. "(In the lab) we had a lot of discussion about whether the program could be open ended—could you have a universe in which life could evolve?"[186]

Myth or not, such perceptions and expressions are characteristic of the post-Fordist computer culture of the late twentieth century, either in the form of software agents roaming the networks and computers, communicating in interaction with human and nonhuman partners, or in the form of popular narratives of "the nature of the computer" and "life in the gray box." Around the late 1980s/early 1990s, the popular press took up the issue in newspaper articles,[187] and I have already mentioned that the theme was part of the cyberpunk science fiction genre, which facilitated the translation of the phenomenon into narratives and

discourses.[188] In this framework of mythically lifelike computers, the conceptualization of the viral as alive was easy in newspaper articles and books, as several examples above have already testified.[189] Such translations of events into meanings, significations, and valorizations positioned the issue in a grid of societal concern[190] and also acted as a vehicle for domestication, as with animals in general.

Of course, the complex structures of network computing were particularly easily incorporated into figures of nature and ecology. Since the 1990s, the complex structurations of the Internet have been depicted in terms of "grass roots", "branching structures", "growing", and "evolution." As Douglas Rushkoff noted in the mid-1990s, "biological imagery is often more appropriate to describe the way cyberculture changes. In terms of the way the whole system is propagating and evolving, think of cyberspace as a social petri dish, the Net as the agar-medium, and virtual communities, in all their diversity, as the colonies of microorganisms that grow in petri dishes."[191] Such articulations were supplemented with statements underlining the complexity of the novel systems of networking. In this complexity, the organisms of such systems, for example, viruses, were seen as potential aids in revealing the potentialities of the net, as *Wired* wrote in 1995: "'We're just going to have to live with them,' artificial life researcher Chris Langton says of computer viruses. Our global web of digital systems, he predicts, is fast unfolding towards a degree of complexity rich enough to support a staggering diversity of autonomously evolving programs.'[192]

As I argued in Chapter 1, the ecological understanding of network technologies was quickly turned into part of the capitalist abstract machine. Capitalism was now seen as a complexity theory–inspired system, a self-organizing platform that tolerates multiplicities and diversities in contrast to the old Fordist capitalism of mass production, state intervention, and stable controlled currencies and flows of capital. The serialism of the Fordist production system was supplemented with a reflexive touch that spread across the whole biopolitical creation of digital culture and expressed itself in the new "viral quality" of network actors. This, of course, was not restricted to the nonorganic life of network programs; shifts in organizational structures and labor relations can also be seen moving toward such themes of distributed systems, interactional units, and flexibility. A certain type of complexity theoretical naturalization was used as a tactic of capitalist interest; this is what I keep referring to as the apparatus of capture of viral capitalism.

In addition to the Clinton administration, and the Al Gore–influenced information superhighway plans in particular, the neoliberal digerati were active in proposing a more decentralized ecology as the utopia of the Internet era. These ideas continued the neoliberalist wave of the 1980s that struck the field of

telecommunications. Alvin Toffler, George Gilder, Newt Gingrich, and Esther Dyson, the strong woman of the pack, connected the rhetoric of ecosystems with information capitalist tendencies for free flow of information: "'Cyberspaces' is a wonderful pluralistic word to open more minds to the Third Wave's civilizing potential. Rather than being a centrifugal force helping to tear society apart, cyberspace can be one of the main forms of glue holding together an increasingly free and diverse society."[193] This quotation expresses well the double movement of the neoliberal agenda of the simultaneous desire to cultivate diversity and glue it together so that it does not get out of control. Despite the rhetoric of freedom, the cybernetic systems were primarily about how to control the unknown future.

For the Progress and Freedom Foundation,[194] cyberspace (of which the Internet was merely a part) was "more ecosystem than machine", "a bioelectronic environment" that "exists everywhere there are telephone wires, coaxial cables, fiber-optic lines or electromagnetic waves."[195] Inhabited by organisms of knowledge (including incorrect ideas), this world of electronic form was meant as the next frontier after the space race: cyberspace as the next Gold Rush, as the writers painted the promising future.

Such emphases can be seen as part of the "Californian Ideology" of information capitalism, a term proposed by Richard Barbrook and Andy Cameron. This specific brand of high-tech liberalism springs from the conjoining of the "cultural bohemianism of San Francisco" with its countercultural roots in the hippy movement and from the success story of the post-Fordist industries of Silicon Valley: "Promoted in magazines, books, TV programmes, Web sites, newsgroups and Net conferences, the Californian Ideology promiscuously combines the free-wheeling spirit of the hippies and the entrepreneurial zeal of the yuppies." [196] More specifically, we can pinpoint such publications as *Wired* and *Mondo 2000*,[197] the Progress and Freedom Foundation, and the cyber cultural theories of Timothy Leary and Kevin Kelly (a founder of *Wired* in 1993)[198] as keen proponents of the media ecologies of complex, diverse information capitalism.

These arguments are backed by Stefan Helmreich's meticulous ethnographically based analysis of the culture of artificial life as it is practiced in the famous Santa Fe Institute. As Charlie Gere notes, the institute was founded in 1984 as a nonprofit institution. Yet, the funding of complexity research was intimately tied to capitalist interests, and the Santa Fe Institute was itself funded by Citibank, "with the expectation that its research might contribute to the bank's capacity to understand and manage the complexities of globalized capital."[199] The Santa Fe Institute offered tools for a novel view of complex network capitalism.

Analyzing John Holland's Echo system in particular, "a computational plat-
form for simulating evolutionary processes in a variety of 'complex adaptive
systems,'"[200] Helmreich pinpoints the very concrete intimacies complexity theo-
ries, adaptive organisms, and evolutionary patterns display between the supposedly
distinct fields of artificial life experiments in computers and economics and capi-
talism. By following the institutional practices of Santa Fe researchers, Helmreich
tracks the path from the "International Finance as a Complex System" workshop
in 1986 to one similar called "Evolutionary Paths of the Global Economy" in
1987 and on to the fascination expressed in interviews with economists. Via the
connection of information, information economies and biology (also an infor-
mation science) find the common ground that so reminiscently of the previous
fin-de-siècle discussions of evolution and capitalism approaches post-Fordism as
a flexible mode of production of ways of life that "evolve." Of course, evolu-
tion is now nonlinear, adaptive, and flexible, and works in chaotic border states.
Nevertheless, it is remarkable how smoothly the talk of ecological niches in artifi-
cial life and, for example, evolutionary algorithms finds itself recontextualized in
viral, parasitic capitalism. "Through the medium of the complex adaptive system,
envisioned finally as a kind of computer or information-processing system, the
economy becomes a kind of ecology and vice versa",[201] as Helmreich writes.

Moreover, accepted virus-like programs entered the arena. Cohen's utility
programs from the 1990s were touted as benevolent as they could be tied to
business interests (for example, his virus-like PayBack virus program that collects
unpaid bills).[202] Similarly, the programs introduced by *Wired* in 1995 were exem-
plary of viral code transformed into financial profit. General Magic Corporation,
working with hand-held communications devices, came up with an idea of how
to really turn viral code into accepted form. Designing intelligent agents that act
similarly to viruses somehow testifies to the idea that viruses might just be the way
to get the full benefits out of the Internet. Although they were not called viruses,
the link to such forms of action was underlined:

> Still, despite rather severe restrictions on the agents' ability to replicate, it's hard to deny
> certain broad similarities between intelligent agents and the offerings of your typical
> Vx board. Both wild viruses and Telescript agents routinely copy themselves from one
> computer to another. Both viruses and Telescript agents can run themselves on the
> computers they travel to, and, for those same reasons, raise differing degrees of concern
> about their security.[203]

Such intelligent agents seemed to form the ontology of the new digital culture,
incorporating also the essential capitalist digital utopia of intelligent agents,

semi-autonomous programs that ease the pressures put on the (in)dividual by the increasing information input.²⁰⁴ Intelligent agents that take care of the ordinary tasks on your computer or run such errands as reserving tickets, arranging meetings, and finding suitable information from the (Inter)net are, according to J. Macgregor Wise, describing changes in the understanding of agency in the age of digital culture,²⁰⁵ and we might emphasize further that such programs are actually the culmination of key potentials within the ontology of digital network culture. They represent a new class of capitalist actors and functions that roam across technological networks. The viral also had a friendly and accepted face, it seems. Although the fear that crept in from the 1980s had banned the use of the term "virus" in such contexts, the basic principles lived on and prospered in the assemblages of informational capitalism and its new network platforms, among them the Internet. This is why, for example, Cohen opted to use terms such as "Living Programs" or "Tiny Experts" in these contexts.²⁰⁶

COUPLING AND MEDIA ECOLOGY

To underline the methodology of eventualization presented in the Introduction, I want to add another twist to the analyses above, which might otherwise end up with a rather overly hegemonic picture of capitalism, media ecologies, and viruses. The media ecology of networking and artificial life must be approached as multifarious, as a multiplicity framed in virtuality.

Hence, complementing Barbrook and Cameron's otherwise apt remarks on the Californian Ideology of the Internet ecology, we might want to follow Franco (Bifo) Berardi's objections that the net and the culture of globalizing capitalism must not be taken as a unitary territory of one Hegelian movement toward capitalism but as a co-symbiotic proliferation of differences.²⁰⁷ Although capitalism does serve as a decoding parasitic machine of actualization of the virtual tendencies inherent in software culture and networking, there remains a residue, an event. This is where the stance toward thinking media *ecologies* might help.

This focus on virtual potentials can be connected to Isabelle Stengers's affirmation of the practices and dreams of artificial life. Stengers, originally in the context of a 1995 European meeting of artificial life scientists, argued for a method of dreaming with the visions of artificial life to see where they end up. Recognizing that there is a very strong tendency that takes artificial life along the fixed tracks of modern science and its myths of control and conquest, she also sees the aspira-

tions within this specific field of connectionism in a positive manner. Although the image of creating autonomous creatures that break free from prescribed laboratory frames is one of the founding myths of the field, Stengers seems to hope that this idea of breaking loose, of open-ended systems, would feedback into the scientific ideals and practitioners themselves, who are always connected to these machinations. When material is no longer considered as passive, Stengers hopes that such creations might lure the parties involved "towards new feelings, new possibilities, new ways of becoming."[208] Naturally Stengers is not giving an integrated view of the field of artificial life research in its various expressions; seeing the whole of ALife as one of revolutionary science would be to overestimate the field. Instead, her pointers can be seen as extracting certain crucial tendencies that pop up in various fields of digital culture from ALife to other machinic formations that resist seeing matter, energy, or their informational expressions as passive.

Stengers's ideas could perhaps be connected to a remark Keith Ansell-Pearson made in relation to Western philosophy's stance toward machines. Ansell-Pearson noted the role binary machines and organisms have traditionally played in philosophy. Organisms are thought of as self-organized unities that (according to Kant) "display finality (purposiveness)."[209] Technologies are, in contrast, subjected to their designers and remain mere artifices of humans without the ability to "self-produce, reproduce, and self-organize."[210] Most often, computers are thought of as determined machines, bound by the original linear instructions inserted into them (another idea of hylomorphic nature). This, of course, is exactly contested by the creation of self-reproductive software or, more fundamentally, the principles of the Turing machine and von Neumann automata, ideas that are taken one step further in the speculative projects of ALife. The projects also perhaps provide a new stance toward speculative materialism.

In such a model of nurturing the new and the monstrous, the above-mentioned ideas of the machinic phylum and media ecology become essential. Nurturing new tendencies of the material we have at hand is to be seen as an ethos of experimentality and cultivation of hybrids. In addition, this etho-ecology of practices can be connected to issues of media ecology. To follow Stengers's line of thought, the ethos of media ecology could also lie in the need to create new assemblages of enunciation "which will undo the molar socio-professional strata and their order-words."[211] Such assemblages might just act as temporary passwords that open up new spheres of ideas and action.

We need tools to understand the complexity, the connectionism, and the flexibilities that function at the core of the contemporary media condition, which justifies the use of "ecology" as a central concept here. In a way, this also accentu-

ates the need to ground a theory of digital culture in cybernetics (Wiener, von Neumann) and, even more urgently, in second-order cybernetics (Maturana, Varela, Simon, also Bateson), which might provide an even more subtle and complex understanding of the connectionist technologies and assemblages of contemporary culture. As discussed above, such projects and orientations took as their leading preoccupation the *couplings* of systems and environments and the self-organization of complexity. Hence, approaching the issue of ecology with Gregory Bateson means apprehending ecology as the "study of the interaction and survival of ideas and programs (i.e., differences, complexes of differences, etc.) in circuits",[212] implying that primary importance should be given to the *coupling* of organisms and their environment as the basic unit of a system. Such ideas were built into the cybernetic agenda with the ecology movement of the 1960s.[213] The issue resonates also with Maturana and Varela's influential theories of autopoiesis: "Living systems are units of interaction; they exist in an ambience. From a purely biological point of view they cannot be understood independently of that part of the ambience with which they interact: the niche; nor can the niche be defined independently of the living system that specifies it."[214] Maturana and Varela insisted that "autopoiesis" is a term reserved for living systems, using the term "allopoiesis" to refer to social systems and technology. In allopoiesis the product is something else from the producer.[215] Here I stick, however, to Guattari's use of the term "autopoiesis" as applicable also to other than biological systems. To be exact, machinic systems can be seen as incorporating both autopoietic and allopoietic elements. For example, the media ecology of network culture is at the same time self-referential and self-recreative as well as designed, engineered, and planned in various assemblages of enunciation.[216]

Herbert A. Simon had actually articulated the same issue in 1969 in his *The Sciences of the Artificial,* viewing ants as creatures whose collective complex behavior is to be understood as the reflection of the *environment* in which they live. For Simon, complex systems were constituted both of emerging and hierarchical parts, and he saw no contradiction in such an assemblage.[217] Living and affective systems are in this regard not restricted to their personal boundaries but constitute larger collectivities, or assemblages, with their surroundings.

In this vein, the perspective of ecologies should be understood as self-referential systems, or processes, where to understand (or observe) the functioning of the system, one cannot detach single elements from its synthetic consistency (and label some elements as purely anomalous). Instead, one should focus on Maturana's question "How does it happen that the organism has the structure that permits it to operate adequately in the medium in which it exists?"[218] In

other words, a focus on such a systems approach allows one to think also of digital culture as couplings where "organisms" or "components" participate in the autopoiesis of the general system, which in our case is the digital culture of networking. This is also the abstract sense in which the *life* of digital culture could be understood: as a machine (in the Deleuzian–Guattarian sense) of coupling and connecting, of linking between and across assemblages and abstract machines— the continuous movement that keeps such machines working and renewing themselves. Incidentally, Deleuze and Guattari were also keen on drawing from second-order cybernetics and Maturana and Varela. Hence, the focus on autopoietic systems seems to be justified; the autopoietic system is a reproductive system, aiming to maintain its unity in organizational form:

> This circular organization constitutes a homeostatic system whose function is to produce and maintain this very same circular organization by determining that the *components* that specify it be those whose synthesis or maintenance it secures. Furthermore, this circular organization defines a living system as a unit of interactions and is essential for its maintenance as a unit; that which is not in it is external to it or does not exist.[219]

Yet, such a reproductive system should be seen as consisting of both actual and virtual parts in order to allow it a certain dynamism and to short-circuit the often too conservative focus on homeostasis found in some strands of systems theories. Systems do not merely aim at minimizing energy and restraining change.

This is where the above-mentioned ethos of experimentality and novelty steps in and connects with media ecological interests. Especially pertinent is Matthew Fuller's way of twisting the status of the standard object and seeing media ecological experimentality as a method of immanent engagement:

> Accumulate information, techniques, spread them about, stay with a situation long enough to understand its permutations. Find a conjunction of forces, behaviors, technologies, information systems, stretch it, make it open up and swell so that each of the means by which it senses and acts in the world become a landscape that can be explored and built in. Speed it up and slow it down so that its characteristic movements can be recognized at a glance. Lead it through a hall of mirrors until it loses a sense of its own proper border, begins to leak or creates a new zone.[220]

Here experimentality connects as a method to mapping, or experimentality *as* mapping—not mere writing of representations or reacting to a preexisting solidified reality but a simultaneous testing of the limits of an operational field, an assemblage, and, consequently, a phylum. Media objects are always multiplicities in the sense that they can be twisted into new connections and assemblages.

Similarly, systems can be seen as occupying a potential for such twistings, becomings. Here the role of the media archaeologist resembles that of an experimental programmer, mentioned above, as both work through following material flows, probing the potential turns to be taken in relation to the sphere of media technology. What we are after are not merely self-enclosed facts, but tendencies.

As technicalities, viruses and worms are program objects but also *tendencies* within this machinic ecology of digital culture of recent decades. They are part of a machinic phylum of network culture, which can be understood as the level of potential interactions and connections. It is a plane of *virtuality* where specific actualizations, or individuations, are able to occur. Thus there is always the perspective of (nonlinear) evolution in such a grasping of virtuality. The virtual as a plane of potentiality is something that does not exactly actually exist (although it is real), for it is in a constant process of becoming. Just as nature cannot be grasped as something "given", media ecologies should be seen as planes of giving, an iterative reserve. Brian Massumi writes about nature as virtuality and as a becoming, which "injects potential into habitual contexts", where "nature is not really the 'given,'" but in fact "the giving—of potential."[221] As Massumi continues, this is Spinoza's "naturing nature", which cannot be reduced to an actual substance, an extensive and exhaustible state of being. This stance of active creation can underline for us the fact that media ecologies cannot be seen as static, hylomorphic structures of autonomous technologies but as active processes of creation, or a useful orientation, horizon, on which to think the media condition of digital culture. The future of a media ecological system is open-ended, making radical changes possible. The system is not a determined *natura naturata* but has a constant potential for change; viruses are a good example here in their unstable interaction with their environments. Yet, fundamentally, nature works via parasitism and contagion. Nature is in fact "unnatural" in its constant machinic striving and adaptation.

From the point of view of a plane of immanence, nature is not constituted around a lack or a transcendental principle of naturalness; instead it constantly operates as a self-creating process: "That is the only way Nature operates—against itself."[222] This is also in accordance with the above-mentioned Spinozan understanding of life, which sees it as an affect: movements, rests, and intensities on a plane of nature (whether media ecological or otherwise). Life is, then, not a form, but movement and coupling, as Deleuze's reading of Spinoza affirms: "The important thing is to understand life, each living individuality, not as a form, or a development of form, but as a complex relation between differential velocities, between deceleration and acceleration of particles."[223] This perspective on *the*

musical form of technology does not, then, rely on formal characteristics of life but is a tracing of the lineages of the machinic phylum and also a tracing of the paths of organisms that move on this plane. Nature as a potential becoming connects to Guattari's project of virtual ecology, ecosophy: "Beyond the relations of actualized forces, virtual ecology will not simply attempt to preserve the endangered species of cultural life but equally to engender conditions for the creation and development of unprecedented formations of subjectivity that have never been seen and never felt."[224] This experimental ethos amounts to a project of *ecosophy* that cultivates "new systems of valorization, a new taste for life."[225] In other words, the media ecology, or machinic phylum, of network computing cannot be reduced to a work of purification where some elements are categorized as anomalous without engaging with their hybridity.[226] As I have been arguing all along, viruses are integral to the whole issue at hand, and, perhaps, through such anomalies novelties can arise. This justifies the turn toward assemblages of artificial life where the notions of self-reproducing digital organisms and simulations of digital ecologies have been addressed as positive potentialities of the new. Chris Langton called the science of artificial life digging into not merely what life is but into "life-as-it-could-be."[227]

In short, on a plane of media ecology as a self-referential system it becomes irrelevant to label some elements as "anomalous", as not part of the system, for every element is *given* by the virtual system (which in itself and in its virtuality cannot be taken as given, as a preformed Platonist idea). Anomaly can be identified only in a predefined grid of identities (self versus other, inside versus outside). Instead, "anomalies", if defined alternatively as figures of potentiality, are particular trackings of certain lineages, of potentials on that plane, not necessarily disruptions of a system. "Desiring-machines work only when they break down, and by continually breaking down",[228] as Deleuze and Guattari note. Technological machines can in this sense also be taken as *desiring* machines on a plane of immanence, a self-organizing plane of its own type, which again implies the impossibility of judging the interactions of such a plane from a vantage point outside it. Just as the communication theory of Shannon and Weaver recognized that noise is internal to any communication system, every media ecological system has its white noise, essential to any functioning system. At times, of course, the noise might become too loud and enact a change to another constellation.[229]

The late 1980s saw a new exchange between computer viruses and artificial life research that affected the incorporeal wedding of self-reproductive processes and also sparked new attention to the material tendencies inherent in artificial population platforms. As a concrete example to illustrate the theoretical points,

Thomas S. Ray's Tierra project borders well with this zone of liminality between the Internet infrastructure (both the corporeal and incorporeal aspects of it), computer viruses and parasites in general, and artificial life and the experimental ethos of digital creation. Ray's Tierra has been frequently cited as one of the most exciting examples of early 1990s ALife projects, although it has its historical affinities with the digital ecologies of the 1950s, for instance, Nils Barricelli's work and the Leviathan project. Ray, originally an evolutionary biologist occupied with fieldwork in rainforests in Central America, designed the first version of the program, or simulatory ecology, at the start of 1990. His idea was to model the Cambrian era, which is a specific period of the evolution of Earth (approximately 600 million years ago), on a computer platform and hence "relive" the physico-chemical events that took place. An evolution machine of sorts, Tierra was a virtual computer that was designed to work within actual hardware. This method was adopted because of the control problem encountered so many times with dynamic software from the early ARPANET programs to the Shoch–Hupp worm programs. The Tierra computer system allocated memory space and computing time to each organism, as well as controlling their life cycles and deleting the older programs. In addition, the operating system also allocated mutations to organisms, which caused "some organisms to self-replicate imperfectly."[230] This meant in a way making the programs stutter and potentially create novel offspring.

The idea originated from way back, actually from Ray's time as a graduate student at Harvard in 1979. Stumbling across a Go game club, he started to observe the play and ask about the basics of the game. Ray got into a conversation with a professor from the MIT Artificial Intelligence lab, and the conversation strayed quickly to self-replicating software and how easy it would be to create such programs. As Ray remembers it:

> I imagined: start with self-replication, then add mutation, and get evolution. A very simple formula for life: self-replication with errors should generate evolution, the essence of life. I was intimately familiar with the beautiful complexity and diversity that evolution had generated in the tropical rain forests. I imagined an independent evolution generating a digital jungle in a computational universe, teeming with unimaginably alien evolving digital life forms.[231]

Computers proved to be the phylum needed (yet not sufficient or determinant) for such projects. Ray got his first computer at the end of the 1980s and equipped it with Borland's Turbo C compiler and its Turbo Debugger. Working himself into thinking of the computer as an ecology "that could be inhabited by life (self-replicating computer programs)",[232] Ray started with computer archi-

tectures, operating systems, programming, and all the computer theoretical stuff that seemed to open up new worlds to an evolutionary biologist. As he recalls, finding the research community of Santa Fe in 1989 was a groundbreaking event: there were people already doing this stuff on computers, not merely thinking about it! Steen Rasmussen's work struck Ray as exemplary in its occupation with computer ecologies and self-reproduction (although it also differed from Ray's interests).[233]

Developing his ideas, Ray's next step was the 1995 proposal for an Internet-spanning virtual ecology of organisms. To bypass the problems with the von Neumann architecture that processes things serially, Ray needed a parallel processing machine, or a network, and the Internet seemed to provide just this. Of course, the idea was something that Danny Hillis was thinking of already in the mid-1980s with his diagrams and designs of parallel connection machines.[234] Ray's step also marked a move toward emphasizing the machinic phylum of networking, instead of the mere processing power of solitary computers. In addition, such a machinic phylum of artificial life meant a novel form of substratum for new types of phenomena, a novel *mechanosphere* for technological demons: "cultural and technical phenomena providing a fertile soil, a good soup, for the development of insects, bacteria, germs, or even particles. The industrial age defined as the age of insects."[235] This is a drawing of a plane of immanence, which makes no division between biospheres and technospheres but looks for patterns of organizations, movement, and matter–energy. As Nigel Clark notes in his article "Panic Ecology", the ALife viruses of the early 1990s can be understood also as hybrids of scientific and aesthetic concerns that were growing mixed forms of commentaries of nature in the midst of our polluted cultures of late modernity. Set in the context of post-Chernobyl global culture, such projects might, then, perhaps be understood as affirmative experimentations with novel structurations of nature and "out-of-control biology" in computational platforms.[236]

Ray's "A Proposal to Create Two Biodiversity Reserves: One Digital and One Organic" leads us straight to Guattarian thematics of ecological "cultivation." The organic reserve plan was designed to conserve the existence and diversity of large areas of rainforests in northern Costa Rica, and it was paralleled with a digital ecology project:

> The proposed project will create a very large, complex and inter-connected region of cyberspace that will be inoculated with digital organisms which will be allowed to evolve freely through natural selection. The objective is to set off a digital analog to the Cambrian explosion of diversity, in which multi-cellular digital organisms (parallel MIMD processes) will spontaneously increase in diversity and complexity. If successful,

this evolutionary process will allow us to find the natural form of parallel processes, and will generate extremely complex digital information processes that fully utilize the capacities inherent in our parallel and networked hardware. The project will be funded through the donation of spare CPU cycles from thousands of machines connected to the net, by running the reserve as a low priority background process on participating nodes.[237]

The 1990s saw several projects that attempted to capture the idle powers in network processes, such as SETI, which looked for extra-terrestrial life, and ideas of "parasite computing", which tapped into the protocols of the Internet to extract computing power. Even though Tierra experiments were reduced to cooperation and interaction between research facility computers via local area networks in the latter half of the 1990s,[238] the proposal has not lost any of its vital nature. Demonstrating that viral organisms can be employed also in beneficial, even perhaps etho-aesthetic processes, is key in terms of understanding the multiplicity of the phenomena at hand. A curious form of remediation of the Cambrian era several million years ago, Ray's project is a positively twisted type of media archaeological digging into the segments and flows of life. It also functions as a positive sort of accident, an event that exposes the machine it works with. An experimention (a creative stuttering) with the media ecology of networking and with virus-like programs, it serves as the perfect example of the virtual potentialities inherent in the diagrams of media ecologies.[239] In this, it perhaps also can be made to infect people, practices, and principles in the digital culture of networking in the manner Stengers was thinking of. At least it provides us with an important viral tool to think about the media ecological condition.

CODA: VIRAL PHILOSOPHY

As the foregoing discussions have revealed, the viral expands into various contexts from cybernetics and computing to biology, literature, television, cinema, and media art. In addition, especially in the 1980s, the concept gained ground in philosophical discourse, and what in the United States was labeled "postmodernism." This vague term is taken to refer to certain strands of "French theory" (Lyotard, Foucault, Baudrillard, Derrida, Deleuze, Guattari) and their reception, in particular, in the Anglo-American academic context. This, unfortunately, produced at times too homogeneous a view of the French scene and its conceptual work. In any case, as noted in the Introduction, various strands of theory that I have been using are actually part of the same "object" of analysis, namely

virality. There has, since the 1960s, been a constant feedback loop between, for instance, post-structuralist theories of culture and computer sciences, cybernetics, and biology. This has led to some criticism of these theorists as merely using such scientific terms in a metaphoric fashion. As Ruth Mayer and Brigitte Weingart aptly note, the viral culture of the 1980s and its marginalization of AIDS carriers gave birth to a counterphenomenon within philosophy and cultural theory where the liminality of the viral and its associations with subversion, novelty, and transversality were underlined and taken as motors of this certain brand of post-structuralism (another term that remains a little too vague).[240] True, the resonance of the term "viral" with Derrida's *pharmakon* is obvious, and hence also the incorporation of the viral into theories of deconstruction and plays of difference.[241] In addition, in the chapter on "Rhizome" in their *A Thousand Plateaus*, Deleuze and Guattari highlight the philosophical underpinnings and promises of the idea of a "virus." The virus is an agent of multiplicity and rhizomatic thinking that does not submit to hierarchical models of thought that rely on descent, rigid evolution, and determined history. Instead, the virus is to be understood as a vector of becoming where two series (the host and the parasite) momentarily resonate together and form a novel circuit of intertwinedness. With Deleuze and Guattari, evolution does not have to rely on the arborescent models of hierarchy and descent. Instead, viral evolution is a transversal connection machine that jumps across species and smuggles renegade bits of DNA along with it. Not merely "biological fact", it amounts to an image of thought as well, jumping scales: "We form a rhizome with our viruses, or rather our viruses cause us to form a rhizome with other animals. (…) Transversal communications between different lines scramble the genealogical trees. Always look for the molecular, or even submolecular, particle with which we are allied."[242]

From French theory virality as a subversive strategy infected media critique and net activism in the 1990s. During that decade, viruses were suddenly a common theme from net art to more capitalist ventures in viral marketing. Similarly, the viral was celebrated also in the cyberfeminism of the 1990s, well exemplified in the *détournement* of the VNS Matrix cyberfeminist manifesto:

we are the virus of the new world disorder
rupturing the symbolic from within
saboteurs of big daddy mainframe
the clitoris is a direct line to the matrix[243]

Although it might be easy to deconstruct such concepts as metaphorics of a certain era of media theory, I want to think through such figurations as potential vectors of affirmative critical thought. Instead of being merely "critical" (in the negative sense of tearing apart, deconstructing, destructing without building at the same time), I want to be synthetic and think through such viral philosophies and see where they can take us as vehicles of nomadic cultural analysis. Even if these theories of recent decades stem from the same context as computer viruses and, for example, second-order cybernetics, this does not make using them less interesting. This cultural historical contextualization does not remove the fact that the concepts can be used to gather and summon up forces to give a better understanding of the virality of late twentieth-century culture—a virality that is not a mere metaphor but a description of how various cultural platforms from technology to biological sciences and, for example, economics and aesthetics work. Furthermore, concepts do not merely describe "matters of fact" but act as creators of new circuits of concern and hence can be used to highlight, for example, previously neglected issues concerning digital culture.

More specifically, what I want to underline in my short coda is that the past few years of viral philosophy are perhaps a little more than metaphorical games and might contain important strands of thought for the abstract layerings of power (and knowledge) of contemporary societies of control within biotechnologies and computer technologies. My claim is that as contemporary power operates on increasingly abstract levels such as the molecular interactions of the body (as in genome research) or at level of the program code (digital culture), we also need complex theories and insights into this field of new production of network biopower. With this, I believe that "viral philosophy" can help us.

In the wake of Deleuze and Guattari, there rose a certain appreciation of the whole "viral ontology" during the last decades of the twentieth century. I have already touched upon the subject briefly in Chapter 2, where I argued that the "virus" is a central symbol and a mode of action of the information capitalist age. What follows is a brief philosophical epilogue on this theme of interconnectivity, posthumanism, and the becoming viral not only of digital culture but of philosophy as well. I proceed with the help especially of Rosi Braidotti, Keith Ansell-Pearson, and Elizabeth Grosz.

The viral and parasitic have deterritorialized across a range of fields and theoretical discourses to describe, for example, the state of subjectivity in network society and the logic of global power. For Steven Shaviro, selfhood is increasingly depicted as an information pattern, where the "individual" becomes merely a host of parasitic invasion by information capitalist patterns of repetition.[244] On the

other hand, Hardt and Negri regard the parasite as an apposite description of how the empire dips into the virtual powers of the multitude.[245]

Yet, what needs to be underlined is the danger in code-centered thought, as Tony Sampson argues. According to Sampson, the thematics of the viral have tended to reduce the matter to an emphasis on the issue of viral *code* as in itself subversive instead of looking at the larger assemblages of media ecologies where viral behavior is supported.[246] Focusing on viral code risks making "virality" in itself an objectified piece of rebel code, a mode of critical resistance, a Luddite gesture. Hence, in a similar manner, I turn toward seeing the parasite and the viral not merely as qualities of a specific piece of software but as assemblages of network culture, working in concrete machines and in the abstract machine (diagram) of network capitalism.[247] Similar to Sampson, I underscore the environmental dynamics of virus research, where there is a constant layering of territories (ecologies) of heterogeneous nature—that is, technical, conceptual, social, and historical.

If we take such perspectives seriously, the need to elaborate a "viral politics" and a "viral ontology" is even more emphatic: power operates in the imperceptible networks of the digital code and molecular biology. As mapped above, information capitalism is increasingly tied to the viral and the autopoietic diagrams of flexibility, resistant to the theorizations of national, centripetal state capitalism.[248] Hence, as I have tried to stress, issues of software and cultural history of digitality should be approached from perspectives that take into account the corporeal materiality *and* the incorporeal order-words of power/knowledge. This is also where we can think through Guattari's three ecologies and the ethics of diversity. Viral articulations highlight the conceptual power of the term "virus" and its territorial force to map transversal ideas, which makes it a potentially promising pairing with ecology. In this, I relate especially to certain themes of virality elaborated by Braidotti and Ansell-Pearson, which, by supplementing the viral focus on the digital, are taking us toward molecular bodies.

Braidotti addresses the need for a viral politics, a theme that follows from her emphasis on philosophical nomadism. Basically, Braidotti articulates what I have been approaching as an issue of ecology: to find concepts and approaches that rely on interconnectivity, interaction, and the constant foldings of the outside and the inside. For Braidotti, viral politics is "a form of micro-politics that is embedded in the human body. It is territorially-based and environmentally-bound, much like an animal-machine compound. It is also a relentlessly generative organism that aims at living on."[249] It is a form of agency that abandons anthropocentricity, being always directed toward the external, the outside—that is, such a politics

avoids the creation of rigid segments of interiority with which we are so familiar: the ego, the family, the sex, and so forth. Even though Braidotti focuses on the body–machine imaginaries, her insights are valuable concerning the patterns of the viral as well. Braidotti's affirmative mission is to take the pathologized body imaginaries of the Western cultural unconsciousness, the monsters and grotesque figures, and turn them into positive figures. This amounts to loving the monstrously new and different in hope of a future of *affirmative difference*. For us, of course, this connects to the possibility of affirming the virus, the anomalous, and with it a culture of complexity and difference. Is not the virus also a relative of these monstrous figures of the nineteenth century, a cousin of Frankenstein and other human-made figures of horror?

As I have tried to map the context or archive of malicious software, we also need to build a counterarchive of viruses and artificial life that short-circuits the all-too-simple (and all-too-human) understanding of the agenda at hand. Clearly, this is an issue that has been forthcoming from, and under construction by, several thinkers over recent years (whereas my work tries to think these issues through in the context of digital network culture). One of the most interesting writers in this respect is Elizabeth Grosz, who engages with issues of life, duration, and becoming. In this, she tackles also the issue of virality. Just as viruses question the rigid boundaries between life and nonlife as entities of RNA and DNA at the liminal zone between organic and inorganic, *computer* viruses, too, are such elements of complexification. To paraphrase Grosz, viruses are by definition agents of replication and evolution regardless of their material substance in carbon or silicon. The analogous symmetry between biological and computer viruses is, therefore, not to be neglected. For Grosz, this parable produces blurrings of "conceptual and definitional boundaries" concerning organisms, life, and inorganicity. In this, the question connects essentially to the tension between being and becoming: "How can any clear line be drawn in any case, such that material objects are characterized by inertia and by temporal self-containment (i.e., by being) that the organic world enlivens (through becoming)?"[250]

Grosz's question strikes at the core of the issue. As the problematics of life, biological lineage, and technological autopoiesis have been at the center of modernity, especially since the end of the nineteenth century, so the virus is an agent of such a deterritorialization that short-circuits itself within the key issues of philosophy of life and nature and technology. This blurring forces one into a reconsideration, or a Nietzschean reevaluation, of values, concepts, and practices of life and technology. In biology and biophilosophy, the viral has already been addressed by Ansell-Pearson. For Ansell-Pearson the issue connects to finding

alternative ways to understand evolution, life, and technologies, all of which are transversally intertwined. One key biological context for this thought probing is introduced by Lynn Margulis and her ideas on symbiosis as a subversive (but increasingly mainstream) view on evolution. To paraphrase Ansell-Pearson, since the 1950s the biological disciplines have been so organized into discrete departments (virology, genetics, pathology, etc.) that synthetic views on evolution have been hard to establish. In other words, until then and the point at which genetics also addressed microorganisms, sex was seen as the only vehicle for transmitting genes. But with Margulis's work from the 1970s on in particular, symbiotic bacteria challenged such an anthropocentric account. These ideas of bacterial symbiosis provided the hypothesis that evolution rested not only on mere slow accumulation of random changes, or mutations, but also on "intracellular symbiosis in which some cells incorporated into their own cell contents partner cells of another kind that [have] different metabolic activities."[251] A symbiotic view of evolution offered an alternative to accounts that focus on individuals and selection. Symbiotic perspectives see individuals (whether humans, cells, or software) as cooperative colonies that feed (and feed back) on their environments.[252] Instead of a reduced view of evolution as competition, there are a number of coexisting ecological strategies.

Viroids had also, according to some researchers, acted as such "intracellular symbionts", transversal vectors of genetic material. These biological-objects-turned-philosophical-vectors can be read in terms of evolution as well. Drawing from Deleuze and Guattari, Ansell-Pearson argues the need to understand evolution as *creative involution*. The notion is critical of the more passive Darwinian model of adaptation, and it underlines the transversal communication between heterogeneous series that occasionally launch blocks of becoming. This is what Deleuze and Guattari refer to as the fruitfulness of the rhizomatic model of evolution and thought in contrast to the tree model. Neither thinking nor evolution proceeds via clean-cut filiations expressed in the evolutionary trees that have been part of the standard iconography of phylogeny since the 1860s. A more accurate description is found in the simulation systems of artificial life or in the trackings of viral patterns in the global networks of information. Rhizomes are such open systems that interact transversally across predetermined lineages. As Ansell-Pearson writes:

> Like philosophy, the field of biology is full of born Platonists, but symbiosis shows that
> the delineation of "organic units", such as genes, plasmids, cells, organisms, and genomes,
> is a tool of a certain mode of investigation, not at all an absolute or ideal model. It chal-

lenges notions of pure autonomous entities and unities, since it functions through assemblages (multiplicities made up of heterogeneous terms) that operate in terms of alliances and not filiations (that is, not successions or lines of descent). The only unity within an assemblage is that of a plural functioning, a symbiosis or "sympathy."[253]

Hence, the overall mission is to think through biology with new concepts and orientations, whether it is a non-Platonic view or affirmative feminism, as with Grosz or Luciana Parisi, or the patterns of becoming described by Braidotti's viral politics.[254] Such perspectives are inspiring and address the need to rethink the ontologies of network culture, a techno-biology of sorts, which is not to be reduced to "postmodern metaphorics."

An ethological perspective sees bodies entangled with their surroundings, their social-material territories. Bodies and their environments are like two milieus that resonate together, infect each other. Drawing, for example, from the ethologist Jakob von Uexküll's works, Deleuze and Guattari focus on animal milieus as self-sustaining processual unities, an example of which is the blood-sucking tick, with its own restricted milieu, *Umwelt*. It is receptive only to specific phenomena: butyric acid found in mammals that attracts the tick, sunlight, the sense of mammalian heat, hair, skin, and the taste of blood. This is an affectual perspective on the world, a pragmatic viewpoint where the focus is on what bodies do, with what other bodies, with what types of relationships (affects).[255] Such are the coordinates, or the attractors, that define the tick's world. Of course, with more complex animals and milieus there are enormous numbers of coordinates and attractors, but still it is an option to approach such systems as consisting of movements and moments of rest. A plane of immanence where bodies interact, affect each other, form together is *a life*—"[t]he important thing is to understand life, each living individuality, not as a form, or a development of form, but as a complex relation between differential velocities, between deceleration and acceleration of particles."[256] The issues of autopoiesis and the structural couplings (think of Maturana and Varela) addressed above are also inherently connected to such ethological views.

This *bordering* (moving transversally, on border zones, crossing them, zigzagging) is what could be thought forward as an ethological perspective on the world and a *melodical* view of technology. Just as ethological views have provided important insights into nature and territoriality, these views can be extended to the technological nature of media assemblages that we are occupied with. In this sense, the Deleuzian–Spinozan approach to bodies and territories provides a key addition to the issue of media ecology we were occupied with above.

What attracts me in this perspective is that it renounces the linear and teleological notion of technology, just as these views have complexified the understanding of nature we have. This is a specific musical approach to the world, *natura musicans*, where the world is seen as consisting of territorializing refrains, deterritorializing music, rhythms flowing between milieus, making them vibrate.[257] This means a focus on relations, movement, and rhythms as cosmological constituents, not predefined forms, terms, substances, subjects, or objects. Technological culture, or media culture, can be followed along similar conceptualizations: neither as hierarchical techno-scientific plans of modern nature nor purely as postmodern self-organizing systems of fluidity but as movements between different stages of rigidity, stratification, and opening up.[258] Of course, what has been emphasized in recent decades, and what I have focused on in particular, are the new modes of technology and technological thought that are exemplified in computer worms and viruses, network cultures, and artificial life projects.

Artificial life as a mode of inquiry into the transdisciplinary field of biology and technology is perhaps something that tries to approach such musical-ethological planes of technology. In another context, ALife has been labeled as a postmodern science of simulacra that disconnects from reality and creates its own objects.[259] Such views are interesting as they connect with, for example, Mackenzie Wark's ideas of "third nature", a sort of communication technological ecology that builds on the layers of "natural ecology" and industrialization. And, true, such simulations of life might put the very basic categories and dualisms of biology into question as a form of scientific drag show or transvestitism, as Stefan Helmreich proposes. Nevertheless, there is no disconnection from reality but a more intense tapping into the processes working across platforms. Such a view that focuses on creational processes instead of fixed forms is meant to disrupt and expose the presumed molar identities and naturalities inherent in biology (and in technology, we might add). Helmreich calls ALife a *playful* science, something that I find a wonderful idea of scientific practice.[260] With such views we are not far from ethological interests, experimental views of science and technology, which focus on the formation of assemblages: how are composites, assemblages formed of heterogeneous parts; how do technological ecologies assemble, dissemble, and change; what is the "molecular economy" of media assemblages? The way I understand ethology here is actually, then, very close to my understanding of ecology, informed both by Ansell-Pearson's writings based on Deleuze and by the biological sciences: "there is no centre which is formally controlling behaviour; that is, there is not a top-down subject or agent of evolution (whether a nervous centre or

a homunculus), but only distributed intelligence that encompasses brains, bodies, molecules and worlds, all of which exist in terms of overlapping territories."[261]

To repeat, we are moving into a Spinozan territory here, thinking of bodies not in terms of preestablished categories (healthy software, malicious software, etc.) but in terms of their relative speeds and slowness. The perspective of "an ethological ethics" is therefore one that "involves the experimentation of affect in which a living thing is to be approached not in terms of its specific form and determinate functions but in terms of its capacities for affect and being affected."[262] In other words, the attention is on the assemblages in which media technological aspects interact, on the interconnections, with a special focus on the "inter", between. The connective lines are primary to the points they connect.[263] How do worms and viruses relate, resonate with the assemblages of digital culture? How do they interact? Where are the patterns of dissonance located? What are the common rhythms found between different milieus? The questions relate to mapping the affects of such processes of network culture to know their intensities. Such a knowledge of what a body can do and what its intensities are is exactly what is needed in an "evaluation" of the workings of software in network culture to find new positive practices (affects of joy) and learn to distinguish destructive "overdoses" (as with, for instance, harmful programs).[264] Interestingly, such questions have already been incorporated into technological and biological culture in the form of the experimental science of ALife, if it is to be understood following Langton's definition from the late 1980s: the issue is not focused on life (or technology we might add) as it is and has been, but as it could be.[265]

Furthermore, in recent years ALife has expanded its focus into how artificial computation could develop new, more radical operating models by learning from "natural computation-as-it-is."[266] Here computer scientists are mapping new territories also for cultural theorists to excavate, acting as probeheads of potential modes of digital culture. Artificial life, virality, and the uncontrollability in viruses prove, then, to be wonderful tropes for cultural analysis as well, resonating with ethological ethics: to infect across established categories, boundaries, and habits, to short-circuit issues in order to provide tactical rewirings concerning the power/knowledge networks that define the boundaries of digital culture. ·

Notes

1. McAfee & Haynes 1989, 36.
2. Foucault 2000d, 476.

3. Channell 1991, 83–84. See also Marvin 1988, 141–143.

4. Deleuze 1994, xx–xxi.

5. Butler 1918, 64–65. See also Dyson 1997, 15–34.

6. Butler 1918, 253.

7. Parisi 2004a, 186–187.

8. See Speidel 2000. Parisi 2004a.

9. Gere 2002, 53–54. Fox Keller 1995, 79–118.

10. Peter Friedland & Laurence H. Kedes: "Discovering the Secrets of DNA." *Communications of the ACM*, vol. 28, issue 11, November 1985, 1164.

11. Quoted in Channell 1991, 131.

12. Monod 1970, 102. For a critical view, see Lafontaine 2004, 199–206.

13. For a wonderful cultural history of the genetic code, see Kay 2000.

14. Borck 2004, 52. Kay 2000, 221.

15. See Mayer & Weingart 2004b, 16.

16. Galloway 2004, 111.

17. Kittler 1999, 1–19. Kittler 1990, 214.

18. See Dougherty 2001.

19. Gere 2002, 121–124.

20. See Whitelaw 2004.

21. Hayles 1999, 225.

22. Lupton 1994, 56.

23. Cf. Massumi's note concerning diagrammatics: "The important thing is that any theoretical analysis or 'diagram' of a phenomenon is an incomplete abstraction designed to grasp from a restricted point of view an infinitely abstract monster fractal attractor that is alone adequate to the complexities of life. (…) No presentation envelops a complete knowledge of even the simplest system." Massumi 1992, 68. Hence, "ecology" offers us *a* view of the functioning of network culture, channeling our thoughts and perceptions toward thinking this interfacing of nature and technology.

24. See Siegfried Zielinski's (2006) "an-archaeological" research.

25. See Ilkka Keso: "View from Large Corporation: Anti-Virus Tests" and "Cloaked Business." *EICAR Conference Proceedings* 1994, supplementary papers. Kari Laine: "The Cult of Anti-Virus Testing." *EICAR Conference Proceedings* 1994, 65–87. See also in general the discussions in the Computer Underground Digest in the early 1990s. <http://www.soci.niu.edu/~cudigest/>.

26. Such bulletin board systems were probably globally quite common, with, for instance, Finland having its own fair share of them, often run by teenagers. See F-Prot, Data Fellows, *Päivitystiedote*, vol. 2, issue 4, June. 1992. Such trading posts were, in addition, backed up by the novel virus construction kits, such as the Virus Construction Set (1990), the Virus Creation Laboratory (1992), the Instant Virus Producer, and GenVir, which was probably a completely commercial program tool fabricated in the Netherlands. See F-Prot, Data Fellows, *Päivitystiedote*, vol. 2, issue 7, January 1993.

27. See Sampson 2005, 2007.

28. Terranova 2004, 67. In more practical context, this essential of "parasitic computation" as part of the Internet infrastructure was articulated in 2001 by a bunch of scientists. Albert-László

Barabási, Vincent W. Freeh, Hawoong Jeong, & Jay B. Brockman: "Parasitic Computing." *Nature*, vol. 412, August 30, 2001, 894–897.

29. "More on 'Little Black Book of Comp. Viruses.'" *Computer Underground Digest*, vol. 4, issue 55, November 4, 1992. The online version of the book is at <http://vx.netlux.org/lib/vml00.html>.

30. As Cohen recollected in 1994: "By now, I have published almost everything that has come up. The only real disappointments relate to my inability to find any paying work related to computer viruses. Lots of people have offered me work if I will say things that aren't true, or endorse a product that I think is not very good. People want the use of my name, but not the results of my effort and analysis. A good example is the controversy surrounding benevolent viruses. I have been black balled by many members of computer security community because I refuse to renounce what I feel to be the truth. Among the leaders of the black balling are academics who I think should be fighting for academic freedom and the proliferation of new ideas, but it turns out they can get more research grants by speaking out against new ideas than by giving them a fair airing. It should be no big surprise—after all, as recently as 1988, I had an NSF grant proposal rejected by poor reviews from academics who claimed that there was no such thing as a computer virus and that viruses could not work in systems with memory protection. Obviously, they never bothered to read any of the 50 or so papers I have written on the subject." "The Legend—Fred Cohen." *Alive* (electronic magazine), vol. 1, issue 1, 1994. <http://www.cs.uta.fi/~cshema/public/vru/alive/alive.11>.

31. Ludwig 1996, 1.

32. Bernd Fix, e-mail to author, November 7, 2005. On hacker subculture, see Ross 1990.

33. See the editor's introduction in *Alive*, vol. 1, issue 0, March 1994. <http://www.cs.uta.fi/~cshema/public/vru/alive/alive.10>.

34. Galloway 2004, 171.

35. Kelly 1995. See the book online at <http://www.kk.org/outofcontrol/>.

36. Barlow 1996.

37. Ibid.

38. Cf. Ludwig 1996, 7.

39. Mattelart 2003, 139.

40. Ludwig 1996, 12–14.

41. Ludwig 1993, 22.

42. Cohen 1986, 219–220. Cohen and, for instance, Thomas Ray also attracted popular attention. See "Is There a Case for Viruses?" *Newsweek*, vol. 125, issue 9, February 27, 1995, 65. See also "The Virtuous Virus." *Economist*, vol. 325, issue 7781, October 17, 1992.

43. See Langton 1989a.

44. Johnston 2007.

45. See Trogemann 2005, 124–125.

46. See Speidel 2000. Parisi 2004a.

47. Ludwig 1993, 305.

48. Tony Sampson (2007) suggests a move from code-reductionist accounts of the viral toward analyzing the machinic network environments that support viral behavior. This approach is closely tied to my ecological thematics.

49. Fred Cohen has been careful not to make any hasty statements and the hacker Bernd Fix, for instance, did not see an allegory of viruses as artificial life as especially fruitful: "Artificial life?

With the development of better anti-virus tools some viruses that can change appearance popped up (polymorphic viruses), but I (personally) don't think that this is sufficient to be called AL. Viruses don't evolve—the simply spread. No genetics at all." Bernd Fix, e-mail to author, November 7, 2005.

 50. Cohen 1986, 222. At the same time, in the early 1980s, David Jefferson, an artificial life researcher, was active at the University of Southern California, providing Cohen with his support. Levy 1992, 254, 315.

 51. See Kittler 1999, 243–263. Turing's original paper can be found at the Turing Digital Archive. <http://www.turingarchive.org/browse.php/B/12>. Cf. John E. Hopcroft: "Turing Machines." *Scientific American*, vol. 250, May 1984.

 52. See Langton 1989b.

 53. Cohen 1986, 52–53.

 54. Ibid., 13–14.

 55. See Cohen 1994, 65–87.

 56. Sampson 2004, 6. See Cohen 1991b.

 57. Levy 1992, 324.

 58. Fred Cohen, e-mail to author, March 3, 2005.

 59. Quoted in Aspray 1990, 190.

 60. Simon 1969, 6–7, 14.

 61. Grosz 1995, 108–110

 62. Munster & Lovink 2005.

 63. Massumi 1992, 93. Deleuze & Parnet 1996, 62.

 64. Burger 1988, 255.

 65. Dyson 1997, 108. On von Neumann and artificial life, see Langton 1989b, 12–15.

 66. Aspray 1990, 189.

 67. Von Neumann 1966, 94. Aspray 1990, 202–203.

 68. Heims 1980, 204–205, 212.

 69. Thomas R. Peltier, "The Virus Threat", Computer Fraud & Security Bulletin, June 1993, 15.

 70. Kay 2000, 108.

 71. "Reconstruction of a Virus in Laboratory Opens the Question: What Is Life?" *New York Times*, October 30, 1955. See also "Mutation Agent Held Clue to Life." *New York Times*, January 26, 1960.

 72. Kay 2000, 185.

 73. Aspray 1990, 189–202.

 74. Mayer & Weingart 2004b, 16.

 75. Von Neumann 1966, 95.

 76. John G. Kemeny: "Man Viewed as a Machine." *Scientific American*, vol. 159, April 1955, 65.

 77. Von Neumann 1966, 32.

 78. John G. Kemeny: "Man Viewed as a Machine." *Scientific American*, vol. 159, April 1955, 66.

 79. Dyson 1997, 125.

 80. Von Neumann 1966, 20.

81. See Dyson 1997, 111–113. Cf. Margulis & Sagan 1995. Interestingly, the anarchist thinker Pjotr Kropotkin also introduced ideas of "mutual aid" and coevolution in the early twentieth century (1902). Armand Mattelart (2003, 43–44) links Kropotkin to early ideas of decentralization that stem from Joseph Proudhon's mid-nineteenth-century views on decentralized organization of community to Kropotkin's thoughts from the 1880s on, when he started to emphasize decentralization as pertinent to the neotechnical era. This was a form of evolutionary stance toward mutual support, symbiosis, which also represented a form of anarchist organization.

82. Dyson 1997, 114.

83. Quoted in ibid., 117.

84. Dyson 1999, 78–79.

85. See Mattelart 2003, 50–53.

86. Dyson 1997, 178–179. Gere 2002, 66–74. In general, the U.S. Air Force's need for computers was pushing the requirements for complex systems. The huge SAGE early warning system was a pioneering project. When it was finished in 1961, it was already technologically obsolete, but several ideas and components from SAGE were useful for the development of simulations. According to Charlie Gere (2002, 63), such inspirational spin-off technologies and techniques included magnetic memory, video displays, effective computer languages, graphic display techniques, simulation techniques, analog-to-digital and digital-to-analog conversion techniques, multiprocessing, and networking.

87. "Leviathan: A Simulation of Behavioral Systems, to Operate Dynamically on a Digital Computer." System Development Corporation report no. SP-50, November 6, 1959.

88. Dyson 1997, 178. See information on the corporation's archives at Burroughs Corporation Records System Development Corporation Records. <http://www.cbi.umn.edu/collections/inv/burros/cbi00090-098.html>.

89. "Leviathan Studies." *Communications of the ACM*, vol. 4, issue 4, April 1961, 194.

90. Ibid.

91. Quoted in Dyson 1997, 182.

92. Ibid., 183. Later Beatrice and Sydney Rome moved to analyze issues of organization and decision making in the use of computers. See Rome & Rome 1971.

93. See John H. Holland: "Outline for a Logical Theory of Adaptive Systems." *Journal of the ACM*, vol. 9, issue 3, July 1962, 297–314. Daniel J. Cavicchio Jr.: "Reproductive Adaptive Plans." *Proceedings of the Annual ACM Conference*, vol. 1, 1972, 60–70. See also the report on MIT's program on self-learning software: "Computers: Machines That Learn from Mistakes." *The Times*, August 10, 1974, 14.

94. Selfridge 1989, 118. Cf. Dyson 1997, 185.

95. DeLanda 1991, 177–178.

96. Selfridge 1989, 121.

97. Apter 1966, 71,

98. Wiener 1961, 169.

99. Wiener 1964, 29.

100. Ibid. "Nevertheless, behind all this fantastically complex concatenation of processes lies one very simple fact: that in the presence of a suitable nutritive medium of nucleic acids and amino acids, a molecule of a gene, consisting itself of a highly specific combination of amino acids and nucleic acids, can cause the medium to lay itself down into other molecules which either are mole-

cules of the same gene or of other genes differing from it by relatively slight variations. It has been thought indeed that this process is strictly analogous to that by which a molecule of a virus, a sort of molecular parasite of a host, can draw together from the tissues of the host, which act as a nutrient medium, other molecules of the same virus. It is this act of molecular multiplication, whether of gene or of virus, which seems to represent a late stage of the analysis of the vast and complicated process of reproduction."

101. "Computers: Machines That Learn from Mistakes." *The Times*, August 10, 1974, 14. The project included a curious-sounding "Hacker" program that was designed as a self-learning program for debugging, for instance.

102. Galloway 2004, 105–106.

103. Apter 1966.

104. On third nature, see Wark 1994. See also Simon 1969.

105. Foucault 2000e, 374.

106. Riskin 2003. Bagrit 1965.

107. DeLanda 1991, 167–173. DeLanda 1998. Simon 1969, 84–118.

108. "When Perforated Paper Goes to Work. How Strips of Paper Can Endow Inanimate Machines with Brains of Their Own." *Scientific American*, vol. 141, December 1922, 394. (My italics.)

109. See "Darwin, A Game of Survival of the Fittest among Programs." A Letter by V. Vissotsky et al. to C.A. Land, 1971, transcribed and online at <http://www.cs.dartmouth.edu/~doug/darwin.pdf>.

110. Vic Vyssotsky, e-mail to author, June 2, 2005. Doug McIllroy recalls similarly: "Darwin was sui generis, except perhaps for the old puzzle that every programmer has attacked: write a program whose sole output is the program source. We were also familiar with the work of our colleague C. Y. Lee, who described a universal Turing machine that began its computation by outputting a description of itself. Nothing further was inspired by Darwin until Dewdney's article in the *Scientific American*." Doug McIllroy, e-mail to author, April 25, 2005.

111. "Darwin, A Game of Survival of the Fittest among Programs." <http://www.cs.dartmouth.edu/~doug/darwin.pdf>.

112. A.K. Dewdney: "In the Game Called Core War Hostile Programs Engage in a Battle of Bits." *Scientific American*, vol. 250, May 1984, 15.

113. Vic Vyssotsky, e-mail to author, June 2, 2005.

114. See "Early Viruses (RE: RISKS-6.48)." *The Risks Digest*, March 24, 1988. <http://catless.ncl.ac.uk/Risks/>.

115. "Two Old Viruses." *The Risks Digest,* March 29, 1988, <http://catless.ncl.ac.uk/Risks/>.

116. Ken Thompson, e-mail to author, April 27, 2005.

117. Ibid.

118. Richard Stallman, e-mails to author, June 3 & 4, 2005.

119. Emmeche 1994, 81–83. Forbes 2004, 34.

120. Ibid., 33.

121. Kay 2000, 321.

122. Forbes 2004, 33. There are various versions of the Game of Life on the Internet; see, e.g., <http://www.bitstorm.org/gameoflife/>.

123. Terranova 2004, 111.

124. See Ward 2000, 70.

125. Martin Gardner: "The Fantastic Combinations of John Conway's New Solitaire Game 'Life.'" *Scientific American*, vol. 223, October 1970, 120.

126. Beeler 1973, 1.

127. Apter 1966. See in general on the inteconnections of biology and technology, Channell 1991. Cf. Fox Keller 2002, 247–248, 265–294.

128. Fox Keller 1995, 108.

129. Ward 2000, 72.

130. Dyson 1997, 121–122.

131. Munster & Lovink 2005.

132. Quoted in Mosco 2004, 137. See also Ralph Lee Smith: "The Wired Nation." *Nation*, vol. 210, May 18, 1970.

133. Galloway 2004, 35. The plan had been accepted by Congress after World War II, yet it was implemented only years later.

134. Mosco 2004, 138.

135. Cf. Gere 2002, 13.

136. Hafner & Markoff 1991, 280. Lundell 1989, 21.

137. Barry M. Leiner et al.: "The Past and Future History of the Internet." *Communications of the ACM*, vol. 40, issue 2, February 1997, 104.

138. Robert E. Kahn. "Networks for Advanced Computing." *Scientific American*, vol. 257, October 1987. Of course packet-switching networks represented merely one model of networking. See Stephen R. Kimbleton & G. Michael Schneider: "Computer Communication Networks: Approaches, Objectives, and Performance Considerations." *Computing Surveys*, vol. 7, issue 3, September 1975. On the history of packet switching, see Abbate 2000, 27–41. Matthew Fuller (2005, 128–129) makes a very important point when underlining the hierarchical nature of the packet-switching technique: even though it connotates self-organization, it is at the same time controlled by protocols and other socio-technical dimensions.

139. Chun 2006, 3–4.

140. DeLanda 1991, 120–121.

141. Stephen R. Kimbleton & G. Michael Schneider: "Computer Communication Networks: Approaches, Objectives, and Performance Considerations." *Computing Surveys*, vol. 7, issue 3, September 1975, 139.

142. Gere 2002, 67. Barabási makes an important argument when writing how the contemporary Internet is actually not modeled on the Baran diagram of distributed networks. Instead, argues Barabási (2003, 143–159), the Internet is to be seen as a scale-free topological formation where not every node is democratic but certain nodes act as key hubs that have more contacts than others. This means that such a topology contains distributed and hierarchic elements. See also Sampson 2007. In another context, Barabási sketches an interesting idea of "parasitic computing" as part of the Internet infrastructure, a mode of operation that blurs "the distinction between computing and communication" and takes advantage of the Internet protocols. Albert-László Barabási, Vincent W. Freeh, Hawoong Jeong, & Jay B. Brockman: "Parasitic Computing." *Nature*, vol. 412, August 30, 2001, 894–897.

143. Baran 1964, ch. 4.

144. John Walker: "The Animal Episode." 1985. <http://www.fourmilab.ch/documents/univac/animal.html>.

145. Ibid.

146. Baran 1964.

147. As Paul N. Edwards (1996, 15) has argued, in the United States during the cold war, computers were discussed together with international and domestic political practices. What Edwards calls "closed-world discourse" refers to a set of mathematical techniques, computer technologies, and computer simulations as well as different political and ideological fictions and fantasies and linguistic articulations of global mastery, nuclear strategies, and centralized automated command-and-control structures.

148. John F. Shoch & Jon A. Hupp: "The 'Worm' Programs—Early Experience with a Distributed Computation." *Communications of the ACM*, vol. 25, issue 3, March 1982, 173.

149. Ibid.

150. Ibid., 177–179.

151. Ibid., 179.

152. Ibid.

153. See Terry Winograd: "Beyond Programming Languages." *Communications of the ACM*, vol. 22, 7/July 1979, 391–401. Jerome A. Feldman: "High Level Programming for Distributed Computing." *Communications of the ACM*, vol. 22, 6/June 1979, 353–368. Cf. Halbach 1998. For similar examples in programming and databases, see, e.g., J.B. Gunn: "Use of Virus Functions to Provide a Virtual Interpreter under User Control." *Proceedings of the International Conference on APL Programming Language*, vol. 14, Issue 4, 1984, 163–168. Alan Demers et al.: "Epidemic Algorithms for Replicated Database Maintenance." *ACM SIGOPS Operating Systems Review*, vol. 22, issue 1, January 1988, 8–32.

154. Barabási 2003, 144–145.

155. DeLanda 1992, 129. DeLanda 1998.

156. Turkle 1996, 136.

157. Prigonine & Stengers 1984, 12–14.

158. Hardt & Negri 2004, 92.

159. Cf. Terranova 2004, 98–130. However, as Thacker (2004) importantly notes, networks and swarms do not automatically translate as radical politics of multitude.

160. See DeLanda 1999, 32. Cf. Fuller 2005, 17–24.

161. Deleuze & Guattari 1987, 409.

162. Ibid., 408–413.

163. I am grateful to Jukka Sihvonen for helping with the formulation of the idea.

164. Paul Bratley & Jean Millo: "Self-Reproducing Programs." *Software—Practice and Experience*, vol. 2, 1972, 397.

165. John Burger, David Brill, & Filip Machi: "Self-Reproducing Programs." *Byte*, August 1980, 74.

166. Hofstadter 1979, 498–504.

167. Kittler 1999, 258. The IF/THEN pair functions also at the heart of the viral principle: first, in the infection mechanism that looks for infectable objects, then in the trigger part, and finally in the potential payload part. IF the condition for date accords with, for example, Friday 13, THEN set the trigger status to yes. See Harley, Slade, & Gattiker 2001, 87–88.

168. Dawkins 1977, 206. See also Richard Dawkins: "Is God a Computer Virus?" *New Statesman & Society*, December 18, 1992. Symbiotic theories of evolution provide an alternative

account concerning population thinking and evolution. They proceed in terms of transversal connections across populations (instead of a genealogical lineage) and heterogeneous assemblages (bacteria, animals, plants, humans, technology). See Parisi 2004a, 141.

169. Fuller 2005, 111.

170. Terranova 2004, 125.

171. Hayles 1999, 225.

172. Blackmore 2000, 204–213. Cf. Dawkins 1977, 203–215.

173. See, e.g., Benjamin's "The Work of Art in the Age of Mechanical Reproduction" (1969, 217–251). Cf. Gere 2002, 32–35.

174. Blackmore 2000, 217.

175. Douglas R. Hofstadter: "Virus-Like Sentences and Self-Replicating Structures." *Scientific American*, vol. 248, January 1983, 14–19.

176. Forbes 2004, xiii.

177. Emmeche 1994, x.

178. Packard 1989.

179. Pattee 1989, 74.

180. Smith 1992. Spafford 1992. Of course, viruses and artificial life had been discussed in the same breath in the 1980s. See, e.g., Burger 1988, 269–274. See also the *Alive* e-magazine archives online at <http://www.cs.uta.fi/~cshema/public/vru/alive/>. A quote from the first "Beta" issue from 1994: "This magazine is one more try to find answers to some questions. The search for the best definition of computer virus will be continued. It is a general opinion that computer viruses are inherently malicious software. The possibility of viruses to be beneficial will be (hopefully) discussed here. However, protection against malicious viruses will not be neglected. This magazine will try to introduce new ways of protection, e.g. 'immune systems.' The question 'What can be "alive" in a computer environment?' will be repeated in all possible variations as long as the wish to find answers exists. The examples or descriptions of 'liveware' will be presented here as soon as they appear. Probably some new topics will arise as 'Alive' progresses. And, of course, I expect a lot of fun for both readers and contributors."

181. Spafford 1992, 744.

182. Galloway 2004, 147–186.

183. See Tozzi 1991.

184. Turkle 1996, 157.

185. Ceruzzi 1998, 264.

186. Turkle 1996, 157.

187. John Markoff: "Beyond Artificial Intelligence, a Search for Artificial Life." *New York Times*, February 25, 1990. Richard Marton: "Real Artificial Life." *Byte*, January 1991. "Is There Life in Your Computer?" *Boston Globe*, October 5, 1992. Cf. James Daly: "Can a 'Good' Virus Be a Bad Idea?" *Computerworld*, vol. 26, October 5, 1992. Julian Dibbell: "Viruses Are Good for You." *Wired*, vol. 3, issue 2, February 1995. <http://www.wired.com/wired/archive/3.02/viruses.html?pg=12&topic=>. See also Pattie Maes: "Intelligent Software." *Scientific American*, vol. 273, September 1995.

188. Cf. Harrasser 2002.

189. See, e.g., Hafner & Markoff 1991, 254.

190. See here Van Loon 2002b. On actor network theory, see Latour 2005.

191. Rushkoff 1996, 247.

192. Julian Dibbell: "Viruses Are Good for You." *Wired*, vol. 3, issue 2, February 1995. <http://www.wired.com/wired/archive/3.02/viruses.html?pg=12&topic=>.

193. Dyson et al. 1994. Terranova 2004, 120.

194. See their homepage at <http://www.pff.org/>.

195. Dyson et al. 1994.

196. Barbrook & Cameron 1996. See also Helmreich 2000b, 94.

197. See Rucker, Sirius & Mu 1993.

198. See Leary 1992. Kelly 1995. Kelly's book is online at <http://www.kk.org/outofcontrol/contents.php>.

199. Gere 2002, 143.

200. Helmreich 2000b, 162.

201. Ibid., 174.

202. "The Virtuous Virus." *The Economist*, vol. 325, October 17, 1992. See also "Is There a Case for a Virus?" *Newsweek*, vol. 125, February 27, 1995.

203. Julian Dibbell: "Viruses Are Good for You." *Wired*, vol. 3, issue 2, February 1995. <http://www.wired.com/wired/archive/3.02/viruses.html?pg=12&topic=>.

204. Negroponte 1995, 149–159.

205. Wise 1997, 150–157.

206. "The Virtuous Virus." *Economist*, vol. 325, October 17, 1992. Cohen 1994.

207. Berardi n.d.

208. Stengers 2000, 118.

209. Ansell-Pearson 1997, 136.

210. Ibid., 137.

211. Stengers 2000, 90.

212. Bateson 1972, 483.

213. See Gere 2002, 121–122.

214. Maturana & Varela 1980, 9.

215. See Parisi 2004a, 142.

216. Guattari (1995, 37) writes in *Chaosmosis* how autopoietic machines differ from structures. Instead of a "desire for eternity", there is a movement of difference (of abolition) at the heart of the self-recreation of autopoietic machinic systems. Such machines are always characterized by disequilibria, which implies an alterity—a radical, material potential of the new that does not just stem from a creative human factor but from a machine's relation to other virtual or actual machines (nonhuman).

217. Simon 1969, 24.

218. Maturana & Varela 1980, xvi.

219. Ibid., 9.

220. Fuller 2005, 106.

221. Massumi 2002, 237.

222. Deleuze & Guattari 1987, 241–242.

223. Deleuze 1988, 123. Cf. the discussions concerning the "body" in the previous chapter.

224. Guattari 1995, 91.

225. Ibid., 92. Guattari places special emphasis on the aesthetic machines in such a cultivation of a virtual ecology.

226. On hybrids and the purification work of modernity, see Latour 1993.

227. Langton 1989b, 2.

228. Deleuze & Guattari 1983, 8.

229. See Serres 1982. Of course, there are cancerous organisms in any environment in the sense that they might be harmful to the very existence of the environment that supports them—we have examples of such programs as well. For example, the Leligh virus (1987) was actually too destructive in that it prevented its own chances of spreading outside the university computers it was originally found in. But it represents merely one actualization of viruses.

230. Forbes 2004, 46. See also Dyson 1997, 125–127. Emmeche 1994, 39–44. Ward 2000, 195–212. Tierra web page at <http://www.his.atr.jp/~ray/tierra/>. Images of the Tierra system at <http://www.his.atr.jp/~ray/pubs/images/index.html>.

231. Ray 1993. Cf. Ward 2000, 195–197.

232. Ray 1993.

233. On Rasmussen's work, see Rasmussen 1989. Rasmussen, Knudsen & Feldberg 1992.

234. See Hillis 1989. Ward 2000, 207–208. Relevant are also Hillis's later research interests, for instance, his paper at the second Artificial Life conference in 1990, where he discussed coevolving parasites and simulated evolution. Hillis 1992. In addition, his Thinking Machines Inc. company was already looking into evolutionary software in the early 1990s. See "A Darwinian Creation of Software." *New York Times*, February 28, 1990.

235. Deleuze & Guattari 1987, 69. Cf. Parisi 2004a, 140–145.

236. Clark 1997.

237. Ray 1995.

238. Ward 2000, 209–212.

239. The issue of artificial life art is of interest here as well. See Whitelaw 2004.

240. See Mayer & Weingart 2004b.

241. Derrida 1972, 71–196. Cf. Bardini 2006.

242. Deleuze & Guattari 1987, 10–11.

243. Quoted in Plant 1996, 171.

244. "I may describe this process that subtends my consciousness in several ways: as embryonic infolding, as fractal self-similarity, or as viral, cancerous proliferation. But the difference between these alternatives is just a matter of degree. The crucial point is that the network induces mass replication on a miniaturized scale and that I myself am only an effect of this miniaturizing process." Shaviro 2003, 13.

245. "Imperial power is the negative residue, the fallback of the operation of the multitude; it is a parasite that draws its vitality from the multitude's capacity to create ever new sources of energy and value. A parasite that saps the strength of its host, however, can endanger its own existence." Hardt & Negri 2000, 361.

246. Sampson 2007.

247. Cf. Chun 2006, 17–18. On contextual views on software, see also Fuller 2003. Mackenzie 2006.

248. Cf. Lash & Urry 1987.

249. Braidotti 2002, 266.

250. Grosz 1999, 23. See also Grosz 2004, 2005.

251. Ansell-Pearson 1997, 132. See Margulis & Sagan 1995.

252. Parisi 2004a, 56.

253. Ansell-Pearson 1997, 134.

254. Braidotti 2002. Grosz 2004, 2005. Parisi 2004a, 2004b.

255. Deleuze & Guattari 1987, 257. Bogue 2003, 58–59.

256. Deleuze 1988, 123.

257. For an overview, see Bogue 2003, 55–76.

258. See Fuller 2005. Hence, even in thinking through biology, one should not fall for easy analogies between biology and digital culture as with the rhizome boom of the 1990s, where the Internet was suddenly seen directly in terms of the Deleuzian–Guattarian concept. Instead, the Internet is something that connects hierarchies and heterogenesis. See Galloway 2004. Terranova 2004.

259. Emmeche 1994, 156–166.

260. Helmreich 2000b, 246. Of course, Butlerian theory of performativity incorporates several problems from a Deleuzian perspective that I cannot address here. Suffice it to say that these differences have to do with the Hegelian basis of the idea of performativity versus Deleuzian virtuality. See Tuhkanen 2005.

261. Ansell-Pearson 1999, 176.

262. Ibid., 185.

263. Deleuze & Guattari 1987, 293.

264. See Deleuze's lecture on Spinoza and affects/affections at Vincennes, January 24, 1978. <http://www.webdeleuze.com/php/texte.php?cle=11&groupe=Spinoza&langue=1>.

265. Langton 1989b, 2.

266. Johnston 2007.

CONCLUSIONS:
MEDIA ARCHAEOLOGY AS ECOLOGY

In 2002, the Frankfurt Museum for Applied Art added a new type of object to its collections: the computer virus, or more specifically viral code. In addition to its classical collections of ceramics and art from Islamic and East Asian countries, the esteemed museum was willing to consider these pieces of software worth archiving. The task was part of the "I Love You" exhibition curated by Franziska Nori, who emphasized the active role a museum has in preserving and defining cultural memory:

> In addition to collecting and preserving objects, a museum's purpose is to provide cultural contexts and distinctions, whereby the observer is encouraged to rethink his or her own perception of the world of things. Not only do museums serve as a society's cultural memory, they are also places for communicating and researching the new realities and models which are relevant to society. The paramount question: What is digital culture today and what will it become in the age of the information society? not only determines the direction of today's artistic production but should also encourage cultural institutions to examine their own task.[1]

In this perspective, viruses do not merely represent an example of malicious viral code but are part of a cultural-historical assemblage of digital culture. Aptly, they are archived as an integral part of the memory and future of network culture and consequently are adapted as explicit parts of the discourse network of digital culture. In other words, the issue is not just about the technical fact of viral code but also about the media ecology of network culture.[2] The perception of viruses as accidents can be channeled into a new seriality that gains consistency and hence creates a minoritarian archive, or a memory, of digital culture. This is the task of temporally oriented cultural analysis: to multiply events and accidents and create heterogeneous assemblages that endure and sustain a new understanding of practices and discourses; to repeat the accidental so that it does not remain

anomalous but opens up as a new, creative horizon in theoretical and perhaps in practical spheres of action as well. The virus, as argued throughout this book, is not merely "noise", in the sense of being a random pattern without sense, but a certain rationality. This is not only a metaphor but reflects how noise has become refigured in the age of Shannon and Weaver's information theory. Noise is something programmable and hence a mode of algorithmic rationality, which reflects its status as a cultural object. Noise is not just noise but something that can be cultivated, as in early sonic media arts from Edgar Varése's musical pieces integrating "noise" as organizatory element to John Cage and, for example, the experiments with feedback turned into the new aesthetic craze of rock music (distorted sound). Stochastic patterns and turbulence are taken much use of.

The virus can be seen as a key cultural condensation point of network culture, a sort of fundamental object. Yet, as demonstrated, in a way it is not an object but a network. Opening up this seemingly solid piece of technicality and software reveals a world reaching out in time and space, across scales and various platforms. The virus, then, is a passage to analyzing certain traits of formation of network culture, here analyzed specifically in terms of security, body, and (artificial) life.

During recent years, various net art projects have addressed computer viruses as a curious aesthetic and media cultural phenomenon. One such example was the Biennale.py net art virus from 2001, which was distributed on T-shirts and sold on CD-ROMs ($1,500 each). With the virus, computer code became a media performance. Image by Eva and Franco Mattes (0100101110101101.org), source: <http://0100101110101101.org/download/biennalepy.html>.

The first chapter engaged with the tactical creation of fear inherent in network culture. Given the security aspects of this media ecology, computer viruses and worms connect to the agenda of risk society and risk filtering in contagious media. This is part of what I called "viral capitalism"—the ability to translate seemingly hostile cultural flows into an integral part of the production of digital software and services in the form of the security industry. Viruses and similar semiautonomous programs were not a security concern during the 1970s, even though several fiction writers depicted virus-like and worm-like program patterns as potential intruders into computer networks. Only after the mid-1980s and the 1988 Morris worm did self-reproducing and self-moving programs enter a new assemblage in which they were christened as malicious software. The nonvisual nature of the digital code of viruses was effectively remediated into audiovisions through mass media channels, whether in texts or on television news and, during the 1990s, in movies. Here, the media assemblage itself demonstrated patterns of contagion in its handling and adaptation of this perception of digital risk.

The risk society of network culture can be seen as a second-order capitalist system from which noise is not excluded. Instead, the more tolerant systems are, the more strongly they function. Rigid systems, trying to cast out their parasites, noise, and viruses, do not last as long as a system accustomed to the deviant. "Flexibility" became a key word in network society, and in the software context the change can be situated in the 1980s. There is no mathematical possibility that a system can be totally virus-free, claimed Fred Cohen. Basically, since then, various counteractions have aimed not at total security and control of threats but "only" at adjustment and toleration of uncertainty and risk. Risk management became a key concern of software as well.

To be sure, self-reproducing software existed before it was labeled malicious. Experimental reproductive software had been programmed in various computer labs and university departments in the United States since the 1950s. Such experiments could perhaps be thought of as probing ideas of "sentient" software and computing that was not merely about simple deductive number crunching. Software could be used in parallel, interactively, and in network contexts. Of course, the first "real" viruses spread only during the 1970s, in the early networks, such as ARPANET, and in science fiction. It would be tempting to read these descriptions of fictitious viruses as predictive warnings of worms and viruses breaking loose and causing havoc in national and international data networks, as, for example, in John Brunner's *The Shockwave Rider* (1975). However, fiction literature of the past is not merely a recapitulation of what came to be; it should be read as offering alternative viewpoints to viruses, a new imagination.

Viruses were distributed in various media, and language seemed to occupy a special place in the thematics of the viral. "Language is a virus", claimed William Burroughs in his peculiar style, claiming that basic media processes are chiefly about imitation and reproduction. In a parallel manner, I claimed in the second chapter that the media ecology of viral capitalism acts through special order-words and incorporeal transformations. Instead of speaking of the metaphorics of computer viruses and worms, I chose to approach the issue as one of the pragmatics of language: how are these pieces of code turned into malicious software, and how are the order-words of AIDS, virus anxiety, digital hygiene, and computer immunology used in the diagrams of network culture? During the 1980s, the fear of bodily intrusion by AIDS and general interest in viral issues tallied well with the underscoring of digital viruses as the key risk to future societies of network computing. In other words, the language of the virus did not so much represent but enforce a way of seeing computer culture as a biological system and how outsides and insides are distributed in such a system. Immunology played an interesting role here, just as it has played in biology. Healthy bodies have been defined and constructed in terms of immunological knowledge, especially since the 1980s, and soon this use of concepts infiltrated computers both via professional studies and via popular computing magazines. The idea of computer systems having an immune layer was meant to imply that there is a "self" in computers that should be protected against "infiltrators" such as viruses. Yet, in another context, the idea of flexible immunity gained ground. Of course, computers could not defend themselves: the pragmatic figure of a "responsible user" was created to channel these types of ideas into actions. Responsible use included being consciously motivated to keep one's computer safe from untrusted software (often labeled as pirate software). This was not merely to protect oneself; it was meant to signal a general responsibility of the whole of the computer community. The language of AIDS and protection from contagious diseases was widespread.

In Chapter 2, the analysis of the "body" of network culture took advantage of Deleuze's reading of Spinoza: "Bodies are distinguished from one another in respect of motion and rest, quickness and slowness, and not in respect of substance."[3] Bodies are analyzed, then, as relational entities, defined by the networks they are able to form (and networks they are able to adjust to). Bodies do not preexist their relations; an ethological (and in my take ecological) perspective focuses on the capacities to affect and be affected. This implies the need to develop much more complex models of bodies and boundaries (and hence, for instance, immunology) than the inside–outside models with their warlike implications suggest. The Spinozian ideas resonate strongly with, for example, the autopoietic theories

of Maturana and Varela, where the issue of coupling is primary. Organisms exist only as intimately coupled to their environment, where the border between the two is to be considered as a folding: a continuous surface that stretches from the outside to the inside like a Möbius strip, a strip with multiple dimensions but all testifying to one common reality. This relates closely to Spinoza's claim that there is one voice, one substance connecting its various attributes. Among the alternative ways to think of bodies discussed earlier was Ludwig Fleck's critique of closed, self-contained individuality from the 1930s. In computer science, Terry Winograd and Fernando Flores proposed models of breakdowns to be incorporated at the center of computer systems design. This implied a whole new approach to systems, where "healthy bodies" were not defined in terms of nonfrictional, self-enclosed action but as interconnected assemblages where breakdowns revealed the complex networks that sustained the functioning. Computer systems were not pristine bodies without holes, accidents, or inconsistencies but symbiotic bodies that relied on each other in their daily operation. This focus on breakdowns leads to an understanding of the interconnected nature of computers as networks and assemblages, where accidents are, always, internal to the functioning of the machine. In other words, autopoietic systems, or machines as Deleuze and Guattari name them, rely on external elements for their existence (a complementarity with the world), yet this is doubled with an element of differing in relation to the world (an alterity in relation to other machines, virtual or actual).[4]

Such themes relating to Spinozian ethologies and ecologies of bodies can be further expanded. There is a certain potentiality in bodies, and this potentiality is realized in its experimental relationships with the world. Now, this perspective is useful in the context of network culture and software as well. Programs have affects—they can form relations and are part of a vast network of relations, like the virus with its three primary technical affects: (1) the copying routine that enables the distribution of the virus; (2) a trigger that switches the viral code into active mode (for instance, with earlier viruses, a certain date or a certain number of computer boot sequences); (3) a payload, which is often the level users perceive (playing a tune, displaying a message, or something directly harmful). Yet, in addition to such technical ethologies, there exists a much vaster sphere where "bodies" are formed and interact on scales ranging from ideas to politics, economics to aesthetics. This can be seen as the problem of the concept of the body in its Deleuzian and Spinozian take: it is much too broad. The positive side is that exactly as a consequence of this abstractness we are able to see how far a concrete object's relations span. They are not always merely local (although they span from a certain position).

With an eye on potentiality, I emphasized in Chapter 3 how the virus is excess, not merely a product of power/knowledge *dispositifs* that mark it as malicious software. Writing the history of viral assemblages as part of the ideas of complexity and networking, I ended up mapping the countermemory, the genealogy, of the phenomenon, which also accentuates the thematics of life as coupling. The viral is not reducible to its defining contexts; following Deleuze, we can think how the lines of flight and the deterritorializing machines of connectivity come first.[5] Viral patterns of self-reproduction, communication, and even potential emergence have attracted the interest of computer scientists, hobbyists, hackers, and artists for decades. In other words, we have various viralities working in this media ecology, viralities that are not reducible to their technological characteristics but constitute a diagram or an abstract machine that pilots the concrete machines: the viral code is continuously articulated in contexts of (viral) media and (viral) capitalism, without forgetting, for example, the conceptual thematics that have been articulated from Burroughs's idea of the language virus to the meme theory of Dawkins and Blackmore and on to perhaps the arguments for a (viral) philosophy that I mapped in the epilogue of the previous chapter. This mode of thought that proceeds as ecological couplings does not pertain only to "philosophy" as an academic discipline, but can also be found in the practical work done in various artificial life projects. As Isabelle Stengers noted, there is a certain potentiality of creative neomaterialism in ALife research that would map new ways of becoming. ALife projects such as Ray's Tierra digital ecology can be seen in this way as tapping into the machinic phylum and looking for ways to approach the world as itself material, active, and self-organizing. As these themes have spread through the field of philosophy and cultural analysis via the work of, for instance, Deleuze and Guattari, DeLanda, and Parisi, there is a parallel movement going on in computer science and experimental programming that looks for the potential inherent in the phenomenology of software objects.

Thus, as we address artificial life and musical-ethological views of technology, we can also view computer organisms such as viruses as affordances and potentials. As ALife and several scientific (and practical) projects close to it draw extensively from ideas of symbiosis and emergence, viruses also belong conceptually to this group as elements of interconnection and folding. Just as artificial life is not "only" a scientific field that closes on itself, but also one that deterritorializes (or "deconstructs", as some would say) fields around it (biology, technology, etc.), so viruses might be understood not exclusively as technical pieces of code that infect programs. They, too, can be taken as active "tools to think with" that might (1) short-circuit our views concerning the past and the histories of technology and

media ecologies and (2) produce viable futures for novel concepts, paradigms, and formulations concerning media design. As I wrote in the prologue of Chapter 1, perhaps viruses might prove to be intellectual tools, too, with which to create new concepts in, and viewpoints on, digital culture and the cultural history of computing and technology in general. Hence, viruses can be taken not merely as the objects of this book, but as its copartners, presenting their logic of lively virality as a titillating way of doing cultural analysis: to move, to stutter, to repeat but with a difference.

Even though most of the media theory of networking and artificial life has focused on the 1980s and more recent decades, the early experiments in the 1950s and 1960s with networking capabilities had already introduced ideas and programming practices that challenged the traditional image of hierarchical systems. The computer pioneer John von Neumann was not only occupied with computers as brains; his later work provided the first theories of cellular self-repro-ducing automata, which have inspired mathematicians and computer scientists ever since. Less familiar are the experiments by Nils Barricelli at Princeton, where in 1953 he applied symbiogenesis to computers. Barricelli's computerized genesis thought gene interaction in terms of system abilities, not individuals, something that Ludwig von Bertalanffy had also suggested in the 1950s: study biology in terms of systems, not individuals. Quickly his ideas spread across a much wider social field than biology alone. As interesting as Barricelli's claims was Beatrice and Sydney Rome's Leviathan system a few years later. Leviathan was modeled as a computer environment, where the practical use was to analyze decision making. Yet, the implications for simulated computational ecologies went much further and would also merit additional research.

Experimental reproductive software became more than metaphors and was intimately connected to ways of creating new ideas that resonated with the then-popular topics of complex systems, nonlinearity, networks, and even chaos theory. Again, thinking in terms such as "ecology" is to be taken not as a mode of weak metaphorics, but as a way to grasp the interactional and network qualities of software. In this sense, I propose (following, for instance, Matthew Fuller) how the concept of media ecologies proved its worthiness. The network ecology is a media ecology not because of the terms used ("viruses", "worms", "bacteria", etc.) but because of the processes that rely on connectivity, networks, systems, and also becomings (the potential of indeterminacy within the systems).

Media ecological methods of analysis work by creating transversal connec-tions between various spheres, or "ecologies" as Guattari calls them. For Guattari, media are "profoundly political or ethico-aesthetic at all scales."[6] Thought is a

(media) laboratory committed to experimentation, which follows the ethical stance of diversity. Aptly, Braidotti emphasizes that the task of critical theory is a continuous movement and articulation of these various spheres to account for the complexity of contemporary culture.[7] Guattari's *Three Ecologies* encompasses the spheres of the environment, social relations, and human subjectivity (mental ecology), which are all on the verge of an ecological crisis owing to the pressures and pollution induced by IWC, International World Capitalism. These three registers are made of economic, juridical, techno-scientific, and subjectifying semiotics. In my take, the media ecology of network culture traverses these three domains, and it, too, is forced to encounter the same pressures and processes of information capitalism. This theme is approached as one of both standardization (the commercialization of software and standardization of operating systems and software since the 1980s) and controlled complexity since the 1990s (the ability of the capitalist axiomatics to capture even the most diverse parts of digital culture as part of its flows of profit). In relation to such trends, Guattari's quest for "cultivating a dissensus"[8] and heterogenesis of network digital culture includes the need to diversify the mental ecologies in the sense of producing new images to think with concerning viruses and worms—and also the need to find new social relations not merely between people but between technologies, people, and nature.

Objects are interdependent and networked: worms and viruses are part of processual networks of media ecology, not self-sustaining but always dependent on other, symbolic and material, elements within the network to maintain their existence. Media ecologies are, then, parasitic and coupling by nature. The challenge is not to take any notion of a healthy cultural network without disturbances or noise as the starting point but to see elements of breakdown as part and parcel of those systems. Even if we are used to thinking of systems as harmonious, "in the beginning there was noise",[9] as Serres notes, emphasizing the priority we should give to the parasites that reveal the networks that otherwise go unnoticed: assemblages reveal their structurations and links only at the point of breaking down.[10] This should be seen also as an ecosophical stance toward valuing the accidental, the minoritarian, and the virtual: heterogenesis.

Foucault's archaeology's major contribution was, in resonance with this horizon of media ecological thinking, to point toward a more heterogeneous level of *savoir*—underlying, for instance, scientific disciplines—where scientific and nonscientific discourses interact.[11] For Foucault, archaeological analysis means also digging the overlapping, changing, and transversal lines of discourses and practices on which traditional historical analysis (of molar entities such as science and technology) rests. In the wake of such ecological analysis, media archaeology,

too, should be seen as transversal mappings of various heterogeneous lines, from fiction to science, from politics to theory, and from media to economics. These lines are the molecular lines of force (*puissance*) or levels of *savoir* that are fundamental to cultural analysis committed to complexity and temporality. Here also lies the need for further work within, for instance, the field of media archaeology, which needs to develop nonlinear approaches that take into account the specificity of technical media but that does not neglect discursive and incorporeal events.[12]

In other words, various heterogeneous lines traverse the media ecology of viral network culture: some lines aim at stagnating measures, others at deterritorializing movement toward experimentality.[13] As *Digital Contagions* has shown, the agenda does not assemble itself according to binary coordinates of security officials and antivirus researchers versus the hackers and virus writers. Instead, we have a multiplicity of actors who design and define the digital culture and its software. To further complexify the issue, my take on ecology works also toward temporal layering and the media archaeology of the virus phenomenon. The ecology of network culture is layered just as layering is used as a design technique in multimedia production (the layering of design modules) or in archaeology, where layers can be seen as soil material that stores or preserves traces of cultures past. The image of a layer as a conceptual tool demonstrates how objects are always temporally condensed, stratified, and overdetermined. The layers are not, however, homogeneous self-sufficient strata but continuously open up toward other layers, having links in various time coordinates and durations. They are constituted of phylogenetic lines (of various durations) and of ontogenetic lines, which cross transversally between assemblages.[14]

Different types of rhythms, variations, and durations coexist in a temporal tension. The so-called present is always a tension between various temporalities, where every actuality collects together movements of different rhythms.[15] Similarly, software objects and media technological assemblages are layered in time, which calls for an agenda of historical media archaeology. As I started the book with Virilio's plea for a specific interest of knowledge in accidents of media technologies, now I want further to emphasize the temporal tensions and durations such an agenda has, connecting it to the politics of cultural memory. Such a focus on cultural analysis takes the historical, the archaeological into its core.[16]

Of course, as noted throughout the book, computer worms and viruses are not merely accidents (of the Aristotelian substance) but span more deeply into the logic of network capitalism and artificial life, for instance. Yet, the idea and concept of accident can be taken here, as proposed above, as a good tool for thought. The apocalyptic tones in digital accidents can be understood, to

follow Charlie Gere, via their Greek etymology in *apo-kalyptein*, a revealing of the (discourse networks) otherwise concealed.[17] Machines reveal their logic as they break down, and this state of accidentality bears in itself important episte-mological and ontological repercussions. Gere also refers to Walter Benjamin's concept of history where the time of the revolution, of the breaking down of everyday rhythms, has a special political value. In his "Theses on the Philosophy of History", Benjamin conceptualizes the stopping of clocks on the first night of the French Revolution as the creation of a novel temporal duration.[18] The homogeneous time of clocks was replaced with a halt, a pause, that promised an opening of a potentiality. Benjamin can in many respects be considered the first media archaeologist in his emphasis on temporal analysis as a critical constellation that can be short-circuited as part of the present to inflict cracks and discontinui-ties. This is a stereographic view of historical research where the image of the past is made dimensional in connection with the image of the present—a synthetic conjoining.[19] Benjamin, born in the age of new optical technologies, wrote about stereographical images; we could, in a parallel fashion, write about digital image processing and animation technologies, part and parcel of the cultural techniques of contemporary media culture. These are synthetic devices to think with in their capability to overlayer, integrate, merge, and recreate new series from old material. It is a question of how and with what media technological tools to think with we sketch temporal layers, historical paths, and archaeological events.

Apocalypses reveal new temporalities, new layers for a media archaeology of the present. This means a move from the time of Chronos as one of imposed line-arity that homogenizes the past and the future toward the registers of Aion and Kairos. Aion means for us the time of the nonhuman duration, the rhythms of the technological being, the nonrepresentable becomings on the level of computer software, for example. Kairos, on the other hand, is the time of the political: to know how to act in the right moment, and to create new temporalities, cuts in the repetitious nature of Chronos.[20]

Gere connects this to the thematics of network capitalism, where computers (also temporal machines) function as machines of ordering, control, and commu-nication. Where Gere refers to the figure of the hacker as an interruption in these processes, we can also refer to viruses and other accidents as key processes of revealing of the homogeneity that threatens this media ecology. Of course, cancerous growth eats itself, but at the same time there is the possibility to look at the history and future of digital culture through the lens of its accidents and to affirm novel ideas in experimental programming, nonlinear systems, and concep-tual becomings concerning virality, media ecology, and temporal layerings of the

archaeology of media cultures. This is what I referred to as the task of creating a minoritarian cultural memory of the digital culture, which dislodges established notions of technological culture of networking and works toward nomadic becomings—on a conceptual and on a practical level. This is an ecosophy of sorts, working within the ecology of digital culture: ecosophy as a mode of bringing forth multiplicities and diversities.

The real task, then, is a transformation of ecological thinking into ecosophy. This book has proceeded as a mapping, or as a cartography of sorts, but one that has tried not only to trace "what happened." It has also tried to look for affirmative potential in an archaeology of viral programs. Archaeology is something that is not about the past alone; it has the potential to stretch toward a future. Media ecological analysis has in this sense the advantage, perhaps to some a paradoxical one, of steering clear of naturalizing histories of media into timeless "matters of fact." As shown above, media ecology can work toward a concept of nature that would take advantage of Spinoza's notion of *natura naturans*: nature is not merely a collection of law-abiding repetitive patterns (whether we talk about the biological nature or the digital media ecology). Instead, nature works against itself, is self-differing. Media ecology, which strives to see how issues technical relate to politics, economics, aesthetics, and history, is in this sense not to be removed from the ecosophical task of cultivating the potential for a difference. Technicalities do not translate directly into politics, but only via mediations, and cultural analysis that does not steer away from complexities but cultivates them might just be in a key position to carry out such a task of translation and transformation.

NOTES

1. Nori 2002. See also Michelle Delio: "The Beauty and Grace of a Worm." *Wired*, May 22, 2002. <http://www.wired.com/news/culture/0,1284,52687,00.html>.

2. In this contextual focus on assemblages I am following Sampson 2008.

3. Spinoza 2001, 58 (II, Axiom I, Lemma I). Deleuze 1986, 39–40.

4. Guattari 1995, 37.

5. See Deleuze 1997b.

6. Ibid., 5. On mediasophy, see Väliaho 2003.

7. Braidotti 2006, 127.

8. Guattari 2000, 50. For views on "software criticism", see Fuller 2003. See also Lovink 2003.

9. Serres 1982, 13.

10. See Heidegger 1996, §16. Deleuze & Guattari 1983, 8. Lundemo 2003.

11. Gutting 1989, 253.

12. Cf. Ernst 2006.

13. Deleuze (1992, 164–165) writes of the apparatus (*dispositif*) consisting of two types of lines: lines of stratification and lines of creativity, of flight. Here I partially depart from Deleuze's emphasis: for me, history and archives are not merely the static past but can be articulated as essentially resonating with lines of creativity of a future. Benjamin, on the other hand, then, gives a more positive understanding of the powers of the past as forming critical constellations. See Buck-Morss 1991, 289–293. For a fresh analysis on the question of history in Deleuze and Guattari's thought, see Lampert 2006.

14. See DeLanda 1991, 140. Cf. Zielinski's (2006) notion of media archaeological layers and the task of an-archaeology of the deep time of the media.

15. Braudel 1997, 205.

16. On cultural analysis, see Bal 1999, 1, 12–14.

17. Gere 2002, 9.

18. Benjamin 1969, 261–263. Gere 2002, 195–196. Virilio, in particular, sees contemporary technological accidents in terms of temporality. See Redhead 2004.

19. See Buck-Morss 1991, 289–293.

20. Zielinski 2006, 28–32.

APPENDIX

A TIMELINE OF COMPUTER VIRUSES
AND THE VIRAL ASSEMBLAGE

This timeline is intended as a heuristic tool-for-thought that places various events and contexts together on a continuous timeline. It is not an exhaustive archive of all the important dates but gives an overview of the development of viruses and related phenomena. The information has been gathered from a number of sources mentioned in the Bibliography. The estimated numbers of PC viruses are from F-Secure statistics.

1872	Samuel Butler discusses the fear of technology becoming self-reproductive in his novel *Erewhon*.
1936	Alan Turing develops his ideas of a so-called Turing machine that is able to simulate any other machine.
1948	C.E. Shannon formulates his mathematical theory of communication, where he includes noise as part of the communicative act.
1949	John von Neumann lectures on "The Theory and Organization of Complicated Automata."
1950s	Biological virology is established as a key research area.
1953	Nils Barricelli's experiments with ideas of symbiogenesis are applied to computers at the Princeton Institute of Advanced Studies.
1958	The principles of the modem for computer communication are established.
1959	Beatrice and Sydney Rome's experiment on a "Leviathan-computer system" based on adaptability.
1961	Darwin, a game where digital organisms fought for memory space, is developed at the Bell Labs (a precursor of Core Wars, see year 1984).
	The second edition of Wiener's *Cybernetics* (orig. 1948) is published, where he discusses self-reproducing machines.
1964	Paul Baran's key paper "On Distributed Communications" is published.
1966	Michael Apter discusses self-reproductive organisms in his *Cybernetics and Development*.
	Von Neumann's *Theory of Self-Reproducing Automata* is edited and posthumously published by Arthur W. Burks.

	Students program rabbit programs that self-reproduce without limits.
1969	ARPANET is put online in the United States.
Early 1970s	The Creeper and Reaper worms spread through the ARPANET.
	Ralph Smith uses the rhetoric of information highways.
1970	Martin Gardner introduces John Conway's Game of Life in *Scientific American*.
1971	Paterson's informational worm is created at the MIT Artificial Intelligence Lab.
	The e-mail application is designed by Ray Tomlinson.
1972	David Gerrold's novel *When HARLIE Was One* introduces the idea of a VIRUS program that spreads through the telephone network.
	Self-reproducing programs are discussed in *Software—Practice and Experience* journal.
1973	The "flu virus" hits the university of Oulu, Finland.
	The principles of Ethernet local networking are established.
1975	John Brunner's *The Shockwave Rider* plays with the idea of a tapeworm that lives inside a computer. These worms have the ability to spread to other computers.
	Pervasive Animal (or Pervade), a viral-like update program, is developed by John Walker.
1976	Richard Dawkins introduces his viral theory of cultural reproduction: memes.
1977	Thomas J. Ryan's *The Adolescence of P-1* explores similar themes to David Gerrold's novel. The novel was made into the PBS TV movie *Hide and Seek* in 1984.
	Apple II, the computer system with a friendly face and with one of the earliest viruses, is released.
1980	A thesis on self-reproduction is submitted at the University of Dortmund, Germany: "Selbstreproduktion bei Programmen auf dem Apple II-Rechner."
1981	The MS-DOS operating system for PC-compatible computers is released.
1981–1983	Several Apple II viruses recorded, including Elk Cloner by Rich Skrenta and another virus programmed by Joe Dellinger that spread itself via the game Congo.
1982	*Time* magazine names the computer as the machine of the year.
	Researchers Shoch and Hupp report the Xerox Palo Alto Lab worm program tests from the end of the 1970s.
	The information security company Symantec is founded in the United States.
1983	The first computer virus is born—at least officially. On November 3, Fred Cohen participates in an experiment that demonstrates the virus to a security seminar. The name "virus" was conceived by Len Adleman.
	The *War Games* movie features a young computer enthusiast breaking into military computers.
	HIV is argued to be the cause of AIDS.
1984	Professor Dewdney's article in *Scientific American* describes the basics of the Core Wars game. In Core Wars, programs "fight" for memory space.
	Fred Cohen gives a scientific definition of a computer virus.
	William Gibson's novel *Neuromancer* presents computer viruses as part of the population of the cyberspace—along with artificial intelligences, ROM-constructs, cyber cowboys, etc.
1985	Computer viruses are discussed in *Time* magazine.

1986 Fred Cohen's PhD thesis "Computer Viruses" is published. Cohen develops the idea of a "universal viral machine" as a special version of a Turing machine.

Perhaps the first PC virus, Brain, originates from Pakistan and infects 360-kb floppy disks.

Ralf Burger's VIRDEM is demonstrated, a virus distributed at the Chaos Computer Club conference in December.

The Computer Fraud and Abuse Act is approved by the U.S. Senate.

1987 The Los Alamos conference on artificial life is held.

The destructive Leligh file virus and the most widespread PC virus Stoned are recorded.

The Christmas Tree worm spreads through the IBM network.

The Computer Fraud and Abuse Task Force is founded in the U.S.

Amiga's SCA virus, Atari's Pirate Trap virus, and Macintosh's nVIR virus are recorded.

1988 Dr. Solomon's Anti-Virus Toolkit is released, as are many other antivirus detection and removal programs.

The Jerusalem virus breaks out at a large financial institution.

The MacMag virus declares peace. The Scores, Ping Pong, and Cascade viruses are released into the wild.

Computer viruses make it to the cover of *Time* magazine.

Antivirus company Data-Fellows (which later becomes F-Secure) is founded in Finland.

The Computer Emergency Response Team (CERT) is founded in the United States to battle threats to computers and computer networks.

The Virus Epidemic Center is founded in Hamburg.

1989 Approximately 90 PC viruses are estimated to exist.

The Friday 13th virus causes virus hysteria.

The Datacrime virus is found, causing much overreaction. The Dutch police sell Datacrime detector programs at police stations for $1.

The AIDS Trojan incident takes place.

The Computer Virus Crisis by Fites, Johnston, and Kratz is published.

Computer Viruses, Worms, Data Diddlers, Killer Programs & Other Threats to Your System by McAfee and Haynes is published.

Lundell's *Virus! The Secret World of Computer Invaders That Breed and Destroy* is published.

IBM releases its first antivirus product.

Virus Bulletin is founded.

1990 Viruses written by The Dark Avenger (Bulgaria) introduce the idea of subtle and slow damage. The viruses also infected backup disks.

The Microsoft Windows 3.0 operating system is released. It is the first commercial success in the Windows series.

Robert T. Morris Jr. receives his sentence for the Internet worm. Morris received three years' probation, a fine, and community service.

In the United Kingdom, the Computer Misuse Act is passed.

The European Institute for Computer Antivirus Research is founded.

Symantec releases the Norton Antivirus program.

1991	Approximately 360 PC viruses are estimated to exist.
	The Tequila mutating virus is recorded.
	The High Performance Computing Act is passed in the United States.
	The first Virus Bulletin Conference takes place.
	Computer viruses also infect humans in Pat Cadigan's novel *Synners*.
	Computers Under Attack: Intruders, Worms, and Viruses, edited by Peter Denning, is published.
	Little Black Book of Computer Viruses by Mark Ludwig causes a stir in the antivirus community.
1992	The Michelangelo virus causes a media panic. It did not cause great damage, but the scare was advantageous for the antivirus companies: sales boomed.
	The Dark Avenger releases the *Mutating Engine* virus design kit.
	Neal Stephenson's novel *Snow Crash* includes a virus as a key part of its plot.
	The Iraqi virus is recorded.
	David Ferbrache's *A Pathology of Computer Viruses* is published.
1993	Approximately 2,450 PC viruses are estimated to exist.
	A new virus construction kit from the Trident group (Holland) called the Trident Polymorphic Engine is distributed.
	The National Information Infrastucture program is established in the United States.
	Computer Viruses, Artificial Life and Evolution is published by Ludwig.
1995	Approximately 5,500 PC viruses are estimated to exist.
	The Word Concept virus infects Microsoft Word documents.
	The human world is saved by a computer virus in the science fiction film *Independence Day*.
	Thomas S. Ray proposes an Internet-spanning virtual ecology of organisms.
	The Black Baron is found guilty of spreading viruses in the United Kingdom.
1996	"Declaration of Independence of Cyberspace" by John Perry Barlow is published.
1997	Approximately 10,350 PC viruses are estimated to exist.
1999	Approximately 33,500 PC viruses are estimated to exist.
	The Melissa e-mail worm is recorded.
2000	The I Love You virus makes the headlines.
2001	Approximately 55,000 PC viruses are estimated to exist.
	The Nimda virus and the Sircam, CodeRed, and BadTrans worms are recorded.
	The Biennale.py-media art virus is released at the Venice art Biennale.
2002	The author of Melissa is sentenced to prison.
	The Klez worm acts as a malicious overwriting malware.
	The Bugbear worm and the Shakira, Britney Spears, and Jennifer Lopez viruses are recorded.
	The I Love You exhibition is held in Frankfurt on the culture of computer viruses.
2003	Approximately 80,000 PC viruses are estimated to exist.
	The Slammer worm breaks the record as the fastest-spreading worm.
2004	The MyDoom and Sasser worms are recorded.
2006	Approximately 185,000 PC viruses are estimated to exist.
	According to *Wired*, malicious botnets represent a graver threat than viruses.

BIBLIOGRAPHY

MOVIES AND TV SERIES

Alien (1979) UK. Director: Ridley Scott. Writers: Dan O´Bannon and Ronald Shusett.

Alphaville (1965) France. Director and writer: Jean-Luc Godard.

Andromeda Strain (1971) USA. Director: Robert Wise. Writers: Michael Crichton (novel) and Nelson Gidding (screenplay).

Crazies, The (1973) USA. Director: George A. Romero. Writers: Paul McCullough and George A. Romero.

Hackers (1995) USA. Director: Iain Softley. Writer: Rafael Moreau.

Il etait une fois la vie (1986) France. Director and Writer: Albert Barillé.

Independence Day (1996) USA. Director: Roland Emmerich. Writers: Dean Devlin and Roland Emmerich.

Johnny Mnemonic (1995) Canada / USA. Director: Robert Longo. Writer: William Gibson.

Jurassic Park (1993) USA. Director: Steven Spielberg. Writer: Michael Crichton.

Matrix, The (1999) USA. Directors and writers: Andy and Larry Wachowski.

Outbreak (1995) USA. Director: Wolfgang Petersen. Writers: Laurence Dworet and Robert Roy Pool.

Scanners (1981) Canada. Director and writer: David Cronenberg.

Species (1995) USA. Director: Roger Donaldson. Writer: Dennis Feldman.

Tron (1982) USA / Taiwan. Director: Steven Lisberger. Writers: Steven Lisberger and Bonnie MacBird.

Videodrome (1983) Canada / USA. Director and Writer: David Cronenberg.

Wargames (1983) USA. Director: John Badham. Writers: Lawrence Lasker and Walter F. Parkes.

Westworld (1973) USA. Director and writer: Michael Crichton.

MAGAZINES, JOURNALS, REVIEW PUBLICATIONS

ACM SIGCOMM Computer Communication Review 1981
ACM SIGOPS Operating Systems Review 1978, 1988
Bankers Monthly 1988
Boston Globe 1992
Byte 1980, 1985, 1989, 1991
C=lehti 1989

Communications of the ACM 1960–1961, 1967, 1979, 1982–1989
Computer Fraud & Security Bulletin 1983, 1985, 1988, 1989, 1993, 1995
Computer Law & Security Report 1990–1992
Computers & Security 1987
Computerworld 1990–1992
Computing Surveys 1969, 1975, 1979
Economist 1992
IEEE Computer 1989
Infosystems 1985
InfoWorld 1988, 1992
Journal of the ACM 1962
Mikrobitti 1987, 1988, 1991
Nation 1970
Nature 2001
Network World 1991
New Statesman & Society 1992
Newsweek 1995
New York Times 1955, 1960, 1989, 1990, 1992
Scientific American 1922, 1955, 1970, 1980–1989, 1995
Time 1983–1988, 1992, 2000
The Times 1972, 1974, 1983, 1985
Virus Bulletin 1989–1995
Wall Street Journal 1989–1992
Wired 1993, 1995, 1997, 2002, 2006
World Press Review 1993

CONFERENCE PROCEEDINGS

Anti-Virus Asia Researchers (AVAR) Conference 2001
Eicar Conference Proceedings 1994–1995
National Computer Security Association (NCSA) Conference Proceedings 1995
Proceedings of the Annual ACM Conference 1972
Proceedings of the international conference on APL Programming Language 1984
Proceedings of the Northeast ACM symposium on Personal computer security 1986
SIGPLAN Proceedings of the 1973 meeting on Programming languages and information retrieval 1974
Virus bulletin proceedings 1992–1995, 1997

INTERVIEWS

Cohen, Fred (2003) E-mail to Jussi Parikka, November 4, 2003.
Fix, Bernd (2005) E-mail to Jussi Parikka, November 7, 2005.
Kleinrock, Leonard (2005) E-mail to Jussi Parikka, October 14, 2005.
Latva, Risto (2004) E-mail to Jussi Parikka, November 29, 2004.
McIlroy, Doug (2005) E-mail to Jussi Parikka, April 25, 2005.

Slade, Rob (2004) E-mail to Jussi Parikka, October 8, 2004.

Stallman, Richard (2005) E-mails to Jussi Parikka, June 3 & 4, 2005.

Sulonen, Reijo (2005) Phone Interview with Jussi Parikka, November 23, 2005.

Thompson, Ken (2005) E-mail to Jussi Parikka, April 27, 2005.

Vyssotsky, Victor (2005a) E-mail to Jussi Parikka, June 2, 2005.

Vyssotsky, Victor (2005b) E-mail to Jussi Parikka, June 11, 2005.

SALES BROCHURES

All s.a., early 1990s:

F-Secure anti-virus program

Information Security-brochure from Computer Security Engineers (CSE)

ThunderBYTE PC Immunizer

VIREX anti-virus program brochure

LITERATURE

2600 web site. <http://www.2600.com/>. Accessed 9.11.2006.

Abbate, Janet (2000) *Inventing the Internet*. Cambridge, MA: MIT Press.

Agamben, Giorgio (1998) *Homo Sacer: Sovereign Power and Bare Life*. Translated by Daniel Heller-Roazen. Stanford, CA: Stanford University Press.

Ahonen, Kimmo (1999) "Palkoihmisten ongelma historiantutkimuksessa–Don Siegelin tieteiselo-kuva *Varastetut ihmiset* (1956) oman aikakautensa pelkojen tulkkina." In: *Pitkät jäljet. Historioita kahdelta mantereelta*, edited by Eero Kuparinen. Turku: Turun yliopisto, yleinen historia, 14–43.

Alive. Electronic Magazine. Volumes I–III (1994–1995). <http://www.cs.uta.fi/~cshema/public/vru/alive>. Accessed 8.6.2006.

Anderson, Alison & Shain, Michael (1994) "Risk management." In: *Information Security Handbook*, edited by William Caelli, Dennis Longley, and Michael Shain. New York: Macmillan, 75–127.

Ansell-Pearson, Keith (1997) *Viroid Life: Perspectives on Nietzsche and the Transhuman Condition*. London & New York: Routledge.

Ansell-Pearson, Keith (1999) Germinal Life. The Difference and Repetition of Deleuze and Guattari. London: Routledge.

Apter, Michael J. (1966) *Cybernetics and Development*. Oxford: Pergamon Press.

Armstrong, Tim (1998) *Modernism, Technology and the Body: A Cultural History*. Cambridge: Cambridge University Press.

Aspray, William (1990) *John von Neumann and the Origins of Modern Computing*. Cambridge, MA: The MIT Press.

Bagrit, Leon (1965) *The Age of Automation*: The Reith Lectures 1964. Harmondsworth: Penguin Books.

Bal, Mieke (1999) "Introduction." In: *The Practice of Cultural Analysis: Exposing Interdisciplinary Interpretation*, edited by Mieke Bal, with the assistance of Bryan Gonzales. Stanford, CA: Stanford University Press, pp. 1–14.

Balsamo, Anne (1996) "Forms of Technological Embodiment: Reading the Body in Contemporary Culture." In: *Cyberspace/cyberbodies/cyberpunk: Cultures of Technological Embodiment*, edited by Mike Featherstone and Roger Burrows. London: Sage, 215–237.

Bangeman-Report (1994) Europe and the Global Information Society. <http://europa.eu.int/ISPO/ infosoc/backg/bangeman.html>. Accessed 14.12.2006.

Barabási, Albert-László (2003) *Linked: How Everything is Connected to Everything Else and What It Means for Business, Science, and Everyday Life*. New York: Plume.

Baran, Paul (1964) "On Distributed Communications." RAND Memorandum, August 1964. Online at <http://www.rand.org/pubs/research_memoranda/2006/RM3420.pdf> Accessed 27.1.2007.

Barbrook, Richard & Cameron, Andy (1996) "The Californian Ideology." <http://www.hrc.wmin. ac.uk/theory-californianideology.html>. Accessed 8.3.2007.

Bardini, Thierry (2006) "Hypervirus: A Clinical Report." *CTheory–An International Journal of Theory, Technology, and Culture*, 2/2/2006, <http://www.ctheory.net/articles.aspx?id=504>. Accessed 13.3.2007.

Barlow, John Perry (1996) "A Declaration of Independence of Cyberspace." <http://homes.eff. org/~barlow/Declaration-Final.html>. Accessed 9.3.2007.

Barr, Lukas (s.a.) "Long Live the New Flesh. An Interview with David Cronenberg." <http:// industrycentral.net/director_interviews/DC01.HTM>. Accessed 6.3.2007.

Bateson, Gregory (1972) Steps to an Ecology of Mind. New York: Ballantine Books.

Bauman, Zygmunt (1993) *Postmodern Ethics*. Oxford & Cambridge: Blackwell.

Bauman, Zygmunt (1995) *Modernity and Ambivalence*. (Orig. 1991). Cambridge: Polity Press.

Bear, Greg (2001) *Blood Music* (Orig. 1985). London: Gollancz.

Beck, Ulrich (1986) *Risikogesellschaft. Auf dem Weg in eine andere Moderne*. Frankfurt am Main: Suhrkamp.

Beck, Ulrich (1988) *Gegengifte. Die Organisierte Unverantwortlichkeit*. Frankfurt am Main: Suhrkamp.

Beck, Ulrich (2000) "Risk Society Revisited: Theory, Politics and Research Programmes." In: *The Risk Society and Beyond: Critical Issues for Social Theory*, edited by Barbara Adam, Ulrich Beck, and Joost Van Loon. London, Thousand Oaks, CA, & New Delhi: Sage, pp. 211–229.

Beck, Ulrich (2002) "The Cosmopolitan Society and its Enemies." *Theory, Culture & Society*, vol. 19 (1–2), 17–44.

Beeler, Michael (1973) "Paterson's Worm." *Massachusetts Institute of Technology, A.I. Laboratory, Artificial Intelligence, memo 290*, June 1973. Online at <ftp://publications.ai.mit.edu/ai-publi-cations/pdf/AIM-290.pdf>. Accessed 8.6.2006.

Bell, D.E. & La Padula, L.J. (1976) "Secure Computer System: Unified Exposition and Multics Interpretation." MITRE Corporation report, March 1976.

Beniger, James R. (1997) *The Control Revolution: Technological and Economic Origins of the Information Society*. (Orig. 1986). Cambridge, MA & London: Harvard University Press.

Benjamin, Walter (1969) *Illuminations*. Edited with an Introduction by Hannah Arendt. New York: Shocken Books.

Berardi, Franco (Bifo) (s.a.) "Responses to the Californian-Ideology." Online at <http://www.hrc. wmin.ac.uk/theory-californianideology-responses2.html>. Accessed 8.3.2007.

Blackmore, Susan (2000) *The Meme Machine*. Oxford: Oxford University Press.

Bogue, Ronald (2003) *Deleuze on Music, Painting and the Arts*. New York: Routledge.

Bolter, Jay David and Grusin, Richard (1999) *Remediation: Understanding New Media*. Cambridge, MA: MIT Press.

Bolz, Norbert (1998) "The user-illusion of the world." *Mediamatic*, vol. 9(2–3). Online at http://www.mediamatic.net/article-5672-en.html>. Accessed 26.1.2007.

Borck, Cornelius (2004) "Vivarium des Wissens. Kleine Ontologie des Schupfens." In *Virus! Mutationen einer Metapher*, edited by Ruth Mayer and Brigitte Weingart. Bielefeld: Transcript, 43–60.

Boyer, Christine M. (1996) *Cybercities: Visual Perception in the Age of Electronic Communications*. New York: Princeton Architectural Press.

Braidotti, Rosi (2001) "How to Endure Intensity-Towards a Sustainable Nomadic Subject." In: *Micropolitics of Media Culture*, edited by Patricia Pisters. Amsterdam: Amsterdam University Press, 177–201.

Braidotti, Rosi (2002) *Metamorphoses: Towards a Materialist Theory of Becoming*. Cambridge: Polity Press.

Braidotti, Rosi (2006) *Transpositions: On Nomadic Ethics*. Cambridge: Polity Press.

Braudel, Fernand (1997) *Les Ambitions de l'Histoire*. Paris: Éditions de Fallois.

Breton, Thierry and Beneich, Denis (1984). *Softwar - La Guerre Douce*. Paris: Robert Laffont.

Briggs, Asa & Burke, Peter (2002) *A Social History of the Media: From Gutenberg to the Internet*. Cambridge: Polity Press.

Brothers, M.H. (1991) "Computer Virus Protection Procedures." In: *Computers Under Attack. Intruders, Worms, and Viruses*, edited by Peter J. Denning. New York: ACM Press, pp. 357–380.

Brown, Steven D. (2002) "Michel Serres: Science, Translation and the Logic of the Parasite." *Theory, Culture & Society*, vol. 19(3), 1–27.

Brunner, John (1976) *The Shockwave Rider* (Orig. 1975). New York: Ballantine Books.

Buck-Morss, Susan (1991) *The Dialectics of Seeing: Walter Benjamin and the Arcades Project*. Cambridge, MA: MIT Press.

Buckner and Garcia Official Pacman Fever Site, <http://www.bucknergarcia.com/>. Accessed 8.3.2007.

Bukatman, Scott (1993) *Terminal Identity: The Virtual Subject in Post-modern Science Fiction*. Durham & London: Duke University Press.

Bürger, Ralf (1988) *Computer Viruses: A High-Tech Disease*. Düsseldorf & Grand Rapids, MI: Abacus / Data Becker.

Burke, Peter (2004) *What is Cultural History?* Cambridge: Polity Press.

Burroughs, William S. (1985) *The Adding Machine*. Collected Essays. London: John Calder.

Burrougs Corporation Records. System Development Corporation Records, 1946–1982. <http://www.cbi.umn.edu/collections/inv/burros/cbi00090-098.html>. Accessed 5.3.2007.

Butler, Octavia (1985) *Clay's Ark*. New York: St. Martin's Press.

Butler, Samuel (1918) *Erewhon, or Over the Range* (Orig. 1872). London: William Brendon and Son.

Cadigan, Pat (2001) *Synners* (Orig. 1991). New York: Four Walls Eight Windows.

Caelli, William & Tickle, Alan (1994) "Communications Security." In: *Information Security Handbook*, edited by William Caelli, Dennis Longley, and Michael Shain. New York: MacMillan, pp. 649–746.

Campbell-Kelly, Martin (2004) *From Airline Reservations to Sonic the Hedgehog: A History of the Software Industry*. Cambridge, MA: MIT Press.

Campbell-Kelly, Martin & Aspray, William (1996) *Computer: A History of The Information Machine*. New York: Basic Books.

Castells, Manuel (1996) *The Rise of the Network Society*. Cambridge, MA: Blackwell.

Castells, Manuel (2001) "Informationalism and the Network Society." In: *The Hacker Ethic and the Spirit of Capitalism*, edited by Pekka Himanen. New York: Random House, 157–178.

Caygill, Howard (2004) "Walter Benjamin's Concept of Cultural History." In: *The Cambridge Companion to Walter Benjamin*, edited by David S. Ferris. Cambridge: Cambridge University Press, 73–96.

Ceruzzi, Paul E. (1998) *A History of Modern Computing*. Cambridge, MA: MIT Press.

Channell, David F. (1991) *The Vital Machine: A Study of Technology and Organic Life*. New York: Oxford University Press.

Chartier, Roger (1997) *On the Edge of the Cliff: History, Language, and Practices*. Translated by Lydia G. Cochrane. Baltimore, MD & London: Johns Hopkins University Press.

Chun, Wendy (2006) *Control and Freedom: Power and Paranoia in the Age of Fiber Optics*. Cambridge, MA: MIT Press.

Clark, Nigel (1997) "Panic Ecology: Nature in the Age of Superconductivity." *Theory, Culture & Society*, vol. 14(1), 77–96.

Clough, Bryan and Mungo, Paul (1992) *Approaching Zero: Data Crime and the Computer Underworld*. London & Boston: Faber and Faber.

Cohen, Fred (1984) "Computer Viruses–Theory and Experiments." DOD/NBS 7th Conference on Computer Security, originally appearing in IFIP-sec 84, also appearing as invited paper in IFIP-TC11, "Computers and Security, V6#1 (January 1987), 22–35, online http://www.all.net/books/virus/index.html (accessed 6 March, 2007).

Cohen, Frederick B. (1986) *Computer Viruses*. Dissertation presented at the University of Southern California, December 1986.

Cohen, Fred (1991a) "Implications of Computer Viruses and Current Methods of Defense." In: *Computers Under Attack. Intruders, Worms, and Viruses*, edited by Denning, Peter J. New York: Addison-Wesley Publishing Company, 381–406.

Cohen, Fred (1991b) "Friendly Contagion: Harnessing the Subtle Power of Computer Viruses." *The Sciences*, Sep/Oct 1991, Vol. 31(5), 22–29.

Cohen, Fred (1994) *It's Alive! The New Breed of Living Computer Programs*. New York: John Wiley & Sons.

Colebrook, Claire (2002) *Understanding Deleuze*. Crows Nest, Australia: Allen & Unwin.

Colwell, C. (1996) "Deleuze, Sense and the Event of AIDS." *Postmodern Culture*, vol. 6(2). Online at <http://www3.iath.virginia.edu/pmc/text-only/issue.196/colwell.196>. Accessed 13.3.2007.

Computer Immune Systems. <http://www.cs.unm.edu/~immsec/>. Accessed 8.3.2007.

Computer Underground Digest, volumes 1–7 (1990–1995). <http://www.soci.niu.edu/~cudigest/>. Accessed 4.3.2007.

Computer Virus Timeline. <http://www.infoplease.com/ipa/A0872842.html>. Accessed 8.3.2007.

Computers Under Attack: Intruders, Worms, and Viruses, edited by Denning, Peter J. New York: Addison-Wesley, pp. 381–406.

Crichton, Michael (1998) *Andromeda Strain* (Orig. 1969). London: Arrow Books.

"Darwin, A Game of Survival of the Fittest among Programs." A Letter by V. Vissotsky et al. to C.A. Land, 1971, transcribed and on-line at <http://www.cs.dartmouth.edu/~doug/darwin.pdf>. Accessed 8.3.2007.

Davis, Martin (2000) *The Universal Computer: The Road From Leibniz to Turing*. London & New York: W.W. Norton & Company.

Dawkins, Richard (1977) *The Selfish Gene*. Oxford: Oxford University Press.

Debray, Régis (1996) *Media Manifesto: On the Technological Transmission of Cultural Forms*. (Orig. 1994). Translated by Eric Rauth. London & New York: Verso.

Debray, Régis (2001) *Cours de médiologie générale*. Paris: Gallimard.

DeLanda, Manuel (1991) *War in the Age of Intelligent Machines*. New York: Zone Books.

DeLanda, Manuel (1992) "Nonorganic Life." In: *Incorporations*, edited by Jonathan Crary and Sanford Kwinter. New York: Zone Books, 129–167.

DeLanda, Manuel (1998) "Meshworks, Hierarchies, and Interfaces." In: *The Virtual Dimension*, edited by John Beckman. New York: Princeton Architectural Press, 275–285.

DeLanda, Manuel (1999) "Deleuze, Diagrams, and the Open-Ended Becoming of the World." In: *Becomings: Explorations in Time, Memory, and Futures*, edited by Elisabeth Grosz. Ithaca & London: Cornell University Press, 29–42.

DeLanda, Manuel (2002) *Intensive Science and Virtual Philosophy*. London & New York: Continuum.

DeLanda, Manuel (2003) *A Thousand Years of Nonlinear History* (Orig. 1997). New York: Zone Books.

Deleuze, Gilles (1986) *Nietzsche & Philosophy*. (Orig. 1962). Translated by Hugh Tomlinson. London: The Athlone Press.

Deleuze, Gilles (1988) *Spinoza: Practical Philosophy* (Orig. 1970). Translated by Robert Hurley. San Francisco: City Lights Books.

Deleuze, Gilles (1990) *Pourparlers 1972–1990*. Paris: Les éditions de minuit.

Deleuze, Gilles (1992) "What is a Dispositif?" In: *Michel Foucault Philosopher*, essays translated from the French and German by Timothy J. Armstrong. New York: Harvester Wheatsheaf, 159–168.

Deleuze, Gilles (1994) *Difference & Repetition*. (Orig. 1968). Translated by Paul Patton. New York: Columbia University Press.

Deleuze, Gilles (1997a) "Immanence: A Life." Translated by Nick Millett. *Theory, Culture & Society*, vol. 14(2), 3–7.

Deleuze, Gilles (1997b) "Desire and Pleasure." In: *Foucault and His Interlocutors*. Edited by Arnold I. Davidson. Chicago & London: Chicago University Press, 183–192.

Deleuze, Gilles (1998) *Foucault*. (Orig. 1986) Translated by Seán Hand. Minneapolis, MN & London: University of Minnesota Press.

Deleuze, Gilles & Guattari, Félix (1983) *Anti-Oedipus: Capitalism and Schizophrenia*. (Orig. 1972). Translated by Robert Hurley, Mark Seem and Helen R. Lane. Minneapolis, MN: University of Minnesota Press.

Deleuze, Gilles & Guattari, Félix (1987) *A Thousand Plateaus. Capitalism and Schizophrenia* (Orig. 1980). Translated by Brian Massumi. Minneapolis, MN & London: University of Minnesota Press.

Deleuze, Gilles & Guattari, Félix (1994) *What is Philosophy?* (Orig. 1991). Translated by Hugh Tomlinson & Graham Burchell. New York: Columbia University Press.

Deleuze, Gilles & Parnet, Claire (1996) *Dialogues*. Nouvelle edition. Paris: Champs flammarion.

Denning, Peter J. (ed.) (1991a) *Computers Under Attack: Intruders, Worms, and Viruses*. New York: Addison-Wesley.

Denning, Peter J. (1991b) "Computer Viruses." In: *Computers Under Attack: Intruders, Worms, and Viruses.*, edited by Denning, Peter J. New York: Addison-Wesley, pp. 285–292.

Derrida, Jacques (1972) *La Dissémination*. Paris: Seuil.

Dictionary of Computing (1986). Oxford: Oxford Science Publications, 2ⁿᵈ Edition (1ˢᵗ Edition 1983).

Dictionary of the History of Ideas: Studies of Selected Pivotal Ideas, edited by Philip P. Wiener. Online at <http://etext.virginia.edu/DicHist/dict.html>. Accessed 14.12.2006.

Doane, Mary Ann (2006) "Information, Crisis, Catastrophe." In: *New Media, Old Media: A History and Theory Reader*, edited by Wendy Hui Kyong Chun & Thomas Keenan. New York & London: Routledge.

Dougherty, Stephen (2001) "The Biopolitics of the Killer Virus Novel." *Cultural Critique*, vol. 48(Spring 2001), 1–29.

Douglas, Susan J. (1989) *Inventing American Broadcasting 1899–1922*. Baltimore, MD & London: Johns Hopkins University Press.

Dyson, Esther, Gilder, George, Keyworth, George & Toffler, Alvin (1994) "Cyberspace and the American Dream. A Magna Carta for the Knowledge Age." Published by Progress and Freedom Foundation, Release 1.2, August 22, 1994. Online at <http://www.hartford-hwp.com/archives/45/062.html>. Accessed 8.3.2007.

Dyson, Freeman (1999) *Origins of Life*. Cambridge: Cambridge University Press.

Dyson, George B. (1997) *Darwin Among the Machines: The Evolution of Global Intelligence*. Reading, MA: Helix Books.

Edwards, Paul E. (1996) *The Closed World: Computers and the Politics of Discourse in Cold War America*. Cambridge, MA: MIT Press.

EICAR Homepage. <http://www.eicar.org/>. Accessed-14.12.2006.

Elsaesser, Thomas (2004) "The New Film History as Media Archaeology," *Cinémas*, vol. 14(2-3), Printemps 2004. Online at < http://www.erudit.org/revue/cine/ >. Accessed 24.8.2006.

Emmeche, Claus (1994) *The Garden in the Machine: The Emerging Science of Artificial Life*. Princeton, NJ: Princeton University Press.

Erickson, Christa (2002) "Networked Interventions: Debugging the Electronic Frontier." *NMEDIAC*, vol. 1(2). Online at <http://www.ibiblio.org/nmediac/summer2002/networked.html>. Accessed 8.3.2007.

Ernst, Wolfgang (2002) *Das Rumoren der Archive. Ordnung aus Unordnung*. Berlin: Merve.

Ernst, Wolfgang (2006) "Dis/continuities. Does the Archive Become Metaphorical in Multi-Media Space?" In: *New Media, Old Media: A History and Theory Reader*, edited by Wendy Hui Kyong Chun & Thomas Keenan. New York & London: Routledge, 105–123.

Ferbrache, David (1992) *A Pathology of Computer Viruses*. Berlin: Springer-Verlag.

Fites, Philip, Johnston, Peter, & Kratz, Martin (1989) *The Computer Virus Crisis*. New York: Van Nostrand Reinhold.

Fleck, Ludwig (1979) *Genesis and Development of a Scientific Fact* (Translation of *Entstehung und Entwicklung einer wissenschaftlichen Tatsache: Einführung in die Lehre vom Denkstil und Denkkollektiv*, 1935). Chicago & London: University of Chicago Press.

Flichy, Patrice (2001) *L'imaginaire d'Internet*. Paris: La Découverte.

Flieger, Jerry Aline (2003) "Is Oedipus On-Line?" In: *Jacques Lacan Critical Evaluations in Cultural Theory, Volume III: Society, Politics, Ideology*, edited by Slavoj Žižek. London & New York: Routledge, 394–410.

Forbes, Nancy (2004) *Imitation of Life. How Biology is Inspiring Computing*. Cambridge, MA: The MIT Press.

Foucault, Michel (1976) *Histoire de la sexualité. La volonté de savoir*. Paris: Gallimard.

Foucault, Michel (2000a) "The Birth of Biopolitics." In: *Ethics: Subjectivity and Truth: Essential Works of Foucault 1954–1984, Vol. 1*, edited by Paul Rabinow, translated by Robert Hurley et al. London: Penguin Books, 73–79.

Foucault, Michel (2000b) "Introduction to 'The Use of Pleasure'" (Orig. 1984). Translated by Robert Hurley. In: *Identity: A Reader*, edited by Paul Du Gay, Jessica Evans and Peter Redman. London: Sage, 360–370.

Foucault, Michel (2000c) "Questions of Method." In: *Power: Essential Works of Foucault 1954–1984, Vol. 3*, edited by Paul Rabinow. London: Penguin Books, 223–238.

Foucault, Michel (2000d) "Life experience and science" (Orig. 1985). In: *Aesthetics: Essential Works of Foucault 1954–1984*, Vol. 2, edited by James D. Faubion, translated by Robert Hurley et al. London: Penguin Books, 465–478.

Foucault, Michel (2000e) "Nietzsche, Genealogy, History" (Orig. 1971). In: *Aesthetic:. Essential Works of Foucault 1954–1984*, Vol. 2, edited by James D. Faubion, translated by Robert Hurley et al. London: Penguin Books, 369–391.

Foucault, Michel (2002) *The Archaeology of Knowledge* (Orig. 1969). Translated by A.M. Sheridan Smith. London & New York: Routledge.

Fox Keller, Evelyn (1995) *Refiguring Life. Metaphors of Twentieth-Century Biology*. New York: Columbia University Press.

Fox Keller, Evelyn (2002) *Making Sense of Life. Explaining Biological Development with Models, Metaphors, and Machines*. Cambridge, MA & London, England: Harvard University Press.

F-Prot anti-virus software brochure, sa., beginning of the 1990s.

F-Prot Päivitystiedotteet (update memos) 2.04–2.24 (1992–1996).

Freud, Sigmund (1995) "Civilization and its Discontents." (Orig. 1930). In: *The Freud Reader*, edited by Peter Gay. London: Vintage, 722–772.

F-Secure White Paper, 2001.

F-Secure The Number of PC Viruses 1986-2006 Chart, 2006.

Fuller, Matthew (2003) *Behind the Blip: Essays on the Culture of Software*. New York: Autonomedia.

Fuller, Matthew (2005) *Media Ecologies: Materialist Energies in Art and Technoculture*. Cambridge, MA: MIT Press.

Galloway, Alexander R. (2004) *Protocol: How Control Exists after Decentralization*. Cambridge, MA: MIT Press.

Gane, Nicholas (2005) "Radical Post-Humanism: Friedrich Kittler and the Primacy of Technology." *Theory, Culture & Society*, vol. 22(3), 25–41.

Gates, Bill (1996) *The Road Ahead*. London: Penguin Books.

Gere, Charlie (2002) *Digital Culture*. London: Reaktion Books.

Gerrold, David (1975) *When HARLIE Was One* (Orig. 1972). New York: Ballantine Books.

Gibson, William (1984) *Neuromancer*. New York: Ace Books.

Goffey, Andrew (2003) "Idiotypic Networks, Normative Networks." *M/C: A Journal of Media and Culture*, vol. 6(4). Online at <http://journal.media-culture.org.au/0308/07-idiotypic.php>. Accessed 24.1.2007.

Goodchild, Philip (1996) *Deleuze & Guattari: An Introduction to the Politics of Desire*. London: Sage.

Gravenreuth, Günter Frhr. von (1995) *Computerviren und ähnliche Softwareanomalien – Überlick und rechtliche Einordnung*. 2. Überarbeitete Auflage. München: Computer Verlag.

Grossberg, Lawrence (2000) "Contexts of Cultural Studies?" In: *Inescapable Horizon: Culture and Context*, edited by Sirpa Leppänen and Joel Kuortti. Jyäskylä: Publications of the Research Unit for Contemporary Culture 64, 27–49.

Grosz, Elizabeth (1995) *Space, Time, and Perversion: Essays on the Politics of Bodies*. New York: Routledge.

Grosz, Elizabeth (1999) "Thinking the New: Of Futures Yet Unthought." In: *Becomings: Explorations in Time, Memory, and Futures*, edited by Elisabeth Grosz. Ithaca, NY & London: Cornell University Press, 15–28.

Grosz, Elizabeth (2001) "Deleuze's Bergson: Duration, the Virtual and a Politics of the Future." In: *Deleuze and Feminist Theory*, edited by Ian Buchanan and Claire Colebrook. Edinburgh: Edinburgh University Press, 214–234.

Grosz, Elizabeth (2004) *Nick of Time: Politics, Evolution, and the Untimely*. Durham, NC & London: Duke University Press.

Grosz, Elizabeth (2005) *Time Travels: Feminism, Nature, Power*. Durham, NC & London: Duke University Press.

Guattari, Félix (1992) "Regimes, Pathways, Subjects." Translated by Brian Massumi. In: *Incorporations*, edited by Jonathan Crary and Sanford Kwinter. New York: Zone Books, 16–37.

Guattari, Félix (1995) *Chaosmosis: An Ethico-Aesthetic Paradigm* (Orig. 1992). Translated by Paul Bains and Julian Pefanis. Sydney: Power Publications.

Guattari, Félix (2000) *The Three Ecologies*. (Orig. 1989). Translated by Ian Pindar and Paul Sutton. London: Athlone Press.

Guattari, Félix (2001) "Machinic Heterogenesis." In: *Reading Digital Culture*, edited by David Trend. Mulden, MA & Oxford: Blackwell, 38–51.

Guillaume, Marc (1987) "The Metamorphoses of Epidemia." In: *Zone ½: The Contemporary City*, edited by Michel Feher and Sanford Kwinter. New York: Zone Books, 59–69.

Gutting, Gary (1989) *Michel Foucault's Archaeology of Scientific Reason*. Cambridge: Cambridge University Press.

Hack-Tic magazine, 1989–1994. <http://www.hacktic.nl/>. Accessed 14.12..2006.

Haddon, Leslie (1993) "Interactive games." In *Future Visions: New Technologies of the Screen*, edited by Philip Hayward and Tana Wollen. London: BFI Publishing, 123–147.

Hafner, Katie & Markoff, John (1991) *Cyberpunk: Outlaws and Hackers on the Computer Frontier*. London: Fourth Estate.

Halbach, Wulf R. (1998) "Netzwerke." In: *Geschichte der Medien*, edited by Manfred Faßler and Wulf Halbach. München: Wilhelm Fink, 269–307.

Halewood, Michael (2005) "A.N. Whitehead, Information and Social Theory." *Theory, Culture & Society*, vol. 22(6), 73–94

Hallward, Peter (2006) *Out of This World: Deleuze and the Philosophy of Creation*. London: Verso.

Haraway, Donna J. (1991) *Simians, Cyborgs and Women: The Reinvention of Nature*. New York: Routledge.

Hård, Mikael & Jamison, Andrew (2005) *Hubris and Hybrids: A Cultural History of Technology and Science*. New York: Routledge.

Hardin, Michael (1997) "Mapping Post-War Anxieties onto Space: *Invasion of the Body Snatchers* and *Invaders from Mars*. *Enculturation*, Vol. 1, No. 1, Spring 1997, <http://enculturation.gmu.edu/1_1/hardin.html>. Accessed 13.3.2007.

Hardt, Michael & Negri, Antonio (2000) *Empire*. Cambridge, MA. & London: Harvard University Press.

Hardt, Michael & Negri, Antonio (2004) *Multitude: War and Democracy in the Age of Empire*. New York: Penguin Press.

Harley, David, Slade, Robert, & Gattiker, Urs E. (2001) *Viruses revealed! Understand and Counter Malicious Software*. New York: Osborne/McGraw-Hill.

Harrasser, Karin (2002) "Transforming Discourse Into Practice: Computerhystories and Digital Cultures Around 1984." *Cultural Studies,* vol. 16(6), 820–832.

Hayles, Katherine N. (1999) *How We Became Posthuman: Virtual Bodies in Cybernetics, Literature, and Informatics*. Chicago & London: University of Chicago Press.

Hebdige, Dick (1985) *Subculture: The Meaning of Style*. London & New York: Methuen.

Heidegger, Martin (1993) *Basic Writings: From Being and Time (1927) to The Task of Thinking (1964)*. Edited by David Farrell Krell. San Francisco: Harper.

Heidegger, Martin (1996) *Being and Time*. (Orig. 1927). Translated by Joan Stambaugh. Albany, NY: SUNY Press.

Heims, Joshua (1980) *John Von Neumann and Norbert Wiener: From Mathematics to the Technologies of Life and Death*. Cambridge, MA: The MIT Press.

Helmreich, Stefan (2000a) "Flexible Infections: Computer Viruses, Human Bodies, Nation-States, Evolutionary Capitalism." *Science, Technology, & Human Values*, vol. 25(4), Autumn 2000, 472–491.

Helmreich, Stefan (2000b) *Silicon Second Nature: Culturing Artificial Life in a Digital World*. Updated edition with a New Preface. Berkeley, CA: University of California Press.

Heylighen, Francis & Joslyn, Cliff (2001) "Cybernetics and Second-Order Cybernetics." In: *Encyclopedia of Physical Science & Technology*, edited by R.A. Meyers, 3rd Edition. New York: Academic Press.

Highland, Harold Joseph (1991a) "The BRAIN Virus: Fact and Fantasy" (Orig. 1988). In: *Computers Under Attack: Intruders, Worms, and Viruses*, edited by Denning, Peter J. New York: Addison-Wesley, pp. 293–298.

Highland, Harold Joseph (1991b) "Computer Viruses – A Post Mortem" (Orig. 1988). In: *Computers Under Attack: Intruders, Worms, and Viruses*, edited by Denning, Peter J. New York: Addison-Wesley, pp. 299–315.

Hillis, Daniel (1989) *The Connection Machine*. (Orig. 1986). Cambridge, MA: MIT Press.

Hillis, Daniel (1992) "Co-Evolving Parasites Improve Simulated Evolution as on Optimization Procedure." In: Artificial Life II, SFI Studies in the Sciences of Complexity, vol. X, edited by C.D.Langton, C.Taylor, J.D.Farmer, and S. Rasmussen. Redwood City, CA: Addison-Wesley, pp. 313–324.

Hiltzik, Michal (1999) *Dealers of Lightning. Xerox PARC and the Dawn of the Computer Age*. New York: HarperBusiness.

History of Computer Security, Early Computer Security Resources. <http://csrc.nist.gov/publications/history/index.html>. Accessed 9.11.2006.

Hofstadter, Douglas (1979) *Gödel, Escher, Bach: an Eternal Golden Braid*. Stanford Terrace, Hassocks: Harvester Press.

Hughes, Thomas P. (1989) *American Genesis: A Century of Invention and Technological Enthusiasm 1870–1970*. New York: Viking.

Huhtamo, Erkki (1995) "Armchair Traveller on the Ford of Jordan: The Home, The Stereoscope and the Virtual Voyager. Mediamatic, vol. 8(2,3). Online at <http://www.mediamatic.net/article-5910-en.html>. Accessed 24.1.2007.

Huhtamo, Erkki (1996) "From Cybernation to Interaction: Ein Beitrag zu einer Archäologie der Interaktivität." In: *Wunschmaschine Welterfindung. Eine Geschichte der Technikvisionen seit dem 18. Jahrhundert.* New York: Springer, 192–207.

Huhtamo, Erkki (1997) "From Kaleidoscomaniac to Cybernerd: Notes Toward an Archaeology of the Media." *Leonardo,* vol. 30(3), 221–224.

Hyppönen, Ari & Turtiainen, Esa (1990) *Virus – Tietokone sairastaa.* Espoo: Suomen ATK-kustannus.

Institute for Computational Engineering and Sciences, University of Texas at Austin. <http://www.ticam.utexas.edu/~organism/bug.html>. Accessed 8.3.2007.

Järvinen, Petteri (1990) *Tietokonevirukset.* Helsinki: WSOY.

Järvinen, Petteri (1991) *Uusi pc-käyttäjän käsikirja.* Helsinki: WSOY.

Johnston, John (1997) "Friedrich Kittler: Media Theory After Poststructuralism." In: *Literature, Media, Information Systems: Essays by Friedrich A. Kittler,* edited and introduced by John Johnston. Amsterdam: G+B Arts International, 2–26.

Johnston, John (2007) "Mutant and Viral: Artificial Evolution and Software Ecology." Article manuscript forthcoming 2008 in: *The Spam Book: On Viruses, Spam, and Other Anomalies from the Dark Side of Digital Culture,* edited by Jussi Parikka and Tony Sampson. Cresskill: Hampton Press.

Kay, Lily E. (2000) *Who Wrote the Book of Life? A History of the Genetic Code.* Stanford, CA: Stanford University Press.

Kelly, Kevin (1995) *Out of Control: The New Biology of Machines, Social Systems, and the Economic World.* Reading, MA: Perseus.

Kelly, Kevin, *Out of Control.* On-line at <http://www.kk.org/outofcontrol/>. Accessed 4.3.2007.

Kittler, Friedrich (1990) *Discourse Networks 1800/1900.* (Orig. 1985). Translated by Michael Metteer, with Chris Cullens. Stanford, CA: Stanford University Press.

Kittler, Friedrich (1993a) "Es gibt keine Software." In *Draculas Vermächtnis. Technische Schriften.* Leipzig: Reclam Leipzig, 225–242. English version "There Is No Software," published in *CTheory* (1996). Online at <http://www.ctheory.net/articles.aspx?id=74>. Accessed 13.3.2007.

Kittler, Friedrich (1993b) "Protected Mode." In *Draculas Vermächtnis. Technische Schriften.* Leipzig: Reclam Leipzig, 208–224.

Kittler, Friedrich (1996) "The History of Communication Media." *Ctheory,* 30.7.1996. Online at <http://www.ctheory.net/text_file.asp?pick=45>. Accessed 13.3.2007.

Kittler, Friedrich (1999) *Gramophone, Film, Typewriter* (Orig. 1986). Translated by Geoffrey-Winthrop-Young & Michael Wutz. Stanford CA: Stanford, CA: Standford University Press.

Kittler, Friedrich (2001) *Eine Kulturgeschichte der Kulturwissenschaft.* 2, verbesserte Auflage. München: Wilhelm Fink.

Kruger, Steven F. (1996) *Aids Narratives; Gender and Sexuality, Fiction and Science.* New York & London: Garland Publishing.

Künzel, Werner & Bexte, Peter (1993) *Allwissen un Absturz. Der Ursprung des Computers.* Frankfurt am Main: Insel.

Lafontaine, Céline (2004) *L'empire cybernétique. Des machines à penser à la pensée machine.* Paris: Èditions du Seuil.

Lampert, Jay (2006) *Deleuze and Guattari's Philosophy of History*. London: Continuum.

Lampo, Luca (2002). "When The Virus Becomes Epidemic." An Interview with Luca Lampo by Snafu and Vanni Brusadin, 18.4.2002. <http://bbs.thing.net/c >. Accessed 24.1.2007.

Langton, Christopher (ed). (1989a) *Artificial Life*: A Proceedings Volume in the Santa Fe Institute in the Sciences of Complexity. Redwood City, CA: Addison-Wesley.

Langton, Christopher (1989b) "Artificial Life." In: *Artificial Life: A Proceedings Volume in the Santa Fe Institute in the Sciences of Complexity*, edited by Christopher Langton. Redwood City, CA: Addison-Wesley, pp. 1–47.

Lash, Scott and Urry, John (1987) *The End Of Organized Capitalism*. Cambridge: Polity Press.

Latour, Bruno (1993) *We Have Never Been Modern*. (orig. 1991). Translated by Catherine Porter. New York & London: Harvester Wheatsheaf.

Latour, Bruno (2004) *Politics of Nature: How To Bring the Sciences Into Democracy*. (orig. 1999). Translated by Catherine Porter. Cambridge, MA & London: Harvard University Press.

Latour, Bruno (2005) *Reassembling the Social: An Introduction to Actor-Network-Theory*. Oxford: Oxford University Press.

Lazzarato, Maurizio (2004) "From Capital-Labour to Capital-Life." *Ephemera: Theory and Politics in Organization*, vol.4(3), August 2004. Online at <http://www.ephemeraweb.org/journal/4-3/4-3index.htm>. Accessed 13.3.2007.

Leary, Timothy (1992) *Chaos & Cyberculture*, edited by Michael Horowitz. Berkeley, CA: Ronin Publishing.

Levy, Steven (1985) *Hackers: Heroes of the Computer Revolution* (Orig. 1984). New York: Dell Books.

Levy, Steven (1992) *Artificial Life: A Report From the Frontier Where Computers Meet Biology*. New York: Vintage Books.

Library of Congress. <http://thomas.loc.gov/>. Accessed 24.8.2006.

Licklider, J.C.R. (1960) "Man-Computer Symbiosis." Orig. in IRE Transactions on Human Factors in Electronics, Volume HFE-1, March 1960, pp. 4–11. Reprinted digitally at <http://memex.org/licklider.pdf>. Accessed 8.3.2007.

Lister, Martin et al. (2003) *New Media. A Critical Introduction*. London: Routledge.

Longley, Dennis (1994a) "Access Control." In: *Information Security Handbook*, edited by William Caelli, Dennis Longley and Michael Shain (Orig. 1991). Basingstoke: Macmillan, 455–544.

Longley, Dennis (1994b) "Security of Stored Data and Programs." In: *Information Security Handbook*, edited by William Caelli, Dennis Longley and Michael Shain. Basingstoke: Macmillan. (Orig. 1991), 545–648.

Lovink, Geert (2003) *Dark Fiber: Tracking Critical Internet Culture*. Cambridge, MA & London: The MIT Press.

Ludwig, Mark A. (1993) *Computer Viruses, Artificial Life and Evolution*. Tucson, AZ: American Eagle.

Ludwig, Mark A. (1996) *The Little Black Book Of Computer Viruses*. (Orig. 1991). E-version. Tucson, AZ: American Eagle.

Lundell, Allan (1989) *Virus! The Secret World of Computer Invaders That Breed and Destroy*. Chicago: Contemporary Books.

Lundemo, Trond (2003) "Why Things Don't Work. Imagining New Technologies From *The Electric Life* to the Digital." In: *Experiencing the Media: Assemblages and Cross-overs*, edited by Tanja Sihvonen and Pasi Väliaho. Turku: University of Turku, 13–28.

Lupton, Deborah (1994) "Panic Computing: The Viral Metaphor and Computer Technology." *Cultural Studies*, vol. 8(3), 556–568.

Mackenzie, Adrian (1996) "'God Has No Allergies': Immanent Ethics and the Simulacra of the Immune System." *Postmodern Culture*, vol. 6(2). Online at < http://www3.iath.virginia.edu/pmc/text-only/issue.196/mackenzie.196>. Accessed 8.3.2007.

Mackenzie, Adrian (2006) *Cutting Code: Software and Sociality*. New York: Peter Lang.

Magner, Lois N. (2002) *History of the Life Sciences*, 3rd edition. New York: Marcel Dekker.

Manovich, Lev (2001) *The Language of New Media*. Cambridge, MA: The MIT Press.

Margulis, Lynn & Sagan, Dorion (1995) *What is Life?* New York: Simon & Schuster.

Marshall, Jon (2003) "Internet Politics in an Information Economy," *Fibreculture Journal*, Issue 1. Online at <http://journal.fibreculture.org/issue1/issue1_marshall.html> Accessed 22.1.2007.

Martin, Emily (1994) *Flexible Bodies: The Role of Immunity in American Culture from the Days of Polio to the Age of AIDS*. Boston: Beacon Press.

Marvin, Carolyn (1988) *When Old Technologies Were New: Thinking About Electric Communication in the Late Nineteenth Century*. New York & Oxford: Oxford University Press.

Massumi, Brian (1992) *A User's Guide to Capitalism and Schizophrenia: Deviations from Deleuze and Guattari*. Cambridge, MA & London: MIT Press.

Massumi, Brian (1993) "Everywhere You Want to Be: Introduction to Fear." In: *The Politics of Everyday Fear*, edited by Brian Massumi. Minneapolis, MN & London: University of Minnesota Press, 3–37.

Massumi, Brian (2002) *Parables for the Virtual: Movement, Affect, Sensation*. Durham, NC & London: Duke University Press.

Massumi, Brian (2005) "The Future Birth of the Affective Fact." In: *Conference Proceedings of Genealogies of Biopolitics*, October 2005. Online at <http://www.radicalempiricism.org/biotextes/textes/massumi.pdf>. Accessed 12.01.2007.

Mattelart, Armand (2003) *The Information Society: An Introduction* (Orig. 2001). Translated by Susan G. Taponier and James A. Cohen. London: SAGE.

Maturana, Humberto & Varela, Francisco (1980) Autopoiesis and Cognition. Dordrecht: D. Reidel.

Mayer, Ruth & Weingart, Brigitte (eds.) (2004a) *Virus! Mutationen einer Metapher*. Bielefeld: Transcript.

Mayer, Ruth & Weingart, Brigitte (2004b) "Viren zirkulieren. Eine Einleitung." In *Virus! Mutationen einer Metapher*, edited by Ruth Mayer and Brigitte Weingart. Bielefeld: Transcript, 7–41.

McAfee, John & Haynes, Colin (1989) *Computer Viruses, Worms, Data Diddlers, Killer Programs & Other Threats to Your System*. New York: St. Martin's Press.

McCarron, Kevin (1996) "Corpses, Animals, Machines and Mannequins: The Body and Cyberpunk." In: *Cyberspace/cyberbodies/cyberpunk: Cultures of Technological Embodiment*, edited by Mike Featherstone and Roger Burrows. London: Sage, 261–273.

McLuhan, Marshall (1962) *The Gutenberg Galaxy*. Toronto: Toronto University Press.

McNeill, William (1998) *Plagues and People*. New York: Anchor Books.

Monod, Jacques (1970) *Le hasard at la nécessité: Essai sur la philosophie naturelle de la biologie moderne*. Paris: Seuil.

Mosco, Vincent (2004) *The Digital Sublime: Myth, Power, and Cyberspace*. Cambridge, MA & London: MIT Press.

Munster, Anna & Lovink, Geert (2005) "Theses on Distributed Aesthetics. Or, What a Network is Not." *Fibreculture Journal*, issue 7. Online at <http://journal.fibreculture.org/issue7/issue7_munster_lovink.html>. Accessed 12.01.2007.

Murphie, Andrew & Potts, Jon (2003) *Culture & Technology*. New York: Palgrave McMillan.

National Information Infrastucture (1994). <http://clinton1.nara.gov/White_House/EOP/OVP/html/nii1.html>. Accessed 13.3.2007.

Naval Historical Center, "The First Computer Bug." <http://www.history.navy.mil/photos/images/h96000/h96566kc.htm>. Accessed 8.3.2007.

Negroponte, Nicholas (1995) *Being Digital*. London: Hodder & Stoughton.

Neumann, John von (1966) *Theory of Self-Reproducing Automata*, edited and compiled by Arthur W. Burks. Urbana, IL & London: University of Illinois Press.

Neumann, Peter (1991) "A Perspective From the RISKS Forum." In: *Computers Under Attack. Intruders, Worms, and Viruses*, edited by Denning, Peter J. New York: Addison-Wesley, pp. 535–543.

Nissenbaum, Helen (2004) "Hackers and the Contested Ontology of Cyberspace." *New Media & Society*, vol. 6(2), 195–217.

Nori, Franziska (2002) "I Love You." In: The I Love You-exhibition Catalogue. Online at: <http://www.digitalcraft.org/index.php?artikel_id=284>. Accessed 7.6.2006.

Olkowski, Dorothea (1999) *Gilles Deleuze and the Ruin of Representation*. Berkeley, CA, Los Angeles, & London: University of California Press.

O'Neill, Mathieu (2006) "Rebels for the System. Virus Writers, General Intellect, Cyberpunk and Criminal Capitalism." *Continuum: Journal of Media & Culture Studies*, vol. 20, No.2, 225-241.

Ornstein, Severo M. (1991) "Beyond Worms." In: *Computers Under Attack: Intruders, Worms, and Viruses*, edited by Denning, Peter J. New York: Addison-Wesley, pp. 518–521.

Otis, Laura (1999) *Membranes: Metaphors of Invasion in Nineteenth-Century Literature, Science and Politics*. Baltimore, MD & London: Johns Hopkins University Press.

Oxford English Dictionary. Online at <http://www.oed.com/>. Accessed 24.8.2006.

Packard, Norman (1989) "Evolving Bugs in a Simulated Ecosystem." In: *Artificial Life*: A Proceedings Volume in the Santa Fe Institute in the Sciences of Complexity, edited by Christopher Langton. Redwood City, CA: Addison-Wesley, pp. 141–155.

Parikka, Jussi (2005a) "Digital Monsters, Binary Aliens-Computer Viruses, Capitalism and the Flow of Information." *Fibreculture Journal*, Issue 4, Contagion and the Diseases of Information, edited by Andrew Goffey. Online at < http://journal.fibreculture.org/issue4/issue4_parikka.html>. Accessed 6.3.2007.

Parikka, Jussi (2005b) "Viral Noise and the (Dis)Order of the Digital Culture." *M/C Journal*, vol. 7 (6), 19 May 2005. Online at <http://journal.media-culture.org.au/0501/05-parikka.php>. Accessed 8.3.2007.

Parikka, Jussi (2005c) "The Universal Viral Machine: Bits, Parasites and the Media Ecology of Network Culture." *CTheory* 12/15/2005. Online at <http://www.ctheory.net/articles.aspx?id=500>. Accessed 7.3.2007.

Parikka, Jussi (2007) "Fictitious Contagions: Computer Viruses in the Science Fiction of the 1970s." In: *SciFi in the Mind's Eye: Reading Science Through Science Fiction*, edited by Margret Grebowicz. Chicago: Open Court.

Parikka, Jussi & Tiainen, Milla (2006) "Kohti materiaalisen ja uuden kulttuurianalyysia-tai representaation hyödystä ja haitasta elämälle." *Kulttuurintutkimus* 23(2), 3–20.

Parisi, Luciana (2004a) *Abstract Sex: Philosophy, Bio-Technology and the Mutations of Desire*. London & New York: Continuum books.

Parisi, Luciana (2004b) "For A Schizogenesis of Sexual Difference." *Identities: Journal for Politics, Gender and Culture*, vol. III(1), Summer 2004, 67–93.

Parker, Donn B. (1976) *Crime by Computer*. New York: Charles Scribner's Sons.

Parker, Donn B. (1991a) "The Trojan Horse Virus and Other Crimoids." In: *Computers Under Attack: Intruders, Worms, and Viruses*, edited by Denning, Peter J. New York: Addison-Wesley, pp. 544–554.

Parker, Donn B. (1991b) "Take a Strong Stand." In: *Computers Under Attack. Intruders, Worms, and Viruses*, edited by Denning, Peter J. New York: Addison-Wesley, pp. 521–522.

Pattee, H.H. (1989) "Simulations, Realizations, and Theories of Life." In: *Artificial Life*: A Proceedings Volume in the Santa Fe Institute in the Sciences of Complexity, edited by Christopher Langton. Redwood City, CA: Addison-Wesley, pp. 63–77.

Patton, Cindy (2002) *Globalizing AIDS*. Minneapolis, MN & London: University of Minnesota Press.

Perry, John (1992) "Core Wars Genetics: The Evolution of Predation." Online at <http://corewar.co.uk/perry.htm>. Accessed 8.3.2007.

Pisters, Patricia (2001) "Glamour and Glycerine. Surplus and Residual of the Network Society: From Glamorama to Fight Club." In: *Micropolitics of Media Culture: Reading the Rhizomes of Deleuze and Guattari*, edited by Patricia Pisters, with the assistance of Catherine M. Lord. Amsterdam: Amsterdam University Press, 125–141.

Pividal, Rafaël (1999) "Leibniz ou le rationalisme poussé jusqu'au paradoxe" (Orig. 1972). In: *La philosophie du monde nouveau du XVI et XVII siècle. Histoire de la Philosophie III*, edited by Francois Châtelet. Paris: Hachette.

Plant, Sadie (1996) "On The Matrix: Cyberfeminist Simulations." In: *Cultures of the Internet: Virtual Spaces, Real Histories, Living Bodies*, edited by Rob Shields. London: Sage, 170–183.

Porush, David (1994) "Hacking the Brainstem: Postmodern Metaphysics and Stephenson's *Snow Crash*." *Configurations*, vol. 2(3), 537–571.

Prigogine, Ilya & Stengers, Isabelle (1984) *Order Out of Chaos: Man's New Dialogue with Nature*. Toronto: Bantam Books.

Progress and Freedom Foundation, The, < http://www.pff.org/>. Accessed 24.8.2006.

Protevi, John (2001) *Political Physics: Deleuze, Derrida and the Body Politic*. London & New York: Athlone Press.

Rasmussen, Steen (1989) "Towards a Quantitative Theory of the Origin of Life." Artificial Life: A Proceedings Volume in the Santa Fe Institute in the Sciences of Complexity, edited by Christopher Langton. Redwood City, CA: Addison-Wesley, pp. 79–104.

Rasmussen, Steen, Knudsen, Carsten, & Feldberg, Rasmus (1992) "Dynamics of Programmable Matter." In: *Artificial Life II*, SFI Studies in the Sciences of Complexity, vol. X, edited by C.D. Langton, C. Taylor, J.D. Farmer, & S. Rasmussen. Redwood City, CA: Addison-Wesley, 211–254.

Ray, Thomas S. (1993) "How I Created Life in a Virtual Universe." Online at <http://www.his.atr.jp/~ray/pubs/nathist/>. Accessed 8.3.2007.

Ray, Thomas S. (1995) "A Proposal to Create Two Biodiversity Reserves: One Digital and One Organic" Online at <http://www.his.atr.jp/~ray/pubs/reserves/>. Accessed 8.3.2007.

Redhead, Steve (2004) *Paul Virilio: Theorist for an Accelerated Culture*. Toronto & Buffalo: University of Toronto Press.

Reith, Gerda (2004) "Uncertain Times. The Notion of 'Risk' and the Development of Modernity." *Time & Society*, vol. 13(2/3), 383–402.

Riskin, Jessica (2003) "The Defecating Duck, Or, The Ambiguous Origins of Artificial Life." *Critical Inquiry*, vol. 20(4), 599–633.

Risks Digest Forum Archives, The. Volumes 1–16 (1985–1995). <http://catless.ncl.ac.uk/Risks>. Accessed 5.3.2007.

Rodowick, D.N. (2001) *Reading the Figural, or, Philosophy After the New Media*. Durham, NC & London: Duke University Press.

Rome, Beatrice K. & Rome, Sydney C. (1971) *Organizational Growth Through Decisionmaking: A Computer-Based Experiment in Educative Method*. New York: American Elsevier.

Ross, Andrew (1990) "Hacking Away at the Counterculture." *Postmodern Culture*, vol. 1(1). Online at <http://www3.iath.virginia.edu/pmc/text-only/issue.990/ross-1.990>. Accessed 13.3.2007.

Ross, Andrew (1991) *Strange Weather: Culture, Science and Technology in the Age of Limits*. London & New York: Verso.

Rucker, Rudy, Sirius, R.U., & Mu, Queen (eds.) (1993) *Mondo 2000: A User's Guide to the New Edge*. London: Thames and Hudson.

Runme.org Say it with Software Art. <http://www.runme.org/>. Accessed 13.3.2007.

Rushkoff, Douglas (1996) *Media Virus! Hidden Agendas in Popular Culture*. New York: Ballantine Books.

Ryan, Thomas J. (1985) *The Adolescence of P-1* (Orig. 1977). New York: Baen Books.

Saarikoski, Petri (2004) *Koneen lumo.Mikrotietokoneharrastus Suomessa 1970-luvulta 1990-luvun puoliväliin*. Jyväskylä: Nykykulttuurin tutkimuskeskuksen julkaisuja 83.

Salmi, Hannu (1995) "Elämän tragedia. Katastrofin pelon historiaa." *Historiallinen Aikakauskirja* 3, 195–203.

Salmi, Hannu (1996) *"Atoomipommilla kuuhun!" Tekniikan mentaalihistoriaa*. Helsinki: Edita.

Salmi, Hannu (2006) "Televisio, tietokone ja tietämisen politiikka." In: *Välimuistiin kirjoitetut. Lukuja Suomen tietoteknistymisen kulttuurihistoriaan*, edited by Hannu Salmi et al. Turku: K&H, 55–79.

Sampson, Tony (2004) "A Virus in Info-Space: The Open Network and Its Enemies." *M/C: A Journal of Media and Culture*. Online at <http://journal.media-culture.org.au/0406/07_Sampson.php>. Accessed 8.3.2007.

Sampson, Tony (2005) "Dr Aycock's Bad Idea: Is the Good Use of Computer Viruses Still a Bad Idea?" *M/C Journal*, vol. 8(1). Online at <http://journal.media-culture.org.au/0502/02-sampson.php>. Accessed 8.3.2007.

Sampson, Tony (2007) "How Networks Become Viral." Forthcoming 2008 in *The Spam Book: On Viruses, Spam, and Other Anomalies from the Dark Side of Digital Culture*, edited by Jussi Parikka and Tony Sampson. Cresskill, NJ: Hampton Press.

Samuelson, Pamela (1991) "Computer Viruses and Worms: Wrong, Crime, or Both?" In: *Computers Under Attack. Intruders, Worms, and Viruses*, edited by Denning, Peter J. New York: Addison-Wesley Publishing Company, 479–485.

Sarah Gordon's web page. <http://www.badguys.org/>. Accessed 13.3.2007.

Sasso, Robert & Villani, Arnaud (eds.) (2003) *Le Vocabulaire de Gilles Deleuze*. Nice: Les Cahiers de Noesis. Centre de Recherches d'Histoire des Idées, l'Université de Nice-Sophia Antipolis.

Scherlis, William, Squires, Stephen & Pethia, Richard (1991) "Computer Emergency Response." In: *Computers Under Attack: Intruders, Worms, and Viruses*, edited by Denning, Peter J. New York: Addison-Wesley, pp. 495–504.

Schivelbusch, Wolfgang (1977) *Geschichte der Eisenbahnreise. Zur Industrialisierung von Raum und Zeit im 19. Jahrhundert*. München and Wien: Hanser.

Sconce, Jeffrey (2000) *Haunted Media. Electronic Presence from Telegraphy to Television*. Durham, NC & London: Duke University Press.

Selfridge, Oliver G. (1989) "Pandemonium: a paradigm for learning." (Orig. 1958) In: *Neuro-computing. Foundations of Research*. Edited by James A. Anderson and Edward Rosenfeld. Cambridge, MA & London, England: The MIT Press, 117–122.

Seltzer, Mark (1992) *Bodies and Machines*. New York: Routledge.

Sennett, Richard (1994) *Flesh and Stone: The Body and the City in Western Civilization*. London & New York: W.W. Norton & Company.

Serres, Michel (1982) *The Parasite*. Translated by Lawrence R. Schehr. Baltimore, MD & London: Johns Hopkins University Press.

Shain, Michael (1994) "An Overview of Security" (orig. 1991). In: *Information Security Handbook*, edited by William Caelli, Dennis Longley, and Michael Shain. Basingstoke: Macmillan.

Shannon, Claude E. & Weaver, Warren (1949) *The Mathematical Theory of Communication*. Urbana: The University of Illinois Press.

Shaviro, Steven (2003) *Connected, or What it Means to Live in the Network Society*. Minneapolis, MN & London: University of Minnesota Press.

Simon, Herbert A. (1969) *The Sciences of the Artificial*. Cambridge, MA: The MIT Press.

Slack, Jennifer Daryl & Wise, J. Macgregor (2002) "Cultural Studies & Technology." In: *Handbook of New Media. Social Shaping and Consequences of ICTs*, edited by Leah A. Lievrouw and Sonia Livingstone. London: Sage, 485–501.

Slade, Robert (1992) "History of Computer Viruses". <http://members.tripod.com/thermopyle/sladehis.htm#C01>. Accessed 8.3.2007.

Smith, Alvy Ray (1992) "Simple Nontrivial Self-Reproducing Machines." In: Artificial Life II, SFI Studies in the Sciences of Complexity, vol. X, edited by C.D. Langton, C. Taylor, J.D. Farmer, & S. Rasmussen. Redwood City, CA: Addison Wesley, 709–726.

Sontag, Susan (2002) *Illness as Metaphor and Aids and Its Metaphors* (Orig. 1979 and 1989). London: Penguin Books.

Spafford, Eugene H. (1992) "Computer Viruses – A Form of Artificial Life?" In: *Artificial Life II*, SFI Studies in the Sciences of Complexity, vol. X, edited by C.D. Langton, C. Taylor, J.D. Farmer, & S. Rasmussen. Redwood City, CA: Addison-Wesley, pp. 727–745.

Spafford, Eugene H. (1997) "Computer Viruses as Artificial Life." In: *Artificial Life: An Overview*, edited by Christopher G. Langton. Cambridge, MA & London: MIT Press.

Spafford, Eugene, Heaphy, Kathleen & Ferbrache, David (1991) "A Computer Virus Primer." In: *Computers Under Attack: Intruders, Worms, and Viruses*, edited by Denning, Peter J. New York: Addison-Wesley, pp. 316–355.

Speidel, Michelle (2000) "The Parasitic Host: Symbiosis *contra* Neo-Darwinism." *Pli* vol. 9: 119–138.

Spinoza, Benedict (2001) *Ethics*. Translated by W.H. White and A.H. Stirling. Hertfordshire: Wordsworth Editions.

Stengers, Isabelle (2000) "God's Heart and the Stuff of Life." *Pli* vol. 9:86–118.

Stephenson, Neal (1993) *Snow Crash* (Orig. 1992). London: Roc.

Sterling, Bruce (1994) *The Hacker Crackdown: Law and Disorder on the Electronic Frontier* (Orig. 1992). London: Penguin Books.

Stewart, D.J. (2000) "An Essay on the Origins of Cybernetics" (Orig. 1959). <http://www.hfr.org.uk/cybernetics-pages/origins.htm> . Accessed 8.3.2007.

Suominen, Jaakko (2003) *Koneen kokemus. Tietoteknistyvä kulttuuri modernisoituvassa Suomessa 1920-luvulta 1970-luvulle*. Tampere: Vastapaino.

Terranova, Tiziana (2004) *Network Culture: Politics for the Information Age*. London: Pluto Press.

Thacker, Eugene (2004) "Networks, Swarms, Multitudes. Part One." *CTheory*, 18.5.2004. Online at <http://www.ctheory.net/articles.aspx?id=422>. Accessed 28.12.2006.

Thacker, Eugene (2005) "Living Dead Networks." *Fibreculture Journal*, Issue 4, Contagion and the Diseases of Information, edited by Andrew Goffey. Online at <http://journal.fibreculture.org/issue4/issue4_thacker.html>. Accessed 6.3.2007.

Theriault, Carole (1999) "Computer Viruses Demystified." <http://www.securitytechnet.com/resource/rsc-center/vendor-wp/sopho/demy_wen.pdf>. Accessed 13.3.2007.

Tierra Web Page (Thomas S. Ray). <http://www.his.atr.jp/~ray/tierra/>. Accessed 13.3.2007.

Toffler, Alvin (1971) *Future Shock*. Orig. 1970. New York, Bantam Books.

Tomes, Nancy (1998) *The Gospel of Germs: Men, Women, and the Microbe in American Life*. Cambridge, MA & London: Harvard University Press.

Tozzi, Tommaso (1991) "Rebel! Virus.asm." In: *Oppositions '80'*, edited by T. Tozzi. Milan: Amen Editions.

Trogemann, Georg (2005) "Experimentelle und spekulative Informatik." In: *Zukünfte des Computers*, edited by Heausgegeben von Claus Pias. Zürich-Berlin: Diaphanes, 109–132.

Tuhkanen, Mikko (2005) "Judith Butler, Gilles Deleuze ja tulemisen kysymys." *Naistutkimus* vol. 18(2), 4–14.

Tuomi, Ilkka (1987) *Ei ainoastaan hakkerin käsikirja*. Juva: WSOY.

Turing Digital Archive. <http://www.turingarchive.org/>. Accessed 14.12.2006.

Turkle, Sherry (1996) *Life on the Screen. Identity in the Age of the Internet*. London: Weidenfeld & Nicolson.

Turner, Bryan S. (2003) "Social Fluids: Metaphors and Meanings of Society." *Body & Society*, Vol. 9(1), 1–10.

Urry, John (2003) *Global Complexity*. Cambridge: Polity Press.

U.S. Code Collection <http://www4.law.cornell.edu/uscode/>. Accessed 13.3.2007.

Väliaho, Pasi (2003) "From Mediasphere to Mediasophy – Nature, Machine, Media." In: *Experiencing the Media: Assemblages and Cross-overs*, eds. Tanja Sihvonen & Pasi Väliaho. Turku: Media Studies, University of Turku, 281–299.

Vanderbilt News Archive. <http://tvnews.vanderbilt.edu/>. Accessed 13.3.2007.

Van Helvoort, Ton (1996) "When Did Virology Start?" ASM News, vol. 62, n.3, 142–145.

Van Loon, Joost (2000) "Virtual Risks in an Age of Cybernetic Reproduction." In: *The Risk Society and Beyond: Critical Issues for Social Theory*, edited by Barbara Adam, Ulrich Beck, and Joost Van Loon. London: SAGE, 165–181.

Van Loon, Joost (2002a) "A Contagious Living Fluid: Objectification and Assemblage in the History of Virology." *Theory, Culture & Society*, vol. 19(5/6), 107–124.

Van Loon, Joost (2002b) *Risk and Technological Culture: Towards a sociology of virulence*. London: Routledge.

Virilio, Paul (1993) "The Primal Accident." Translated by Brian Massumi. *The Politics of Everyday Fear*, edited by Brian Massumi. Minneapolis, MN & London: University of Minnesota Press, 210–218.

Virilio, Paul & Kittler, Friedrich (1999) "The Information Bomb: A Conversation." Edited and Introduced by John Armitage. In: Special issue on: *Machinic Modulations: new cultural theory & technopolitics. Angelaki: journal of the theoretical humanities*, vol. 4(2), September, 81–90.

Virus Bulletin (1993) *Survivor's Guide to Computer Viruses*. Abingdon: Virus Bulletin.

Virus Bulletin-journal. <http://www.virusbtn.com/>. Accessed 24.8.2006.

Vuorinen, Heikki S. (2002) *Tautinen historia*. Tampere: Vastapaino.

Walker, John (1996) "The Animal Episode." Online at <http://www.fourmilab.to/documents/univac/animal.html>. Accessed 14.12.2006.

Ward, Mark (2000) *Virtual Organisms: The Startling World of Artificial Life*. New York: St Martin's Press.

Wark, McKenzie (1994) "Third Nature." *Cultural Studies*, vol. 8(1), 115–132.

Webdeleuze. <http://www.webdeleuze.com>. Accessed 5.3.2007.

Weingart, Brigitte (2004) "Viren visualisieren: Bildgebung und Popularisierung." In: *Virus! Mutationen einer Metapher*, edited by Ruth Mayer and Brigitte Weingart. Bielefeld: Transcript, 97–130.

Weinstock, Jeffrey A. (1997) "Virus Culture." *Studies in Popular Culture*, vol. 20(1), 83–97. Online at <http://www.pcasacas.org/SPC/spcissues/20.1/weinstock.htm>. Site accessed 8.3.2007.

Whitelaw, Mitchell (2004) *Metacreation: Art and Artificial Life*. Cambridge, MA, & London: MIT Press

Wiener, Norbert (1961) *Cybernetics, or control and communication in the animal and the machine,* 2nd edition. (1st edition 1948). New York & London: M.I.T. Press and John Wiley & Sons.

Wiener, Norbert (1964) God and Golem, Inc. Cambridge, MA: The MIT Press.

Wikipedia <http://en.wikipedia.org/wiki/Main_Page>. Accessed 8.3.2007.

Wiley, Stephen B. Crofts (2005) "Spatial materialism: Grossberg's Deleuzean cultural studies." *Cultural Studies*, vol. 19(1), January 2005, 63–99.

Winograd, Terry & Flores, Fernando (1986) *Understanding Computers and Cognition. A New Foundation for Design*. Norwood, NJ: Ablex Publishing.

Wise, J. Macgregor (1997) *Exploring Technology and Social Space*. London: Sage.

Zielinski, Siegfried (1999) *Audiovisions. Cinema and Television as Entr'actes in History*. Translated by Gloria Custance. Amsterdam: Amsterdam University Press.

Zielinski, Siegfried (2006) *Deep Time of the Media: Toward an Archaeology of Hearing and Seeing by Technical Means*. (Orig. 2002). Translated by Gloria Custance. Cambridge, MA: MIT Press.

Žižek, Slavoj (2004) *Organs Without Bodies: On Deleuze and Consequences*. New York & London: Routledge.

INDEX

General Editor: *Steve Jones*

Digital Formations is an essential source for critical, high-quality books on digital technologies and modern life. Volumes in the series break new ground by emphasizing multiple methodological and theoretical approaches to deeply probe the formation and reformation of lived experience as it is refracted through digital interaction. **Digital Formations** pushes forward our understanding of the intersections—and corresponding implications—between the digital technologies and everyday life. The series emphasizes critical studies in the context of emergent and existing digital technologies.

Other recent titles include:

Leslie Shade
 *Gender and Community in the Social
 Construction of the Internet*

John T. Waisanen
 Thinking Geometrically

Mia Consalvo & Susanna Paasonen
 Women and Everyday Uses of the Internet

Dennis Waskul
 Self-Games and Body-Play

David Myers
 The Nature of Computer Games

Robert Hassan
 The Chronoscopic Society

M. Johns, S. Chen, & G. Hall
 Online Social Research

C. Kaha Waite
 *Mediation and the Communication
 Matrix*

Jenny Sunden
 Material Virtualities

Helen Nissenbaum & Monroe Price
 Academy and the Internet

To order other books in this series please contact our Customer Service Department:
 (800) 770-LANG (within the US)
 (212) 647-7706 (outside the US)
 (212) 647-7707 FAX
To find out more about the series or browse a full list of titles, please visit our website:
 WWW.PETERLANG.COM

DATE DUE
